NET WORKS

Net Works offers an inside look into the process of successfully developing thoughtful, innovative digital media. In many practice-based art texts and classrooms, technology is divorced from the socio-political concerns of those using it. Although there are many resources for media theorists, practice-based students sometimes find it difficult to engage with a text that fails to relate theoretical concerns to the act of creating. *Net Works* strives to fill that gap.

Using websites as case studies, each chapter introduces a different style of web project—from formalist play to social activism to data visualization—and then includes the artists' or entrepreneurs' reflections on the particular challenges and outcomes of developing that web project. Scholarly introductions to each section apply a theoretical frame for the projects.

Combining practical skills for web authoring with critical perspectives on the web, *Net Works* is ideal for courses in new media design, art, communication, critical studies, media and technology, or popular digital/internet culture.

xtine burrough is a media artist, educator, and co-author of *Digital Foundations*. She believes art shapes social experiences by mediating consumer culture and envisioning rebellious practices. As an educator at California State University, Fullerton, she bridges the gaps between art and design histories, theories, and practices. Her website is: www.missconceptions.net.

D0761546

NET WORKS

CASE STUDIES IN WEB ART AND DESIGN

Edited by xtine burrough

Routledge
Taylor & Francis Group

NEW YORK AND LONDON

First published 2012
by Routledge
711 Third Avenue, New York, NY 10017

Simultaneously published in the UK
by Routledge
2 Park Square, Milton Park, Abingdon, Oxon OX14 4RN

Routledge is an imprint of the Taylor & Francis Group, an informa business

© 2012 Taylor & Francis

The right of the editor to be identified as the author of the editorial material, and
of the authors for their individual chapters, has been asserted in accordance with
sections 77 and 78 of the Copyright, Designs and Patents Act 1988.

All rights reserved. No part of this book may be reprinted or reproduced or utilized
in any form or by any electronic, mechanical, or other means, now known or
hereafter invented, including photocopying and recording, or in any information
storage or retrieval system, without permission in writing from the publishers.

Trademark notice: Product or corporate names may be trademarks or registered
trademarks, and are used only for identification and explanation without intent to
infringe.

Library of Congress Cataloging in Publication Data
Net works : case studies in Web art and design / edited by xtine burrough. – 1st ed.
 p. cm.
 Includes bibliographical references and index.
 1. Art and the Internet. 2. Web sites–Case studies. I. Burrough, Xtine.
 II. Title: Case studies in Web art and design.
 NX180.I57N47 2011
 776–dc23

 2011022626

ISBN: 978-0-415-88221-7 (hbk)
ISBN: 978-0-415-88222-4 (pbk)
ISBN: 978-0-203-84794-7 (ebk)

Typeset in Garamond
by Wearset Ltd, Boldon, Tyne and Wear

Printed and bound in the United States of America by Walsworth Publishing
Company, Marceline, MO on acid-free paper.

SUSTAINABLE
FORESTRY
INITIATIVE

Certified Sourcing
www.sfiprogram.org
SFI-00555

The SFI label applies to the text stock.

One wedding + one manuscript: for Paul Martin Lester, my December groom, whom I married just two weeks before sending this manuscript to the publisher. Thank you, always, for your support.

CONTENTS

FIGURES

ACKNOWLEDGMENTS

I would like to thank my colleagues who have encouraged and inspired me to write this book at California State University, Fullerton, including Paul Martin Lester, Tony Fellow, Rick Pullen, Emily Erickson, Henry Puente, Jason Shephard, Genelle Belmas, Laura Triplett, Coral Ohl, and Mark Latonero. Peers and friends, including Lucy HG, Shani, Crystal Adams, Laurie JC Cella, and Jennifer Justice were equally supportive.

Many thanks to each contributor for his/her influence and feedback which shaped the book.

Net Works would not have been possible without the support of Routledge. Matt Byrnie understood this project from day one, Carolann Madden intuitively knew how to keep the ball rolling when Matthew left Routledge in the middle of 2010. Erica Wetter was instrumental in the final stages. I am eternally grateful for her ability to navigate some of the licensing issues left for her to handle in the eleventh hour.

I would like to thank my teachers, both "on and off the mat." Barbara Bannerman, Cindy Anderson, Elizabeth Bolla, and Sasha Papovich kept me relaxed, even in December. Thank you, repeatedly, to Christopher James, Steven Kurtz, Charles Recher, Ellen Rothenberg, and Humberto Ramirez.

Super huge thank you to my students—past, present, and future.

Last, I would like to thank my family. Dear Paul Martin Lester, Viola and Bill Burrough, thank you for your continued support.

CONTRIBUTORS

Peter Baldes is a new media artist and educator. As a member of Virginia Commonwealth University's Painting and Printmaking faculty, his work and teaching focus on the integration of new technologies with the traditions of printmaking, performance, and collaborative art works. With a focus on the use of readily available consumer-level digital tools for artistic production, his courses stress the importance of new media history and literacy as well as the significance of the Internet and browser as a new platform for creative expression. Peter has been creating artworks for the web since 1996 and has been teaching since 2001.

David M. Berry is a Lecturer in the Department of Political and Cultural Studies at Swansea University. He writes widely on issues of code and media theory, and his work includes *Copy, Rip, Burn: The Politics of Copyleft and Open Source* (Pluto Press, 2008), *Understanding Digital Humanities* (Palgrave Macmillan, 2011), and *The Philosophy of Software: Code and Mediation in the Digital Age* (Palgrave Macmillan, 2011).

Jonah Brucker-Cohen is a researcher, artist, and writer. He received his PhD in the Disruptive Design Team of the Networking and Telecommunications Research Group (NTRG), Trinity College Dublin. He is an Adjunct Assistant Professor of Communications in the Media, Culture, Communication Department of New York University Steinhardt School of Culture Education and Human Development, teaches at Parsons MFA Design + Technology, and has also taught at NYU's Interactive Telecommunications Program (ITP). He worked as an R&D OpenLab Fellow at Eyebeam in New York City in 2006–2007. From 2001 to 2004 he was a Research Fellow in the Human Connectedness Group at Media Lab Europe. He received his Masters from ITP in 1999 and was an Interval Research Fellow from 1999 to 2001. His work and thesis focuses on the theme of "Deconstructing Networks," which includes projects that attempt to critically challenge and subvert accepted perceptions of network interaction and experience. He is co-founder of the Dublin Art and Technology Association (DATA Group) and a recipient of the ARANEUM Prize sponsored by the Spanish Ministry of Art, Science, and Technology and Fundacion ARCO. His writing has appeared in numerous international publications including *WIRED Magazine, Make Magazine, Neural, Rhizome. org, Art Asia Pacific, Gizmodo* and more, and his work has been shown at events such as DEAF (2003, 2004), Art Futura (2004), SIGGRAPH (2000, 2005), UBICOMP (2002, 2003, 2004), CHI (2004, 2006), Transmediale (2002, 2004, 2008), NIME (2007), ISEA (2002, 2004, 2006, 2009), Institute of Contemporary Art in London (2004), Whitney Museum of American Art's ArtPort (2003), Ars Electronica (2002, 2004, 2008), Chelsea Art Museum, ZKM Museum of Contemporary Art (2004–2005), Museum of Modern Art (MOMA—NYC) (2008), and the San Francisco Museum of Modern Art (SFMOMA) (2008).

xtine burrough is a media artist, educator, and co-author of *Digital Foundations* (New Riders/AIGA, 2009). Informed by the history of conceptual art, she uses social networking, databases, search engines, blogs, and applications in combination with popular sites like Facebook, YouTube, and Mechanical Turk, to create web communities that promote interpretation and autonomy. xtine believes art shapes social experiences by mediating consumer culture with rebellious practices. As an educator, she bridges the gap between histories, theories, and production in design and new media education. Her work is archived at www.missconceptions.net.

Critical Art Ensemble (CAE) is a collective of five tactical media practitioners of various specializations including computer graphics and web design, film/video, photography, text art, book art, and performance.

Formed in 1987, CAE's focus has been on the exploration of the intersections between art, critical theory, technology, and political activism. The group has exhibited and performed at diverse venues internationally, ranging from the street, to the museum, to the Internet. Museum exhibitions include the Whitney Museum and the New Museum in New York City; the Corcoran Museum in Washington, DC; the Institute of Contemporary Arts, London; the Museum of Contemporary Art, Chicago; Schirn Kunsthalle, Frankfurt; Musée d'Art Moderne de la Ville de Paris; and the Natural History Museum, London.

The collective has written six books, and its writings have been translated into 18 languages. Its book projects include: *The Electronic Disturbance* (Autonomedia, 1994), *Electronic Civil Disobedience and Other Unpopular Ideas* (Autonomedia, 1996), *Flesh Machine: Cyborgs, Designer Babies, Eugenic Consciousness* (Autonomedia, 1998), *Digital Resistance: Explorations in Tactical Media* (Autonomedia, 2001), *Molecular Invasion* (Autonomedia, 2002), and *Marching Plague* (Autonomedia, 2006).

Beatriz da Costa is an interdisciplinary artist based in Los Angeles. She works at the intersection of art, science, and activism. Da Costa co-founded the artist collective "Preemptive Media," and is an Associate Professor at the University of California, Irvine.

Joseph DeLappe is a media artist/activist and educator. He has been working with electronic and new media since 1983. Projects in online gaming performance, installation, and sculpture have been shown throughout the United States and abroad. A pioneer of gaming performance, much of his work over the past decade has involved taking creative agency in online shooter games and virtual communities. The works engage politics, war, work, play, protest, and human–machine relations, with the intention to critically and conceptually engage while connecting with the everyday; to reify the ordinary into the extraordinary; to intervene in social and political realities both real and virtual.

Michael Demers has taught college-level digital art and new media courses since 2007. His work incorporates culture and cultural identity in a synthesis of critical investigation and his own adolescent preoccupation with toys and other weird ephemera. He is a member of the White Columns Artist Registry (New York), the Rhizome Curated ArtBase (New Museum, New York), BitStream New Media, and is a core commentator for TINT Arts Lab (London). He received his BFA from Florida Atlantic University, an MFA from Ohio University, and a Staatliche Hochschule für Bildende Künste Diplom from the Akademie der Bildenden Künste, Munich.

Eva Díaz is an Assistant Professor of Art and Design History at Pratt Institute. Last year she received her PhD from Princeton University for her dissertation titled "Chance and Design: Experimentation in Art at Black Mountain College."

Constant Dullaart (the Netherlands, 1979, Rietveld Academie Amsterdam, Rijksakademie Amsterdam) is trained as a video artist, his work has recently focused on the Internet and re-contextualizing found material. His works are widely discussed online. Brian Droitcour writes for *Art in America*,

> Dullaart's readymades, however, demonstrate his interest in what might be called "default" style—the bland tables of sans serif text and soulless stock photography that frame ads for some of the most common search terms (auto insurance, cheap airline tickets, pornography), baring the underbelly of the Internet's popular use.

But Dullaart's readymades are more than a formalist exploration of the Internet at its most banal. They are also a study in the relationship of the index to its referent, an issue that Rosalind Krauss connected to the readymade in her 1976 essay "Notes on the Index, Part 1." Krauss defines indices as "the traces of a particular cause, and that cause is the thing to which they refer, the object they signify." Dullaart is a persistent investigator of new modes of constructing and relating meaning brought about by the Internet. He recently quit his job teaching at the Gerrit Rietveld Academie, and curated several events in Amsterdam, such as the periodically held "Lost and Found" evenings (with his final event in the New Museum), "Contemporary Semantics Beta" in Arti et Amicitiae, and the recently finished exhibition "Versions" in the Dutch Media Art Institute (NIMK). His work is shown internationally in places as the Centre Pompidou in Paris; Art in General and MWNM gallery in New York; Institute of Contemporary Arts, London; Montevideo, NIMK; de Appel, W139; the Stedelijk Museum, Ellen de Bruijne projects, and Gallery West. Dullaart lives/works in Berlin and Amsterdam.

Amy Franceschini (www.futurefarmers.com) is an artist and educator who uses various media to encourage formats of exchange and production, often in collaboration with other practitioners. An over-arching theme in her work is a perceived conflict between humans and nature. Her projects reveal the history and currents of contradictions related to this divide by collectively challenging systems of exchange and the tools we use to "hunt" and "gather." Using this as a starting point, she often provides a playful entry point and tools for an audience to gain insight into deeper fields of inquiry—not only to imagine, but to participate in and initiate change in the places we live.

Amy founded the artists' collective and design studio Futurefarmers in 1995, and co-founded Free Soil, an international artist collective in 2004. She is currently a visiting faculty member in the MFA program at California College of the Arts and Stanford University.

Freckles Studio is Antonio Serna and Peggy Tan, two artists who live and work in New York. They work with galleries and artists, musicians, and designers such as Laurie Anderson, David Byrne, and Trisha Brown.

Christian Fuchs is Chair and Professor for Media and Communication Studies at Uppsala University's Department of Informatics and Media Studies. He is also board member of the Unified Theory of Information Research Group, Austria, and editor of *tripleC*

(cognition, communication, co-operation): Open Access Journal for a Global Sustainable Informa-tion Society. Fuchs is author of more than 120 academic publications, including *Inter-net and Society: Social Theory in the Information Age* (Routledge 2008) and *Foundations of Critical Media and Information Studies* (Routledge, 2010). Together with Kees Boersma, Anders Albrechtslund, and Marisol Sandoval, he edits the collected volume *The Internet and Surveillance* (Routledge, 2011). He is coordinator of the research project Social Net-working Sites in the Surveillance Society which is funded by the Austrian Science Fund (FWF). His website is http://fuchs.uti.at.

Ken Goldberg is craigslist Distinguished Professor of New Media, co-founder and past Director of the Berkeley Center for New Media, and Founding Director of Univer-sity of California, Berkeley's Art, Technology, and Culture Lecture Series. He is an artist and Professor of Industrial Engineering and Operations Research at UC Ber-keley, with secondary appointments in Electrical Engineering and Computer Science and the School of Information. Goldberg earned his PhD in Computer Science from Carnegie Mellon University in 1990. Goldberg has published over 150 peer-reviewed technical papers on algorithms for robotics, automation, and social information filter-ing and holds seven U.S. patents. He is Founding co-Chair of the IEEE Technical Committee on Networked Robots and co-Founder the IEEE Transactions on Auto-mation Science and Engineering (T-ASE). Goldberg's art installations have been exhibited internationally at venues such as the Whitney Biennial, Centre Pompidou in Paris, Buenos Aires Biennial, and the ICC in Tokyo. Goldberg was awarded the Presidential Faculty Fellowship in 1995 by President Clinton, the National Science Foundation Faculty Fellowship in 1994, the Joseph Engelberger Award in 2000, and was named IEEE Fellow in 2005. Ken Goldberg lives in Mill Valley, CA with his daughters and wife, filmmaker and Webby Awards founder Tiffany Shlain.

Stamatina Gregory is an independent curator and critic. She is a doctoral candidate at the Graduate Center at the City University of New York, writing on contemporary landscape photography, militarism, activism, and the media.

The influence of **Ethan Ham**'s former career in game development can be seen in the art he makes. The artworks are often playful and demonstrate his continuing inter-est in the interaction between an artwork and its beholder. Ethan's artworks often explore themes of translation and mutation. His projects include literary/art hybrids, kinetic sculptures, and Internet-based artworks. Ethan is an Assistant Professor of New Media at the City College of New York.

Marc Horowitz is a Los Angeles-based interdisciplinary artist, working primarily with performance, video, and installation. The central concerns driving most of his work have to do with engaging strangers in public and on the Internet around an absurd-ist principle. His projects also aim to engage in a dialogue with a diverse range of subjects from entertainment, advertising, architectural environments, and commerce, to how to find joy and happiness on a day-to-day basis. Continually, the work carries a makeshift, DIY aesthetic; within this world, he is able to encourage and facilitate exchanges of laughter, provocation, problem-solving, and "improved" ways of living. He is constantly making lists of potential inventions, neologisms, money-making schemes, jokes, absurdist drawings, and impromptu actions, which often inform larger projects or reside on his website. His work speaks to "the moment," reflects and critiques American idealism, expansionism, and capitalism, and parodies pop culture so when successful, it becomes re-appropriated by it.

Steve Lambert's father, a former Franciscan monk, and mother, an ex-Dominican nun, imbued the values of dedication, study, poverty, and service to others—qualities which prepared him for life as an artist.

Lambert made international news just after the 2008 U.S. election with the *New York Times* "Special Edition," a replica of the gray lady announcing the end of the wars in Iraq and Afghanistan and other good news. He is the founder of the Anti-Advertising Agency, lead developer of Add-Art (a Firefox add-on replacing online advertising with art). He was a Senior Fellow at the Eyebeam Center for Art and Technology and is faculty at the School of the Museum of Fine Art in Boston. He dropped out of high school in 1993.

David Lu (www.vellum.cc) is a nomadic designer and software developer. He writes software for drawing and mapmaking. David studied design at Interaction Design Institute Ivrea, Italy, and has BA degrees in Computer Science, Economics, and Psychology from Rutgers College. He is also a member of the Drawing Center's curated artist registry.

Conor McGarrigle is a Dublin-based artist and researcher. His work is concerned with mapping, psychogeographical exploration of urban space, and the impact of locative technologies on our perception of the city. He received an MFA from the National College of Art and Design, Dublin and is currently a researcher at the Graduate School for Creative Arts and Media in Dublin, conducting research into participation in locative media.

Michael Mandiberg sold all of his possessions online on Shop Mandiberg, made perfect copies of copies on AfterSherrieLevine.com, and created web browser plug-ins that highlight the environmental costs of a global economy on TheRealCosts.com. He is a co-author of Digital Foundations and Collaborative Futures. A former Senior Fellow at Eyebeam, he is an Assistant Professor at the College of Staten Island/CUNY. He lives, works, and rides his bicycle in Brooklyn. His work lives at Mandiberg.com.

Myriel Milicevic is an artist, researcher, and interaction designer based in Berlin. With her Neighbourhood Satellites (www.neighbourhoodsatellites.com) she explores the hidden connections between people and their natural, social, and technical environments. She received her MA from the Interaction Design Institute, Ivrea, Italy and her diploma in Graphic Design from the Gerrit Rietveld Academie, Amsterdam.

Carlos Motta is a Colombian-born interdisciplinary artist and educator. Working primarily in photography, video, and installation, he engages with political history by employing strategies used in documentary genres and sociology in order to interrogate governmental structures, to observe the repercussions of political events, and to suggest alternative ways in which to interpret those histories.

Eduardo Navas researches the crossover of art and media in culture. His production includes art and media projects, critical texts, and curatorial projects. He has presented and lectured about his work and research internationally. Navas collaborates with artists and institutions in various countries to organize events and develop new forms of publication. He has lectured on art and media theory, as well as practice, at various colleges and universities in the United States, including Otis College of Art and Design, San Diego State University, Penn State University, and Eugene Lang College The New School for Liberal Arts. Navas received his PhD from the Department of Art and Media History, Theory, and Criticism at the University of California in San Diego, and is a Postdoctoral Fellow in the Department of Information Science

and Media Studies at the University of Bergen, Norway. He researches the history of Remix in order to understand the principles of remix culture. Selected texts and research projects are available on Remix Theory at http://remixtheory.net. His main website is http://navasse.net.

Robert Nideffer researches, teaches, and publishes in the areas of virtual environments and behavior, interface theory and design, technology and culture, and contemporary social theory. He holds an MFA in Computer Arts (1997) and a PhD in Sociology (1994), and is a Professor in Studio Art and Informatics at University of California, Irvine. Robert has participated in a number of national and international online and offline exhibitions, speaking engagements and panels for a variety of professional conferences.

Mark Nunes teaches courses in New Media Studies at Southern Polytechnic State University, where he is also Chair for the Department of English, Technical Communication, and Media Arts. He is author of *Cyberspaces of Everyday Life* (University of Minnesota Press, 2006). His most recent work includes an edited collection of essays entitled *Error: Glitch, Noise, and Jam in New Media Cultures* (Continuum, 2010).

Paolo Pedercini is an artist, independent game designer, and educator. His work investigates the relationship between digital entertainment and ideology. On the Internet he is mostly known as *Molleindustria*, an entity that re-appropriates video games as tactical and strategic media. He dreams of a world without barriers between high and low culture, where artists desert galleries and museums to inject critical thinking in mainstream cultural production.

Christian Marc Schmidt is a German/American designer and media artist. Stemming from an interest in working with data, his approach is parametric and content-oriented, often resulting in the design of adaptive systems—dynamic models that change form as their content changes. Generally, his work is concerned with evidence, disclosure, and the materiality of information, while thematically he is interested in modeling individual experiences and behaviors in aggregate to identify patterns that may help describe a collective identity.

Trebor Scholz is a writer, conference organizer, Assistant Professor in Media and Culture, and Director of the conference series "The Politics of Digital Culture" at the New School in New York City. He also founded the Institute for Distributed Creativity, which is known for its online discussions of critical Internet culture, specifically the ruthless casualization of digital labor, ludocapitalism, distributed politics, digital media and learning, radical media activism, and micro-histories of media art. Trebor is co-editor of *The Art of Free Cooperation* (Autonomedia, 2007), a book about online collaboration, and editor of *Digital Labor: The Internet as Playground and Factory* (Routledge, forthcoming). He holds a PhD in Media Theory and a grant from the John D. and Catherine T. MacArthur Foundation. Forthcoming edited collections by Trebor include *The Digital Media Pedagogy Reader* and *The Future University* (both iDC, 2011). His book chapters, written in 2010, zoom in on the history of digital media activism, the politics of Facebook, limits to accessing knowledge in the United States, and mobile digital labor. His forthcoming monograph offers a history of the social web and its Orwellian economies.

Edward A. Shanken writes and teaches about the entwinement of art, science, and technology with a focus on interdisciplinary practices involving new media. He is a researcher at the Amsterdam School for Cultural Analysis at the University of Amsterdam (UvA) and a member of the Media Art History faculty at the Donau

University in Krems, Austria. He was formerly Universitair Docent of New Media at UvA, Executive Director of the Information Science + Information Studies program at Duke University, and Professor of Art History and Media Theory at Savannah College of Art and Design. Recent and forthcoming publications include essays on art and technology in the 1960s, historiography, and bridging the gap between new media and contemporary art. He edited and wrote the introduction to a collection of essays by Roy Ascott, *Telematic Embrace: Visionary Theories of Art, Technology and Consciousness* (University of California Press, 2003). His critically praised survey, *Art and Electronic Media*, was published by Phaidon Press in 2009. Many of his publications can be found on his website: www.artexetra.com.

Brooke Singer is a media artist and educator who lives in Brooklyn. Her practice blurs the borders between science, technology, politics, and art. She works across different media to provide entry into important social issues that are often characterized as specialized to a general public. She is Associate Professor of New Media at Purchase College, State University of New York, and co-founder of the art, technology, and activist group Preemptive Media.

Stefan Sonvilla-Weiss (AT/FI), PhD, is Professor of Communication and Education Technologies in Visual Culture and Head of the international Master of Arts program ePedagogy Design—Visual Knowledge Building at Aalto University/School of Art and Design Helsinki. He coined the term *Visual Knowledge Building*, referring to "a visualization process of interconnected models of distributed socio-cultural encoded data representations and simulations that are structured and contextualized by a learning community." In his research he tries to find answers to how real and virtual space interactions can generate novel forms of communicative, creative, and social practices in global connected communities.

For the last 20 years he has worked as an art and design teacher, media artist, graphic designer, author, multimedia-developer, and university teacher. Sonvilla-Weiss has also served as an expert advisor and reviewer for a number of scientific and research bodies, including the European Commission, and has received several honors and scholarships.

He is the author of *Synthesis and Nullification: Works 1990–2010* (Springer, 2011), *(In)visible: Learning to Act in the Metaverse* (Springer, 2008), *Virtual School: kunstnetzwerk.at* (Peter Lang, 2003), and has edited *Mashup Cultures* (Springer, 2010) and *(e)Pedagogy Design: Visual Knowledge Building* (Peter Lang, 2005).

Fernanda Viégas and **Martin Wattenberg** are digital artists and computational designers. Viégas is known for her pioneering work on depicting chat histories and email. Wattenberg's visualizations of the stock market and baby names are considered Internet classics. The two became a team in 2003 when they decided to visualize Wikipedia, leading to the "history flow" project that revealed the self-healing nature of the online encyclopedia. Their visualization-based artwork has been exhibited in venues such as the Museum of Modern Art in New York, Institute of Contemporary Arts, London, and the Whitney Museum of American Art, New York.

Lee Walton's work takes many forms, including drawing, performance, net art, video, public art, and more. Walton has exhibited and created projects for museums, institutions, and cities both nationally and internationally. His public art is often situational and involves collaboration with numerous participants. His work can be viewed at www.leewalton.com.

INTRODUCTION TO NET WORKS

xtine burrough

This introductory book was written for new media practitioners, artists, and students of communications technologies and media art. As a new media educator who teaches art in a department labeled "communications," I wanted to create a book that I could use in a variety of classroom situations—one that would bridge the gap between theory and practice in a way that satisfies the curiosities of students interested in either or both disciplines. In so many practice-based art texts and classrooms, the technology is divorced from the socio-political concerns of those using it. Meanwhile, there are excellent resources for media theorists, but practice-based students sometimes find it difficult to engage with a text that fails to relate theoretical concerns to the act of creating. In my own classroom, I rely on lectures, discussions, demonstrations, and critiques; but I also use my personal experience both in the commercial industry (albeit, that was long ago) and as a practicing artist. Through dialogue with my colleagues and peers, I realized that many of us tell personal stories in the classroom to help students relate to new technologies. This first-person narrative was something I wanted to capture here. So, remaining true to the spirit of *Net Works*, here is the story of its making:

I first wrote my chapter for this book, "Mechanical Olympics," as a submission to an entirely different edited collection. Had the chapter been rejected, I probably would have put it away until enough time passed that I could regain some sense of confidence with the material. Instead, the editors reported that they had lost my submission. When I mentioned my disappointment in not even being seen to my husband Paul, he suggested that I edit my own collection, using the structure of the chapter I had already completed. Even though it seems like an obvious path now, I never would have thought about organizing this collection if Paul had not suggested it. Thank you, Paul Martin Lester.

In the summer of 2009 I proposed the book to Matthew Byrnie at Routledge and by the end of December we agreed on a contract. I spent the first quarter of 2010 asking artists to write chapters for this book. I did not open a call for submissions because I already had a conceptual map of the book outlined, including the artists whom I had hoped would be willing to participate. In retrospect, I may have opened this to a public call for submissions, but I wanted to complete the manuscript within the year and I knew that the sooner I could confirm each author, the more likely I would meet my deadline. For each of the ten themes governing the chapters in this book, I am well aware that hundreds of other artists have created suitable projects. However, I wanted to keep in mind the technical learning trajectory that a student might be taking. The earliest chapters in this book are about works that are not terribly complicated from a technical perspective, and remain true to themes I tend to address in the first few meetings of an introductory course. I selected the ten themes based on topics I have been teaching in the new media classroom for a decade. This likely ensures that some of the themes will continue to be relevant in future years, while others will surely become outdated. Similarly to the 20 chapter contributions, there are many

other themes that perhaps should have been included. For instance, one contributor asked why I did not include a section about mobile media. Since I never have enough time to reach this topic (or many others) in an introductory practice-based course, it is not surprising that I ran out of page-count for this important topic. In the classroom, mobile media is simply too advanced (we spend the first few weeks writing HTML code by hand) at the time of this writing. In the future, it may be as simple to create applications and projects for mobile media as it is to produce "hello world" in a web browser, but the technology currently requires a steep learning curve for beginners. So, I believe that even if, as *Wired Magazine* declared on the cover of their August 2010 issue, "the web is dead," students will continue to learn how to create interactive, networked-based projects using the methods outlined by artists in the chapters that follow.

The scope and depth of so many of the chapters included in this book push against the boundaries set by the themes of each section. Creating themes is helpful for outlining course material, while simultaneously preventative for those wishing to cross boundaries. One contributor wrote that while she was happy to fulfill the "assignment" I had given, asking her to write about her project with a specific theme in mind, she became aware that her project actually fit several of the section topics in the book. I agreed. My own chapter, which I placed in the "crowdsourcing and participation" section could just as easily fit the themes of "collections and communities" or even "performance." I encourage readers to consider thematizing new media projects as they encounter them, to propose new themes that could-have-would-have-should-have been included in a book such as this, and to rethink the order of the projects in this book, as most fit multiple themes.

By the summer of 2010 I had secured the media scholars and practitioners who agreed to write short introductions to each section. There is a noticeable difference between the scholarly voices of the theorists and the first-person narratives written by the artists/authors of each chapter. The reader is left to find relationships between the introductory texts and their following chapters. In many cases the scholars were able to read the artists' chapters before writing an introduction, but in some instances it was not possible. Like so many books and projects, this one became "finished" about a day before the deadline. By the end of 2010, all of our materials were declared final, and you are reading a version of the text that is just one edit away from being something else entirely.

Finally, I was shy about using the term *net.art* in the title of this book. Many of the artist/authors consider their projects net.art works. However, I wanted this text to appeal to a wider audience. My own students are interested in professional communication industries, including (but not limited to) journalism, advertising, public relations, photography, interactive media design, and entertainment studies. Viral media, communities, collections, crowdsourcing, participation, error/noise, data visualization, surveillance, democracy, open source, hacking and remixing, and performance are topics or practices common to art and communication specialists.

PART I

FORMALISM AND CONCEPTUAL ART

Edward A. Shanken

Many important parallels can be made between conceptual art and the art and technology movement in the 1960s. As a result, the history of conceptual art has great relevance to contemporary artists using the World Wide Web as an artistic medium.

Conceptual art has its roots in the event scores of Fluxus artists such as George Brecht and Yoko Ono, dating from around 1960. Informed by the aesthetic theories of John Cage, these simple textual descriptions served as a "score" to be contemplated or performed, as in La Monte Young's *Composition 1960 #10 To Bob Morris*:

> Draw a straight line
> And follow it.

Conceptual art, as theorized in the work of philosopher and anti-artist Henry Flynt (who coined the term "concept art" in 1961) focused on concepts rather than the physical form of a work, further connecting this emerging tendency to language and away from actions.

> "Concept art" is first of all an art of which the material is "concepts," as the material of, for example, music is sound. Since "concepts" are closely bound up with language, concept art is a kind of art of which the material is language.[1]

Conceptual art was further elaborated in the work of artists such as Sol LeWitt, Joseph Kosuth, Lawrence Wiener, and Art & Language later that decade, also employing language as an essential element. Their work, like that of artists exploring performance and other experimental practices, can be seen as a revolutionary counterbalance to the dominant formalist art theory prescribed by critic Clement Greenberg. Following Greenberg, the physical materiality of paint and canvas took on unprecedented importance in postwar art, exemplified by the New York School of abstract expressionism (including Jackson Pollock, Mark Rothko, and Willem De Kooning.) By contrast, conceptual artists, following Marcel Duchamp, explicitly challenged the "beholder discourse" of modernist formalism. Such postformalist tendencies (to use theorist Jack Burnham's term) were identified as heralding the "dematerialization" of art. Informed by Marxism, many artists sought to undermine the art market's capitalist logic by producing dematerialized works that defied commodification. For example, Brecht's artist's book *Water Yam* (1963), which included many event scores, was published as an "inexpensive, mass-produced unlimited edition ... [in order] to erode the cultural status of art and to help to eliminate the artist's ego."[2]

In his essay "Paragraphs on Conceptual Art" (1967), LeWitt asserted that "In conceptual art the idea or concept is the most important aspect of the work ... [t]he idea

becomes a machine that makes the art ..." Such a notion underlies the artist's wall drawings, in which the "idea" for the work would be written by LeWitt (sometimes accompanied by a diagram) and then executed on site, typically by assistants. In many of them, the title of the work describes the idea that "makes the art," as in *Wall Drawing #46: Vertical Lines, Not Straight, Not Touching, Covering the Wall Evenly* (1970). Kosuth emphasizes "idea" even further, insisting that in conceptual art, the art is not the result of the formal elaboration of an idea, as LeWitt suggests, but that the conceptual core of a work of conceptual art remain an immaterial idea. This conviction is made explicit in his phrase "art as idea (as idea)," which appears as a subtitle in many of his early works. Thus the "art" in Kosuth's classic *One and Three Chairs* (1965) consists not of the formal realization of an idea in a material artwork, but solely in the underlying idea itself, which persists immaterially as an idea.

Conceptual art has sought to analyze the ideas underlying the creation and reception of art, rather than to elaborate another stylistic convention in the historical succession of modernist avant-garde movements. Investigations by conceptual artists into networks of signification and structures of knowledge (that enable art to have meaning) typically have employed text as a strategic device to examine the interstice between visual and verbal languages as semiotic systems. In this regard, conceptual art is a meta-critical and self-reflexive art process. It is engaged in theorizing the possibilities of signification in art's multiple contexts (including its history and criticism, exhibitions and markets). In interrogating the relationship between ideas and art, conceptual art de-emphasizes the value traditionally accorded to the materiality of art objects. It focuses, rather, on examining the preconditions for how meaning emerges in art, seen as a semiotic system.

There are important parallels between the historic practices of conceptual art and the art and technology movement that emerged in the 1960s. The latter, reincarnated in the 1990s as New Media Art, has focused its inquiry on the materials and/or concepts of technology and science, which it recognizes artists have historically incorporated in their work. Its investigations include: (1) the aesthetic examination of the visual forms of science and technology, (2) the application of science and technology in order to create visual forms, and (3) the use of scientific concepts and technological media both to question their prescribed applications and to create new aesthetic models. In this third case, new media art, like conceptual art, is also a meta-critical process. It uses new media in order to reflect on the profound ways in which that very technology is deeply embedded in modes of knowledge production, perception, and interaction, and is thus inextricable from corresponding epistemological and ontological transformations. In doing so, it challenges the systems of knowledge (and the technologically mediated modes of knowing) that structure scientific methods and conventional aesthetic values. Further, it examines the social and aesthetic implications of technological media that define, package, and distribute information.

A visionary pairing of conceptual art and new media took place in the "Software" exhibition (1970). Curator Jack Burnham conceived of "software" as parallel to the aesthetic principles, concepts, or programs that underlie the formal embodiment of actual art objects, which in turn parallel "hardware." He interpreted contemporary experimental art practices, including conceptual art, as predominantly concerned with the software aspect of aesthetic production. In this way, "Software" drew parallels between the ephemeral programs and protocols of computer software and the increasingly "dematerialized" forms of experimental art, which the critic interpreted, metaphorically, as functioning like information processing systems. "Software" included works by conceptual artists such as Kosuth, Robert Barry, John Baldessari, and Les

Levine, whose art was presented beside displays of technology including the first public exhibition of hypertext (*Labyrinth*, an electronic exhibition catalog designed by Ned Woodman and Ted Nelson) and a model of intelligent architecture (*SEEK*, a reconfigurable environment for gerbils designed by Nicholas Negroponte and the Architecture Machine Group at MIT.)[3]

A key figure bridging conceptual art and new media art is Roy Ascott, who used textual and diagrammatic elements in his work, employing the thesaurus as a central metaphor in 1962. While Lucy Lippard's book, *Six Years: The Dematerialization of the Art Object from 1966–1972* (1997), was dedicated to Sol LeWitt, Ascott was prominently quoted on the dedication page. In the mid-1960s, he envisioned remote collaborations between artists, writing that, "Instant person to person contact would support specialised creative work ... An artist could be brought right into the working studio of other artists ... however far apart in the world ... they may separately be located."[4] His classic 1983 telematic artwork, *La Plissure du Text*, used computer networking to link artists around the world, who used ASCI text to create a collaborative "planetary fairy tale." This homage to Roland Barthes' essay, "Le Plaisir du Texte," emphasized the "generative idea" of "perpetual interweaving," but at the level of the tissue itself, which is no longer the product of a single author but is now plaited together through the process of "distributed authorship" on computer networks. At the conceptual core of Ascott's telematic art theory is the idea that computer networking provides "the very infrastructure for spiritual interchange that could lead to the harmonization and creative development of the whole planet." In this light, Ascott's work can be seen as visionary working models of forms of community and sociality that have, in significant ways, emerged over the last two decades.

Since the advent of Graphical User Interfaces (i.e., computer desktops and web browsers) and the World Wide Web in the mid-1990s, many contemporary artists with a prevailing interest in ideas and concepts have mined online media as a vehicle for artistic creation. Fields of practice such as "software art" and "database aesthetics"[5] have emerged as artists have deployed browsers, search engines, databases, and social networks in critical investigations of the technical systems and protocols that construct and disseminate knowledge, structure identity and community, and produce and determine value. In addition to the following case studies of work by Michael Demers and Constant Dullaart, a shortlist of works that offer critical insights into these issues must include wwwwwwwww.jodi.org, the Web Stalker, Bodies INCorporated, Carnivore, They Rule, Female Extension, We Feel Fine, Google Will Eat Itself, The Sheep Market, The Real Costs (see Chapter 15), and A Tool to Deceive and Slaughter. Of particular relevance to the trajectory defined by LeWitt is Casey Reas *et al.*'s *{Software} Structures* (2004), in which the artists used computer code to interpret and implement the conceptual artist's wall drawings as computer programs in order to "explore the potential differences and similarities between software and LeWitt's techniques."[6]

Notes

1. Henry Flynt, "Concept Art," in *An Anthology*, ed. La Monte Young, New York: George Maciunas & Jackson Mac Low, 1962. Note: slight grammar modifications in this quotation were made by the author.
2. Michael Corris, "Fluxus," *Grove Art Online*, Oxford: Oxford University Press, 2007–2010.
3. See Edward A. Shanken, "Art in the Information Age: Technology and Conceptual Art," in *SIGGRAPH 2001 Electronic Art and Animation Catalog*, New York: ACM SIGGRAPH, 2001: 8–15; expanded *Leonardo*, 35, 4, August 2002: 433–438.

4. Roy Ascott, "Behaviourist Art and the Cybernetic Vision," in *Telematic Embrace: Visionary Theories of Art, Technology, and Consciousness*, ed. and intro. by Edward A. Shanken, Berkeley: University of California Press, 2003, 2007.

5. See, for example, Florian Schneider and Ulrike Gabriel, "Software Art" (2001), November 19, 2010, www.netzliteratur.net/cramer/software_art_-_transmediale.html; and Victoria Vesna, ed., *Database Aesthetics: Art in the Age of Information Overflow*, Minneapolis: University of Minnesota Press, 2007.

6. Casey Reas, "A Text about Software and Art," *{Software} Structures* (2004), November 19, 2010. http://artport.whitney.org/commissions/softwarestructures/text.html.

Bibliography

Ascott, Roy. "Behaviourist Art and the Cybernetic Vision." In *Telematic Embrace: Visionary Theories of Art, Technology, and Consciousness*. Ed. and intro. Edward A. Shanken. Berkeley: University of California Press, 2003, 2007.

Corris, Michael. "Fluxus." *Grove Art Online*. Oxford: Oxford University Press, 2007–2010.

Flynt, Henry. "Concept Art." In *An Anthology*. Ed. La Monte Young. New York: George Maciunas & Jackson Mac Low, 1962.

Reas, Casey. "A Text about Software and Art." *{Software} Structures*, 2004. November 19, 2010. Online: http://artport.whitney.org/commissions/softwarestructures/text.html.

Schneider, Florian and Ulrike Gabriel. "Software Art." November 19, 2010. www.netzliteratur. net/cramer/software_art_-_transmediale.html.

Shanken, Edward A. "Art in the Information Age: Technology and Conceptual Art." In *SIGGRAPH 2001 Electronic Art and Animation Catalog*. New York: ACM SIGGRAPH, 2001.

Vesna, Victoria, ed. *Database Aesthetics: Art in the Age of Information Overflow*. Minneapolis: University of Minnesota Press, 2007.

1 COLOR FIELD PAINTINGS (BROWSER)*

Michael Demers

Key Words: Browser, Formalism, Hexadecimal Color, HTML, Javascript, Markup Language, Modernism, Modernity, Source Code

Project Summary

Color Field Paintings (Browser) are online artworks created when website visitors click a link to generate a series of browser windows, each with a randomly assigned color based upon a palette established for the piece. These "paintings" reference the color field paintings that emerged in the late 1950s, but in a digital format.

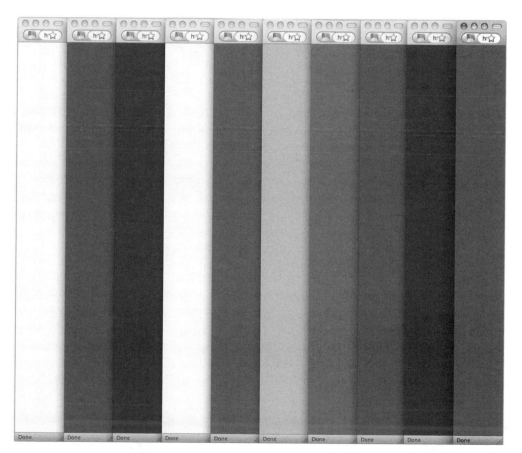

Figure 1.1 *Color Field Paintings (Browser)* by Michael Demers.

7

Figure 1.2 *Color Field Paintings (Browser)* by Michael Demers.

Project Developer Background

Digital art is a tricky field to endorse. Sharing many of the same biases against it as photography endured in its time, digital art is often viewed as a process too new and unfamiliar for many connoisseurs of art and academia to support. Often sacrificing the physical object for a conceptual and technical approach, digital art, like the digital file, finds itself somewhere in the ether, formless and too varied to place into a typical art-historical framework. However, digital art does not have to be ambiguous. One often finds it manifest in mundane and overly familiar territory, such as the personal computer, the browser window, or the inkjet print.

If the great Formalist experiment of the 1950s and 1960s both pointed to and justified an exploration of the most fundamental elements of painting, and presented these findings visually in the form of large canvasses of line, shape, and color, I wondered if there was a parallel to be found for digital art? Could one use the ideas of Formalism's greatest proponent, Clement Greenberg, to justify and ground the objectless digital object?

For the student of digital art these are vital questions, stimulating answers which may determine both success academically as well as in the realm of one's own artistic practice. As a painting student, these were questions that engaged my own work; and as a digital artist, especially within traditional academic circles, these questions remain. What are the fundamental characteristics of digital art, and more specifically, of net art? Can we strip these formless objects down to their most basic elements and still see them function as art objects? If so, what would those objects look like? And is there a way to escape the familiarity of our daily interaction with mundane digital technologies to produce art that speaks to those familiar and mundane characteristics in new ways?

Introduction to *Color Field Paintings (Browser)*

In the summer of 2009 I became interested in the idea of creating a randomly generated online digital work that utilized color as its main focus. Initially I thought of using

javascript (a programming language used to add interactivity to websites) to create a webpage that would cycle through a series of colors that changed depending upon the time of day. Further, I wanted the range of colors to shift within a predetermined array, so that these digital "paintings" would rarely replicate themselves, even if viewed at the same time each day. It didn't take long for me to realize that the code to make such a site work was not only widely available, but was rather mundane. Some code could be used to randomly load an array of colors, other code could recognize the user's time of day, and another line of code could automatically refresh the browser window after a set period of time. How was this work advancing the medium of digital art? Why am I bothering to make such a work, I wondered, if all I am doing is producing the technical and conceptual equivalent of a colorful screensaver?

What my project lacked was conceptual rigor based on an art-historical dialogue. I knew that I wanted to use a particular kind of technology to do something visually specific while recognizing the possibility for variation. This in turn led me to think about what I was originally seeking to explore: color. I thought about the idea of color in Western representation, and the use of color both historically (in Modernist painting and sculpture), and contemporarily (in diverse forms of digital output). More specifically, I thought about color as represented through a browser window, and how that use of color served as a reference to and further investigation of the use of color in Formalist paintings of the 1950s and 1960s.

Technical Description

Browser windows, like Microsoft's Internet Explorer, Apple's Safari, or Mozilla's Firefox, provide the user with a visual representation of what is provided in the webpage's source code. This code is a list of data that tells the browser what content to display (text, images, videos, and so on), and where to place that content. The most basic source code for a webpage looks like this:

```
<html>
<head>
<title> The page title is inserted between the title tags. It is visible to the user at the top of the browser window. </title>
</head>
<body>
The main content of the page is inserted between the body tags. Content that is added here will be displayed on the web page.
</body>
</html>
```

The content of the entire page is situated between the <html> and </html> tags, or the open and close HTML tags. Important instructions to the browser are contained within the <head> and </head> tags. In the example above, instructions for the page title was inserted here. This area is also used to add keywords or meta tags, which make the page easier to catalog for search engines. The main content of the page, including text, images, videos, or other media content, are inserted in the code between the <body> and </body> tags.

Each of the pages in *Color Field Paintings (Browser)* follow this structure, though no media content, in the typical sense, has been included between the body tags. What one

sees in each of these pages is a color based upon instructions given to the browser using javascript, which has been inserted into the <head> and <body> areas. As mentioned earlier, that javascript is both widely available and simple to produce. My aim was to use basic javascript to make the browser display certain colors within the framework and structure of a standard webpage.

There are three main technological aspects to the making of *Color Field Paintings (Browser)*: (1) opening individual browser windows in a specific location, at a specific size; (2) assigning one random color, selected from a specified array of predetermined colors, to load in each window; and (3) automatically closing each browser window in the order that it was initially opened. All of this is accomplished with various lines of javascript code.

1. Opening the Browser Windows

Asking a browser to open windows is basically like asking it to open pop-up advertisements. Given the plethora of junk pop-ups for various sundry services, many users have turned off pop-ups in their browser preferences. My first reaction was to research how to get around this browser security issue. Since the browser has no way of distinguishing between my artistic pop-ups and malware, I later decided that instead of inserting code to break the browser pop-up detection, it would be more ethical if I simply asked the user to allow pop-ups from my domain.

Creating pop-ups is easy, especially when using the Behaviors panel in Adobe's Dreamweaver. The Behaviors panel allows the user to add page events and interactivity from a list of menu options. Dreamweaver adds the javascript code to the HTML page represented by these choices. My code ended up looking like this:

```
<a href="javascript: void(0)" onclick="MM_openBrWindow('1r.htm','','width=100,height=800,top=50,left=100')">
```

In this example, a href="javascript: void(0)" is associated with the phrase "Click here to generate the Color Field Painting." I have multiple paintings available on one page, including red, green, and blue options, so I needed to give the user a way to make her choice. Hence the need to make this particular behavior occur after a link was clicked, as opposed to when the page was opened (as most pop-ups do). This code allows me to create a link to a specific destination, directing the browser to open one of a number of possible windows.

onclick="MM_openBrWindow commands the browser window to open when the user clicks the link, and ('1r.htm','','width=100,height=800,top=50,left=100') dictates which file to open (1r.htm is the first of the windows for the red color field painting), the width and height of the browser window, as well as its position on the screen from the top and left margins.

Of course, this just opens the first window in the series. The code for the remaining windows is not that different, however:

```
<body   onload="MM_openBrWindow('2r.htm','','width=100,height=800,top=50,left=300')">
```

Here, the only substantial difference is that instead of opening the defined window upon clicking the link (onclick), the window opens when the page housing the code is

loaded (onload). This is how typical pop-up advertisements are coded. Thus, the user opens the first window in the painting by clicking a link on the homepage and the remaining nine windows of the painting open automatically.

2. Assigning and Loading Random Colors

Asking the browser window to load a random color is like asking it to load a random image. Each time the browser window is opened or refreshed a new color (or image) can be pulled from an array established in the page source code:

```
var bgcolorlist=new Array("#bd2908", "#c13516", "#c64124", "#d05a40", "#db7962", "#e99c8c", "#f7c1b5", "#fed7ce", "#ffe4dd", "#f0d1ca", "#d9ada2", "#c08172", "#a75645", "#92331f", "#88210a", "#f23208", "#fff6f4", "#5f1505")
document.body.style.background=bgcolorlist[Math.floor(Math.random()*bgcolorlist.length)]
```

Using the red color field painting as an example, the code will load a variable (var) background (bg) color (color) from a list (list), with the colors listed as hexadecimal values. Colors used on the web must be coded in a language the browser can read. Notice these six-digit values as a specific series of letters and numbers preceded by the pound (#) character in the code. Each of three pairs of two-digit values translates one of three color channels used for display on a computer monitor (red, green, and blue) into hexadecimal code. Each time this window is opened in the browser, the background color inherits a different value. When this code is inserted into each of the ten windows constituting the red painting, each panel of the overall painting is assigned a randomly determined shade of red.

3. Automatically Closing Each Browser Window

Once I had each browser window opening in a specific location, and the background colors were loading randomly, I had to address what exactly would happen to the painting after it was produced. Left alone, the user would have to close each window individually (an annoying proposition for the user, to say the least). I researched code that would enable the browser to close itself, which not only took the chore of closing the windows away from the user, but had the added bonus of also keeping the work in an ephemeral and temporary state. With respect to the nature of the medium in which these works were being created, this offered a coherent relationship between form and process. The javascript for this feature is easily defined:

```
setTimeout("self.close();",8000)
```

When inserted into each page, this code tells the browser to close itself (self.close) after a defined duration of time. For this work, the windows would remain open for 8,000 milliseconds, or 8 seconds, before automatically closing.

I produced three versions of the color field paintings: red, green, and blue, representing the computer monitor display mechanics. Computer monitors add various amounts of red, green, and blue light to produce the range of colors visible on the screen. Televisions, projectors, and mobile phone screens all use this additive process for RGB display.

Historical Perspectives

During the height of Modernism in the 1950s, trends in art and painting included degrees of visual abstraction in lieu of realistic representation. A critical theory developed in which the material and technical nature of artistic practices would become of paramount concern. This attitude became known as Formalism, and the American art critic Clement Greenberg would become one of its staunchest supporters.

Greenberg wanted to address the most primal elements in the work of art, its most basic structure. It was only in this way, he surmised, that the work of Modernist art could escape the confines of taste and elevate itself to the respectable level of the Old Masters.

Part of Greenberg's technique for justifying this kind of art was to utilize Immanuel Kant's self-reflexive idea of immanent criticism, a system or process used to investigate that very system or process. "Kant," wrote Greenberg in his seminal essay "Modernist Painting," "used logic to establish the limits of logic, and while he withdrew much from its old jurisdiction, logic was left in all the more secure possession of what remained to it."[1] Greenberg sought to ask questions about the foundational (or formal) elements of a painting by looking to painting itself.

It quickly emerged that the unique and proper area of competence in a work of art coincided with all that was unique to the nature of its medium. The task of self-criticism took root in eliminating the effects on an art work that might conceivably be borrowed from or by the medium of any other work of art. Thereby each artistic medium would be rendered "pure," and in its "purity" find the guarantee of its standards of quality as well as of its independence. "Purity" meant self-definition, and the enterprise of self-criticism in the arts became one of self-definition with a vengeance.[2]

In the case of painting, "Flatness, two-dimensionality, was the only condition painting shared with no other art, and so Modernist painting oriented itself to flatness as it did to nothing else."[3] Important in Greenberg's argument is not just the physicality of flatness but the illusion of representation as well. Traditional painting created the illusion of three-dimensional space through realistic depictions that distract the viewer from what the painting fundamentally is: a flat surface with applied pigment. "Whereas one tends to see what is in an Old Master before seeing it as a picture," Greenberg states, "one sees a [Formalist] painting as a picture first."[4]

Color field paintings emerged in the late 1950s and 1960s within this Formalist context. Consisting of flat fields of color with no discernible representational elements, these were paintings that adhered to the purest Formalist sensibilities. Examining the nature of painting by referencing the most primal elements of painting technologies, these images would "test ... all theories about art for their relevance to the actual practice and experience of art."[5]

Color Field Paintings (Browser) references both the conceptual framework of the original color field paintings, while investigating the formal aspects of internet-based artworks. This web project answers similar questions to those posed by Greenberg in the 1960s.

The basic components of a webpage are the HTML, head, and body tags, within which media content is placed. To state this more essentially, a webpage consists of data placed in the source code. The browser displays content based on this source code. Color, in this context, becomes the one visible source of data that does not

present the viewer with representational media (as would text, images, or video). To bring the color into a useable form by the browser, it must be converted into hexadecimal values. The argument made by *Color Field Paintings (Browser)* is that data, represented by hexadecimal values, is the most basic form of visual representation found on a webpage, the most elemental aspect to the Internet web-based artwork.

Conceptual art, perhaps not surprisingly, continued the Formalist experiment in intellectual investigation, if not the assumed visual aspect. Developing during the mid- to late-1960s, conceptual art used Formalism as an art-historical antecedent to further investigate what constituted the art object, while distancing itself from Formalism in the way objects were constructed and the contexts in which they were viewed. "One of the recurring characteristics in much art that is referred to as conceptual," wrote Alexander Alberro, "is the consideration of every one of the constituting elements of the artwork as equal components."[6] This consideration directly relates to the Formalist critical investigation of each element that comprises a painting or a sculpture, using those elements toward a "self-reflexivity ... that systematically problematizes and dismantles the integral elements of the traditional structure of the artwork."[7] Alberro continues:

> the conceptual in art means an expanded critique of the cohesiveness and materiality of the art object, a growing weariness toward definitions of artistic practice as purely visual, a fusion of the work with its site and context of display, and an increased emphasis on the possibilities of publicness and distribution.[8]

Conceptual art walked a fine line between an art-historical tradition and the object-based aspects of fine art (such as visual concerns, the object in the museum or gallery context, and the exclusive nature of art institutions). How, then, are *Color Field Paintings (Browser)* positioned in this history?

1. The Cohesiveness and Materiality of the Art Object

This is the point most closely associated with Formalism, where the materiality of the object is called into question and put to the task of investigating the object itself. In *Color Field Paintings (Browser)*, the materiality of the virtual object exists in the form of browser code. The object and method of display, the browser window, are cut from the same cloth (digital amalgamations of code). Both are visual representations of data, organized in particular ways.

2. Definitions of Artistic Practice As Purely Visual

While there are undeniable visual aspects to *Color Field Paintings (Browser)*, one could argue that the visual aspects serve a subservient display role to the main content of the work (the hexadecimal values found in the source code), and as such the work is not "purely visual." But when visual art is the subject, the visual must be considered. As Lucy Lippard and John Chandler state in their collaborative essay on conceptual art, "As visual art, a highly conceptual work still stands or falls by what it looks like ... Intellectual and aesthetic pleasure can merge in this experience when the work is both visually strong and theoretically complex."[9] In reference to Alberro's criteria, it is important to stress the phrase "purely visual" recognizes the theoretical basis of the work as a *more significant* concern than the aesthetic details of the work of art.

3. The Work Within Its Site and Context of Display

Whereas conceptual artists were concerned with the context of the art museum or gallery and the impact this context had on the art object, *Color Field Paintings (Browser)*, like many web projects included in this book, rejects this paradigm by existing completely on the web. There is no object in the traditional sense, and the material that comprises the project exists as visualized data (the webpage) within another set of visualized data (the web browser). The conceptual artists of the 1960s (for whom the Internet would have been a fanciful idea) would have been attracted to moving the art object out of the physical art museum or gallery and into a virtual data-based realm. Devoid of an institutional context, the work could finally be viewed on its own terms.

4. Possibilities of Publicness and Distribution

Because this work exists on the web, the nature of distribution far surpasses the potential traditional methods of distribution (the art museum or gallery) previously made available to works of art. According to the International Telecommunication Union, there were 1,587,419.8 global Internet users in 2008. In the United States, the total was 230,630.0.[10] This creates an undeniably greater potential for viewership when the number of visitors to art museums in the United States was 59,822 during the same year.[11] Clearly, the web poses advantages to the distribution of content when compared to analog viewing or distribution practices.

Conclusions and Outcomes

After the success of the first three digital color field paintings (red, green, and blue), I decided to reference the notion of Formalism and color field paintings from the 1960s more explicitly. I created online iterations of historically notable color field paintings following the same compositional arrangements observable in the original works. Two works came to mind immediately: *Where*, by Morris Louis (1960) and *Black Gray Beat*, by Gene Davis (1964). These two paintings consist of vertical bands of alternating color. For both online versions, I sampled color from the original works using Photoshop to determine the hexadecimal value, and placed those color values into the javascript code to generate the random color array.

This work was part of the *HTML Color Codes* exhibition curated by Carolyn Kane of Rhizome. As she stated in her introduction to the exhibition:

> *Color Field Painting ("Where," after Morris Louis)* consists of a series of vertical browser windows that appear consecutively across the screen from left to right ... The piece plays on the codification of online color in the context of art history. Morris Louis' painting "Where" (1960), also consists of a series of multi-colored bands that run vertically on the composition, and all of Demers' color are digitally sampled from this palette. However, where Louis' composition consists of hand-painted lines, and fluid and continuous brush strokes that gently converge at the bottom, Demers' color bars are all formed according to the same rectangular dimensions and orientation. They are also animated in time; after all of the bars have appeared, they disappear after ten seconds, making his appropriation of the original a commentary on the grid-like structure of HTML code, and the ephemeral character of internet art.[12]

Finally, the digital color field paintings referenced the structure of the original Formalist paintings and the digital nature of the medium in which the new work was being presented. The work accomplished what I set out to do in my practice by meeting a conceptual rigor with a technological approach and paying historical homage to the original paintings while maintaining a reflexive understanding of the digital work. Much in the way that Greenberg justified Formalist painting by referencing painting itself, here I had been able to take a similar Kantian approach to the production of a digital object—dispelling, for the time being, traditional biases against emerging digital processes.

Notes

* Images associated with this chapter should be viewed in color. See Routledge website, www.routledge.com/textbooks/9780415882224 or the artists' website, www.michaeldemers.com/colorFieldPaintings_browser.

1. Clement Greenberg, "Modernist Painting," in *Art in Theory*, Malden, MA: Blackwell Publishing, 2003: 774.
2. Ibid.: 775.
3. Ibid.
4. Ibid.
5. Ibid.: 778.
6. Alexander Alberro, "Reconsidering Conceptual Art, 1966–1977," in *Conceptual Art: A Critical Anthology*, Alexander Alberro and Blake Stimson, eds., Cambridge, MA: MIT Press, 2000: xvi–xvii.
7. Ibid.: xvi.
8. Ibid.: xvii.
9. John Chandler and Lucy Lippard, "The Dematerialization of Art," in *Conceptual Art: A Critical Anthology*, Alexander Alberro and Blake Stimson, eds., Cambridge, MA: MIT Press, 2000: 49.
10. International Telecommunications Union, "Internet Indicators: Subscribers, Users and Broadband Subscribers" (2008). Online: www.itu.int/ITUD/icteye/Reporting/ShowReportFrame.aspx?ReportName=/WTI/InformationTechnologyPublic&ReportFormat=HTML4.0&RP_intYear=2008&RP_intLanguageID=1&RP_bitLiveData=False (accessed May 6, 2010).
11. American Association of Museums. Museums FAQ. Online: www.aam-us.org/aboutmuseums/abc.cfm#visitors (accessed May 6, 2010).
12. Carolyn Kane, "HTML Color Codes," Rhizome.org (2009). Online: www.rhizome.org/art/exhibition/html_color_codes (accessed April 15, 2010).

Bibliography

Alberro, Alexander. "Reconsidering Conceptual Art, 1966–1977." In *Conceptual Art: A Critical Anthology*. Ed. Alexander Alberro and Blake Stimson. Cambridge, MA: MIT Press, 2000.

American Association of Museums. Museums FAQ. www.aam-us.org/aboutmuseums/abc.cfm#visitors (accessed May 6, 2010).

Chandler, John and Lucy Lippard. "The Dematerialization of Art." In *Conceptual Art: A Critical Anthology*. Ed. Alexander Alberro and Blake Stimson. Cambridge, MA: MIT Press, 2000.

Greenberg, Clement. "Modernist Painting." In *Art in Theory*. Malden, MA: Blackwell Publishing, 2003.

International Telecommunications Union. "Internet Indicators: Subscribers, Users and Broadband Subscribers" (2008). Online: www.itu.int/ITU-D/icteye/Reporting/ShowReportFrame.aspx?ReportName=/WTI/InformationTechnologyPublic&ReportFormat=HTML4.0&RP_intYear=2008&RP_intLanguageID=1&RP_bitLiveData=False (accessed May 6, 2010).

Kane, Carolyn. "HTML Color Codes." Rhizome.org (2009). Online: www.rhizome.org/art/exhibition/html_color_codes (accessed April 15, 2010).

Links

www.michaeldemers.com/colorFieldPaintings_browser
www.rhizome.org

2 YOUTUBE AS A SUBJECT

Constant Dullaart

Key Words: Conceptual Art, Gesamtkunstwerk, Poster Frame, Screen Time, YouTube

Project Summary

YouTube as a Subject is a tongue-in-cheek series of videos and one sculpture that comment on the temporality of design in everyday life by alluding to the interface used on the online video-sharing platform, YouTube.com. Central to the creation and impact of the work was the ability to post a video response at the location of the original videos on YouTube. Therefore, the responses to my initial series made by other artists have become a key part of the project.

Project Developer Background

Comparisons between media are often made in a discipline-specific historical context and popular culture alike, from the anxieties and fears during their establishment in society (such as the feared negative influence on children resulting from games, television, graphic novels or even books[1]), the celebration of the medium's influence on a better future, to the announcements of their so-called deaths, or exits out of daily use in society. Socrates famously warned against writing because it would "create forgetfulness in the learners' souls, because they will not use their memories."[2] He also advised that since children cannot distinguish fantasy from reality parents should restrict children to wholesome allegories, not improper tales, lest their development go astray. The Socratic warning has been repeated many times since: the older generation warns against a new technology and bemoans that society is abandoning the "wholesome" media it grew up with, seemingly unaware that this same technology was considered to be harmful when first introduced.

In Plato's *Phaedrus*, Socrates warns Phaedrus of the impending downfall of writing (as well as painting and public speaking) as he writes,

> I cannot help feeling, Phaedrus, that writing is unfortunately like painting; for the creations of the painter have the attitude of life, and yet if you ask them a question they preserve a solemn silence. And the same may be said of speeches. You would imagine that they had intelligence, but if you want to know anything and put a question to one of them, the speaker always gives one unvarying answer. And when they have been once written down they are tumbled about anywhere among those who may or may not understand them, and know not to whom they should reply, to whom not: and, if they are maltreated or abused, they have no parent to protect them; and they cannot protect or defend themselves.[3]

Neil Postman, author of the popular book, *Amusing Ourselves to Death*, holds a critical view on the impact of new technologies on media and society. On *PBS Newshour* in 1995, Postman said, "New technology ... always gives us something important, but it also takes away something that is important. That has been true of the alphabet, printing, and telegraphy right up until the computer."[4]

Recent theories about the impact of new technologies on media and society focus more on the Internet and so-called "screen time," not only on the effect of alternate realities on the screen, but also the replacement of social contact, and even the effect of the light itself emitted by the screen influencing a natural day/night rhythm.[5]

The social acceptance period of a medium can be compared to an artist's research of a medium, as I outline in the three steps that follow.

First, the technical possibilities of the medium are often explored, and art is made to exhibit these capabilities. As we can see with the development of film, from the magic lantern until the so-called 4k video of today, new techniques were always introduced with spectacular works to prove their flashy capabilities. For instance, an early celluloid cinema movie by the Lumière brothers, *L'arrivée d'un Train en Gare de la Ciotat*, is associated with an urban legend often told to fans of cinema. The story goes that when the film was first shown, the audience was so overwhelmed by the moving image of a life-sized train coming directly at them that people screamed and ran to the back of the room. Hellmuth Karasek notoriously wrote of the film's impact, causing fear and terror, in the German magazine *Der Spiegel*. However, some have doubted the veracity of this incident, such as film scholar and historian Martin Loiperdinger in his essay "Lumiere's Arrival of the Train: Cinema's Founding Myth."[6] Whether or not it actually happened, the film undoubtedly astonished people in the audience who were unaccustomed to the amazingly realistic illusions created by moving pictures. The Lumière brothers clearly knew that the effect would be dramatic if they placed the camera on the platform very close to the arriving train. Another significant aspect of the film is that it illustrates the use of the long shot to establish the setting of the film, followed by a medium shot, and close-up. (As the camera is static for the entire film, the effect of these various "shots" is generated by the movement of the subject alone.) The train arrives from a distant point and bears down on the viewer, finally crossing the lower edge of the screen.

Eadweard Muybridge's famous works recording movements of animals (using several cameras to take pictures one after the other to show exactly how humans or animals move) seem to be the ultimate use of the technical possibilities of the new medium, film, even while the medium was still in development. Muybridge's works are not only functional, proving the technical capabilities of film, but they are also beautifully composed images.

These works tended to catch the attention of the general public during the establishment of the medium. While technical innovations are new, and offer a fresh way to frame or illustrate ideas, the technical components of new media are interesting on their own. I have never understood why this is true, but it seems that the Internet as a medium is still suffering from the lack of medium-specific content which utilizes new possibilities specific to the medium. The Internet still attracts attention by serving generic, medium-unspecific content (such as articles, photographs, and videos) rather than showcasing its medium-specific capabilities.

Analogies are difficult to draw between the Internet as a medium and older art media such as painting. The Internet is not a static medium, like painting or photography. Although the interests in technical possibilities may have influenced medium-specific content during historic periods in painting or photography, in this case it is hard to do

so since these specific qualities lie so far apart. Comparisons can more easily be made between the birth of cinema, as used in the example above, or very recently video art, and the Internet. Since these are recent media developments, they are fantastically archived for new students. We can go to a museum, an archive, or online to UBUweb to find Bruce Nauman's early films and videos, or installations by Nam June Paik. Comparatively, the developments of these contemporary media are closer to each other in time, and have more similarities and therefore medium-specific qualities that can be compared (such as moving images reproduced on a screen with light).

The second step in artistic-medium research would be to find the boundaries of the technical capabilities in relation to how humans use the media. Here I often think of Nam June Paik's magnets on television monitors that produce a random animation seemingly devoid of connotation, close to today's flurry-effect screensaver on the Mac OS X operating system. Andy Warhol's screen tests were literally tests of the attention span of the subject as well as the audience, and produced intriguing portraits. Jodi's (Dirk Paesmans and Joan van Heemskerk) early CD-ROMs, made to crash the computer they were inserted into, also tested the viewers' (or users') relationship with a new medium.

The third step in researching a new medium is to view the young medium on a metaphysical level, questioning the use of the medium—what is it being used to produce, and how is it being used?

While this outline is not a comprehensive approach to analyzing a new medium, it is the way in which I thought about using the Internet to make art for this project.

Starting Point of the *YouTube as a Subject* Series

With the rise of YouTube's popularity, I found myself critical of approaches made by the latest edition of video-hosting websites. As a video artist with a history of production before the advent of video online, these new video-sharing websites were not the platform I was waiting to use. YouTube was badly designed, the video quality was low, and I had seen more interesting platforms (such as Vimeo and others). YouTube, as a platform, was more interested in the quantity, not quality, of videos uploaded to the website. The necessity for curated video platforms was clear to me, as I was working with the Amsterdam initiative PARK4DTV. From this point of view, I was not yet able to appreciate the social media aspect that makes YouTube popular in mass culture.

For me, the distracting website design, the clumsiness of the play button, and the awkward profile set-ups resonated with my dislike for websites like Myspace. These sites are disorganized, unclear, and open to all kinds of content—which result in an overwhelming amount of poor-quality content (in my opinion, both from an aesthetic and conceptual perspective). Additionally, YouTube, like so many of these types of websites, generates an alibi for people who use the platform to show their failed efforts to make something remarkable or authentic. Of course, I formed these opinions before these social media platforms also became filled with interesting content, and before I found easier ways to utilize social media. To state my appreciation for social media seems unnecessary, as it provides the ability to find a song I want at the moment I think of it, to be able to share ideas, inspiration, and links so much quicker then I ever imagined possible in the beginning of the 1990s. As a user, social media is a dream come true. For instance, Delicious.com provides a platform that has changed my life and practice. However, to stay critical with regard to the media that offer services so welcome is tremendously significant. Lest we lose sight of the economic burden of any new media:

for enormous corporations profit is the biggest interest shaping our technical window on the world. Poor design decisions are symbols of other bad decisions made with regard to social justice issues such as censorship and human rights, or mass media issues such as which video is pushed into the mainstream and what price is to be paid for contemporary entertainment.

At the same time that YouTube was growing in popularity, I was interested in the development of art existing online, not only the presentation and representation of art, but mainly art that would have its most important part exist online, and would therefore be media-specific. The art I wanted to create would have to utilize specific qualities the web had to offer, that other media could not offer. Surrounded by a young generation of artists enthusiastic about a medium, questioning how it is used, and ironically quoting its new vernacular, I found myself interested in the formal aspects of the Internet. What were the parameters and browser limits? What were projects that could be done now, in this time of metaphysical reflection on a medium? How would these online art projects fit in the traditional art world; in other words, how could they be commodified, exhibited, or sold?

Researching these questions during my residency in the Rijksakademie van Beeldende kunsten, I quickly found a lot of these problems had been dealt with decades earlier, for example in the conceptual art movement. In this period I had the pleasure of talking to several influential people from the era that first produced conceptual art. How do works without a physical basis (like a website, or a specific idea, or a performance) get to be commodified, and is it a necessity of the art world to commodify art? The most important lesson that I learned from of all of these conversations is to know your audience, and to have your audience know you. Seth Siegelaub did not need a document proving the Sol LeWitt work he was auctioning was authentic, because it was Seth Siegelaub, after all, and we (the audience) were aware of his role as a dealer and promoter of conceptual art in the 1960s. This seemed like the ideal starting point for a career using social media.

Previous generations worked with invitations through expensive regular mail systems, publications, and galleries. This generation fills out a profile, makes a website, and creates a "web presence" through blogposts, retweets, favorited videos, and so on. One of my early arguments that YouTube was poorly designed continued to burden me. Every now and then a slight improvement on the website would provide hope for the future, but I was still surprised at the fact that so many hours of art, science, instruction, gaming, news, activist, sports, amateur, and music videos watched globally all started with the same image: a badly designed play button in an awkward layout, on a website that was unknown five years before.

Technical Realization

So once I had decided to take the play button as the subject of a video that I would create and upload to YouTube, I took some time to capture the button exactly as it appears on the website. Since the button is designed to be semi-transparent, I needed to use a uniform black background. After some searching, I could not find any video that had a play button over a black background, the so-called "poster frame" was never taken from a black part of a clip (if there was one). So I had to create my own video with only black. After having resolved the screencapture on my computer of the YouTube play button, I imported this image to Final Cut Pro and experimented with basic effects while chatting with my friend, Pascual Sisto, on Skype. Together, we generated some ideas before Pascual came up with the reference to a DVD logo or screensaver.

Most of the effects were made obvious by their names (for instance, "Black and White" converts a color image into a grayscale image), but some were less obvious. I tried all of the video effects available in Final Cut Pro to see which ones were visually attractive. The simplicity of the idea hides how many times I have uploaded videos only to see that YouTube's compression changed the aspect ratio or the size of my video.

Presentation

After having made a series of seven videos, I embedded them on a webpage using HTML, in a simple layout where the videos are stacked one upon the other. I called the webpage and the project *YouTube as a Subject* to emphasize the conceptual nature of the work, and to demonstrate that the medium became the subject of this work of art. This project could be read as a reference to Marshall McLuhan's book and famous line, *The Medium is the Message* (1967), although I thought of the work as a purely formal exercise where the form literally was the content. To have the work exist outside the YouTube website was important to me, as collecting the videos and contextualizing them outside YouTube meant that the work was about the player, and not so much about the social part of the website. Also, this helped to differentiate the idea of the work from the techno-utopian ideas put forth by *The Medium is the Message*. Time passed, and I was happy that I had executed an idea I thought was so obvious. I was surprised nobody else had made the videos I uploaded before I did. I thought this was the end of the project.

I should mention the work made by Cory Arcangel, *Blue Tube*, which was of course an earlier comment on YouTube's design, but had quickly lost significance when YouTube changed their logo on embedded videos. I was happy to post my videos on YouTube as a video response, but I did not consider it a starting point for the *YouTube as a Subject* series, since it was not consciously in my mind when I thought of the work.

Responses

Very soon after the release of the works online, my artist friends started to suggest other possible visual jokes where the YouTube design is a subject. Jokes could be made about the playbar, the loading circle dots, the aspect ratio, and so on. I decided to wait before acting on these, perhaps I felt like doing the more "obvious idea" work on a rainy Sunday afternoon.

Then I received an email from YouTube that user "ilovetoeatmice" had responded to one of my videos; six additional emails like this followed, as well as a Google alert that "Ben Coonley" from Brooklyn, New York City, had made seven video responses to "Constant Dullaart's *YouTube as a Subject*." To me, this was a great compliment and just what I had hoped for: someone was interested in continuing the discussion about YouTube's design, linking new videos to my previous work. Now this meant that my work was

Figure 2.1 Cory Arcangel (US), *Blue Tube*, 2007.

Figure 2.2 Ben Coonley (US), *Be Cool We'll Be Back 100% in a Bit*, 2008. The title references YouTube.com's message during site maintenance.

not just a stand-alone presentation. Since Ben had made his video response about the loading circle animation, he added the following instructions: "For best results, use a dial-up modem connection (28.8 kbit/s or slower) and select YouTube's 'view at high quality' option."[7]

As Ed Halter wrote in his review, "A Series of 'Tubes," on Rhizome.org,

> In true YouTube spirit, Ben Coonley recently posted his own series as response [to Dullart's originals], this time appropriating the spinning wheel of dots that eager viewers need to sit through as a video loads—in keeping with his long-standing interest in media breakdowns and frustrations.[8]

Figure 2.3 Ben Coonley (US), *Opening Ceremonies*, 2008. Both screenshots of Ben Coonley's work were taken from the series, *Seven Video Responses to Constant Dullaart's YouTube as a Subject*.

Figure 2.4 Martin Kohout (CZ), *Moonwalk*, 2008.

Figure 2.5 Adam Cruces (US), *3D YouTube for Constant Dullaart*, 2008.

After this a sequence of responses followed over the next couple of years. I am still delighted if one makes it into my inbox, and every time I talk about the work, I try to mention all of them.

Conclusions and Outcomes

The responses transformed my original seven-video series into a community-based artwork. However, I do not perceive this as a complete work made by several people, as in a "gesamtkunstwerk," but more as a work in which the comments become part of the

Figure 2.6 Julien Levesque (FR), *Most Viewed, All Time, All Category, All Languages*, 2008.

original, without getting lost from their referent. The responses emphasize the medium-specific quality inherent to social media. In this case, the comment is a new medium. The recorded comment was of course already used as a medium in collected response letters to newspapers, or other collected responses to older media formats, but never as quickly or automatically produced, with so many possibilities for individual users or viewers. These possibilities are leading to fast-growing common vernaculars as we continue to use the Internet for social effects.

For the exhibition "Versions" in the Dutch Media Art Institute in Amsterdam (NIMK) I was asked to co-curate and participate in an exhibition around the theme of the comment as a medium. For this exhibition I decided to continue the conversation of the *YouTube as a Subject* series by adding it to the discussion about how to exhibit web-based art, or how to present web-based art in a physical space, by making Ben Coonley's response into a sculpture. Eight white styrofoam balls with a 20 cm diameter were lit by a light system controlled by DMX (a standard fixture that allows one to turn lights on or off, dim lights, or even turn on a fog machine)—a device normally used by amateur disco fanatics. As I was recording the work in order to place it back on YouTube as a response to Ben Coonley's works, Seth Siegelaub, visiting the exhibition opening, passed by the camera. It only struck me later that this small cameo in the documentation of the work was fortuitious. The work had become physical, but would only find its true form on the social networking platform. Later visitors uploaded more documentation of the work to YouTube (without being asked to do so) just because the sculpture reminded them of the YouTube loading balls, a contemporary icon imprinted in their way of experiencing the world online.

Notes

1. See Plato, *Phaedrus*, Fairfield, IA: 1st World Library, 2008: 117, for Socrates' tale of an emperor who rejects the alphabet as it "will create forgetfulness in the learners' souls, because they will not use their memories; they will trust to the external written characters and not remember of themselves." Available online: http://books.google.com/books?id=M8_fP5Vr2b wC&lpg=PP1&dq=phaedrus&pg=PP1#v=onepage&q&f=false.
2. Ibid.: 117.

3. Ibid.: 117–118.
4. Neil Postman, "Visions of Cyberspace," *PBS Newshour*. Online: www.pbs.org/newshour/bb/cyberspace/cyberspace_7-25.html (last modified July 25, 1995; accessed November 20, 2010).
5. See Brightkite Business Wire, "Fact Time Tops Screen Time According to Brightkite Survey." Online: www.businesswire.com/news/home/20090803005674/en/Face-Time-Tops-Screen-Time-Brightkite-Survey (last modified August 3, 2009); John D. Sutter, "Trouble Sleeping? Maybe It's Your iPad," *CNN*. Online: http://edition.cnn.com/2010/TECH/05/13/sleep.gadgets.ipad/index.html?hpt=C1 (last modified May 13, 2010); and Carla Seal-Warner, "Into the Minds of Babes: How Screen Time Affects Children from Birth to Age Five," Review of *Into the Minds of Babes* by Lisa Guernsey, *Television Quarterly*, 38, 2, Winter 2008: 57–60.
6. Martin Loiperdinger and Bernd Elzer, "Lumiere's Arrival of the Train: Cinema's Founding Myth," *The Moving Image*, 4, 1, Spring 2004: 89–118.
7. Ben Coonley, *Be Cool We'll Be Back 100% in a Bit*. Online: www.youtube.com/user/ilovetoeatmicedotcom#p/u/3/AfPsqiP6_yg (accessed November 20, 2010).
8. Ed Halter, "A Series of Tubes," Rhizome.org. Online: http://rhizome.org/editorial/1890 (last modified August 25, 2008).

Bibliography

Brightkite Business Wire. "Fact Time Tops Screen Time According to Brightkite Survey." Online: www.businesswire.com/news/home/20090803005674/en/Face-Time-Tops-Screen-Time-Brightkite-Survey (last modified August 3, 2009).
Halter, Ed. "A Series of Tubes." Rhizome.org. Online: http://rhizome.org/editorial/1890 (last modified August 25, 2008).
Loiperdinger, Martin and Bernd Elzer. "Lumiere's Arrival of the Train: Cinema's Founding Myth." *The Moving Image*, 4, 1, Spring 2004: 89–118.
Plato. *Phaedrus*. Fairfield, IA: 1st World Library, 2008. Available online: http://books.google.com/books?id=M8_fP5Vr2bwC&lpg=PP1&dq=phaedrus&pg=PP1#v=onepage&q&f=false (accessed November 20, 2010).
Postman, Neil. "Visions of Cyberspace." *PBS Newshour*. Online: www.pbs.org/newshour/bb/cyberspace/cyberspace_7-25.html (last modified July 25, 1995; accessed November 20, 2010).
Seal-Warner, Carla. "Into the Minds of Babes: How Screen Time Affects Children from Birth to Age Five." Review of *Into the Minds of Babes* by Lisa Guernsey. *Television Quarterly*, 38, 2, Winter 2008: 57–60.
Sutter, John D. "Trouble Sleeping? Maybe It's Your iPad." *CNN*. Online: http://edition.cnn.com/2010/TECH/05/13/sleep.gadgets.ipad/index.html?hpt=C1 (last modified May 13, 2010).

Links

Corey Arcangel, *Blue Tube*: www.youtube.com/watch?feature=player_embedded&v=1Xn_q_o303E.
Ben Coonley, *Be Cool We'll Be Back 100% in a Bit*: www.youtube.com/user/ilovetoeatmicedotcom#p/u/3/AfPsqiP6_yg.
Ben Coonley, *Opening Ceremonies*: www.youtube.com/user/ilovetoeatmicedotcom#p/u/5/JAsz WelLYEE.
Adam Cruces, *3D YouTube for Constant Dullaart*: www.youtube.com/watch?v=XsB2C3W8n8U.
Constant Dullaart, *YouTube as a Subject*: www.constantdullaart.com/project/youtube-as-a-subject-i.
Martin Kohout, *Moonwalk*: www.youtube.com/watch?v=0DVN4m41QCE.
Julien Levesque, *Most Viewed, All Time, All Category, All Languages*: www.youtube.com/watch?v=YE3AJD6pPng.

PART II
COLLECTIONS AND COMMUNITIES

VIRTUAL COMMUNITIES

An Interview with Howard Rheingold

xtine burrough and Howard Rheingold

In Howard Rheingold's 1993 book, *The Virtual Community*, he established that a virtual community is created "when people carry on public discussions long enough, with sufficient human feeling, to form webs of personal relationships."[1] Since then, popular use of the web includes two-way sharing, social networking, online banking, gaming, and commercial utilities. The two websites outlined in this chapter foster sharing by creating online collections and communities. *WTF?!* is a parody of World of Warcraft (WoW). It is a virtual gaming community for critical thinkers. The *Garden Registry* surveys urban food production zones and enables people to contribute their garden plots and data to a collective map. Users share seeds, harvests, and knowledge both online and in the physical world.

I asked Howard Rheingold a few questions about how he interprets virtual communities in the 2010s.

Q: In your brainstorming article "Virtual Communities, Phony Civil Society?" you wrote,

> When we are called to action through the virtual community, we need to keep in mind how much depends on whether we simply "feel involved" or whether we take the step to actually participate in the lives of our neighbors, and the civic life of our communities.[2]

This resonated with me as important advice for those engaged in using virtual communities, and, more importantly, for the artists and designers who create virtual communities. What steps can one take to ensure that a virtual community is designed in such a way that users are motivated to actually participate in the lives of their neighbors or communities?

HR: 1. Unless there is a compelling reason for anonymity (substance abuse, spousal abuse, whistle-blowing come to mind), insist that people use real names. If they can include pictures of their faces (or avatars—for instance, the way Twitter displays them), all the better.
2. Sponsor face-to-face get-togethers. Sponsors of the online community should secure the physical location and buy refreshments. Encourage community members to do everything else themselves.

3. Enable people to opt-in to email or RSS alerts to events and opportunities in the face-to-face world.
4. Encourage informational potlatching (people can ask each other questions about how to use software of various kinds, for example)—make the network useful to its members.
5. Community organizers ought to participate actively.
6. Encourage people to take action—get out the vote, volunteer, etc. Give them opportunities and information.

Q: On the final page of your 2002 book, *Smart Mobs*, you asked, "Will nascent smart mobs be neutralized into passive, if mobile, consumers of another centrally controlled mass medium? Or will an innovation commons flourish, in which a large number of consumers also have the power to produce?"[3] Reflecting on innovations made in the past eight years, what are your thoughts on the current digital activities of the mass population?

HR: I see BOTH directions happening. The iPad and the advent of "apps" encourage passive media consumption. But look at the explosive growth of Twitter and YouTube. Blogs haven't gone away. More people are using wikis to self-organize. Social media are part of the political toolkit across the political spectrum. At the same time, the Digital Millennium Copyright Act, the breaking of Net Neutrality by Comcast and others, the duopoly of cable/DSL providers for broadband access have narrowed options. The iPad is a great device for consuming digital media, but (so far) not so great for creating and sharing your own.

Notes

1. Howard Rheingold, *The Virtual Community*, Reading: Addison Wesley, 1993. Online: www.rheingold.com/vc/book/intro.html (accessed November 30, 2009).
2. Howard Rheingold, "Virtual Communities, Phony Civil Society?" Rheingold.com, *Rheingold's Brainstorms*. Online: www.rehingold.com/texts/techpolitix/civil.html (accessed July 2, 2010).
3. Howard Rheingold, *Smart Mobs: The Next Social Revolution*, Cambridge, MA: Basic Books, 2002: 215.

Bibliography

Rheingold, Howard. *The Virtual Community*. Reading: Addison Wesley, 1993.
Rheingold, Howard. *Smart Mobs: The Next Social Revolution*. Cambridge, MA: Basic Books, 2002.
Rheingold, Howard. "Virtual Communities, Phoney Civil Society?" Rheingold.com, *Rheingold's Brainstorms*. Online: www.rehingold.com/texts/techpolitix/civil.html (accessed on July 2, 2010).

3 WTF?!

Robert Nideffer

Key Words: Endgame, Extensible Markup Language (XML), Flash, Heterogeneous, Machinima, Massively Multiplayer Online Role Playing Games (MMORPG), Non-Player Character (NPC), Raiding Guild, Software Development Kit (SDK), *World of Warcraft (WoW)*

Project Summary

This chapter discusses a project called *WTF?!,* a parody of the hugely popular Massively Multiplayer Online Role Playing Game *World of Warcraft (WoW).* Think *WoW* meets social theory meets game studies meets, well ... tabloid journalism, since plenty of dirt gets dug up along the way.

Project Developer Background

I tend to be obsessive compulsive. I'm also a bit of a perfectionist. I don't wash my hands a lot, but a pixel off bothers me. This may be fine when it comes to digital design, but it's not so great with other stuff. Over the years I've become skilled at avoidance and/or sublimation, where one learns to displace a negative behavior with one seen to serve a more "socially productive" purpose. In high school the compulsions were punk rock, skateboarding, chewing tobacco, smoking clove cigarettes, drinking, doing recreational drugs, cutting classes, masturbation, and most relevant to the mission here, playing video games. They were actually quite complementary activities ... well ... except for the masturbation part, since the gaming happened largely in public places like bowling alleys, convenience stores, arcades, and dance clubs. I also did a lot of reading and drawing, just not as compulsively. My virtual communities back then were largely imagined, and given form from things like the images found in *Skateboarder* magazine, and the words found in the fantasy/sci-fi literature I consumed. As imagined spaces, they were actually quite flexible and easily modded, they just weren't particularly conducive to synchronous interaction with others over significant amounts of time and space.

Once I took my education seriously and was admitted into university (after paying the dues for my earlier transgressions with a two-plus year stint in four different community colleges spread throughout Southern California), I was able to displace those earlier compulsions with things like exercise, masturbation, and video games. Actually that's not quite true. I didn't play that many video games in university. OK ... so I'd occasionally lose a week here or a month there, but nothing too dramatic or destabilizing. I didn't really start playing seriously again until soon after I took my first faculty position at University of California, Irvine in 1998. It was at that point that I worked very hard to make play my job.

In 1999 I proposed a Minor in Game Studies, and founded the Game Culture and Technology Laboratory. The lab has served as a vehicle to generate funding to support the hiring of talented students to work on projects. In fact, one of the best of those former students, Alex Szeto, has become a key collaborator. Alex and I first started working together when he volunteered to help with a project called *unexceptional.net*[1] which was in development from 2003 to 2006. A couple of years and several projects later, I got the idea for what would become *WTF?!*

Introduction to *WTF?!*

In 2004 one of my art students, Dan Repasky, was in the Game Lab playing a beta release of a new Massively Multiuser Online Role Playing Game (MMORPG) called *World of Warcraft*. Every now and then I'd watch over his shoulder, but it wasn't until 2006 that I began playing *WoW*. For that I blame my colleague Antoinette LaFarge,[2] who seduced me into playing with her husband, her brothers, and her nephews and nieces. They played together as a way to keep in touch and have fun, from various locations around the country. I became a part of their "virtual family," so to speak.

By 2007 there were some eight million *WoW* subscribers worldwide, and, by 2008, that number had jumped to some ten million, with more than two million in Europe, 2.5 million in North America, and about 5.5 million in Asia.[3] As of this writing, *WoW* has more than 12 million subscribers.[4] We don't know much beyond sheer numbers. The registration data collected by Blizzard is, of course, proprietary. Thus reliable data about player's "real-world" identity is difficult to find. The Daedalus Project run by Nick Yee, of Xerox PARC, is starting important work that will attempt to link in-game demographics to real-life player demographics.[5] But projects such as these will always suffer skewed samples, since they require voluntary participation on the part of the player community. Nevertheless, we'll hopefully learn more about the relationship between in-game and out-of-game identity before long.

1. Getting Hardcore

In January 2007, Blizzard released the first major expansion to *WoW* called *The Burning Crusade*. With the initial release of the game in 2004, there were two continents (Eastern Kingdoms and Kalimdor) which together made up the world of "Azeroth," two warring factions (Alliance and Horde), eight races (Dwarves, Gnomes, Humans, and Night Elves on the Alliance side; Orcs, Tauren, Trolls, and Undead on the Horde side), and a level cap of 60. Each continent is composed of "zones," which are bounded regions most easily thought of as analogous to countries. With *The Burning Crusade*, significant new content was introduced, including an entirely new world known as "Outland" (which at times also gets referred to as another continent), two additional races (the Draenei on the Alliance side and the Blood Elves on the Horde side), and a level cap of 70. In November 2008, the second major expansion called *Wrath of the Lich King* was released. Again, a new continent called "Northrend" was introduced, and the level cap jumped to 80. The third major expansion, *Cataclysm*, is poised for release. In *Cataclysm*, the old-world areas that were part of the *Classic* release, Eastern Kingdoms and Kalimdor, will be completely rebuilt, and the level cap will increase to 85. Two additional races will become playable—Goblins and Worgen.

From a design standpoint, *WoW* is multiple games in one. At the most basic level, until one reaches the level cap, *WoW* is essentially a quest-based leveling game. Players

create accounts where they choose a race, class, and sex, set some appearance attributes, select a name, and then begin play. Players can have up to ten characters per account. The designers created consistency in the experience no matter which faction, race, class, or sex was chosen. Each race has a starting area within a predetermined zone, where they "spawn" upon entering the world for the first time. Within the starting zone are NPC (Non-Player Character) quest-givers that gradually introduce the player to the basic game mechanics, as well as the various quest types (solo, group, dungeon, raid, Player versus Player [PvP], repeatable, seasonal) and sub-types (collect, kill, talk, escort, etc.). Entry-level quests are designed to encourage players to learn how to control their character, interact with NPCs, and navigate the starting zone. After the first few levels, the player is given a quest to travel to a new zone, and thus the world begins to expand. Certain zones have major cities which function as hubs of community activity, with shops, auction houses, class and profession trainers, travel ports, dungeon instances, and so on.

Once the level cap is reached, the game fundamentally changes. The experience bar, which was used to track level progress, disappears. The zones have largely been explored, and a majority of the associated leveling quests completed. Some players are content to continue exploring the world, hang out in the major cities making money by trading goods and services, or do the occasional dungeon run, where one groups up with four other players to battle unique bosses that drop desired gear or loot. Gear acquisition is a main motivator in the game. Gear grants statistical bonuses to players, which aides performance. Gear quality scales in relation to encounter difficulty, from "uncommon" rewards to "epic" items.

Raids are large-scale groupings of players, composed of specific classes and abilities, who collaborate to explore dungeons containing difficult "game bosses." In *Classic WoW* the number of players required for a raid was 40. With *The Burning Crusade* that number was reduced to 25, and in certain cases 10. Over the years the developers have increasingly tried to figure out ways to get greater numbers of players to experience the endgame content. This desire has led to a lot of tension within the player community, as many of the competitive players feel that the game has been dumbed-down to pander to the (presumably less-skilled) masses. From the developer standpoint, facilitating more people to see content that takes significant resources to create, and provides some of the most sophisticated game play, is financially sound. It allows casual players to experience all the game has to offer.

To raid, whether with 40, 25, or even 10 players, the most practical organizational framework is that of the Raiding Guild. Raiding Guilds are associations of players that agree to meet in-game at predetermined times in order to figure out how to successfully complete the most difficult dungeon encounters the game has to offer. As one might imagine, these guilds can become extremely competitive. In fact, guilds and their members are rapidly professionalizing, with players receiving sponsorship, payment, and participating in national and international competitions.

It was during *The Burning Crusade* era in 2007 that I became a "hardcore player," meaning that I would spend a considerable number of hours per week, as part of a competitive high-end raiding guild, exploring endgame content. For many, play at this level is like a second job. In fact, I eventually had to stop raiding for reasons of personal health and professional responsibility. I played obsessively for the better part of a year. My story is not particularly unique. I would often spend upwards of 40 hours playing each week. I would stay awake playing until 3 a.m., and wake up four hours later to start again. It got to a point where work, meetings, food, exercise, and relationships all

revolved around raiding and PvP. It was simultaneously exhilarating and exhausting. I was running myself ragged, lying, and making excuses for failing to do things I'd promised at work and at home. I was getting flabby from not going outside, suffering from repetitive stress, and becoming anxious and unpleasant to be around from lack of sleep. I dreamt *WoW* at night, and thought about what gear I needed to get, and how best to tweak my stats, while in front of the class I pretended to be engaged with what I was teaching.

The depth of my involvement and the game environment that facilitated it was fascinating to me, artistically, philosophically, and sociologically. It eventually led to a series of works that I developed in an effort to justify my obsession. It also led to my developing a game-design course organized as a case study of *WoW*, which Blizzard actually sponsored.

WTF?! Proper

Put simply, *WTF?!* is a *WoW*-inspired Flash-based Role-Playing Game (RPG) where an odd assortment of historical and contemporary figures such as Sigmund Freud, Karl Marx, feminist theologian Mary Daly, Albert Einstein, and others have been trapped in a 2D side-scrolling re-creation of *WoW*. The player's job is to help this array of characters make sense of the game world. *WTF?!* is structured to be episodic. The first release in 2008 was a ten-level example showcasing much of the game's core functionality.[6] *WTF?!* attempts to do two main things: faithfully recreate a majority of the *core game mechanics* of *WoW*, a rather Herculean task; and introduce *new* game mechanics extending beyond the conventional combat system to incorporate the notion of *ideological* combat or exchange.

When *WoW* installs on a player's machine, it takes approximately 11GB of hard-disk space. This is a lot of space. Instead of downloading game assets as they are needed, all the assets are stored on and retrieved from the computer hard drive (or locally). Just snippets of text data are spammed back and forth to the server farms in order to keep track of what players are doing and to synchronize activity. In making *WTF?!* I wanted to access, appropriate, and reuse some of that locally stored game data. Luckily I wasn't alone in this desire. A couple of really useful tools had been written, largely to support the emerging machinima (in-game movie-making) community. These tools allowed me to access and extract the actual characters, animations, spell effects, and game graphics used in *WoW*, so I could repurpose them.

The goal in *WTF?!* was to use interesting thinkers as a means to explore a range of issues relating to the work *WoW* does to the player while playing. I wanted to investigate repetition, representation, race,

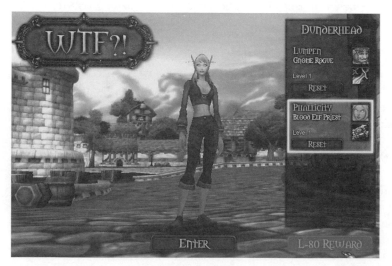

Figure 3.1 *WTF?!* character login screen.

class, gender, combat mechanics, and labor. But I wanted those investigations to be fun, not overly didactic and blatantly educational. So to start, players chose one of two playable characters, "Phallicity," a Blood Elf Priest, or "Lumpen," a Gnome Rogue. The game is different depending upon which character is selected.

Whether selecting Phallicity or Lumpen, the player first meets "Hegemon," a rather dark and swarthy figure surrounded by little pigs. By offering various quests, as in the original *WoW*, Hegemon introduces the player to the different quest types and game interfaces. The nature of those quests, unlike those in *WoW*, asks the player to reflect on game-design mechanics found in *WoW*. Hegemon tries to sway the player into joining his cause. If a player chooses Phallicity, she is eventually sent to the "Rightern" edge of the forest (it *is* a side-scroller after all), she will be asked to spy on "Mr. Marx" who is hanging out in front of a Tavern with his companion "Herr Freud," fomenting a revolution against the likes of Hegemon. Lumpen is sent to the Abbey down by the "Leftern"-most edge, where "Mary Daly" is organizing the wives of Marx, Freud, and other important women who have been written out of history, in an effort to foment a revolution of her own.

The player soon learns that Hegemon is not to be trusted, and if playing Lumpen, aligns with Mr. Marx and Herr Freud. If the player chooses Phallicity, she aligns with Mary Daly. Mr. Marx gives Lumpen a series of tasks. The first requires escorting sheep back to him, so that he can release them from the chains that bind them. Others require him to go to the city and help "Gramsci," who is held captive in a cage, and becomes a key figure in advancing the game. Mary Daly enlists Phallicity to help reduce the "typical male" population by emasculating them, over and over again. Eventually, she too gets sent to the city, where she meets Gramsci as the game continues to unfold. In the interest of those who may actually play *WTF?!*, I will resist the spoiler.

The most time-consuming and rewarding part of *WTF?!* was the way we were able to faithfully reproduce *WoW*'s core game mechanics in the context of a Web-delivered side-scrolling Flash game. I often found myself playing *WTF?!* and becoming frustrated when I couldn't zoom in or rotate the world in 3D, because I'd mistakenly think I was actually playing *WoW*. But even more rewarding was the way we could do things that we wished *WoW* would do, or that *WoW* would never have dared do, with game content as well as with game mechanics and interaction. For example, we could select NPCs and view their gear, something that is impossible in *WoW*. This actually became

an important feature, as it provided a mechanism whereby I could name and describe gear in ways that commented upon the thinkers it had equipped. Mr. Marx's "Materialist Mantle" shoulders, his "Neck of Negation," and his "Feuerbach's Thesis" trinket are all anthropomorphic treatments of graphic elements. So many opportunities for inside jokes presented themselves, and were taken, for so many different communities of players.

Figure 3.2 *WTF?!* NPCs.

Players schooled in Marxist or Freudian theory might appreciate references to their works in the naming of their gear. Players familiar with the lore of *WoW*, and the *WoW* style of game play, might find the nature of the interaction and the way the quests were structured to comment on it amusing. The real hope was that players that *weren't* so familiar with one or the other (or any for that matter), might develop a curiosity for either *WoW* culture and/or contemporary social theory.

Technical Description

I decided to use Flash as the primary development platform. I resisted using Flash for years. The two major works I finished prior to *WTF?!*, *unexceptional.net* and *PROXY*, utilized custom-built, or kluged together, tools and technologies. *PROXY* was developed over a three-year period between 1999 and 2002. It explored alternative strategies for knowledge discovery, file-sharing, and information mis/management in relation to networked identity construction and collective behavior.[7] Both *PROXY* and *unexceptional.net* were centrally concerned with creating communities of users but, rather ironically, because both were developed and deployed with such complex technology requirements, they significantly limited a general audience from experiencing them.

PROXY was created using a custom-designed Java-based multiagent system interfaced to a MOO and Web portal. The project was shown in the Whitney Biennial in 2002, one of the largest and most respected contemporary art exhibitions in the world. During the space of the show, some several hundred new accounts were created. Of those accounts that were created, I would wager far fewer were able to

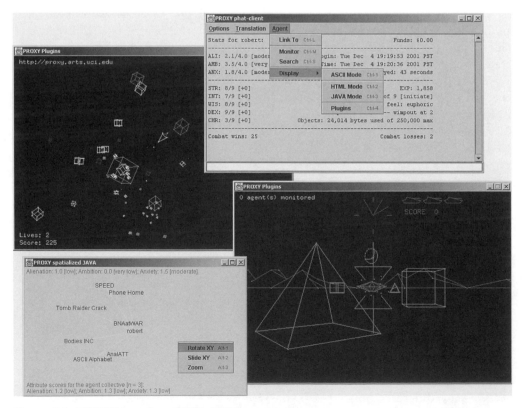

Figure 3.3 *PROXY* interfaces (1999–2002).

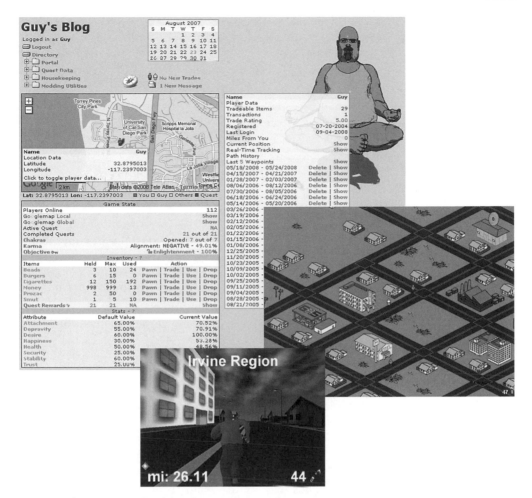

Figure 3.4 *unexceptional.net* interfaces (2003–2006).

successfully install and run the software on their home systems. Of those that did, an even smaller number spent more than a few minutes playing. This was evident to me from tracking various in-game activities such as the amount of data players linked to their agent, the number of MOO spaces that got dynamically created during the ingest process, and so on.

unexceptional.net was even more complicated. Suffice to say it required things like registration through a Web portal, Web questing, dynamic delivery of Blog posts based on player status, real-time Google-mapping of player activity when using GPS-based cell phones as the game client, and three modes of phone play—one where you controlled *in-game* avatars by moving them to partially complete a quest, another where the player's physical body had to move in order to flag a quest as complete, and a third where automated calls were made to players based on their location, which required text-to-speech and speech-to-text translation services so a bot could direct players by speaking commands to accomplish certain goals, or engage in exchanges with other players.

It also required streaming game assets in real-time so that the game world in the phone approximated the physical space the players were in, and streaming assets when playing via a 3D game client, so that the 3D world also corresponded to physical world locations. All of this stuff had to be coordinated so that picking up items when playing

with the phone or in the 3D client were immediately reflected in the Blog, and so on. You can imagine the technical challenges to support all those components. I think it worked flawlessly for *possibly* several months.

I didn't want to repeat those problems. The decision to use a fairly ubiquitous technology like Flash for distributing *WTF?!* had immediate payoffs. As soon as it was posted to Flash-based game sites in late May 2008, *WTF?!* became so popular that our service provider was forced to throttle (reduce bandwidth to) our site. During the first month our distribution site[8] was ranked by Google as one of the top 250,000 most heavily trafficked sites on the Web, placing it in the 99.8th percentile. On average we were getting upwards of 15,000 unique play sessions per day through August.

This popularity was a double-edged sword. It was good to discover that the potential audience was out there, but bad to find out that the volume of traffic would force us to disable the game from running in the Web-browser environment as intended. Instead we had to refer people to a compressed version of the game to download so they could play locally. Much of this traffic resulted from major game and technology websites reviewing and linking to us (such as *WoW Insider*, *Grand Text Auto*, *Newgrounds*, *Kotaku*, *Boing Boing*, among many others). To compensate for this we created a version that other sites and/or individuals could take and distribute from within their own domains. It is impossible to know how many players there were with any certainty, but millions of unique game sessions have been played.

1. Platform Hacking

Even though we used a stable development platform, we still ended up doing things that Flash really wasn't designed to support. As a simple example, with *WTF?!* I wanted to be able to modify or update the project once it was released, similar to the expansions released for *WoW*. To support this, Alex implemented a way to load content in the game stored outside of the Flash executable file during runtime. Things like images used for scrolling backgrounds, objects in various zones, items, rewards, and quest objects could be stored inside sub-directories that the game would load on startup and during zone transitions.

In our initial release, we stored all of the external data required by the game in one central location on a commercial service provider. The not fully anticipated consequence of this approach (since we simply didn't expect to get such a high volume of traffic), which contributed to our service provider throttling us, was that each time a frame of animation was loaded, or an item was spawned, a unique thread was created to handle the request. Thus a single play session would generate thousands of threads, all of which pulled various game assets from our central server. So hundreds of thousands of play sessions equaled … well … you do the math. Even when the game was posted to a third-party Flash-distribution site, whenever it was launched, it would make requests to our server. Fun, fun.

2. XML Pointers and Containers

We decided to use Extensible Markup Language (XML) as the main way to link to game assets, and to contain textual data for *WTF?!* XML provides sets of rules for encoding documents in machine-readable form, and is a textual data format widely used for the representation of arbitrary data structures. Alex wrote a Flash/XML interface that allowed a huge amount of the critical game data to be tagged and stored textually. On startup the game would slurp in all the required XML data, then spit it back out when

the player saved or quit the game. All the definitions for the game environments, asset locations, player stats, character attributes and animations, loot and experience, inventory, equipment, projectile and spell effects, and much more were contained in various XML files. Thus, as a developer, I could drop down into the sub-directory that stored the XML and do some basic script-editing, and fundamentally alter the game world for everyone playing it. I could make hot-fixes, create new items, quests, zones, characters, and whatever else I wanted.

3. Modding

Providing the infrastructure and tools to facilitate content creation, for developers as well as players, has been a major goal in much of my work. The flexibility that Alex's Flash/XML interface gave me was really exciting. Along the way, Alex had also built a few Flash-based tools that allowed me to more easily create content for the game. These tools were quite primitive at the time of our initial release. I decided to convince Alex that we should really focus some time on improving them, and then release them to the Flash game-development community. We worked on this sporadically between 2008 and 2010. Eventually it became a full-blown game-development environment, or, for lack of a better term, "SDK" (Software Development Kit), that we ultimately decided to call the *WTF?! SDK*. The *WTF?! SDK* is a suite of integrated tools that provides a visual front-end to a highly flexible XML scripting environment.

In web development, the front-end is the design-side of the project, or what the user sees; the back-end is the code that makes the project functional. By using the *WTF?! SDK* anyone with a little patience and skill can learn to create custom terrains, characters, equipment, spells and effects, inventory, levels and experience metrics, stats, weather and particle effects, scripted events, quests, and many other advanced features related to the genre of action adventure role-playing game design.

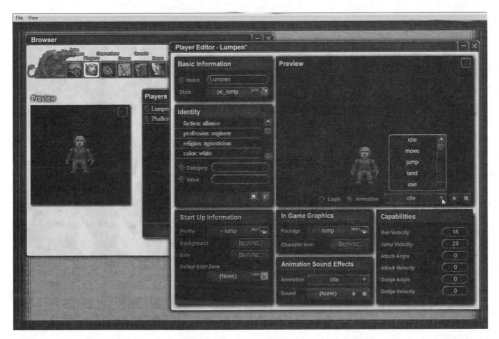

Figure 3.5 *WTF?! SDK* player editor.

Conclusions and Outcomes

Creating *WTF?!* was without doubt some of the most fun I have ever had while developing a project. Alex and I worked on it for the better part of a year. It served as a vehicle for both of us to channel our obsession with *WoW* into something of our own making. Alex, though he hid it well, had in fact fallen far deeper down that rabbit hole than I. We were finally in the position of proactive creation as opposed to reactive consumption. Moreover, for us to be successful we *had* to have intimate knowledge of game design and mechanics, we *had* to research the algorithms behind the surface. In fact, the more intimate we were with the game, the more likely we would succeed! We no longer had to make any excuses for our play! This was wonderfully liberating, and perhaps even a bit therapeutic.

My earlier works more directly addressed the concern of this chapter, the virtual community. They both created a context within which players would have to communicate, share, and engage with each other in order to fully participate in the experience. Also, the result of that engagement was instantly reflected back into the larger game environment. *WTF?!* was different. Although *WTF?!* was designed as a single-player experience *in-game*, in many ways I think the community that formed *around it* was far more vibrant and engaged than with either of the earlier works. Enough people played it that a nascent community formed around it for discussion, gaming help, and criticism.

I also think it is interesting to reflect on what requisite elements must be in place in order to believe a community exists. Traditionally, within the field of sociology, community has been defined as a group of interacting people living in a common location, often sharing values that contribute toward social cohesion. Clearly, these days, geography has become less important. So, one could argue, has biology. Ideas of what constitutes sentience, an ability to perceive and react in relation to an environment, are radically expanding. Even something as mundane and simple as the modification to the NPCs in *WTF?!* can be considered part of a virtual community. They are fairly sophisticated actors, with not entirely predictable scripted behaviors and outcomes.

Riding on the coattails of a hugely popular game like *WoW* allowed me to capitalize on the massive community that had already developed. Although the experience while actively playing *WTF?!* may look *solitary*, the depth of engagement scales in relation to the knowledge one holds, as Benedict Anderson might say "in the imaginary"[9] as part of the larger *WoW* player community, and thus remains quite *social* as it gets reconstructed during play.

Finally, *WTF?!* and the *WTF?! SDK* have served another important purpose. For years I have taught courses on game design. I was forced to explore far more deeply the design decisions, game mechanics, and implementation approaches chosen by the world's most successful **MMORPG** than I would have if I weren't working on *WTF?!* This, in turn, influenced and increased my knowledge base while teaching game design. Similarly, for years I searched for a usable game-development environment for non-programmers. I tried many different commercial and freely available or open-source platforms. All were difficult to use. With the *WTF?! SDK* I was able to solve this problem by working with Alex to create our own. As of this writing I've conducted one class where students successfully used the *WTF?! SDK* to make their own creative projects. I'm on the books to do it again. One of the amazing things I observed while teaching the class, and the required playing of *WoW* and *WTF?!* that went along with it, was how the students and I bonded as we worked and played together, forming our own community—in and out of the classroom, co-present and at a distance; a community we sustained not only during the course, but long after.

Notes

1. http://nideffer.net/promo/proj/unexceptional.html.
2. www.forger.com.
3. Wikipedia, 2010.
4. Adam Holisky, "World of Warcraft reaches 12 million players," *WoW Insider*. Online: http://wow.joystiq.com/tag/wow-player-base (last modified October 7, 2010).
5. Nick Yee, "Be A Part of Our New Study," *The Daedalus Project*. Online: www.nickyee.com/daedalus/archives/001652.php (accessed March 15, 2010).
6. http://aoedipus.net/primer.html.
7. http://nideffer.net/promo/proj/proxy.html.
8. http://aoedipus.net.
9. Benedict Anderson, *Imagined Communities: Reflections on the Origin and Spread of Nationalism*, London: Verso, 1983 (revised and extended, 1991).

Bibliography

Anderson, Benedict. *Imagined Communities: Reflections on the Origin and Spread of Nationalism*. London: Verso, 1983 (revised and extended, 1991).
Holisky, Adam. "World of Warcraft reaches 12 million players," *WoW Insider*. Online: http://wow.joystiq.com/tag/wow-player-base (last modified October 7, 2010).
Wikipedia. "World of Warcraft." 2004–2010. Online: http://en.wikipedia.org/wiki/World_of_Warcraft.
Yee, Nick. "Be Part of Our New Study." *The Daedalus Project*. Online: www.nickyee.com/daedalus/archives/001652.php (accessed March 15, 2010).

Links

AddOns: http://aoedipus.net/addons.
Antoinette LaFarge: www.forger.com.
Daedalus Project: www.nickyee.com/daedalus/archives/001652.php.
PROXY: http://nideffer.net/promo/proj/proxy.html.
UCI Gamelab: http://nideffer.net/proj/gamelab.
unexceptional.net: http://nideffer.net/promo/proj/unexceptional.html.
World of Warcraft: www.worldofwarcraft.com.
World of Warcraft on Wikipedia: http://en.wikipedia.org/wiki/World_of_Warcraft.
WTF?!: http://aoedipus.net.
WTF?! SDK: http://aoedipus.net/wtf_sdk.html.

4 SF GARDEN REGISTRY

Amy Franceschini, David Lu, and Myriel Milicevic

Key Words: Adobe Flash Builder, Adobe Flash, Application Programming Interface (API), Cascading Style Sheets (CSS), Google Maps API, Information Design, Interaction Design, Map Tile, MySQL, PHP, Tile Engine, User Interface (UI)

Project Summary

While *Garden Registry* grew out of a multipart project entitled *Victory Gardens 2007+*, it is also part of a lineage of projects created by Amy Franceschini, David Lu, and Myriel

Figure 4.1 Amy Franceschini, David Lu, and Myriel Milicevic, *SF Garden Registry* can be viewed at gardenregistry.org.

Milicevic. Myriel and Amy's *F.R.U.I.T.*[1] was an installation and website that presented information about food miles and the many relationships involved in bringing food from the farm to your table. A fruit stand was presented in the museum space offering wrapped oranges and a computer kiosk. The fruit wrappers were printed with information about local food movements, urban gardening plans, food miles, and an invitation to participate in an online demonstration.

Of Planting, Protesters and Growing a Demonstration

Traditionally, demonstrators meet at a given time, raise their banners and move through the streets to give voice to their injustices, demands, and aching desires. With the *F.R.U.I.T.* project we raised the aching issue of citizens' food illiteracy—including information about how and where food is produced, and how far it traveled. We established an online platform for people to demonstrate for their right to know where their food comes from, featuring personal slogans and urban plans. Cyber demonstrators would not protest by marching down a street, but take root deep in their virtual plaza, holding up their slogans through time, steadily growing in numbers. They could be presented together or sorted by city or features (demonstrators would look differently whether they were city dwellers or rural residents, whether growing their own food, and so on.)

While this demonstration could function as a real meeting opportunity for people to get in touch with others in their city and grow food together, it was first of all a platform of collective voices, and a community that is still growing.

Redrawing the City

When designing the *Garden Registry*, the community aspect and motivation was similar; however, this time the project includes online planting and "real" live cultivating in backyards, rooftops, window boxes, parks, or vacant lots.

The *Garden Registry* surveys urban food-production zones and enables people to contribute their garden plots and data to a collective map. Users share seeds, harvests, and knowledge both online and in the physical world. It does not just show the city as it is, but the process of transformation as both the virtual map and the real city.

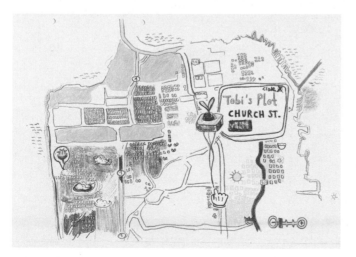

Figure 4.2 A hand-drawn map for the *SF Garden Registry*.

Introduction to *SF Garden Registry*

The Garden Registry is part of a two-year pilot project, *Victory Gardens 2007+*, which was a collaboration between the city of San Francisco, Amy Franceschini, and the Garden for the Environment. The project was initially launched as an art project at the San Francisco Museum of Modern Art, and shortly after adopted by the city of San Francisco as a pilot project to reimagine a citywide urban agriculture program based on the historic Victory Garden programs of World War I and World War II. Through an exciting process of meeting city officials and orchestrating a team, we received funding from the city and two private funders. Through this project, a city food ordinance was developed which states that the city of San Francisco will support urban agriculture with the aim of growing 40 percent of all food within city limits by 2015. We see this project as a creative and effective response to a local issue that can be translated to a global scale.

Victory Gardens 2007+ derives its title from a nationwide program developed by the Department of Agriculture that promoted the cultivation of food by citizens with the aim to reduce pressure on the public food supply brought on by the war effort. In 1943, over 20 million Victory Gardens were producing 8 million tons of food. Throughout the country, people plowed front yards, lawns, back yards, flower gardens, and vacant lots to grow their own vegetables. In the city of San Francisco, vegetable gardens were

Figure 4.3 Upload Image page on *SF Garden Registry*.

grown in every park, the lawn of City Hall, and throughout Golden Gate Park. By drawing an example from this period of massive participation, *VG2007+* suggests that what might otherwise be seen as a radical gesture is in fact historically proven to be viable.

The *Garden Registry* is one channel for quantifying participation in this new program. In the early stages of research for this project, the San Francisco Department of City Planning provided a 1970 Lot and Block Map that illustrated public and private land use and allocation of open space. From this we could quantify the total acreage of open, farmable space within San Francisco city limits, totaling 1,820 acres. This map inspired the creation of our online tool. *Garden Registry* allows people and planners to see land-use patterns and food production on one annotated map and facilitates exchange by accepting and presenting qualitative input in the form of photos, comments, and discussion boards. A surplus alert allows users to announce surplus food that has been a catalyst for new exchanges and decentralized growing networks.

Developer Backgrounds

David Lu

I met Amy during a media knitting workshop she led at the Dutch Electronic Art Festival in 2003. Our first collaboration, *Portable Portrait Mobile*, featured a computer program that made blind contour drawings of festival goers kind enough to sit for it (the program could "see" via a webcam), while I made hand-drawn portraits and casual conversation. In addition to injecting a human, social element into a project that might otherwise have been a cold technology demo, Amy designed and built a beautiful wooden cart for the piece.

I have always appreciated Amy's ability to tell a human story in her projects; her *Garden Registry* notion presented a compelling story. The timing was also good. In the summer of 2008, when she approached me with the project idea, I was writing mapping software at Local Projects in New York. I had acquired deep knowledge of the Google Maps API—the application programming interface that allows Google's Maps to be embedded in any website with a data overlay. I concluded that the locative aspect of the registry could be built quickly and easily, which might leave more time to explore design ideas (appealing to me) or other aspects of the project execution.

Amy Franceschini

I am always looking for a reason to collaborate with David, and for me he was really the perfect person who could realize this piece. David and I have worked together for over seven years, during which time we developed a working rhythm and a common aesthetic ground—a mutual admiration, I believe. Myriel and I met in the same year while she was an artist in residence at Futurefarmers. Together we created *The Great Park Project*, a utopian proposal for a new park to be placed on a former military site in Orange County, California. We created a suite of sculptures, costumes, and proposals for possible uses for this great swath of land, including an online or PDA application called *Ad-Hoc Ecosystem*[2] that allowed participants to collectively monitor the social, political, and material land use within the *Great Park*.

For me, online tools are an extension of my analog artistic practice. They are a space to continue, reimagine, and document the exchanges set in motion in "real" life and

vice versa. *Garden Registry* is an example of this blurred territory. It quantifies land use and food production, and through this visualization establishes connections and creates a precedent for action between individuals on a local and citywide scale.

Explanation of Technical Components (David)

Previous Experience

A few circumstances influenced my selection of technical components. As mentioned, I had been working with Local Projects on a mapping application that ran on interactive tables in a high-profile space. Google, a technology partner on the project, showed us how to download map tiles and host them locally. Having our own copies of the map tiles meant that we could style the maps any way we liked (within limits). I reused this technique for the *Garden Registry* implementation. One of our information design goals was to reduce the amount of visual noise (colors, unnecessary labels, and so on) baked into the map tiles, and to allow the garden data, painted above the maps, to shine. At the time, very few options existed for customizing map styles, markers, and behaviors. As a result, using the Google Maps API for Flash made sense.

Our Approach

This project evolved organically. The three of us were living in different time zones: Amy in San Francisco, Myriel in Germany, and David in New York City and Cambridge, MA. We were all busy with other projects, which made the collaboration difficult to begin. Communication via iChat and email helped facilitate the remote collaboration. We started by passing Adobe Illustrator files to each other. Our initial work varied from high-level concepts to visual design directions to wireframes. Amy sent out conceptual design sketches and a project brief. Myriel came up with a beautiful concept for a hand-drawn map of the city and its gardens (which would still be lovely to make, now that we have data to work with). David explored visual treatments of Google Maps tiles, which helped set the stage for what the visual design might include. Amy and Myriel riffed on this work and began to craft the visual language for the site. We soon had a minimal set of designs that David used as a baseline reference for developing the software. While he was writing code, Amy revised the visual design. We sculpted this work over time, making small decisions and building on them, together in spirit, while physically apart.

Flash-based Maps with Google Maps API

I knew this set of technologies to be reliable, fast, and easily customizable from a design standpoint. My previous knowledge here also saved development time. We overlaid two sets of data above our maps: gardens and microclimates. San Francisco weather can vary dramatically from neighborhood to neighborhood, so it was important to show where gardens were (and were not) located in relation to the city's microclimates. Drawing the microclimates as shapes above the map turned out to be tedious. The shapes are defined by a set of latitude/longitude coordinates. I had hoped to find an open source set of microclimate shapes, but failing to find a good one meant spending a few days drawing them myself. Constructing city-sized polygons from hundreds of precisely placed street-level vertices was painful. I also made a mistake the first time through, not realizing until it was too late, so I had to start the tedious process anew.

Figure 4.4, 4.5 *Making Hand Drawn Maps:* Redrawing the city on paper should be just as easy as changing the "real" city. We first drew maps by hand including animations with the intention that this vernacular should influence people to feel like the city is not something that should be left to be planned by architects or urban planners but something that can be modified with as little effort as using a colored pencil, a seed, or a shovel.

Custom Map Tiles

At the beginning of development, I wrote a small program in Processing[3] that downloaded all of the map tiles for San Francisco and applied simple styling, such as a grayscale, neutral color palette, to the saved images. Processing is an open-source programming language and environment for manipulating images, animation, and interactions. I used it to create new tiles. This download and manipulation process happened once, before the site was deployed, and took about two days to complete. Whenever the *Garden Registry* map displays a tile, the standard Google Maps tiles are replaced by tiles hosted on gardenregistry.com.

Flash-based User Interface

Beyond the map, there was quite a bit of user interface (UI) to design, much of which consisted of form elements. Amy was interested in seeing an extremely customized interface (such as custom fonts, dropdown menus, sliders, and checkboxes). This level of design execution was beyond what could be achieved with the then current state of CSS and JavaScript. So we opted to write (and draw) our own UI in Flash (well, Flex Builder).

PHP and MySQL

We used PHP and MySQL on the server side for storing and retrieving users' garden data. PHP is a language used to produce dynamic webpages, and MySQL is a database-management system.

Limitations and Observations

Cities beyond San Francisco have approached us to create registries for their locations. Because of the amount of customization involved, in both the design and implementation, this has been impractical to offer. The data side of the site is set up to handle a single city, and all of the UI on the site assumes one particular set of map tiles and microclimates. Supporting many cities (with the current design and a revised implementation) would require at least a few days of specialized work.

We developed a social feature, Surplus Alerts, consisting of data blurbs indicating when a grower had surplus food that was sharable in the real world. It seems that users rarely use or even see that feature. We observed that users typically sign up and upload a photo of their garden, but do not return to the site. It would have been interesting to encourage the growth of the community and iterate on the design of the social features, perhaps integrating with services and devices that users return to frequently, such as a Facebook or an iPhone application.

A small detail that annoys us is the problem of many overlapping markers in a confined area of the map. When markers are occluded, one cannot interact with them. This is a common problem in the mapping world. The current Beta version of Bing Maps has a lovely solution that employs summary markers that, when clicked, unpack into individual markers.

Some aspects of the site are the result of limited development time. The gallery, for instance, only lets you see five gardens at a time, and is not a shining example of good information design. The map, too, is fixed width—it would be great if it could take over the screen, to give users the ability to see more gardens (and more of the city) at once.

The Current State of Mapping Technologies

More options for creating and styling custom maps now exist. CloudMade,[4] for instance, makes it easy to create custom map styles, highlighting or suppressing objects like roads, footpaths, railways, and so on. Polymaps,[5] a collaboration between Stamen and SimpleGeo, displays multi-zoom datasets over maps, through a lightweight JavaScript library, without the need for third-party plug-ins like Flash.

Mainstream map providers such as Bing Maps are making the switch from bitmap to vector map tiles, allowing certain data layers (labels, streets, colors) to be turned on and off at will. This not only reduces the amount of visual noise present in a map but also enables new languages for expression in maps. Imagine seeing symbols representing real-time traffic move along roads on a map. Vector creates wonderful time-based possibilities for mapmakers.

An Ideal Version (If We Were to Do This Again)

An ideal *Garden Registry* site would allow any city to create its own registry. It would be generic, shedding the Flash implementation in favor of HTML and Javascript. It would be viewable on any device (iPad, iPhone, Android, BlackBerry, Windows Phone), and it would function as a layer above the social graph. This layer would inform city leadership about urban gardening and support a continuous feedback loop among leadership, growers, and non-growers. Perhaps expert growers could mentor less-experienced growers in urban gardening.

Conclusion

The unexpected outcomes of dynamic, online tools are always the greatest reward for doing these types of projects. For *Garden Registry*, the most unexpected outcome was the users' desire to share their surplus food. By learning about our users, we were able to improve their online experience by adding a "surplus alert," allowing users to post information about surplus on the spot. Many of our projects serve as prototypes for larger applications. Since we launched the project we have been approached by several cities, including Philadelphia, Detroit, Vancouver, Ann Arbor, and Seattle, to build a similar tool. Our dream is to build this as an open-source iPhone application that can be shared and easily adapted by any city worldwide.

Notes

1. See www.free-soil.org/fruit.
2. See www.co8.com/greatpark/popup.html.
3. See www.processing.org.
4. See www.cloudmade.com.
5. See www.polymaps.org.

Bibliography

Eco, Umberto. *On the Impossibility of Drawing a Map of the Empire on a Scale of 1 to 1.* New York: Mariner Books, 1995: 95–107.
Lynch, Kevin. *The Image of the City.* Cambridge, MA: MIT Press, 1960.

Links

Information Design

www.edwardtufte.com

Interaction Design

www.billverplank.com/IxDSketchBook.pdf

Practitioners and Examples

http://stamen.com
http://prettymaps.stamen.com
www.radicalcartography.net
http://chicagoatlas.areaprojects.com
http://envisioningdevelopment.net/map
www.zillow.com/howto/api/neighborhood-boundaries.htm
www.nytimes.com/interactive/2009/08/29/opinion/20090829-smell-map-feature.html
www.nytimes.com/interactive/2009/03/07/nyregion/20090307-nyc-poll.html
http://walking-papers.org
http://urbanomnibus.net/2009/07/designers-and-citizens-as-critical-media-artists
www.ninakatchadourian.com/maps/worldmap.php
http://graph.masa6.com
http://emergencestudios.com/historicearth
http://google-latlong.blogspot.com/2009/03/look-back-in-time.html

Frameworks and Tools

http://polymaps.org
www.openstreetmap.org
http://cloudmade.com
http://code.google.com/apis/maps/index.html
www.microsoft.com/maps/developers
www.digitalurban.org/2007/10/tutorial-how-to-capture-google-maps-for.html
http://modestmaps.com
http://tiledrawer.com
www.zillow.com/howto/api/neighborhood-boundaries.htm

PART III
CROWDSOURCING AND PARTICIPATION

CHEAPER BY THE DOZEN

An Introduction to "Crowdsourcing"

Trebor Scholz

A few years ago, the telecommunications company Verizon began an experiment with what they called "company-sponsored online communities for customer service," as part of which unpaid volunteers, motivated by varying degrees of praise, worked as long as 20 hours a week for the company. One of these volunteers reports that he found the experience deeply satisfying because in his role as customer service representative he had the opportunity to help thousands of people. If "handled adeptly," a study by the telecom giant suggested, such volunteer communities "hold considerable promise."[1]

Today, volunteers translate documents, write encyclopedia articles, moderate online discussion groups, fill in surveys, and even provide legal or medical expertise. The Texas Sheriff's Border Coalition used web-based volunteers for their project *Virtual Border Watch*,[2] and a similar setup of surveillance cameras and distributed monitors, called *Internet Eyes*,[3] is used to fight shoplifting in the United Kingdom.

There is, of course, a long tradition of people volunteering in hospitals, soup kitchens, museums, and non-profit organizations. Free labor has taken hold throughout the economy. In fast food restaurants, customers took on some of the work that was traditionally performed by waiters. In grocery stores, shoppers "opt in" to use machines that scan their purchases and accept payment, tasks that were previously performed by a cashier. In the fashion industry, companies like Forever 21 appropriate street graffiti for the design of their clothes without crediting or paying the artist.

Or, take the runaway leader in exploitative digital labor: Amazon.com's Mechanical Turk (MTurk). You don't have to be a media buff to join MTurk's "elastic workforce" and "people can get paid by the penny or nickel to do tasks that a computer can't figure out how to do but that even the dimmest bulb, if he's a human, can do."[4] In one chilling instance, MTurk workers made $1.45 an hour, which is exploitative no matter if workers feel used.

Using MTurk, the artist xtine burrough created *Mechanical Olympics*, which she calls an open version of the Olympic Games where anyone can play and vote for gold medal winners. *The Sheep Market*,[5] by artist Aaron Koblin, is a phalanx of 10,000 sheep, all drawn by random strangers through Amazon.com's task-distribution mechanism.

While free labor has taken hold throughout the economy, the Internet really is the apex of this phenomenon. "Crowdsourcing," a term that is sometimes used in this context, describes practices that were traditionally performed by one paid person but can now be more effectively executed by large numbers of people who frequently do not

get paid. Often, the term is incorrectly applied to peer-production projects, as I will explain later.

"Crowdsourcing" is a thorny practice that simultaneously inspires unambiguous excitement about the potentials of the Open Web and moral indignation about the exploitation of new formations of labor. While this complexity is not always acknowledged, "crowdsourcing" is mobilized in the service of liberal ideologies but it is also employed in support of non-commercial and explicitly anti-capitalist projects.

Etymologically, "crowdsourcing" relates to "outsourcing." Companies outsource subcontract tasks to hordes of people online who may get the job done swiftly and at rockbottom costs. However, the term "crowdsourcing" mischaracterizes projects that bring together peers to create something because there is no centralized entrepreneur who subcontracts tasks.

While the potential for information monopolists to profit from taking ownership of our data and time is ever-present, it is not always realized. Already in the 1910s, advocates of scientific management, Frank Bunker Gilbreth, Sr. and Lillian Gilbreth, conducted time and motion studies, examining every manual twist and turn of workers. Their goal, however, was not merely efficiency and profit (often seen as Frederick Taylor's chief objective) but ultimately the welfare of laborers. Similarly today, "crowdsourcing" can serve the public good, but it also makes human beings available as resources for the maximization of profits.

The discussion about digital labor is sometimes associated with a dourness that frames all work as exploitation, therefore crushing the pleasure of those who generate and submit content. Why would they remix a video or write a piece of software if their labor of love merely fills the pockets of the mega-rich? One reason for concern is that the flow of information is largely invisible and exploitation is rarely obvious. In the face of the booming data-mining industry, we should not think of ourselves as tourists who tip their hosts in the land of network culture without considering the broader questions about exploitation, pleasure, labor, possibility, and utopia.

Since the privatization of the Internet backbone in the early 1990s, centralized hubs became magnets for online traffic and by the end of the decade, the Internet started to deliver on the promise of serving low-friction marketplaces. In 2004, the Italian media theorist Tiziana Terranova[6] explained that the so-called new economy is built on the cultural and mental labor of Internet users, and only five years later, the Web 2.0 ideology started to lend a patina of novelty to long-existing technologies that made it remarkably easier to play online.

"Crowdsourcing" is just one aspect of this labor market. It is one form of digital labor that has the goal of distributing the workload from one (usually paid) individual to many (frequently unwaged) volunteers. In his 2006 article in *Wired Magazine*,[7] Jeff Howe first coined the term. *Wikinomics* co-author Don Tapscott proclaims that the old, ironclad vessels of the industrial era sink under the crushing waves where smart firms connect to external ideas and energies to regain the buoyancy they require to survive.[8] Crowdsource-or-perish: learn how to instrumentalize the cognitive and geographic surplus of Internet users and your business will thrive. For Michel Bauwens of the Peer-to-Peer Foundation, "crowdsourcing" reflects the rest of capitalism. He defines it as "the most capitalist model [of digital labor], which … captures part of the value created by … outside producers."[9] The private firm profits from the public pool.

Exploitation, a term that means many things to many people, doesn't only take place by way of data collection, privacy invasion, and utilization of our social graph; it is also about cultural power, exerted all across society. As Tapscott suggests, "this is a new

mode of production that is emerging in the heart of the most advanced economies in the world—producing a rich new economic landscape."[10] While Bauwens rejects the corporate framing of co-creation, he stresses the potential of public-minded peer production.

In everyday parlance, "crowdsourcing" and "wisdom of the crowd" are used interchangeably, which is misleading. Crowdsourcing can but does not have to enable the "wisdom of the crowds." American journalist James Surowiecki framed it as "aggregation of information in groups, [which results] in decisions that … are often better than what could have been made by any single member of the group."[11] "Wisdom of the crowds," illustrated by sites like Yahoo!Answers or social-referral websites like Digg.com, is contingent on critical mass of participants and diversity of opinion.

Without airbrushing the crisis in digital labor, we need to acknowledge what legal scholar Yochai Benkler holds up as hierarchy-defying, and often unpaid, commons-based peer production.[12] While commercial interests exert an iron grip on the Internet, there are also large, meaningful projects that are not market-oriented. People do not contribute to Wikipedia to make a buck, the encyclopedia benefits from the wisdom-of-the-crowd effect; it is the quintessential example of peering. An online encyclopedia that approaches four million articles in English alone "outcollaborates" commercial competitors. But Wikipedia also benefits from the dynamics of the digital economy, specifically a symbiosis with Google. Historian and philosopher Philip Mirowski reminds us that the success of Wikipedia is traceable to how the site fits into the larger business plan of commodification of the Internet.

> Wikipedia materialized as a Godsend for Google's business plan. Moreover, the supposed Chinese wall between Google and Wikipedia makes it possible for wiki-workers to think they are squirreling for the betterment of humankind, while Google positions itself to be the premier portal for information on the web and the biggest corporate success story of the "New Information Economy."[13]

Mirowski's comment shows that Wikipedia and other projects whose contributors are not driven by profit motives are not outside the dynamics of the digital economy. The honorable wiki-work, performed by thousands, also, indirectly, aids corporate titans like Google. Not all projects thrive on the collaborate-or-perish principle and only few get around paying "rent" to corporate landowners. Peer projects are not outside the digital economy even if producers are not driven by market motives.

A chief scientist at the software company Arbor Networks reports that in 2009 "30 large companies—'hyper giants' like Limelight, Facebook, Google, Microsoft and YouTube—generate and consume a disproportionate 30% of all Internet traffic."[14] In his new book *The Master Switch* (2010), legal scholar Tim Wu identifies a clear and present danger of this centralization. Using the radio industry, the early telephone industry, and the film industry as historical reference points, he analyzes the risk of the conglomeration of today's main information monopolists into a singular consolidated monopoly. The smaller the number of companies that hold most of the traffic/attention on the Internet, the greater becomes their power to flip the master switch, which may entail paying their executives salaries far in excess of their social worth (in fact, more than any human could possibly be worth) while other actors only receive pitiful slices of the accumulated wealth. In *Common as Air* (2010), Lewis Hyde asks if there can be a capitalist commons, a commons inside or adjacent to capitalism. For Benkler, net-worked peer production is such an alternative, but who owns and profits from the platforms on which most online sociality is playing out and the above statistic give a clear

answer: the vast majority of people who spend time online do so on corporate real estate; their files are not stored on individual servers in people's homes. Even activist Facebook groups about the Monks in Burma or the Egyptian April 6th Youth Movement contribute to that company's baseline. There really is no "outside" of the digital economy.

Going forward, let's tease apart some of the dangers—what I call the violence of participation—from the promises of commons-based peer production.

The Promise

New York University professor Gabriela Coleman argues that we need to "emphasize partial, positive solutions all the while noting some of their limitations because if we're going to criticize [capitalism/digital labor] in a wholesale sort of way, then we're left without alternatives."[15] For Coleman, key examples include the developers of software such as Mozilla and Linux which have created these projects largely through collaborative, volunteer-run initiatives such as Debian. Debian is a project that joins more than 1,000 software developers who create various versions of the Linux operating system that can be downloaded free of charge.

Other important, positive examples of "crowdsourcing" include the Science Commons, which is a project by the Creative Commons that aims to enable scientific research by making resources easier to find and access. A shortlist of other examples of commons-based peer projects should include the private/public volunteer computing project *SETI@Home*, which uses networked computers worldwide to analyze radio telescope data in an experiment to find extraterrestrial intelligence.

Projects like Wikipedia, Debian developers, Science Commons, and Flickr Commons show the promise of "crowdsourcing" as a practice that benefits the public interest. Many initiatives are hybrid; they are situated between private and public interests. Disturbingly, private and public interests grow closer and closer. Google's re-Captcha,[16] for example, is a service that helps the company to digitize books and newspapers more accurately by capturing 150,000 hours of distributed volunteer labor each day.

Yahoo, which owns the photo-sharing site Flickr, profits from public investment as more users are drawn to its service because of the wealth of government-contributed historical photographs. The Library of Congress has moved a large number of photographs to the Flickr Commons[17] in hopes that Flickr users would create metadata for these images, an activity for which the Library of Congress does not have the resources. Government-provided services are therefore transformed into work performed by the public. In their spare time, citizens execute work that was traditionally financed by taxes, deepening the broad assault on the leisure time of citizens. Tax-financed workers previously performed these very services. In a system in which the public interest is an afterthought, "crowdsourcing" is used to mend systemic failures.

Various networked digital art exhibits are de facto celebrations of distributed creativity. The artists Peter Baldes and Marc Horowitz, for example, jointly take a virtual trip across the United States using Google Maps Street View. Other cultural producers ask for contributions through an open call for submissions. They become context providers who provide a vehicle for the aggregation and distribution of "crowdsourced" artwork. *Learning to Love You More*[18] by Harrell Fletcher and Miranda July, for example, offers a context, a framework, for people to contribute their creativity to a platform set up by the artists who have staged exhibitions in galleries and museums with the collected material. The artist Perry Bard created *Man With a Movie Camera (Global Remake)*,[19] which is a participatory video shot by people around the world who are invited to record

images interpreting the original script of Vertov's *Man With a Movie Camera* and upload them to her site.

Global Lives Project[20] and *One Day on Earth*[21] are participatory documentary projects that do not highlight the facilitating (star) artists. They celebrate the possibilities of networked action and co-creativity. The *Delocator*[22] project by the artist xtine burrough is a database of independently owned coffee shops, created by volunteer participants. All of these projects bring forth the shining potentials of "crowdsourcing."

The Violence of Participation

Today, companies that make their boundaries porous to external ideas and human capital outperform companies that rely solely on the internal resources and capabilities.

The originator of cybernetics, Norbert Wiener, warned that the role of new technology under capitalism is to intensify the exploitation of workers.[23] Indeed, the Internet is an information-generating global machine in which unwitting participants in distributed labor become the most frequent victims of exploitation. In the above quotation, Tapscott frames what I may call exploitation literacy for the twenty-first century as a necessity for the survival of companies who merely have to learn to be more receptive for taking in outside resources.[24] Social software ecosystems—single labor interfaces, privatized collection points—absorb, aggregate, analyze, and sell every iota of data and generate a slice of Web wealth. On the Internet, we are all qualified to labor, and for-profit entities get "all the work without the worker."[25] Every click is monitored and big brother is (also) you, watching. Even fan creativity becomes "just another set of productions in the realm of the creative industries."[26]

The artist Burak Arikan created *Metamarkets*,[27] a project that allows members to trade shares of their Social Web assets from social networking, social bookmarking, photo- and video-sharing services, creating broader awareness of the cycles of value creation.

The virtual world Second Life (SL) offers a social milieu in which consumers coproduce the products that they then consume. Environments like SL provide a context for experimentation and play—an experiential nexus, and entertaining labor interface—and then, through surreptitious tracking, seize on the things that users create. What is most astonishing is that this entire process of expropriation has been so breathtakingly normalized. The art project *Invisible Threads*[28] by Stephanie Rothenberg and Jeff Crouse calls attention to that. *Invisible Threads* is based on a factory in SL in which virtual workers can produce jeans without leaving the comfort of their own home or Internet café.

Digital labor and domestic work, mostly shouldered by women, have much in common. Companies circumvent labor regulations if people work at home and any hour of the day could be work time. Work such as making a baby laugh or caring for the sick doesn't result in a tangible product, which makes it easier to not think of it as labor, and consequently these activities are frequently unpaid, undervalued, and largely go unnoticed.

The inequalities between the largely unpaid workforce and the corporate hyper giants are growing. This relationship is asymmetrical and capitalizes on free labor.

The geography of this asymmetry places those who live on less than $2 a day at the bottom of the participation gap. For employers, responding to the global financial crunch, the service TxtEagle[29] delivers access to a cheap labor force in sub-Saharan Africa and beyond. On their website, TxtEagle invites companies to "Harness the capacity of 2 billion people in over 80 countries to accomplish work with unprecedented speed, scale and quality." The company interfaces workers with the overdeveloped world

through their cell phones, exemplifying what *Washington Post* writer Matt Miller calls "Liberalism's crisis on trade."[30] Miller asks, "Why is it 'liberal' or 'progressive' to stop poor workers abroad from using the one competitive advantage they have?" We may ask how sustainable and transformative income from companies like TxtEagle really is. Miller might be right that some workers develop marketable skills but he ignores the globalization utopia of "crowdsourcing" because such (exploitative) labor practices would not even be possible without the uneven global development produced in the first place by the Global North.

Avenues for Action

How can we live and politicize our troubled complicity in practices of expropriation? Which values really matter to us and are worth defending?

In the struggle over the terms of our own participation and in the search for escape routes, some suggest going off the social media grid. Indian legal scholar Lawrence Liang recently asked what "would be a Facebook without faces or a Twitter without tweeters?"[31] While such withdrawal sounds like a desirable escape route, participation is also a personal and professional imperative for those who are not privileged enough to be able to log off.

Is unionization a realistic way to resist the global forces that are expropriating their lives? Bottom-up transnational labor organization is still nearly non-existent and few users seem to get prickly in the face of their exploitation. Should we accompany user communities and make them aware that their rights should exceed use rights, similar to what the labor movement did in the nineteenth and twentieth centuries? We might want to rethink how click workers of the world can organize that space and see if it is possible to organize online as if it were a sweatshop.

Pointing to Negri and Hardt's latest book *Commonwealth* (2009), the Austrian-Swedish scholar Christian Fuchs proposes a communist (self-managed) Internet for a communist society.[32] Such a vision that builds on a full-fledged revolution is an all-or-nothing proposal, which turns us into complaining bystanders; it does not expand the capacity for action in the near future. In this introduction to the uneasy, yet widespread, concept of "crowdsourcing," I provided a glimpse of the inequalities and vulnerabilities of expropriated publics. In the near future, change will come through policy regulation that addresses transparency, centralization, user rights beyond use rights, and raised awareness of systemic injustice. Change is also about an imagination of a new political language that puts deceiving language like "crowdsourcing" to the test. Also, artworks can play an important role; they can function as incursions that shed light on the conditions of labor and cultural production. However, critiques of digital labor, and specifically "crowdsourcing," should move us beyond the attitude that angrily rejects what is but has no clearly articulated vision for what should be now or in the near future. What's ahead is exhilarating: I'm fired up about the possibilities of "crowdsourcing" but also cautious.

Notes

1. Steve Lohr, "Unboxed: Customer Service? Ask a Volunteer," *New York Times*. Online: www.nytimes.com/2009/04/26/business/26unbox.html (last modified April 25, 2009).
2. *BlueServo*: www.texasborderwatch.com (accessed September 12, 2010).
3. *Internet Eyes*: http://interneteyes.co.uk (accessed September 12, 2010).

4. Jonathan Zittrain, *Jonathan Zittrain at The Internet as Playground and Factory* [Video] (2009): http://vimeo.com/8203737 (accessed September 1, 2010).
5. Aaron Koblin, *The Sheep Market*: www.thesheepmarket.com (accessed September 1, 2010).
6. Tiziana Terranova, *Network Culture: Politics for the Information Age*, London: Pluto Press, 2004: 94.
7. Jeff Howe, "The Rise of Crowdsourcing," *Wired Magazine* 14 (2006). Online: www.wired.com/wired/archive/14.06/crowds.html (accessed November 14, 2010).
8. Don Tapscott and Anthony D. Williams, *Wikinomics: How Mass Collaboration Changes Everything*, New York: Penguin, 2010: 63.
9. Michel Bauwens, *Michel Bauwens at The Internet as Playground and Factory* [Video] (2009): http://vimeo.com/7919113 (accessed September 1, 2010).
10. Tapscott and Williams, op. cit.: 25.
11. James Surowiecki, *The Wisdom of Crowds*, New York: Anchor Books, 2005: 63.
12. Yochai Benkler, *The Wealth of Networks: How Social Production Transforms Markets and Freedom*, New Haven, CT: Yale University Press, 2006.
13. Philip Mirowski and Dieter Plehwe, *The Road from Mont Pèlerin: The Making of the Neoliberal Thought Collective*, Cambridge, MA: Harvard University Press, 2009: 425.
14. Arbor Networks, the University of Michigan, and Merit Network, *Two-Year Study of Global Internet Traffic Will Be Presented At NANOG47*. Online: www.arbornetworks.com/en/arbor-networks-the-university-of-michigan-and-merit-network-to-present-two-year-study-of-global-int-2.html.
15. Gabriela Coleman, *Gabriela Coleman at The Internet as Playground and Factory* [Video] (2009): http://vimeo.com/7122412 (accessed September 1, 2010).
16. Google, *reCaptcha*: www.google.com/recaptcha/learnmore (accessed September 12, 2010).
17. Flickr, *The Commons*: www.flickr.com/commons (accessed September 12, 2010).
18. Harrell Fletcher and Miranda July, *Learning to Love You More*: www.learningtoloveyoumore.com (accessed September 12, 2010).
19. Perry Bard, *Man With a Movie Camera: The Global Remake*: http://dziga.perrybard.net (accessed September 12, 2010).
20. *Global Lives*: http://globallives.org/en (accessed September 12, 2010).
21. *One Day On Earth*: www.onedayonearth.org (accessed September 12, 2010).
22. xtine burrough, *Delocator*: http://delocator.net (accessed September 12, 2010).
23. Richard Barbrook, *Imaginary Futures: From Thinking Machines to Global Villages*, London: Pluto Press, 2007: 60.
24. Tapscott and Williams, op. cit.: 21.
25. Alex Rivera, *Sleep Dealer* [DVD], directed by Alex Rivera, France: Anthony Bregman, 2008.
26. Abigail de Kosnik, *Abigail de Kosnik at The Internet as Playground and Factory* [Video] (2009): http://vimeo.com/7956499 (accessed September 1, 2010).
27. Burak Arikan, *MetaMarkets*: http://meta-markets.com (accessed September 12, 2010).
28. Stephanie Rothenberg and Jeff Crouse, *Invisible Threads*: www.doublehappinessjeans.com/10-steps-to-your-own-virtual-sweatshop (accessed September 12, 2010).
29. *Txteagle*: http://txteagle.com (accessed September 12, 2010).
30. Matt Miller, "Liberalism's moral crisis on trade," *Washington Post*, October 7, 2010.
31. In his unpublished talk presented at the Open Video Conference 2010, Lawrence Liang made this comment. Online: www.openvideoconference.org/agenda.
32. Fuchs proposed a "Communist Internet in a Communist Society" in his talk at *The Internet as Playground and Factory* conference in November 2009. *Christian Fuchs at The Internet as Playground and Factory* [Video] (2009): http://vimeo.com/7954268 (accessed September 1, 2010).

Bibliography

Arbor Networks, the University of Michican, and Merit Network. *Two-Year Study of Global Internet Traffic Will Be Presented At NANOG47*. Online: www.arbornetworks.com/en/arbor-networks-the-university-of-michigan-and-merit-network-to-present-two-year-study-of-global-int-2.html.

Barbrook, Richard. *Imaginary Futures: From Thinking Machines to Global Villages.* London: Pluto Press, 2007.

Bauwens, Michel. *The Internet as Playground and Factory—Michel Bauwens.* http://vimeo.com/7919113.

Benkler, Yochai. *The Wealth of Networks: How Social Production Transforms Markets and Freedom,* New Haven, CT: Yale University Press, 2006.

de Koznik, Abigail. *The Internet as Playground and Factory—Abigail de Koznik.* http://vimeo.com/7956499.

Hardt, Michael and Antonio Negri. *Commonwealth.* Cambridge, MA: Harvard University Press, 2009.

Howe, Jeff. "The Rise of Crowdsourcing." *Wired Magazine* 14 (2006). Online: http://www.wired.com/wired/archive/14.06/crowds.html.

Hyde, Lewis. *Common as Air: Revolution, Art, and Ownership.* New York: Farrar, Straus and Giroux, 2010.

Lohr, Steve. "Unboxed: Customer Service? Ask a Volunteer," *New York Times.* Online: www.nytimes.com/2009/04/26/business/26unbox.html (last modified April 25, 2009).

Mirowski, Philip and Dieter Plehwe. *The Road from Mont Pèlerin: The Making of the Neoliberal Thought Collective,* Cambridge, MA: Harvard University Press, 2009: 425.

Surowiecki, James. *The Wisdom of Crowds.* New York: Anchor Books, 2005.

Tapscott, Don and Anthony D. Williams. *Wikinomics: How Mass Collaboration Changes Everything,* New York: Penguin, 2010.

Terranova, Tiziana. *Network Culture: Politics for the Information Age.* London: Pluto Press, 2004.

Wu, Tim. *The Master Switch: The Rise and Fall of Information Empires.* New York: Knopf, 2010.

Zittrain, Jonathan. *The Internet as Playground and Factory—Jonathan Zittrain.* http://vimeo.com/8203737.

Links

The Internet as Playground and Factory conference (2009): http://digitallabor.org.
Videos of participants at IPF conference (2009): http://vimeo.com/ipf2009/videos.

5 MECHANICAL OLYMPICS

xtine burrough

Key Words: Collective Intelligence, Convergence Culture, Crowdsourcing, Domain Name, HITs, Remixable Data, User-Generated Content, Video Compression, Web 2.0, Mechanical Turk, YouTube Channel

Project Summary

Mechanical Olympics is an online, crowdsourced, alternative Olympic Games, where anyone can perform an Olympic event and everyone can vote for gold medal winners. During the Olympic Games, MechanicalOlympics.org hosts daily polls where viewers vote on YouTube videos of Olympic event performances made by Amazon.com Mechanical Turk workers.

Project Developer Background

In 2005, I created Delocator.net to promote independently owned businesses by locating stores within a zip code search. In the first version of the site, the search results page displayed a comparison between the number of Starbucks stores and independent coffee shops within a selected radius. I provided the list of Starbucks stores and addresses, while users entered details about locally owned coffee shops. On the day the site launched, only a handful of independently owned shops populated an empty database. Today there are over 4,500 entries. Although the project is in opposition to a Goliath of the mainstream culture, I did not expect to be involved in the media frenzy that followed the launch. Media reviews, first from the blogs *BoingBoing* and *StayFree!* followed by the *Village Voice*, *New York Times*, *Boston Globe*, international media sources, and radio and television interviews, all drove traffic to the site. Within weeks of launching the project I had to purchase more bandwidth from my Internet service provider. I posted the code used to create the Delocator.net on the website and two international sites were made for "delocating" coffee shops (one in Great Britain and one in Canada). In 2006, movie theaters and bookstores were added to the website. Three years later, I relaunched the site with a better distance calculator and a log-in feature. While many reviewers wrote about Delocator.net as if it were an anti-Starbucks website, my personal attitude has always been that alternatives are healthy for a democratic society. I am not expressively against Starbucks.[1] However, I like to know where alternatives are located and support local stores whenever possible. I created this website in order to develop a tool to help locate independently owned stores, to enable like-minded web users to provide store details in their neighborhoods, and to make this collection of information publicly available. As is common among media artists who make projects with code, I collaborated with several programmers—one during each separate launch or relaunch of the website.[2]

- Time allotment: 30 minutes
- Reward: $0.01
- Description: Given a set of images, provide some relevant and non-obvious tags.[4]

Mturk.com is considered a platform for crowdsourcing, a twenty-first-century networked version of outsourcing. The word "crowdsourcing" was coined by Jeff Howe in a June 2006 issue of *Wired Magazine*. It relies on what sociologist Mark Granovetter describes as "the strength of weak ties," where networks linking to the widest range of information, knowledge, and experience are the most efficient. However, as you can see in this example of a HIT, employers are not using the Turkers[5] to work in collaboration on groundbreaking research and development tasks where the "strength of weak ties" leads to successful innovation. Instead, as Howe suggests, "just about anyone possessing basic literacy can find something to do on Mechanical Turk."[6]

The *reward* amounts listed on Mturk.com are payments for jobs defined in HITs, posted by requesters. I earn a salary in my full-time position as a university professor, and I have worked part- or full-time in many other positions. In these situations I have never considered the payment that I received for work a *reward*. My attitude toward a system such as Mturk.com, where tedious jobs are outsourced for extremely low reward amounts, contributed to my motivation to make something silly and fun with collaborators from the Mturk.com community of workers.[7] Here are the short details included in a HIT I placed with my user name, Mechanical Olympics, on Mturk.com:

- Title: Create and Post a YouTube Video
- Description: Mechanical work can be creative
- Short Request: Make a short, silly video of an Olympic event
- Keywords: Olympics, Performance, Creative, Fun, Silly, Video, YouTube
- Reward: $3.50

Upon clicking to see more details, a viewer would see the full set of instructions before accepting or rejecting the job.

A recurring theme in my art practice is to use the web in order to share information in a way that promotes education, autonomy, or interpretation. The *Mechanical Olympics* provided a framework in which the Turkers were offered a creative and physical alternative to typical HITs placed by requesters. Independent thinking and interpretation among the Turker community is seen in many of the videos, where performers translate athletic events into poetic or absurd visual movements by swimming through air; hurdling over a cane; playing hockey with brooms, dustpans, or ice trays; bobsledding in a bathtub; or using puppets. According to the voting poll on the blog, unexpected or funny videos have the best chance at winning.

2. YouTube

In July 2008, more than five billion videos were viewed on YouTube.com; 75 percent of the total US Internet audience viewed online video. The duration of an average online video was about three minutes.[8] In December 2009, online video viewing reached record levels as 33.2 billion videos were viewed during the month.[9]

Once a YouTube account is created, the profile page is the user's YouTube Channel. Although I already had a YouTube account related to other projects, I created a second

account for my new identity, Mechanical Olympics, so that Turkers would be able to access this collection of videos easily. Again, I had to think of this project from the perspective of Turkers responding to my HITs. It is also important to imagine the outcome of an Internet search for "Mechanical Olympics."

I could have asked the Turkers to create a video and email it or upload it directly to the blog, but using YouTube.com was a smarter solution for the following reasons:

(a) Video files are large, and large files travel slowly over networks. I could not assume the Turkers would be skilled at video compression. By asking workers to post their videos on YouTube.com—a website specifically made to compress videos uploaded by amateurs, I relieved myself of video compression and management responsibilities.[10]

(b) By creating a Mechanical Olympics channel on YouTube, I was able to reach a wide audience. Before MechanicalOlympics.org became active during the Olympic Games, I signed up for a Google Alert with the key words "Mechanical Olympics." Google Alerts are "email updates of the latest relevant Google results (web, news, etc.) based on your choice of query or topic."[11] Once the Olympics began, there was activity on MechanicalOlympics.org and the YouTube channel, so I received daily Google Alerts. One alert directed me to a question posted on Answers.yahoo.com, "What are 'Mechanical Olympics?'," as follows:

> I must admit, I am a youtube addict. I like to see what random people are doing, what can I say? Over the past couple days there seems to be a lot of videos that say "mechanical olympics" without much more explanation. When I search google, all the top hits just lead back to youtube. So, what is this? Does anyone know?
>
> Ok, I have more information now. Google is now finding a site that gives more info, but I still don't totally "get" it. Is this some kinds [*sic*] of weird protest of the Olympics being in China? Any ideas?[12]

The only reason I saw this question was because I received an email alert. I was able to communicate directly with someone who learned about my project by spending time on YouTube and Google. The communication was a result of a Google Alert with regard to a question about my project someone left on Yahoo after seeing a video on YouTube made by one of the Turkers from Mturk.com. That is, four separate websites were involved in the online communication between two strangers. None of this would have happened if the videos were not uploaded to YouTube.

3. MechanicalOlympics.org

MechanicalOlympics.org is the domain name of a website with the WordPress blogging software installed in a sub-directory called "blog" uploaded to the root directory. This project could have been facilitated through YouTube's interface, but I wanted the *Mechanical Olympics* to have a home where people could read about the project and voting could take place during a limited time frame. On YouTube, there is no way to vote on a specific question, such as, "Which one of these three videos deserves the gold medal?" I posted a new event consisting of three embedded YouTube videos and a voting poll on the blog during each day of the Olympics from August 9 to August 24, 2008 and a bonus round on August 25, then repeated the process in February 2010.

Historical Perspectives

The *Mechanical Olympics* was influenced by conceptual art works made in the 1960s and 1970s, and developments in online communication during the first decade of the twenty-first century, as summarized in the following two sections.

1. Conceptual Art

Net.art is considered immaterial when the work is constructed of the code used to generate webpages or bits of information such as pixels or numeric data, and when bits do not produce a tangible object or physical action.[13] The *Mechanical Olympics* is not only immaterial, but the design of the blog or even the formal properties of the videos are less important than the concept of the project. Artists and the work they create are products of history. Net.art has a short history, but early forms of mark-making were created over 32,000 years ago, found in French and Spanish caves. Many artists who create projects for online interactivity are inspired by other movements in the history of art. My practice is informed by the history of conceptual art and photography.[14] In his book *Conceptual Art*, Daniel Marzona explains that

> within Conceptual Art there is an explicit emphasis on the "thought" component of art and its perception ... [as] the art work began in the late 1960s to liberate itself from the material realization, which was seen by many artist as subordinate or even superfluous.[15]

The orchestration of the *Mechanical Olympics* relied on one major factor: workers on Mturk.com had to accept and fulfill my HITs. I was surprised at how quickly the Turkers responded to my HITs and uploaded videos to YouTube. Once all of the jobs were complete, I had a collection of videos to embed on my blog from YouTube. The rest of the project was a matter of watching viewers vote on the polls. Since competitors had a stake in voting, much of the audience probably consisted of friends of the Turkers. In the late 1960s and early 1970s conceptual artist Michael Asher altered existing environments in order to create an artful concept, rather than an artful product. In Marzona's book, Asher said that he "see[s] [him]self as an author of situations, not of the elements involved in them."[16] I created little visual content for the *Mechanical Olympics*: I made a sign for each contestant to wear and a headline graphic for the blog. I did not produce a video, and I did not write most of the code used to realize the project. For the Winter 2010 Games I made award certificates for event winners.

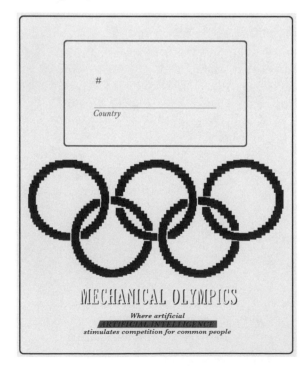

Figure 5.2 Sign created for *Mechanical Olympics* participants to download and wear in their videos.

So where does the *art* happen? In *The Virtual Community* (2000), one of Howard Rheingold's primary books about electronic culture and communication, he wrote "Access to alternate forms of information and, most important, the power to reach others with your own alternatives to the official view of events, are, by their nature, political phenomena."[17] The *art* is the thesis statement of this project: the idea that we can create an alternative to the Olympic Games where anyone can perform and everyone has an equal vote. This is executed by orchestrating participants using multiple websites that they were already familiar with using. The art is also expressed in the set of directions in HITs posted on Mturk.com, which asked the workers to do something intuitive and creative, rather than label images or evaluate search results.[18] Videos created by each of the workers on Mturk.com are also artworks, separate from the project. The *Mechanical Olympics* project is a virtual community that is politically motivated, as Howard Rheingold suggests, because it opposes views of the dominant consumer paradigm, and facilitates an alternative Olympic Games. I consider this project politically motivated, and silly or absurd in its expression.

2. Web 2.0 and Convergence Culture

When I presented this project to peers in 2008 and 2009, someone would usually raise a question about how it fits into the paradigm of Web 2.0. Tim O'Reilly is the founder and CEO of O'Reilly Media, Inc., which publishes computer reference books and hosts conferences on new technologies. *Web 2.0* is a phrase borrowed from the name of an O'Reilly Media conference that began in 2004. Some of O'Reilly's core principles of Web 2.0, and how they relate to this project, are as follows:

(*a*) *Harnessing Collective Intelligence.* Websites or projects that employ Web 2.0 strategies turn their audiences into users by requesting their participation in the form of uploaded media. In return, the user contributes part of their knowledge. MechanicalOlympics.org would be an empty shell if there were no videos to vote for during the Olympic Games.

(*b*) *Value Added.* The website or project developer creates a platform that is difficult to recreate and the project becomes richer and better as more users contribute to the project. MechanicalOlympics.org, as well as Mturk.com, YouTube.com, and other Web 2.0 sites, increase in value (for users and the owner of the website) as more people use and contribute to the site.

(*c*) *Remixable Data.* Each user can add a unique perspective to shared media. Users become authors who contribute to the development of Web 2.0 websites, software, or code in open-source arenas. Instead of a top-down hierarchy, the communication appears to be distributed evenly among users on a Web 2.0 site. Since anyone can access uploaded media, users are able to remix, rewrite, and redistribute the material. Redistribution is key to the *Mechanical Olympics*, as video descriptions are detailed on Mturk, videos are uploaded to YouTube, and then embedded on the WordPress blog at MechanicalOlympics.org and elsewhere.[19]

The *Mechanical Olympics* is a project that was made for, and depends on, convergence. Henry Jenkins welcomes readers to his acclaimed book *Convergence Culture* by describing convergence as: "where old and new media collide, where grass roots and corporate media intersect, where the power of the media producer and the power of the media consumer intersect in unpredictable ways."[20] Jenkins' work is a study in the relationship between collective intelligence, participatory culture, and media convergence. This project exemplifies many of Jenkins' ideas.

As a point of entry to the *Mechanical Olympics*, Mturk.com and YouTube.com are sites that harnessed collective intelligence, followed by votes on the blog. On YouTube, audiences viewed videos related to search terms (during the time of the Olympic Games, it is no stretch of the imagination that searches on YouTube included the word "Olympics"). During this stage of the project and the final blog-posting stage, any user contributions, such as comments on YouTube or on the blog, added value to the project. Finally, videos were published on the blog daily throughout the Games, where voters determined gold medalists. In this layered method of distributing videos, the data was always available for redistribution from multiple sources. Using Jenkins' description of convergence, this project was a grass-roots effort that intersected with the mainstream Olympics (which is not lacking in corporate sponsorship), almost entirely created by amateur media producers.

Conclusions and Outcomes

The *Mechanical Olympics* is a media experiment that relies on three separate websites to conduct an alternative version of the Olympic Games. Framing this project as an on-going experiment renders the notion of "solutions" or "recommendations" inconclusive. However, any project plan includes goals and methods for measuring whether those goals were met. When I first began working on this project I doubted whether anyone would accept my wordy HITs. My only goal for the project was to collect enough videos in order to host a competition each day during the Olympic Games.

After the Games, I analyzed the *Mechanical Olympics* blog. I saw a spike in votes for some of the videos and noticed that certain performers submitted multiple videos, which influenced how I collected videos for the 2010 Games. During the month of August, the site statistics available from my web host revealed that there were just shy of 35,000 hits and 4,500 unique visits to the site. This indicates that there were more people looking at the site than there were voters. I could potentially count the views for each video on YouTube, but this would not be worth my time as viewers could have landed accidentally, or were friends looking for other videos in a collection that included a *Mechanical Olympics* event, and so on. I did receive a positive review of the project on Rhizome.org, but I was not able to encourage members of the mainstream press to report on the alternative Olympic Games.[21] Perhaps it is fitting that the alternative games were reported to a niche audience. One challenge that I did not consider at first was that the traditional media require press releases two weeks before an event. This is ineffective when there are no videos on the blog before the Games begin. As the *Mechanical Olympics* Summer 2008 games are always displayed on MechanicalOlympics.org, later Games, such as the Winter 2010 *Mechanical Olympics*, were easier to publicize. A "bonus" outcome for the project was when it was made an Official Honoree of the 13th Annual Webby Awards alongside *I Can Has Cheezburger* and the Sundance Channel's *Green Porno* in April 2009.

While at a conference in Belfast during August 2009, I met a curator from Cornerhouse, "Manchester's international centre for contemporary visual arts and film."[22] Since the 2012 Olympic Games will be hosted in London, she was interested in bringing the project to the United Kingdom. I was commissioned in 2010 to present the *Mechanical Games* during the Abandon Normal Devices festival of digital culture and new cinema. For this iteration of the project, senior citizens at care homes, dance groups, and church groups participated with the help of videographer Dean Brocklehurst in a competition against the Turkers. A proper awards ceremony was held in Manchester and for the first time since I started organizing this project I met some participants in person to award faux gold medals.

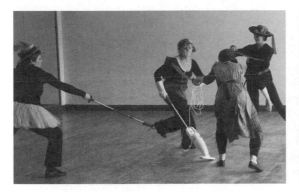

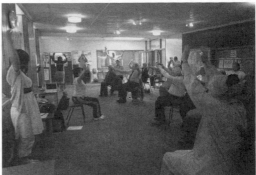

Figure 5.3 Manchester-based Wise Move Dance Group perform fencing for the Mechanical Games. © Cornerhouse, Manchester. Photograph by Alison Kennedy.

Figure 5.4 Participants in Manchester perform an Olympic-style warm-up before creating videos for the Mechanical Games. © Simon Webb Photography.

In summary, the *Mechanical Olympics* was conceived in the tradition of net.art and relies on practices associated with conceptual art. Like many Web 2.0 sites, the MechanicalOlympics.org blog would be meaningless without crowdsourced videos that Turkers posted to YouTube, or, in Web 2.0 lingo, user-generated content. The *Mechanical Olympics* makes use of the convergence culture, as defined by Henry Jenkins, and crowdsourcing, as outlined by Jeff Howe. This project demonstrates how online communication can be orchestrated through various pre-existing web channels, and how crowdsourcing can be used for creative purposes. The *Mechanical Olympics* were made to facilitate an alternative Olympic Games for a virtual community that connects Mturk workers with blog voters and YouTube viewers. It transforms expectations that Olympic Games must be created and perpetuated by the mass media.

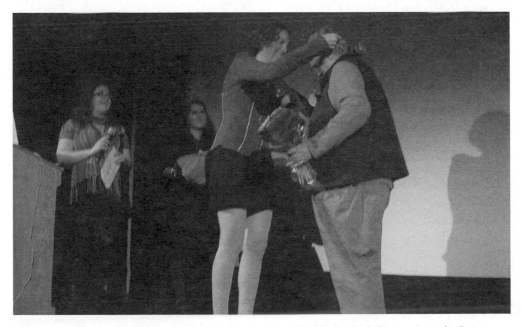

Figure 5.5 Gold medalists receiving their awards at the Mechanical Games Awards Ceremony, Cornerhouse, Manchester, UK, October 3, 2010.

Notes

1. I made *Delocator* years after briefly working as a barista in a Bel Air (Los Angeles) coffee shop. My students think it is funny that I feel guilty when I buy coffee at the Starbucks in our building during the break in the middle of our class.
2. I am thankful to Vasna Sdoeung, Kyle Cummings, and Jim Bursch for their programming efforts on Delocator.net in 2005, 2006, and 2009; and to Beatriz da Costa for her version of the site at Delocator.mapyourcity.net.
3. www.mturk.com/mturk/welcome (accessed May 18, 2009).
4. More HITs are accessed by clicking the "View Hits" button on www.mturk.com (accessed February 6, 2010).
5. Workers on Mturk.com refer to themselves as "Turkers." See Turker Nation at http://turkers.proboards.com/index.cgi.
6. Jeff Howe, "The Rise of Crowdsourcing," *Wired Magazine* 14 (2006). Online: www.wired.com/wired/archive/14.06/crowds.html (accessed May 18, 2009).
7. I worked on Mturk.com for an hour while keeping a legend of the HITs I took and the "rewards" I earned. I made 57 cents (USD) after completing 27 HITs. At that rate, a 40-hour work week would pay less than $25.
8. ComScore: www.comscore.com/press/release.asp?press=2444 (accessed May 18, 2009).
9. ComScore: http://comscore.com/Press_Events/Press_Releases/2010/2/U.S._Online_Video_Market_Continues_Ascent_as_Americans_Watch_33_Billion_Videos_in_December (accessed October 14, 2010).
10. I always download a copy of each Turker video in case she removed it from YouTube before or during the Games.
11. http://google.com/alerts (accessed February 6, 2010).
12. This was originally posted on http://answers.yahoo.com/question/index?qid=20080807193028AAo0dOr (accessed October 10, 2010).
13. See Chapters 19 and 20 for projects where bits of information such as pixels or numeric data produce a tangible object or physical action, or vice versa.
14. It would be negligent of me not to mention the significance of Aaron Koblin's work with the Turkers in his projects, *The Sheep Market* and *Bicycle Built for Two Thousand*.
15. Daniel Marzona, *Conceptual Art*, Germany: Taschen, 2005: 7.
16. Michael Asher in Marzona, op. cit.: 32.
17. Howard Rheingold, *The Virtual Community: Homesteading on the Electronic Frontier*, Cambridge, MA: MIT Press, 2000: 284.
18. There is a historical trajectory of conceptual art that takes root in the act of writing or following instructions. See Lawrence Weiner's *Declaration of Intent* and *Statements*, Sol LeWitt's *Wall Drawings*, and Stanley Brouwn's *This Way Brouwn*.
19. Many Turkers posted their videos to their own blogs, but the most interesting place I saw videos from the Summer Games was on a website dedicated to scuba diving (which was, incidentally, not an event or theme of any of the videos).
20. Henry Jenkins, *Convergence Culture*, New York: New York University Press, 2006: 2.
21. Marisa Olson, "Let's Get Physical," Rhizome.org, August 5, 2008: http://rhizome.org/editorial/446 (accessed February 6, 2010).
22. Cornerhouse: www.cornerhouse.org/about (accessed October 10, 2010).

Bibliography

ComScore. "YouTube Draws 5 Billion U.S. Online Video Views in July 2008." Online: www.comscore.com/press/release.asp?press=2444 (accessed May 18, 2009).

ComScore. "U.S. Online Video Market Continues Ascent as Americans Watch 33 Billion Videos in December." Online: http://comscore.com/Press_Events/Press_Releases/2010/2/U.S._Online_Video_Market_Continues_Ascent_as_Americans_Watch_33_Billion_Videos_in_December (accessed October 14, 2010).

Cornerhouse. "About Cornerhouse." Online: www.cornerhouse.org/about (accessed October 14, 2010).

Howe, Jeff. "The Rise of Crowdsourcing." *Wired Magazine* 14 (2006). Online: www.wired.com/wired/archive/14.06/crowds.html.

Jenkins, Henry. *Convergence Culture*. New York: New York University Press, 2006.

Marzona, Daniel. *Conceptual Art*. Germany: Taschen, 2005.

Olson, Marisa. "Let's Get Physical." Rhizome.org, August 5, 2008: http://rhizome.org/editorial/446 (accessed on February 6, 2010).

O'Reilly, Tim. "What Is Web 2.0." OReilly.com, 2005: www.oreillynet.com/pub/a/oreilly/tim/news/2005/09/30/what-is-web-20.html (accessed February 10, 2010).

Rheingold, Howard. *The Virtual Community: Homesteading on the Electronic Frontier*. Cambridge, MA: MIT Press, 2000.

Standage, Tom. *The Turk: The Life and Times of the Famous Eighteenth-Century Chess-playing Machine*. New York, New York: Walker & Co., 2002.

Links

www.delocator.net
www.google.com/alerts
www.mechanicalolympics.org
www.mechanicalgames.co.uk
www.mturk.com
http://wordpress.org
www.youtube.com/MechanicalOlympics
www.youtube.com/MechanicalGames

6 GOOGLE MAPS ROAD TRIP

Peter Baldes and Marc Horowitz

Key Words: Live Stream, Page Views, Road Trip, Ustream, Viractual

Project Summary

Google Maps Road Trip was a live-streaming documentary produced and performed by Marc Horowitz and Peter Baldes between August 10 and August 18, 2009. The event was the first live-streaming broadcast of a virtual cross-country road trip. Using streaming video technology and the ability to scroll through map imagery using the arrow keys on Google Maps, the pair "virtually drove" from Los Angeles, CA to Richmond, VA, all while never actually leaving their respective home towns. Other websites, such as Flickr.com and Youtube.com, were used to visually augment their journey for viewers and participants of a live chat room hosted throughout the project.

Project Developer Background

Peter Baldes

In 2005, I began to explore Google's new mapping web service. I looked up my old houses, schools, and childhood haunts, all while considering Google Maps as a possible

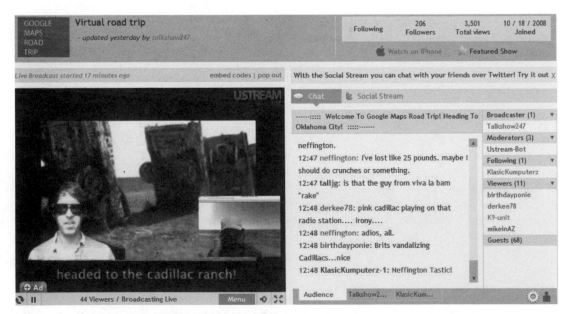

Figure 6.1 Screenshot of the *Google Maps Road Trip* project in action.

tool and space for creating art. This new interactive representation of our world was compelling. At this time the satellite view option was spotty. The available images were of low resolution and often cloudy (literally cloud covered) in all but the largest and most populated cities. In the map view, I realized that by using the arrow keys, one could "drive" and accurately follow a route. It was like a boring real-time video game. As long as you had enough bandwidth, the map tiles would load just quickly enough to keep you interested. One could experience the sensation of scrolling through a landscape within the reduced resolution map space Google had given to us. I found myself taking small trips: driving to the store took two minutes, driving to Washington, DC took 20 minutes, driving home to Albany, NY took a few hours. It was a video game with no goal or rewards beyond the sensation I felt of being in the landscape. At first, I did not give this driving activity much creative thought. I would show my students, I would make little trips in the studio; the activity was somewhat of a joke to me, but it was a joke I could not stop repeating. The sensation of driving in Google Maps was complicated: I'm going somewhere but I'm not moving. At some point, I know I had the distinct thought, "How do I make art with this?" Google Maps also allows one to create one's own custom map. I began exploring the possibilities of this and sharing them on the web-surfing site Nastynets.com, and on my own websites. I made a map of directions for Lombardy Street in San Francisco. Turn left, turn right, turn left, and so on. I mapped out driving directions for the entry and exit points of the book *Adventures of Huckleberry Finn* (which consisted of two spots on the Mississippi River and a blue line connecting them—they didn't drive, either). I also created driving directions for the book *Zen and the Art of Motorcycle Maintenance*. All of these pieces alluded to the limitations of the Google Maps space. In the case of the books, though, something had shifted. *Adventures of Huckleberry Finn* and *Zen and the Art of Motorcycle Maintenance* are both books in which travel across the American landscape is a central component of the story. In both stories, the destination is not important; instead, the journey is celebrated as an agent of transformation. In recent popular culture, the Griswald family is known for their classic cross-country adventure in the 1983 movie *Vacation*, and Miles and Jack, protagonists of the 2004 comedy/drama *Sideways*, went on a Californian wine country expedition that tourists continue to recreate. Road trips involve two important narrative components: time spent in a changing landscape and a companion.

On April Fools' Day in 2005, Slashdot.org posted a fake story that the Google satellites would be over my house at ten o'clock in the morning.[1] I spent three hours lying in my back yard to be captured by the satellites so I could be part of Google Maps. I did not realize it was a joke for several days. In 2007 I created a piece wherein I used screen-capturing software, SnapZ Pro, to record a trip across the country in Google Maps. I exported still frames from this video and used Photoshop's Photomerge to create a panorama of my exported Google Map images. It was 32 feet wide. I was trying to create a seamless experience from the fractured screen- and tile-based interaction I had become accustomed to in Google Maps. Google Maps represents a virtual space, but the purpose seems to go against the type of virtual spaces we have become used to. Rather than representing an imaginary, fantastical space, it seems the goal of Google Maps is to create an accurate depiction of the world we live in. Their version of this world gains resolution every day. Around this time I was also experimenting with another virtual space, *Grand Theft Auto San Andreas*. Released in October 2005, it created a compelling virtual space for interaction. Just as I did with Google Maps, I found myself eschewing the mission-based activities in this game to drive around the virtual space as an independent explorer. Learning the space, I enjoyed finding the

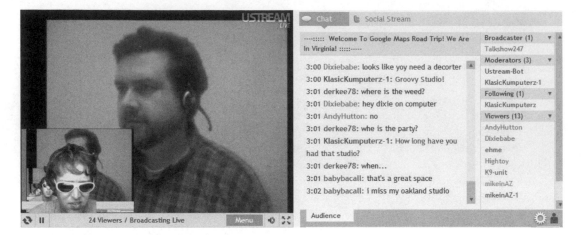

Figure 6.2 Peter Baldes on a green screen in his home set-up for *Google Maps Road Trip*. Marc Horowitz appears in the inset box.

edges of its ability to render. I was using the camera to document my travels while working on a photography book. This became boring, and I abandoned the game once I became familiar with the space it depicted. In the meantime, I purchased several Google-related domain names, Googlemapsroadtrip.com, Googleearthtrips.com, and Googlespacetrips.com.

In early 2008, I visited Los Angeles for the first time. Marc picked me up at the airport and we went out for coffee and lunch. I immediately began to recognize my surroundings, despite the fact I had never actually been to California before. By the time we got to Echo Park, I knew exactly what was coming up next. We parked. I looked around the edge of a building expecting to see the staircase I had driven a motorcycle down in *Grand Theft Auto*, and there it was. The virtual had become real. It was an exciting moment and I began to think that this ability to treat a simulation or virtual space as real held more opportunity than thinking of virtual spaces as mere representations. Stephen Wolfram's theory of computational equivalence states: "Almost all processes that are not obviously simple can be viewed as computations of equivalent sophistication."[2]

I have internalized this statement and come to my own conclusion. A computer simulation is real, at its own resolution. Google Maps and *GTA* should be thought of as real, albeit at their own scale and level of detail. This suspension of disbelief allows for a much richer experience of these spaces. I told Marc I had purchased the Googlemapsroadtrip.com domain and he said he was interested in the project.

Marc Horowitz

Marc is well known for having a good laugh with our great nation. One of his most memorable experiments happened during a photo shoot when he wrote "Dinner w/ Marc 510-872-7326" (his name and actual cell phone number) on a dry-erase board featured in a home office shot for a *Crate & Barrel* catalog. This stunt not only got him fired, but it landed him on *The Today Show* and dozens of other programs and publications. Receiving over 30,000 calls, Marc embarked on a trans-America journey to meet as many people for dinner as possible during "The National Dinner Tour." Consequently, *People Magazine* named him one of their "50 hottest bachelors."[3]

Hungry for more travels and exploits, Marc signed his name on a United States map and drove that route. Along the way he "improved" 19 towns that fell along the path of his signature. These improvements included starting an anonymous semi-nudist colony in Nampa, ID and burying an entire town's problems in Craig, CO.

Marc was born to Karen Meyer and Burton Horowitz, a schoolteacher and pharmacist respectively. At age eight, he founded his first company—a ghost removal and cleaning service. He had his first press at nine when he organized a break-dancing competition as entertainment for senior citizens. At 15, Marc left home. For a while, he lived in an actor friend's basement and attended high school in Paradise, IN, playing football, running track, and buying beer for others with his fake ID as a business venture. He moved around frequently, posing as a foreign exchange student; at age 17, he attended Indiana University in Bloomington, receiving his degree in Business Marketing and Microeconomics. After graduating, he traveled extensively overseas, shearing sheep and turning down offers to start various carpet businesses in Morocco. He ultimately took a job in Silicon Valley with a graphics firm. Later, he left in hope of starting his own venture, and attended the San Francisco Art Institute.

After the Art Institute, Marc and a long-time collaborator, Jon Brumit, reinvented themselves as the business team of Sliv & Dulet Enterprises and opened an office in downtown San Francisco. They staffed their company with 30 people of various backgrounds to help them "develop a summer line of products and services," which they pitched to local businesses. Some examples included a fog-removal initiative for the Golden Gate Bridge, a full-service "office in a tent" for Staples, and a "Swiss Army Cubicle" for Google.

Continuing his social research, Marc initiated his Errand Feasibility Study, which included running his daily errands while riding a pack mule through San Francisco. That same year, every Saturday, Marc ran 1,500 feet of extension cord from his kitchen to the local park three blocks away, where he hooked up a coffee maker and served free coffee to park visitors.

In 2010, Marc hosted the television show *It's Effin Science* for G4. In that same year, from November 1 to November 30, he completed a month-long performative social experiment in which he lived by popular vote. People visited the website www.theadviceofstrangers.com and voted in real time on the choices Marc made every day, from the seemingly mundane to the profound. As with Horowitz's past actions, "The Advice of Strangers" constituted a collaboration between artist and audience; this time, his audience was composed of anyone who visited the website and cast a vote—thus influencing the course of the project, and Marc's life, at the same time.

Backing up just a bit to the summer of 2009, Marc, interested in continuing "artainment" (art and entertainment), prodded Peter to realize the Google Map Road Trip. And so it happened.

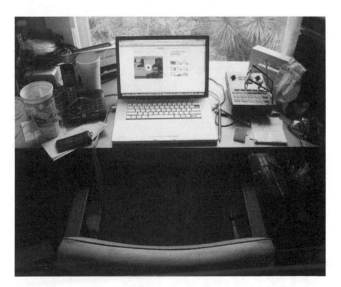

Figure 6.3 A view of Marc Horowitz's home office at the time of his virtual road trip.

Introduction to GoogleMapsRoadtrip.com

MARC: Pete sent me an email that my site sucked and that I needed a blog. This was back in 2005. He gave me his phone number, so I called him and we talked. I eventually started a blog and focused on posting all of my work on the web.

PETER: I'm not sure that I said "sucked," but I remember that his site was not doing a very good job showing off his work.

MARC: Pete and I continued talking online about art and life for several years. In 2008 we met at a mutual friend's wedding in South Carolina. We had a stellar conversation in the back of a shuttle bus from the hotel to the chapel. At that moment, I realized I love Pete—he's a creative genius.

PETER: The whole wedding felt like a stand-up comedy routine to me, being creative when you are around Marc just seems to happen, effortlessly.

MARC: Fast-forward to 2009, Pete came out to Los Angeles and stayed with me. We discussed the Google Maps Road Trip [GMRT] project and a few months later, it was up and we were "driving" across the country.

PETER: I drove from Seattle to Richmond in 2002 with my friend Carl and a dog named Pinky. That real trip and our virtual trip have a lot in common and are becoming conflated in my memory. Both tested my patience and both were rewarding in surprisingly similar ways. I think Marc would agree when I say that we truly became friends and probably know more than we want to about each other as a result of our virtual trip.

MARC: Agreed. Pete lies down in the tub while taking a shower. Case in point.

PETER: GoogleMapsRoadtrip.com is a web-based live performance wherein Marc Horowitz and I virtually drove across the United States using Google Maps. We augmented our experience by using other websites to represent the landscape we virtually traversed. It was all at once a buddy film, road movie, endurance performance, chat room, website, a technical challenge, my introduction to the press, to fleeting fame and as Marc likes to say, "Yeah, that was a weird project." Up until this point, I had only performed in front of the camera a few times. But Marc was right at home behind the camera.

MARC: Literally! Haha! That was so bad. Sorry, go on.

PETER: We really thought it was just going to be us suffering through this crazy idea together. When we were through, we would publish a video document of the trip, and that would represent the project.

Figure 6.4 Peter and Marc chat with road trip guests on Ustream.

MARC: Nope, we had a world of viewers watching us scroll our way across America. Then we were on National Public Radio and Google twittered about our project to millions, we were in the *NY Times*, and mentioned on several blogs. People actually cared. The project began to take on an interesting dialogue between us and our viewers.

PETER: The first thing we did to make this all happen was install a Wordpress blog on the domain, http://Googlemapsroadtrip.com. We only did minor customization, reverse ordering of posts and placed a map image representing our route in the background. We didn't think many people would be seeing this. The website would serve as a receptacle for the recorded videos and a place to keep any viewers up to date on our progress. A few days before the trip we did some testing.

MARC: I wore the worst robe I could possibly find for this testing phase.

PETER: We set a date, August 10th, which coincided with the day Marc had to go to traffic court.

MARC: That was horrible, by the way. The lines! They should at least have you attempt to solve problems for the city or make something for city office workers while you wait in line. So much time is wasted there.

PETER: That afternoon, we began our virtual journey, driving, or scrolling, east. All of our assumptions about the site went up in virtual smoke. It immediately became apparent, that the passengers, the people in the chat room, were why we were doing this and our main audience. The audience became our new friends. I don't think we would have finished if not for the chat room participants and their investment in the project.

MARC: In driving some 40 hours with Pete, I gained a new understanding of him, just like a real road trip. Secrets, annoying ticks, eating habits, musical tastes, fast food preferences, childhood stories, it all came out. It was an irreplaceable experience akin to a real-life road trip.

PETER: I agree.

MARC: I felt that GMRT had to be entertaining. People are tuning in and watching a "show" of sorts and Pete and I are the "performers." You would never think of this on a real physical road trip, because there is no audience. You can space out, pick your nose when your buddy isn't looking, be generally boring for hours on end; but in a broadcast virtual road trip, I felt like there was this expectation to be funny, witty, and clever the whole time. It wasn't possible. Peter can attest to that, as he fought my urges most of the time and in the end it did take on the trimmings of a real-life road trip.

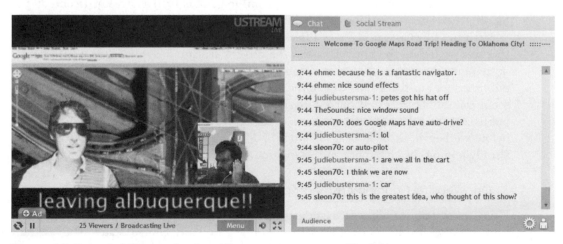

Figure 6.5 Peter and Marc are leaving Albuquerque en route to Virginia.

PETE: I was not opposed to silence, I thought that would reflect a more "real" road trip, but the tension between us became a big part of the entertainment ... and that tension was probably more real than anything else. It was an exhausting experience.

Technical Description

Our set-up included a green screen placed behind a chair (for live chroma key); a computer; a landline speaker phone to talk with each other; a built-in microphone on the computer; Dr. Sampler for road, traveling, and car sound effects; and the MacBook Pro built-in webcam. The technical components of Google Maps Road Trip have four basic components: Google Maps, Camtwist with Ustream.tv, the Googlemapsroadtrip.com website, and supporting websites.

1. Google Maps

In map and satellite views, Google Maps, as Peter described in his introduction, allows one to "scroll" using the arrow keys on the keyboard and follow a course, like navigating a primitive video game. For whatever reasons (processor, operating system, bandwidth), at this particular time, the speed at which you can scroll through the map closely mimics driving at a speed of about 60 miles per hour.

2. Camtwist in Conjunction with Ustream.tv

Camtwist is free software for the Mac operating system that allows for the live compositing of multiple video streams, which can then be streamed as one signal. We composited our desktop (specifically, we used a browser with Google Maps as the desktop layer) with a live webcam view of our faces. The webcam image was on top of the desktop capture, and we used live chroma keying to just show our face floating on the desktop image. Marc had a green screen behind him and Peter used a white wall, so we could easily remove our heads with chroma keying techniques. The desktop image portrayed our location in Google Maps. The person with Google Maps in the background was the "driver." The final composite video signal was then sent to Ustream.com.

Ustream is a website which consists of a network of diverse channels providing a platform for lifecasting and live video streaming. The website has over two million registered users who generate more than one million hours of live streamed content per month, with over ten million unique hits per month.[4]

Ustream, like Google Maps, is a free service. We created a channel for the live stream that was posted on the blog. This was the driver's stream. The passenger would be co-hosted into this stream. So on one channel, two people and four layers of imagery were published for our live event. One of the biggest surprises was the importance of the chat room that all Ustream channels provide. Although we were aware that Ustream had publicized the project on Facebook and Twitter, we were genuinely surprised that even before we began, as Peter "sat" in front of Marc's house in Los Angeles, people were already joining the chat room and asking questions.

3. Our Website, Googlemapsroadtrip.com

Using the system of Camtwist to composite, Ustream to publish and Googlemapsroadtrip. com to aggregate our content, we virtually drove across the United States. The Ustream chat room allowed people to "hitchhike" along with us and participate in our journey.

4. Supporting Websites

We often used Wikipedia, YouTube, or Flickr to aid conversation while we were on the road.

Historical Perspectives

PETER: Viractual is a theory created by Joseph Nechvatal that strives to "create an interface between the biological and the technological." Nechvatal understood the complexity of the hybrid relationship artists would forge between the computed (or virtual) and the corporeal (or actual, real-world) experience. This theory of viractuality is central to the GMRT project. As artists, we were dealing in the realm of the virtual, but as performers, we were living the actual experience. I believe that currently, or in the near future, biological experiments, on the scale in which Nechvatal discusses and uses them, can be fully simulated, in order to fully realize the same resolution of actual biological systems in virtual reality. When this happens, the simulation will become just nearly equivalent to the real experiment.

At Alfred University, New York, Brendon Eaton and Forrest Dowling created the art building (Harder Hall) in Unreal Tournament. At night we would turn off our video-editing software, open Unreal Tournament and run around and shoot each other in a virtual version of the space we simultaneously occupied. That was a viractual performance, although few of us were likely to be too familiar with Nechvatal's work. My avatar would run into the studio, and my body would turn and around and look at an empty, unmoving door. It was unnerving, because the sensation was so real.

Google Maps exists to make money for Google, a company that has a profound ability to create websites and utilities that people become dependent upon and then make money off our wandering eyeballs, the "impressions" we make on online advertisements, and our short attention spans. What does it mean to use a capitalistic tool for a creative endeavor? When you visit Google Maps it is an open question, but your searches reveal the commerce at play behind the scenes. What do you search for? Pizza? An address? Directions to a location? Google gives you the requested information but it is peppered with commerce and transactions between businesses. Papa John's Pizza paid to be there, so did the real-estate conglomerate, and the gas stations on your newly planned route. Location becomes commodity on the Google Maps website. GMRT, as is most of my work and I believe most net.art, is an attempt to subvert the obvious use of the technology (commerce) in order to use it for creative expression. The problem with most net.art is that it only talks about itself and the system it exists within, such as formalist net.art. And I make those types of projects, too.

MARC: The classic cross-country road trip is akin to the American Dream. Big open America is just waiting for you! However, gas has become expensive, we are in the middle of a depression, and time has become very scarce as we have to work or continue to look for it. But with advances in technology, Google Maps, YouTube, Flickr, and Ustream, we can travel alone, or with our friends and family virtually, and on our own schedule. It is not as tangible as the real-life experience, but it affords us a way to see the world from so many different perspectives, which provides a surprisingly rich and unique experience, albeit a virtual one.

I'm interested in performance art works that incorporate travel. This project was a natural follow-up to *The National Dinner Tour* and *The Marc Horowitz Signature Series*. I've done smaller, more local travel-based projects as well. For example, for *Hitchhiking*

Across LA, I hitchhiked from the east end of Sunset Boulevard to the west end of the Boulevard and broadcast the experience live via webcam to an audience of thousands. Ed Ruscha's *Every Building on the Sunset Strip*, where he took continuous photographs of a two-and-a-half mile stretch of the 24-mile boulevard, partly informed this piece. It is darkly funny to think that Ruscha's piece serves as a near precursor to Google Street View.

Painters have been combining travel with visual art for thousands of years. They would venture into the wilderness, or foreign countries, or uncharted territories and paint landscapes and portraits to bring back home for curious crowds. A great deal of literature is based on journey and adventure, such as Homer's *Odyssey*, Joyce's *Ulysses*, Defoe's *Robinson Crusoe*, Steinbeck's *Travels with Charlie*, and Kerouac's *On the Road*. Now we can archive our travels on the web, for anyone to view and explore at any time, from any location. Imagine if Robinson Crusoe broadcast his experience live. He may have left his distant island very quickly, or maybe he would have stuck around and filmed the very first episode of *Lost*, or emailed a few of his friends to create a *Survivor*-style reality show. What if John Steinbeck was able to broadcast his travel experiences live? Would he have made *Travels with Charlie* as a travel vlog?

The ease and accessibility of technology is changing the way we look at our surroundings and informs the way we present documentation, as laymen and artists. Online viewing audiences expect free and accessible content in a way they never have before. As an artist who predominantly works on the web, I directly engage with these demanding online audiences. As a result, I have become very interested in the place where cultural production and art overlap, between the realms of fine art and entertainment. James Franco's almost instantaneous rise to the top of the art world because of his celebrity status highlights this implication; as does the art world's obsession with celebrity culture and entertainment, and the entertainment world's curiosity about the fringes of the fine art world. Francesco Vezzoli's work and Bravo's TV series *Work of Art* exemplify this obsession.

Conclusions and Outcomes

Google Maps Road Trip is a media experiment that relies on several separate websites to conduct an alternate version of the classic American cross-country road trip, but most

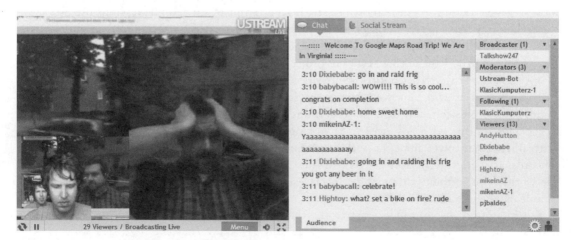

Figure 6.6 Peter Baldes and Marc Horowitz complete the road trip in Virginia.

importantly, it allows people to not just view the trip (as in a cinematic episode), but participate, shape, and interact with the "actors" on the journey.

At any given point there was an average of 30 people watching us trek across the country. Pete actually started crying as we played YouTube videos dedicated to the victims of the Oklahoma City bombing while we "pulled over" at the Oklahoma City National Memorial and Museum. It was moving. Marc could not believe that Elvis had a carpeted kitchen as we took a virtual tour of Graceland. And … they built a replica Parthenon in Nashville, TN. Who wouldda thunk?

GMRT is as much an art project as an entertainment piece. The idea was generated from a place of curiosity, an artistic question. It was then developed into a piece that was intended for anyone who wanted to visit our project and watch us live as we virtually traveled across the country. We took this journey to raise questions about virtual travel and to push the limits of entertainment, art, and the way users can use (or misuse) ubiquitous technologies such as Google Maps.

Notes

1. CmdrTaco, "Say 'Cheese' to Google Satellite at 10AM," Slashdot.org: http://tech.slashdot.org/story/05/03/31/2113253/Say-Cheese-to-Google-Satellite-at-10AM (last modified April 1, 2005).
2. Stephen Wolfram, *A New Kind of Science*, Champaign, IL: Wolfram Media, 2002, 2005: 716–717.
3. Dan Jacobs, "Going to Extremes: For Love," *People Magazine* 63, 25, 2005. Online: www.people.com/people/archive/article/0,,20148009,00.html (last modified June 27, 2005).
4. BusinessWire, "Ustream.TV Continues Rapid Growth, Secures Financing, Appoints General Wesley Clark to Advisory Board and Expands Footprint in Political Arena," Busineswire.com: www.businesswire.com/portal/site/google/index.jsp?ndmViewId=news_view&newsId=20071218005356&newsLang=en (last modified December 18, 2007).

Bibliography

BusinessWire. "Ustream.TV Continues Rapid Growth, Secures Financing, Appoints General Wesley Clark to Advisory Board and Expands Footprint in Political Arena." Busineswire.com: www.businesswire.com/portal/site/google/index.jsp?ndmViewId=news_view&newsId=20071218005356&newsLang=en (last modified December 18, 2007).

CmdrTaco. "Say 'Cheese' to Google Satellite at 10AM." Slashdot.org: http://tech.slashdot.org/story/05/03/31/2113253/Say-Cheese-to-Google-Satellite-at-10AM (last modified April 1, 2005).

Jacobs, Dan. "Going to Extremes: For Love." *People Magazine* 63, 25, 2005. Online: www.people.com/people/archive/article/0,,20148009,00.html (last modified June 27, 2005).

Wolfram, Stephen. *A New Kind of Science*. Champaign, IL: Wolfram Media, 2002, 2005.

Links

http://maps.google.com
www.ustream.tv
www.googlemapsroadtrip.com
www.ineedtostopsoon.com
http://camtwist.en.softonic.com/mac/download

PART IV
DATA VISUALIZATION

ON DATA VISUALIZATION

"The earliest seeds of visualization arose in geometric diagrams, in tables of the positions of stars and other celestial bodies, and in the making of maps to aid in navigation and exploration."[1]

"There are two primary sources of potential error in numerical algorithms programmed on computers: that numbers cannot be perfectly represented within the limited binary world of computers, and that some algorithms are not guaranteed to produce the desired solution."[2]

Accordingly, I fixed upon a tree of average bulk and flower, and drew imaginary lines—first halving the tree, then quartering, and so on, until I arrived at a subdivision that was too large to allow of my counting the spikes of flowers it included. I did this with three different trees, and arrived at pretty much the same result: as well as I recollect, the three estimates were as nine, ten, and eleven. Then I counted the trees in the avenue, and, multiplying all together, I found the spikes to be just about 100,000 in number. Ever since then, whenever a million is mentioned, I recall the long perspective of the avenue of Bushey Park, with its stately chestnuts clothed from top to bottom with spikes of flowers, bright in the sunshine, and I imagine a similarly continuous floral band, of ten miles in length.[3]

"Many different words can be used to describe graphic representations of data, but the overall aim is always to visualize the information in the data and so the term *Data Visualization* is the best universal term."[4]

"For no study is less alluring or more dry and tedious than statistics, unless the mind and imagination are set to work or that the person studying is particularly interested in the subject; which is seldom the case with young men in any rank in life."[5]

Graphical displays should

- show the data
- induce the viewer to think about the substance rather than about methodology, graphic design, the technology of graphic production, or something else
- avoid distorting what the data have to say
- present many numbers in a small space
- make large data sets coherent
- encourage the eye to compare different pieces of data

- reveal the data at several levels of detail, from a broad overview to the fine structure
- serve a reasonably clear purpose: description, exploration, tabulation, or decoration
- be closely integrated with the statistical and verbal descriptions of a data set.[6]

"So geographers, in Afric maps,
With savage pictures fill their gaps,
And o'er unhabitable downs
Place elephants for want of towns."[7]

"The interior decoration of graphics generates a lot of ink that does not tell the viewer anything new. The purpose of decoration varies—to make the graphic appear more scientific and precise, to enliven the display, to give the designer an opportunity to exercise artistic skills. Regardless of its cause, it is all non-data-ink or redundant data-ink, and it is often chartjunk."[8]

The process of seeking relationships within a data set—of seeking accurate, convenient, and useful summary representations of some aspect of the data—involves a number of steps:

- determining the nature and structure of the representation to be used;
- deciding how to quantify and compare how well different representations fit the data (that is, choosing a "score" function);
- choosing an algorithmic process to optimize the score function; and
- deciding what principles of data management are required to implement the algorithms efficiently.[9]

"One of the major themes for 2010 was using data not just for analysis or business intelligence, but for telling stories. People are starting to make use of the data (especially government-related) that was released in 2009, and there was a lot more data made available this year (with plenty more to come). There were also more visualization challenges and contests than I could count."[10]

Notes

1. Michael Friendly and D.J. Denis, "Milestones in the History of Thematic Cartography, Statistical Graphics, and Data Visualization." Online: www.datavis.ca/milestones (accessed December 20, 2010).
2. Micah Altman et al., Numerical Issues in Statistical Computing for the Social Scientist, Hoboken, NJ: John Wiley & Sons, 2004: 2.
3. Francis Galton, Hereditary Genius: An Inquiry into Its Laws and Consequences, 2nd edn., London: Macmillan, 1892: 11.
4. Antony Unwin et al., Graphics of Large Datasets Visualizing a Million, New York: Springer, 2006: 4.
5. William Playfair, The Statistical Breviary, London, 1801.
6. Edward Tufte, The Visual Display of Quantitative Information, Cheshire, CT: Graphics Press, 1983: 13.
7. Jonathan Swift's indictment of seventeenth-century cartographers, "On Poetry: A Rhapsody," The Literature Network, 1773. Online: www.online-literature.com/swift/3515 (accessed on December 21, 2010).

8. Tufte, op. cit.: 107.

9. David Hand *et al.*, *Principles of Data Mining*, Cambridge, MA: MIT Press, 2001: 3.

10. Nathan Yau, "10 Best Data Visualization Projects of the Year: 2010." Online: http://flowingdata.com/2010/12/14/10-best-data-visualization-projects-of-the-year-%E2%80%93-2010 (last updated December 14, 2010).

Bibliography

Altman, Micah, Jeff Gill, and Michael P. McDonald. *Numerical Issues in Statistical Computing for the Social Scientist.* Hoboken, NJ: John Wiley & Sons, 2004.

Friendly, Michael and D.J. Denis. "Milestones in the History of Thematic Cartography, Statistical Graphics, and Data Visualization." Online: www.datavis.ca/milestones (accessed December 20, 2010).

Galton, Francis. *Hereditary Genious: An Inquiry into Its Laws and Consequences*, 2nd edn., London: Macmillan, 1892.

Hand, David, Heikki Mannila, and Padhraic Smyth. *Principles of Data Mining.* Cambridge, MA: MIT Press, 2001.

Playfair, William. *The Statistical Breviary.* London, 1801.

Swift, Jonathan. "On Poetry: a Rhapsody." *The Literature Network.* 1773. Online: www.online-literature.com/swift/3515 (accessed on December 21, 2010).

Tufte, Edward. *The Visual Display of Quantitative Information.* Cheshire, CT: Graphic Press, 1983.

Unwin, Antony, Martin Theus, and Heike Hofmann. *Graphics of Large Datasets Visualizing a Million.* New York: Springer, 2006.

Yau, Nathan. "10 Best Data Visualization Projects of the Year: 2010." Online: http://flowingdata.com/2010/12/14/10-best-data-visualization-projects-of-the-year-%E2%80%93-2010 (last updated December 14, 2010).

7 SUPERFUND365

Brooke Singer

Key Words: CERCLIS, Citizen Science, Co-production, Database, Data Visualization, EPA, Flash, Open Government, Superfund, XML

Project Summary

Superfund365 is an online, data-visualization application that consists of 365 Superfund sites—i.e., the nation's worst hazardous waste sites as designated by the Environmental Protection Agency (EPA). For one year, *Superfund365* featured a site a day, graphically depicting public data such as present contaminants, responsible parties, and regional demographics along with text and image contributions from users.

Project Developer Background

This is a project that fell into my lap. I did not necessarily have time for it. I was not looking to take on something new. But sometimes a statement of fact, a passing comment, or even an image can trigger such intense curiosity that you find you are in pursuit of answers and, before long, you are producing a new body of work.

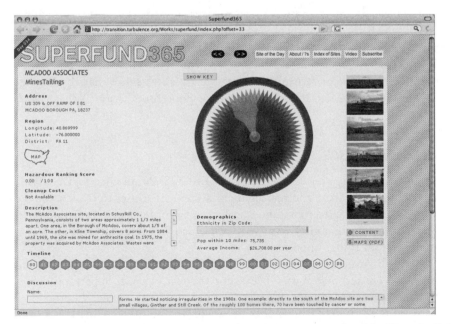

Figure 7.1 Superfund365.org screenshot (McAdoo Associates, day 34 of *Superfund365*).

In early 2006, I met Robert J. Martin, the former National Ombudsman for the EPA, at a pub near Times Square to discuss air sampling in New York City. I had just been awarded a commission with my collective, Preemptive Media, from Eyebeam Art + Technology Center and the Lower Manhattan Cultural Council to build portable air-monitoring devices. The project, which was launched in 2007 as *Area's Immediate Reading (AIR)*, started with the basic premise that the air-quality map of New York City would look radically different if the monitoring devices that supply the data were (a) mobile and (b) in the hands of citizens rather than located at fixed stations selected by the government. The purpose was to build micro air-quality reports that are based on individual paths through the city and that could be aggregated dynamically to determine general readings, an alternative to the Air Quality Index.[1]

A professor of politics and environmental studies at Ithaca College told me that anyone designing a project to measure air quality in New York should contact Robert Martin. From 1992 to 2002, Martin served as the EPA National Ombudsman or mediator between the American public and the US government agency that is charged with protecting human health and the country's natural environment. On 9/11, Martin was driving to his office at the EPA headquarters in Washington, DC, when the World Trade Center collapsed and the streets of New York were blanketed in a record amount of the most toxic substances known to man.

Shortly after we met, Martin said that he could not help much with my technical questions about monitoring hardware and testing for contaminants; he referred me to his former colleague, a scientific advisor, for that information. Instead, he told me what it was like at the EPA in the days following 9/11. While Americans mourned and worried about further attacks, EPA employees immediately recognized the gravity of the environmental impact, swiftly mobilized a team of first responders, and internally debated whether all of Lower Manhattan should be declared a Superfund site, a site so hazardous that it warranted the relocation of inhabitants and immediate cleanup. Martin paused and rephrased his last comment: all of Lower Manhattan qualified for Superfund in 2001.

When I left the meeting, my mind was spinning with information and new insights into the extent to which the government had failed the people of New York and the extreme measures the administration took to ensure that Wall Street would be functioning within days of the worst attack ever launched from abroad against the United States.[2] The one statement I kept returning to was Martin's insistence that the damage inflicted on Lower Manhattan had met the criteria for Superfund action. What *exactly* did that mean?

Introduction to *Superfund365*

If you visit the EPA website, you can access the CERCLIS Public Access Database.[3] CERCLIS is "the national database and management system EPA uses to track activities at hazardous waste sites considered for cleanup under the Comprehensive Environmental Response, Compensation and Liability Act (CERCLA), also known as Superfund."[4] This is the official source for all things Superfund.

Superfund, I have discovered, is generally an unknown term to younger generations or people born in the United States after 1980. For the rest of us, if Superfund means anything, it probably invokes images of Love Canal. Love Canal, a neighborhood in Niagra, NY, was built atop 20,000 tons of toxic waste. In the mid-1970s, Lois Gibbs started a movement in her community by going door to door polling people about their

health problems after her son fell sick and she learned his elementary school was directly above the contamination hot zone. After several years of demanding protection and fed up with government inaction, the community held hostage several EPA officials. This garnered national media coverage and public outrage.[5]

In the wake of these events at Love Canal, the Federal Superfund program was enacted "to address abandoned hazardous waste sites ... [allowing] the EPA to clean up such sites and to compel responsible parties to perform cleanups or reimburse the government for EPA-led cleanups."[6] At that time in the early 1980s, regulators thought there were only a small number of sites eligible for Superfund designation and that the original $1.6 billion trust would be ample to fund the program. But more sites qualified for Superfund status than anticipated, and each year many more sites were added to the list than cleaned up. As of May 2010, there were a total of 1,279 sites on the National Priorities List (NPL) of the worst hazardous waste sites as identified by Superfund.[7] Thousands more sites, specifically 13,253, were active or are under consideration for NPL designation, while another 35,593 were archived sites labeled as "no longer of interest" in the database.[8]

The interface to CERCLIS is a search form offering numerous points of entry into this massive database (see Figure 7.2). Like many other online databases, CERCLIS is not particularly welcoming: it is text heavy, it does not encourage browsing, and, although a lot of information can be extracted, it does not easily produce understanding. It reminds me of my dislike for shopping malls; I will enter only if I know exactly what I want and where it is so I can get in and out as quickly as possible. My initial curiosity about Superfund was dampened by the data deluge. I began to think about user interfaces and the experience of this information on screen versus my one-on-one conversation with Martin. How could I bring the two closer together? Just how public, in fact, was this public database?

Figure 7.2 A view of the CERCLIS interface.

Technical Description

From the start, I was convinced that I should follow a one-a-day format for several reasons. There was so much data that highlighting a new site each day created a manageable pace and avoided overwhelming my visitors. A one-a-day format also allowed a narrative to unfold and I pushed this even further by structuring the project as a travelogue. I knew I would not be able to spend a whole year visiting a different Superfund site each day and the project did not actually require this, but the personal descriptions of place and the "just-snapped" photographs brought the sites to life. In other words, the data became more meaningful and had more of an impact when presented from a human perspective. My hope was that as the journey moved further from my home in New York City, I could use social networking and media attention to attract others to pick up the route with me and, eventually, for me.

When looking at the data, I decided that the main attributes of a Superfund site as described by CERCLIS consisted of the contaminants of concern, the contaminated media (or where the contamination is found), the total site acreage, and the responsible parties. Therefore, this set of data makes up the primary visual of *Superfund365*, which is colorful and flower-like. It is an animation that unfolds and beckons continuing exploration.

As I was designing, I was consciously using beauty as a lure. Specifically I was reacting to the BP logo and rebranding efforts. In 2000, BP adopted a bright green and yellow sunburst or helios for its logo because, in the company's own words, it symbolizes "dynamic energy in all its forms." The same year the company shed the name British Petroleum for BP to allow for new associations like "better people, better products, big picture, beyond petroleum."[9] BP's logo and rebranding are acts of visual veiling; we are instructed to look beyond (beyond the dirty and destructive practices of oil extraction) toward better (meaning select and cheery) outcomes.[10] My visualization is an ironic riff on the BP sunburst. My visual is not there to distract and deceive with manufactured marketing ploys, however, but rather it is intended to entice and lure users into content such as the CERCLIS database.

Scrolling over the individual parts of the *Superfund365* visualization presents specific data like a present contaminant or total number of acres affected. Certain features are also clickable and take a viewer to outside websites. For instance, many of the contaminants link to the appropriate public health statement from the Agency of Toxic Substances and Disease Registry and a responsible party (typically a business) link to the representative website.

After a user interacts with the visualization once and understands its parts (with help from tooltips and a key), it is easy to move forward or backward through the days and immediately grasp if a site is large or small, has many or few responsible parties, has many or few contaminants, and the type of media. This was an essential feature for me. It was important that each of the 365 sites have a unique page, but also that the pages be viewed in relation to one another and easily compared. Making connections between sites is not possible using the current CERCLIS interface provided by the EPA.

The primary *Superfund365* visualization is framed by more information: site name, site type, address, latitude and longitude, Congressional district, map, EPA Hazardous Ranking Score (HRS), cleanup costs to date, site description, EPA action timeline, and demographics. There are images along the right-hand side, which are a mix of EPA documents, historical photographs, Google image results, my photographs, and user-contributed images. Users can also contribute text in a discussion forum at the bottom of the page.

I determined the layout of the page early in the design process. I knew how I wanted it to look and function only after a few days of studying CERCLIS. It then took three months

of solid work with a research assistant, programmer, and business analyst to build the online application and get *Superfund365* up and running.

Most of the work was fairly tedious. The data contained in the CERCLIS database is public and freely available for download but only in a format called CSV or comma-separated values. This format is not the most current and there is a greater potential for making errors when handling it compared with XML. Also, not all of the data I wanted to incorporate in my application was available as one neat download. My assistant, Emily Gallagher, and I had to call the Superfund hotline many times for help.

After downloading numerous datasets from CERCLIS and calling the hotline, I realized that we would have to manually insert a substantial amount of data into our spreadsheets (which were to become the *Superfund365* database). This meant copying and pasting information from the EPA website or searching through PDF documents. When information was entirely missing, we had to request it by email or a phone call to the site manager.

I was most surprised to find that present contaminates for the sites are not in CERCLIS. All the Superfund sites included in *Superfund365* are on the NPL, which means the contaminant lists do exist. Sometimes the information was posted on the regional EPA website, but when we had to call a manager for the information, we would ask why it was not online. The most frequent response from site managers was that their contaminant list was not final and more in-depth testing was needed.

The site managers were generally very willing to help and pleased that someone was expressing interest in their site. When we told them what we were doing, they were interested and supportive mostly because we would be drawing attention to their work and the problem of Superfund.

Piecing the information together took a lot of time, as did cleaning up the data. We found a lot of inconsistencies and inaccuracies—so many that we did not attempt to fix them all. We tried to standardize the contaminant list since it was central to the project. One contaminant can be spelled in several different ways, which, of course, undermines the integrity of the database and makes it impossible to search for how often a single contaminant appears in all 365 sites.[11]

Kurt Olmstead, a business school graduate and skilled programmer, tackled the irregularities apparent in the responsible parties' dataset in CERCLIS. He was able to generate the most current responsible party (as these change due to buyouts and spinoffs or can be obscured through subsidiaries) by extracting information from the SEC EDGAR database, Wikipedia, and Yahoo finance. By cleansing and standardizing the responsible party names, it was then possible to rank them by HRS, list their entity type (e.g., public company, private company, or government agency) and link to existing websites.

This narrative should suggest the extreme tedium that comes with data entry and database development. And there is more! We still had to build the image database. I wanted to include all EPA documents (maps, diagrams, photographs) related to the sites in the image gallery as well as any images describing the general location or the actual site that we could find. This entailed hours of online research (and sometimes more emails and phone calls), downloading and batch processing of images, and then, finally, uploading the files to the growing *Superfund365* database. This way, when the project launched, each site would have at least a few descriptive images and I hoped more would be submitted by users over time.

The programmer on the project, John Kuiphoff, was responsible for taking the spreadsheets and writing PHP scripts to generate the *Superfund365* database. That was probably his easiest task. More difficult was translating my initial Illustrator sketch into Flash and making an application that functioned with the *Superfund365* database. The

final outcome looks implausibly similar to my sketch, which says a lot about John's programming capabilities. We decided to use the Flash programming environment because it would guarantee that the application would appear consistently across browsers and most browsers are equipped to view Flash content. Other emerging technologies, like AJAX, were considered but we did not feel they were up to the job at the time. In retrospect, this was a mistake. Flash is a proprietary and inherently closed system; developing the project in such a way that our information could be easily exported, used, and extended by others should have been a high priority.

Sources other than the EPA and CERCLIS were invaluable along the way and became part of the final application. I have already mentioned the Agency for Toxic Substances and Disease Registry (a divison of the Center for Disease Control that was created along with Superfund in 1980). The Center for Public Integrity's investigation, "Wasting Away: Superfund's Toxic Legacy," provided excellent background research, including a list of the most dangerous Superfund sites. A Superfund "not having human exposure under control and/or not having contaminated groundwater migration under control" is classified as most dangerous.[12] The "Wasting Away" research aided me in selecting my 365 Superfund sites from approximately 1,300 on the NPL in 2007. The US Census Bureau provided the demographic information. As Lois Gibbs emphasizes in her video interview with me, you cannot talk about Superfund without talking about class and race.[13]

I have shared a good bit of detail about the building of the visualization application because it is important to understand the level of accessibility and usefulness of the public data that is at the core of the project. EPA officials often apologized to us when we inquired for more and better source data. I was later told by agency officials that *Superfund365* succeeds because it underscored the errors and irregularities of CERCLIS; several officials told me they preferred using *Superfund365* over CERCLIS.

This was not my purpose, but interesting nonetheless. My goal was to visualize and make tangible what was obscure and disparate. Pulling together various sources of public material and thus enabling new pictures and questions to emerge was paramount for me. That is why a user comment on the final day of the project, day 365 or Pearl Harbor Naval Complex, was very rewarding. The user posted:

> Great work!! I have been tuned in regularly and have even worked on a few of the sites mentioned. I thought the Pearl Harbor description was a little weak. How does a sugar company become PRP [primary responsible party] for a naval base location?? Sounds like there is more to the story somewhere.[14]

Historical Perspectives

During the summer of 2007, when I was in the midst of producing *Superfund365*, English media artist, Graham Harwood, came for a studio visit. His reaction was: "Isn't this the business of government, not artists?"—which is a slightly different version of the more usual question, *why is this art?* I replied that I was filling a void, taking on the project in the absence of government, and, thus, aligning myself with environmental activists and non-government organizations (NGOs). In fact, artists—such as Mierle Ukeles, the Harrisons, and Mel Chin—have been doing the same thing for decades now.

With this work, I am not advocating that the EPA hire more sophisticated interface and interaction designers. That misses the point. I do, however, think the EPA (and likely every other US government agency) needs to do a much better job of maintaining (correcting, standardizing, updating) its data. In addition, the EPA needs to provide

data for the public in more useful formats, employing the newest trends in data sharing, manipulation, and visualization.

The fact that the EPA's data is inadequate and its reporting procedures are outdated probably does not come as a big surprise. Government agencies are notoriously slow and under-funded while the emerging tech world is neither. The government is aware that it needs to improve in this area. President Obama, on his very first day in office, released a memo in which he stated:

> All agencies should adopt a presumption in favor of disclosure, in order to renew their commitment to the principles embodied in FOIA [Freedom of Information Act], and to usher in a new era of open Government. The presumption of disclosure should be applied to all decisions involving FOIA. The presumption of disclosure also means that agencies should take affirmative steps to make information public. They should not wait for specific requests from the public. All agencies should use modern technology to inform citizens about what is known and done by their Government. Disclosure should be timely.[15]

The government should make it as easy as possible for *anyone* (including artists, activists, NGOs, students, businesses, watchdogs, homebuyers, the general public) to access, use, and benefit from data. Obama emphasized the importance of openness, modern technology, and timeliness in his January 21, 2009, memo. In May 2009, the administration delivered on its promise and launched Data.gov, a user-friendly repository for all information the government collects. This is a positive first step, but there is also the issue of quality. For the producers of *Superfund365* and EPA officials working on Superfund, my project reveals the failings of government disclosure even when there *is* openness and public reporting. This is not apparent to most users of the site.

Discussing data quality can be straightforward. The quality of the EPA Superfund data would be improved greatly if the agency adhered to consistent names for present contaminants. If some data is less reliable than other information, that should be noted and the data should be disseminated anyway for whatever value it might provide.

Thinking about quality begs more difficult questions. What are the assumptions and ideologies that determine inclusion? What are the categories for classification and who is doing the classifying? With the Superfund program, I was told repeatedly that obtaining Superfund status is always a highly politicized process. The players typically are the government (federal, state, and local), industry (potential responsible parties), developers, community organizations, individual residents, and others. The conflicting interests, negotiations, and struggles are reflected in the CERCLIS database. For example, Lois Gibbs of Love Canal shared a fascinating story of why in the 1980s it was determined that a site must have a HRS of 28.5 or higher in order to qualify for Superfund designation. The decision had everything to do with politics and nothing to do with science.[16]

Gilles Deleuze reminds us, "machines are social before they are technical."[17] Too often we believe our data is purely technical and forget its social dimension. Once someone or something (since automatic, computerized data creation is becoming the norm) translates our world into data, that data holds power over us. It makes decisions for us. It triggers action—or compels inaction. Lisa Gitelman writes about this problematic from a slightly different perspective in her book, *Always Already New: Media, History and the Data of Culture*. She states: "Media are frequently identified as or with technologies, and one of the burdens of modernity seems to be the tendency to

essentialize or grant agency to technology."[18] "Data" could replace "media" in this quotation and the words are still true.

The list of academics and artists critiquing our data culture is long, but the conversation has also entered popular media. John Allen Paulos discusses the supremacy of data and questions the aptness of pervasive reliance on data-driven decision-making in a recent article in the *New York Times* called "Metric Mania: Do We Expect Too Much from Our Data?" He ends his discussion with these words: "This doesn't mean we shouldn't be counting—but it does mean we should do so with as much care and wisdom as we can muster."[19]

What is needed is a change in cultural perception of data and its technical underpinnings. Such a transformation occurred in the last century with respect to photography. In 1973, Susan Sontag eloquently debunked the myth of photography in her book *On Photography*. She described our relationship to photographs in this way:

> Photographs furnish evidence ... A photograph passes for incontrovertible proof that a given thing happened. The picture may distort; but there is always a presumption that something exists, or did exist, which is like what's in the picture. Whatever the limitations ... a photograph—any photograph—seems to have a more innocent, and therefore more accurate, relation to visible reality than do other mimetic objects.[20]

I like to think *Superfund365* is playing a role in debunking the database myth. In other words, it challenges our perceived relationship to the data, it reveals the structure of the database and allows for new configurations and correlations. It begets new articulations and, as a result, new dialogues. It confuses as much as explicates. It challenges the very concept of incontrovertible proof. It simultaneously pays homage to the existence of public data and encourages government to improve. This is not about being for or against counting, but is rather a call for greatly expanding who is doing the counting and how results are circulated to support multivalent uses.

As I was writing the conclusion to this chapter, I ran into Tim Dye at a locative media symposium in San Francisco. Tim Dye is a Senior Vice President at Sonoma Technology, Inc., where he helped to develop, and now manages, AIRNow. AIRNow is an EPA program that makes accessible air-monitoring data from across the country via the Internet. Dye knew about Preemptive Media's work developing portable air-monitoring devices, and he told me that within five years or so he believes such affordable and off-the-shelf devices will be publically available. In anticipation of this, Dye envisions the AIRNow program will support the use of these devices by citizen scientists across the country and will encourage the upload and integration of citizen data into the government's air-quality database. AIRNow would be co-produced by government and citizens alike. Independent data collection and visualization projects would not be forced into an adversarial role with the government but rather the relationship could be collaborative and mutually informative.

Jason Coburn describes the importance of co-production like this in his book *Street Science: Community Knowledge and Environmental Health Justice*:

> [The] co-production model problematizes knowledge and notions of expertise, challenging hard distinctions between expert and lay ways of knowing ... [The] co-production model emphasizes that when science is highly uncertain, as in many environmental-health controversies, decisions are inherently trans-science—involving questions raised by science but unanswerable by science alone.[21]

This model and Dye's wishful approach to AIRNow is the future for data collection and visualization. It is democratic and responsive. It allows for numerous perspectives from professionals and citizens. Science is not accepted uncritically as fact but is co-produced by numerous stakeholders because the risks are high and solutions are urgently needed.[22]

Conclusions and Outcomes

The focus of this chapter has been the original purpose of *Superfund365* and the production process for developing it. I have described the project as a data visualization application and what it means for me, as an artist, to use government-generated data as my medium.

But *Superfund365* is also a platform, meaning it is not only a place to visit and learn but also to share and connect with others for possible action. On the day it was launched, September 1, 2007, the project was a starting point rather than a completed work. From that day forward, the data visualization gave way to collective storytelling.

It is beyond the scope of this chapter to discuss in any detail the life of *Superfund365* after it was launched, but I will say that after staring at the EPA data on screen for several months, it was almost startling to visit the locations in person. The first several weeks, I traveled to every Superfund site highlighted in *Superfund365*, beginning with Quanta Resources in Edgewater, NJ, which is directly across the Hudson River from the Upper West Side. I expected to find the sites cordoned off and dotted with scientists in Hazmat suits, but this was not the case (see Figure 7.3). Very rarely were the places even marked as Superfund sites and only once did I see any cleanup activity. I found myself in such places as abandoned lots with DO NOT ENTER signs, the largest shopping mall in New York State, an abandoned softball field, an empty square block in a city center, and a Home Depot store. These were, I concluded, common, everyday places.

For this reason, Alex Prud'homme's 2010 Op-Ed in the *New York Times* resonated with me. He wrote:

> We tend to think of oil spills as dramatic events—a sinking ship, a burning rig. So it's easy to forget that across the country, hundreds of spills, many left over

Figure 7.3 Quanta Resources Superfund Site, Bergen County, NJ (day 1 of *Superfund365*).

from a less regulated time, continue to poison groundwater and leak toxic fumes. Instead of letting the Gulf spill divert our attention yet again from slow-moving disasters like Newtown Creek, we should take it as an impetus to address problems much closer to home.[23]

And who better to force attention to these sites, tell their histories, explain the consequences of contamination, and suggest solutions for building a better future than the people who call these places home. With one in four Americans living within four miles of a Superfund site, there is a lot of local expertise to be tapped.[24] The convergence of social media and off-the-shelf monitoring hardware offer tremendous potential for co-production. The challenge remains to transform this kind of knowledge production into actionable solutions.

Notes

1. See www.pm-air.net.
2. On Earth Day 2002, Robert Martin resigned as National Ombudsman. He left the EPA after Administrator Christine Todd Whitman eliminated his office's independence—and therefore its function as internal watchdog—through restructuring. Weeks before, Martin had issued a very public and frank condemnation of the EPA's handling of Lower Manhattan post-9/11 after holding two extensive public hearings. No replacement was ever hired and to this day there is no National Ombudsman at the EPA. To hear Robert tell his story, watch my video interviews with him (link).
3. Cfpub.epa.gov: http://cfpub.epa.gov/supercpad/cursites/srchsites.cfm (accessed May 18, 2010).
4. U.S. EPA: http://epa.custhelp.com/cgi-bin/epa.cfg/php/enduser/std_adp.php?p_faqid=173&p_created=1065036508 (accessed May 18, 2010).
5. To hear the story of Love Canal told by Lois Gibbs, watch the video interview on Superfund365.org: http://turbulence.org/Works/superfund/video.html.
6. Epa.gov: www.epa.gov/superfund/about.htm (accessed May 24, 2010).
7. Epa.gov: www.epa.gov/superfund/sites/query/queryhtm/nplfin1.htm (accessed May 24, 2010).
8. These numbers are in reports run one a month by the EPA and available for download from here: http://epa.gov/superfund/sites/phonefax/products.htm.
9. Bp.com: www.bp.com/sectiongenericarticle.do?categoryId=9014508&contentId=7027677 (accessed May 24, 2010).
10. The extent of the dirty and destructive oil-extraction practices of BP came into sharp focus after the April 2010 Deepwater Horizon Gulf spill.
11. Because we did standardize the contaminant list, we were able to make a list of the top 25 contaminants of Superfund365, available at: http://turbulence.org/Works/superfund/top_25_cont.html.
12. Publicintegrity.org: http://projects.publicintegrity.org/Superfund/HumanExposure.aspx (accessed May 25, 2010).
13. See video interview 003 with Lois Gibbs on Superfund365: http://turbulence.org/Works/superfund/video.html.
14. Turbulence.org: http://turbulence.org/Works/superfund/index.php (accessed May 25, 2010).
15. Eff.org: www.eff.org/deeplinks/2009/01/on-day-one-obama-demands-open-government (accessed May 25, 2010).
16. See video interview 001 with Lois Gibbs on Superfund365: http://turbulence.org/Works/superfund/video.html.
17. Gilles Delueze, *Foucault*, trans. Sean Hand, Minneapolis, 1988: 13.
18. Lisa Gitelman, *Always Already New: Media, History and the Data of Culture*, Cambridge, MA: MIT Press, 2006: 2.
19. John Allen Paulos, "Metric Mania," *New York Times*, May 10, 2010. Online: www.nytimes.com/2010/05/16/magazine/16FOB-WWLN-t.html?scp=1&sq=metric%20mania&st=cse (accessed May 25, 2010).

20. Susan Sontag, *On Photography*, New York: Bantam Doubleday Dell, 1973: 5.
21. Jason Corburn, *Street Science: Community Knowledge and Environmental Health Justice*, Cambridge, MA: MIT Press, 2005: 41.
22. For more on this topic, see Silvio O. Funtowicz and Jerome R. Ravetz, "Science for the Post-normal Age," *Futures*, 25, 7, September 1993: 739–755.
23. Alex Prud'homme, "An Oil Spill Grows in Brooklyn," *New York Times*, May 14, 2010. Online: www.nytimes.com/2010/05/16/opinion/16Prudhomme.html?scp=1&sq=Alex%20 Prud%27homme&st=cse (accessed June 10, 2010).
24. Americanprogress.com: www.americanprogress.org/issues/2006/06/b1777527.html (accessed June 18, 2010).

Bibliography

BP. "BP brand and logo." Bp.com: www.bp.com/sectiongenericarticle.do?categoryId=9014508 &contentId=7027677 (accessed June 21, 2010).
Center for American Progress. "The Toll of Superfund Neglect." Americanprogress.org: www. americanprogress.org/issues/2006/06/b1777527.html (accessed June 21, 2010).
Center for Public Integrity. "Most Dangerous Superfund Sites." Publicintegrity.org: http:// projects.publicintegrity.org/Superfund/HumanExposure.aspx (accessed June 21, 2010).
Corburn, Jason. *Street Science: Community Knowledge and Environment Health Justice*. Cambridge, MA: MIT Press, 2005.
Electronic Frontier Foundation, "On Day One, Obama Demands Open Government." Online: www.eff.org/deeplinks/2009/01/on-day-one-obama-demands-open-government (accessed June 21, 2010).
Deleuze, Gilles. *Foucault*. Trans. Sean Hand. Minneapolis: University of Minnesota Press, 1988.
Funtowicz, Silvio O. and Jerome R. Ravetz. "Science for the Post-Normal Age." *Futures*, 25, 7, September 1993.
Gitelman, Lisa. *Always Already New: Media, History and the Data of Culture*. Cambridge, MA: MIT Press, 2008.
Paulos, John Allen. "Metric Mania." *New York Times*, May 10, 2010.
Prud'homme, Alex. "An Oil Spill Grows in Brooklyn." *New York Times*, May 14, 2010.
Sontag, Susan. *On Photography*. New York: Bantam Doubleday Dell, 1973.
US Environmental Protection Agency. "Basic Questions." Online: www.epa.gov/superfund/ about.htm (accessed June 21, 2010).
US Environmental Protection Agency. "Final National Priorities List (NPL) Sites—by Site Name." Online: www.epa.gov/superfund/sites/query/queryhtm/nplfin1.htm (accessed June 21, 2010).
US Environmental Protection Agency. "Frequent Questions." Online: http://epa.custhelp.com/ cgi-bin/epa.cfg/php/enduser/std_adp.php?p_faqid=173&p_created=1065036508 (accessed June 21, 2010).
US Environmental Protection Agency. "Report and Product Descriptions." Online: http://epa. gov/superfund/sites/phonefax/products.htm (accessed June 21, 2010).
US Environmental Protection Agency. "Search Superfund Site Information." Online: http:// cfpub.epa.gov/supercpad/cursites/srchsites.cfm (accessed June 21, 2010).

Links

http://cfpub.epa.gov/supercpad/cursites/srchsites.cfm
www.data.gov
http://turbulence.org/Works/superfund/index.php
http://turbulence.org/Works/superfund/video.html
http://projects.publicintegrity.org/Superfund/HumanExposure.aspx

8 PASTICHE

Christian Marc Schmidt

Key Words: Agency, Analytical, Collective Gestalt, Collective Memory, Data Visualization, Experiential Expression, Hypothesis-generating, Mythic city, Objective C, Psychogeography, Relevance, Rhetoric, Typography

Project Summary

Pastiche is a dynamic data visualization that maps keywords from blog articles to the New York neighborhoods they are written in reference to, geographically positioned in a navigable, spatial view. Keywords, assigned based on relevance, surround their corresponding neighborhoods. The result is a dynamically changing, three-dimensional description of the city, formed around individual experiences and perspectives.

Project Developer Background

For *DesignInquiry*, a design conference I attended in 2006, I created an experimental visualization of 12 so-called "branded communities" around the world that sought to represent the size, density, and perception of these developments. While size and density were known factors, perception was determined by comparing and ranking communities according to three factors: sustainability, status, and security, the relative values of which were derived from extensive research. Through this work I started forming an interest in the quantitative display of qualitative information, and in how to visualize a collective experience. Shortly thereafter I became aware of *We Feel Fine* (wefeelfine.org), by Jonathan Harris and Sep Kamvar. The piece parses instances of the phrase "I feel" from blog articles and visualizes every instance in several alternate views, called "movements." Some movements are more analytical, others more experiential, but the novelty of *We Feel Fine* is that it quantifies statements made about feelings and by doing so portrays the emotional state of an entire community. These were the two perhaps most formative influences for what would later become *Pastiche*.

Introduction to *Pastiche*

Pastiche is a software application I created in collaboration with Ivan Safrin, a Russian-born software developer. Ivan was the developer for the project, and we also collaborated closely on the concept, visuals, and interaction. Our goal was to model New York City according to what people were writing about it, creating an alternate representation by substituting the physical architecture of the city for people's associations, and in turn imbuing them with a kind of tangibility and permanence.

As a designer and media artist, I am interested in understanding the ways in which the aggregate of individual experiences may lead to insights about a larger cultural or societal condition. I think of my work as exploring what I call "collective gestalt"—an archetypal pattern or gesture emerging from a multitude of sources.

This idea is perhaps most clearly illustrated in several video works I completed between 2006 and 2010. These pieces aggregate hundreds of photographs uploaded to Flickr under a Creative Commons "Non-Commercial Share Alike" license, stitched together in a time-based narrative revealing a particular iconic gesture. In each case the subject matter was a familiar space or environmental condition, including prominent New York City land-marks such as the Brooklyn Bridge and the Grand Central Terminal, as well as images depicting horizons. By choosing iconic subjects that viewers would be intimately familiar with, I found that I could comment on both the individual and the collective. Analyzing each image in terms of location and orientation of the photographer, I was able to identify an inherent formal gesture for each subject, such as a particular radial gesture in the Main Concourse at Grand Central, the linear gesture of crossing the Brooklyn Bridge toward Manhattan, and a skyward-trending upward pan in the case of the horizon imagery.

In each of these pieces, the viewer is participatory in experiencing a space as perceived by a collective. *Pastiche* continues this trajectory by establishing a virtual environment formed by collective activity.

Technical Description

Pastiche depicts keywords parsed from blog articles to describe New York City neighborhoods via an immersive, three-dimensional view of the city (Figure 8.1). Visually, the project relies on a typographic display. Keywords are displayed as clusters around the neighborhoods they refer to, which are in turn mapped in relation to the center point of their geographic neighborhood boundaries. All of the typography in the piece is rotated 90 degrees and pointed upward to reference the vertical architecture of the city, while allowing the information to remain legible. Unlike a traditional, horizontal orientation it does not obscure the geographic locations of each neighborhood or keyword, and due to the narrower footprint, the text maintains higher legibility with fewer overlapping letters.

Pastiche is a desktop or "client" application written in Objective C that currently runs on Intel-based Apple Macintosh computers. Initially, we considered using other technologies such as Adobe Flash or Java that would allow viewing the piece in a Web browser; but decided that optimal performance would yield from an application, given the fluid, immersive experience we wanted to create and the complexity of the presented information.

Figure 8.1 *Pastiche* displays keywords associated with New York City neighborhoods in an immersive spatial view.

Ivan wrote *Pastiche* in two parts, consisting of the client and a server *daemon*, a program that continuously runs in the background on a dedicated server. The daemon collects and processes information from Google Blog Search, storing the processed data in a file on the server, updated every 24 hours and read whenever the application is run. This two-tier approach allowed us to both reduce load times and achieve greater accuracy when parsing keywords, because the server daemon gathers data irrespective of the client.

The daemon, developed in the programming language *Python*, reads RSS feeds from Google Blog Search for a total of approximately two hours each day. It compiles a database of top keywords linked to New York City neighborhoods using a search algorithm with a combination of specific neighborhood names and a set of helper keywords that ensures the results are related to the neighborhood. The top keywords are then parsed by analyzing the blog data for the most frequently repeated words, while eliminating unimportant words (pronouns, prepositions, common unrelated words, etc.). These are omitted using a dataset of undesired words and a set of basic conditions, such as word length and capitalization. The final results are stored on the server as an XML (Extensible Markup Language) file, a common data format. The application was written in the programming language C++ using *Substance*, a framework that Ivan authored specifically for developing interactive applications. It downloads the XML file and displays the data using OpenGL, an open-source technology that enables the rendering of three-dimensional graphics.

As an expressive data visualization, *Pastiche* is both experiential and analytical. We asked ourselves what an alternate view of New York would look like—a view defined not by the architecture, but rather by a collective attitude toward city areas that might lead us to better understand a socio-cultural identity.

We arrived at the formal idea for the visualization during an initial meeting. As Rem Koolhaas outlined in *Delirious New York*, Manhattan is the product of hyper-density resulting in unabashed verticality, the city's singular urban ideology (termed "Manhattanism").[1] We were seeking to create a reference to this concept through the use of typography and to contrast *Pastiche* with the physical, architectural environment. This was a critical argument for the piece, and it led us to consider the use of upright typography, which became the central visual gesture (see Figure 8.2). In our minds, *Pastiche* would become less of an objective, analytical visualization tool. Rather, it would have a particular attitude toward the information it conveyed. Therefore, we allowed the formal idea to drive our process—from the interaction paradigm to the way the information was presented.

While the formal idea took shape early on, the final expression resulted from working closely with the data. For instance, we decided to focus on individual neighborhoods, rather than specific addresses or streets and intersections, once we realized that they increased the likelihood of finding suitable content. We identi-

Figure 8.2 *Pastiche* references the vertical architecture of Manhattan.

fied the geographic center points of each neighborhood with the help of a city base map and used them as anchor points for neighborhood labels. Positioning these labels relative to their actual geographic locations allowed the shape of the city to emerge.

For the blog content, we chose to use keywords rather than full text passages based on concerns about legibility. Over the course of several weeks we refined the algorithm to produce more meaningful keyword results, after which we began viewing the information in a spatial context and making adjustments to type size,

Figure 8.3 A list view allows alphabetical browsing of keywords by neighborhood.

opacity, color, position, and general visibility. We limited the number of keywords to a maximum of three per neighborhood, and arranged them radially around their respective neighborhood labels. Again to improve legibility, both keywords and neighborhood labels always face the user while displayed in three-dimensional space.

To compensate for compromised legibility within the spatial view, we later added a list view (Figure 8.3) to allow pivoting on a particular neighborhood, transporting the user back to the geographic view centered on the selected element. We also programmed the application to highlight neighborhoods that share keywords. Through this key interaction, the entire field of text becomes a stage on which relationships between neighborhoods can be selectively explored (Figure 8.4).

Our initial vision for *Pastiche* was that it update in real time, its form changing during runtime as new data became available. However, after running several tests we soon realized that the piece would be most effective as a cumulative visualization based on relevance. Parsing the keywords most related to their respective neighborhood, rather than simply looking for the most recent keywords, produced a more descriptive set of

results and a more meaningful end result. Consequently, *Pastiche* evolved from a real-time model to one that is cumulative. The final outcome is now best described as a visualization of collective memory.

Theoretical Perspectives

Modeling the City

My fascination with cities stems from a desire to understand the multitude and magnitude of the forces shaping them. New York City, where I live, is the product of a complex array of interacting forces, from politics to the

Figure 8.4 Neighborhood labels are surrounded by their related keywords extracted from blog articles.

real-estate market and the economy, from the dynamics of public and private transportation to cultural trends and traumatic events such as September 11, 2001. Cities are truly living organisms. They retain evidence of the forces at work within them in their very fabric—in the architecture, the streets and public spaces, as well as in the composition of city neighborhoods. Cities are a potent indicator of culture and society and give us a sense of the values and ideals of the people who shaped them.

My interest was perhaps first stimulated by two early texts by Paul Auster: *Moon Palace* and *City of Glass*. In the former, Auster paints a vivid picture of his adolescent experience in New York City, while the latter is a conceptual piece on serendipity and the power of chance, in one memorable instance making a direct analogy between writing and the act of walking in the city. To me, these titles outline two fundamental approaches to understanding cities: one experiential, the other analytical.

I would describe the analytical approach as a generalized set of predictions based on observation. This includes the work of urban planners, sociologists, architectural theorists, and philosophers, from Jane Jacobs to Manuel Castells, Susan Sontag to Rem Koolhaas, who have written about the modern city and the role and effects of politics, culture, development, and technology. I was particularly influenced by the Italian postmodern architect Aldo Rossi, who wrote about urban artifacts in *The Architecture of the City*.[2] As constants within the city fabric that result from and define a particular cultural context, urban artifacts are a pivotal element in the organic development of a city over time.

An example of the experiential approach is the French avante-garde movement, the *Situationist International* (SI). Members of SI subjected themselves, in psychogeographic experiments, to a generative algorithm while traversing the streets of Paris, allowing the program to dictate the course. Freed of intent, they were able to experience serendipity and rediscover the city.

The experiential and analytical sides are of course intrinsically related, cities being both the purveyors and the products of our experiences. Architect and writer James Sanders developed a similar hypothesis in his work *Celluloid Skyline*, in which he described how cinema has represented New York City over time (what he calls the "mythic city") and how the real city, in turn, has shaped itself according to presiding mythologies of New York.[3] The discipline of mapping effectively bridges the realms of the experiential and the analytical, depicting and facilitating cultural mythologies. As Denis Wood wrote in *The Power of Maps*, maps are neither neutral, nor are they authentically objective. Rather, maps have agency, and instead of merely describing a territory, they *become* the territory.[4] By modeling the city, we are not only describing it, but also participating in the act of shaping it.

Data visualization

We are inundated with information. The sheer amount of information we absorb daily demands solutions to help us determine what is relevant and meaningful in our lives. In this information age, we are increasingly searching beyond facts for guidance and interpretation to help us understand their significance. This may explain the recent attention given to data visualization, which presumes to help us understand large and complex datasets and derive meaningful conclusions from them.

Most people who followed the 2008 US presidential election will remember the interactive graphs and maps used by the media to analyze the results of both campaigns and help explain developments to the viewer. It was particularly remarkable that,

instead of simply describing a chart or graph, television anchors often interacted directly with visualizations on large touch-screens. This resulted in a theatrical quality reminiscent of Hans Rosling's famous speech at the 2006 TED conference, where he demonstrated the capability of his Gapminder World software to provide insight from time-series data. Theatrics were also evident in the 2006 documentary *An Inconvenient Truth*. Those who saw it remember Al Gore explaining a so-called "hockey stick" graph, named after its characteristic shape showing the sharp upturn in temperature over the last 90 years (Figure 8.5). As David Womack writes in "Seeing is Believing: Information Visualization and the Debate over Global Warming," the graph has since become an icon for the climate change debate.[5]

In the realm of art and design, Paula Antonelli curated *Design and the Elastic Mind* at the Museum of Modern Art in New York. Data visualization played a significant role in this 2008 exhibition that explored the relationship between science and design.

Several blogs have emerged over the last couple of years that document recent developments in data visualization. Two of the most widely read are Andrew Vande Moere's *Information Aesthetics* (infosthetics.com) and Nathan Yau's FlowingData (flowingdata.com). The *New York Times* also regularly publishes interactive, editorially driven visualizations on current topics (nytimes.com/multimedia), indicating that data visualization has become part of mainstream culture.

However, while there are countless well-known examples of data visualization, it still tends to elude singular definition. In *Readings in Information Visualization*, Stuart Card *et al.* describe visualizations as "computer-supported, interactive, visual representations of

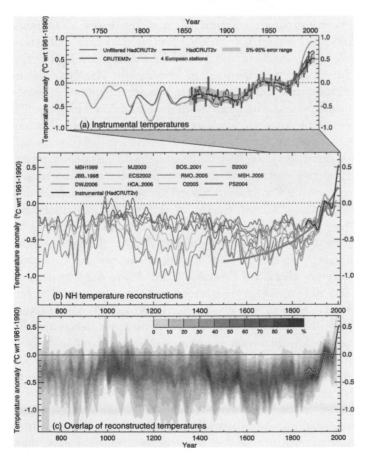

Figure 8.5
The "hockey stick" graph originally published by the IPCC and popularized by *An Inconvenient Truth*. Image credit: *Climate Change 2007: The Physical Science Basis*. Working Group I Contribution of the Fourth Assessment Report of the Intergovernmental Panel on Climate Change, Figure 6.10. Cambridge University Press. Used with permission from the IPCC.

data to amplify cognition."[6] Colin Ware, on the other hand, views visualization as an empirical science. In *Information Visualization*, he suggests that effective information presentation should be based on visual perception, including the perception of color, pattern, objects, and space.[7] Edward Tufte, perhaps the most prominent proponent of information design, regards visualization as a technology, describing techniques and processes that enable clear communication and data analysis.[8] While Ben Fry, MIT Media Lab graduate and former Broad Institute of MIT and Harvard postdoctoral candidate, considers storytelling to be one of the most valuable traits of data visualization.[9] Yet these views ultimately have their limitations. They don't satisfactorily encompass aesthetic data visualization or information art, which utilize data for more expressive ends. And when applied to a critical art context, it is apparent that a study of data visualization would include additional material to the rules of clear information presentation, due to its functioning as a medium in support of the artist's case. In "Critical Visualization," an essay written for the catalog of MoMA's *Design and the Elastic Mind*, Peter Hall recently described data visualization as a science, a technology, and an art.[10] This inclusive view finally points toward data visualization as a medium with a wide range of expressive potential, a view articulated by Eric Rodenbeck of Stamen, a San Francisco-based design firm specializing in data visualization.

On his website, interaction designer W. Bradford Paley addresses the question, "What makes something Information Visualization?" According to Paley, any visualization should be hypothesis-generating, meaning that it should support asking questions.[11] This test applies if the visualization is to function as a tool, after passing the basic tests of being *data-driven* ("Is there data in it?"), *information-driven* ("Is there information in it? … are the visible variations meaningful?"), and *readable* ("… supporting discourse about the subject"). I would add that the *process* of data visualization should always begin by asking questions about the data and formulating a hypothesis, one that is both manifested in and tested by the resulting expression. Thus, in order to be hypothesis-generating, a visualization tool must already contain a hypothesis, establishing its breadth and focus. In that sense, it is a communication tool and ultimately a rhetorical device. Even the most "objective" visualizations display a bias of sorts, merely through their choice of subject matter and focus.

Online social networks are a particularly potent data source for visualization as a means to make sense of their structural composition and analyze emerging topics and trends. Jeffrey Heer, Assistant Professor in the Computer Science Department at Stanford, and Danah Boyd, Social Media Researcher at Microsoft, have investigated the structural composition of social networks. Many early social graph visualizations attempting to represent entire networks suffered from their sheer complexity and scale. Heer and Boyd therefore advocate an "egocentric," selectively expandable view of a social network that facilitates browsing and exploration.[12] Among others, San Francisco-based design firm Stamen has explored the visualization of real-time social network activity for Digg Labs and Twitter. Unlike the work of Heer and Boyd, most of Stamen's output is focused on content rather than the internal structure of social networks, which offers a different perspective on understanding the dynamics present within virtual communities.

Of course, the largest existing social network is the web itself, yet it can be challenging to navigate particularly from a social point of view, as it lacks the tight protocols of Twitter, Facebook, and others. Recently, Google and others have started building tools for websites that use the web itself as the ultimate social platform. By knitting together disparate blog posts based on a single shared element—location—*Pastiche* represents a form of social network with geography, not people, at its center. Both the egocentric

view of Heer and Boyd as well as the dynamic representation of social content set precedents for the resulting visualization.

Outcomes

Pastiche is based on two questions: What are people's associations with New York City and its neighborhoods? What are the relationships and connection points between neighborhoods? Both questions lead to the central hypothesis that New York City is, in fact, two cities—a physical city and a city "of the mind"—and that the two repeatedly inform each other.

Starting with this hypothesis, geography became a decisive factor for us. Associations had to be shown in spatial proximity to demonstrate a correlation between the familiar city landscape and the city of the collective mind.

In essence, *Pastiche* maps information from the realm of blog articles to a geographic plane. The piece also reflects an attitude toward data density, namely that a high density of information allows patterns to become legible. It is critically important that, at times, all information be shown at once, in order for the relationships and connections between neighborhoods to emerge. Furthermore, the data landscape encourages exploration; it functions not only at the macro-level, but also at the (quasi-) street level. This is an important aspect in conveying a parallel experience to the physical city, and becomes necessary for the legibility of individual keywords. *Pastiche* also adheres to a reductionist philosophy interested in representing only the most essential information. Purely typographic, *Pastiche* remains tightly focused on its core objective—representing the city of the mind. By remaining abstract, it allows the viewer to complete the experience with his or her own memories of New York.

Adaptive Landscapes

Pastiche ultimately reflects the activities of a community. While it might appear passive or one-directional in that it does not seemingly facilitate communication among participants, I nonetheless view *Pastiche* as a two-way, participatory experience. Not only does it help users construct the identity of a neighborhood, it also encourages the active (re-) discovery of New York. And, at least in theory, any action within the "real" city environment may have an effect on the one documented by the blogosphere.

Seen in this light, *Pastiche* is a canvas for activity. Changing along with its content, it is an adaptive landscape that can be both experienced and analyzed. By aggregating perceptions of New York, it creates an alternate reality, one that, in turn, has the potential to inform our perceived reality. Ultimately, it is an invitation to experience the city through the lens of the collective mind (Figure 8.6).

Figure 8.6 An aerial perspective view shows the contours of the city.

Notes

1. Rem Koolhaas, *Delirious New York: A Retroactive Manifesto for Manhattan*, New York: Oxford University Press, 1978: 10–11.
2. Aldo Rossi, *The Architecture of the City*, Cambridge, MA: MIT Press, 1982: 28–45, 127–130.
3. James Sanders, *Celluloid Skyline: New York and the Movies*, New York: A.A. Knopf, 2001: 13–22.
4. Denis Wood, *The Power of Maps*, New York: Guilford Press, 1992: 17–25.
5. David Womack, "Seeing is Believing: Information Visualization and the Debate over Global Warming," Adobe Systems Incorporated website, 2006: www.adobe.com/designcenter/think-tank/womack.html (accessed June 13, 2010): 1.
6. Stuart K. Card *et al.*, *Readings in Information Visualization: Using Vision to Think*, San Francisco: Morgan Kaufmann Publishers, 1999: 6.
7. Colin Ware, *Information Visualization: Perception for Design*, San Francisco: Morgan Kaufman, 2000: 1–27.
8. Edward R. Tufte, *The Visual Display of Quantitative Information*, Cheshire, CT: Graphics Press, 1983: 177–190.
9. Ben Fry, *Visualizing Data*, Sebastopol, CA: O'Reilly Media, Inc., 2008: 2–4.
10. Peter Hall, "Critical Visualization," in *Design and the Elastic Mind*, ed. Paola Antonelli, New York: Museum of Modern Art, 2008: 120–131.
11. W. Bradford Paley, "InfoVis tests," *Information Esthetics*, 2007. Online: http://informationesthetics.org/node/27 (accessed June 13, 2010): 1.
12. Danah Boyd and Jeffrey Heer, "Vizster: Visualizing Online Social Networks," Minneapolis: IEEE Symposium on Information Visualization (InfoVis 2005), 2005: 3.

Bibliography

An Inconvenient Truth/Paramount Classics and Participant Productions present a Lawrence Bender/Laurie David Production. Directed by Davis Guggenheim, 2006.

Auster, Paul. *City of Glass*. New York: Penguin Books, 1990.

Auster, Paul. *Moon Palace*. New York: Viking, 1989.

Card, Stuart K., Jock D. Mackinlay, and Ben Shneiderman. *Readings in Information Visualization: Using Vision to Think*. San Francisco: Morgan Kaufmann Publishers, 1999.

Fry, Ben. *Visualizing Data*. Sebastopol, CA: O'Reilly Media, Inc., 2008.

Hall, Peter. "Critical Visualization." In *Design and the Elastic Mind*. Ed. Paola Antonelli. New York: Museum of Modern Art, 2008: 120–131.

"Hans Rosling Shows the Best Stats You've EVER seen." TED Conferences, LLC website, June 2006. Online: www.ted.com/talks/hans_rosling_shows_the_best_stats_you_ve_ever_seen.html (accessed June 13, 2010).

Heer, Jeffrey and Danah Boyd. "Vizster: Visualizing Online Social Networks." Minneapolis: IEEE Symposium on Information Visualization (InfoVis 2005), October 23–25, 2005.

Koolhaas, Rem. *Delirious New York: A Retroactive Manifesto for Manhattan*. New York: Oxford University Press, 1978.

Lynch, Kevin. *The Image of the City*. Cambridge, MA: Technology Press, 1960.

Paley, W. Bradford. "InfoVis tests." *Information Esthetics*. May 19, 2007. Online: http://information-esthetics.org/node/27 (accessed June 13, 2010).

Rossi, Aldo. *The Architecture of the City*. Cambridge, MA: MIT Press, 1982.

Sanders, James. *Celluloid Skyline: New York and the Movies*. New York: A.A. Knopf, 2001.

Tufte, Edward R. *The Visual Display of Quantitative Information*. Cheshire, CT: Graphics Press, 1983.

Ware, Colin. *Information Visualization: Perception for Design*. San Francisco: Morgan Kaufman, 2000.

Wijk, Jarke van. "The Value of Visualization." *IEEE Visualization 2005 (VIS 2005)*. Minneapolis, 2005.

Womack, David. "Seeing is Believing: Information Visualization and the Debate over Global Warming." Adobe Systems Incorporated website, October 18, 2006: www.adobe.com/design-center/thinktank/womack.html (accessed June 13, 2010).

Wood, Denis. *The Power of Maps*. New York: Guilford Press, 1992.

Links

www.christianmarcschmidt.com
www.climatecrisis.net
http://flowingdata.com
www.gapminder.org
http://infosthetics.com
www.moma.org/exhibitions/2008/elasticmind
www.nytimes.com/multimedia
http://stamen.com
http://substanceframework.org
www.ted.com/talks/hans_rosling_shows_the_best_stats_you_ve_ever_seen.html
wefeelfine.org

PART V
ERROR AND NOISE

SEDUCTIVE ERRORS

A Poetics of Noise

Mark Nunes

The devices, interfaces, and protocols that drive our day-to-day new media practices, it would seem, are informed by a powerful, yet often unexplored assumption: We want to find what we are looking for.

Computers are, after all, elaborate control devices—a "control revolution"[1] technology applied to an everyday life that is increasingly caught up in the flow of information across global networks. The process control systems that grew out of nineteenth-century manufacturing depended upon an abstraction of "information" from material production and flesh-and-blood labor—information that could then be "programmed" for greater efficiency. The computer is a tool of this world, a world that by the mid twentieth century, with the rise of cybernetics as a science of control, promised to regulate and correct all processes toward their purposive ends. Through greater control of information, systems could capture any deviation from intended results as feedback used to correct and maximize performance.[2] We know what we are after, such a control logic declares. And in such a world, "error" serves a very definite purpose: to provide feedback on the deviation of outcomes from a system's goals and intentions.

What happens, however, when error *escapes* its own purpose? What of the *errant error*—a heading that leads us decidedly off course? Error captured serves its purpose, yes. But error *uncaptured* challenges the logic of process control systems by threatening closure with the unexpected and the unintended. In this regard, failures, glitches, mistakes, and misfires suggest a creative potential outside of purpose: a potential we might hazard to call a "poetics of noise."

My reading of poetics in this context owes much to Umberto Eco's discussion of information theory in *The Open Work*, in particular, his reading of poiesis as creative opening.[3] Drawing on Claude Shannon and Warren Weaver's information theory, Eco argues that communication *reduces* information in its desire to actualize signal at the expense of noise. In contrast, poetics *generates* information by sustaining a sense of uncertainty between an actual message sent and the *possible* messages received.[4] Shannon and Weaver call this measure of possibility *equivocation*: "an undesirable uncertainty" that the message received was the message sent.[5] Error, in Shannon's account, no longer merely measures the gap between the actual and the intended, captured as feedback; rather, it serves as a *signature of possibility* within the total information of a system.

In effect, noise is errant signal—what Weaver calls "spurious information."[6] As such, noise is *additive*, yielding a proliferation of choices in possible messages received. To speak of a poetics of noise, then, is to foreground the creative potential of these unintended openings. Equivocation marks an experience of the virtual—a "potential of

potential," in the words of McKenzie Wark, that signals an indetermination that exceeds systematic control.[7] Noise in all its forms—pops, glitches, hacks, and jams—offers a creative potential that exceeds programmatic control by *widening* the gap between the actual and the possible. Noise and error, in this regard, might "take away" from a system's efficiency and performance, but in doing so, these errant signals help reveal the potential of potential. A poetics of noise celebrates the creative potential of going astray.

As such, error is indeed *seductive*, offering up an unintended opening that threatens (with a suggestion of pleasure as well) to lead us astray. As a counterpoint to control technologies, a poetics of noise fails as a feedback mechanism by refusing operational closure; and in doing so it marks the creative potential of equivocation. And there is certainly precedent for considering the artistic potentials of error and noise—Luigi Russolo's Futurist "Art of Noises,"[8] for example, along with a wide range of early twentieth-century engagements with collage and happenstance.[9] Likewise, error in the form of unintended sound—from John Cage's *4'33"* to more recent *glitch* music—provides the basis for what Kim Cascone has called "the aesthetics of failure" in the contemporary computer music scene.[10] With the rise of computer art and other works native to new media, the failure of a control system serves to reveal the creative potential of "aberrant" output.[11] In each instance, a failure in the logic that insists we want what we are looking for reveals a seductive potential beyond the constraints of intention, purpose, and control. Error and noise, in effect, reveal a mode of artistic production that simultaneously exceeds and falls short of the control logic inherent in digital media.

The two projects included in this section offer differing takes on a poetics of noise, and in doing so attempt to explore the creative potential embedded in a "failure" of control logic. At a fundamental level, Ethan Ham and Benjamin Rosenbaum's *Tumbarumba* project exploits the artistic potential of irruptive error. The browser add-in, which embeds fragments of short stories in the text of requested webpages, *corrupts* transmission with "spurious information" that results in a heightened experience of equivocation for the end-user. The "almost vertigo-like experience of stumbling upon a nonsensical sentence in the midst of what seems to be a straightforward online text" gives rise to an opening—not merely an invitation to click on a link that will lead readers to the intruding short story, but an opening onto other, unintended, and fortuitous renderings of the corrupted text. As Benjamin Rosenbaum describes the project, these noisy intrusions offer "a secret door which should not be there." Error creates an "open work" on pages where it is least expected, priming users toward a reading strategy appropriate for a poetics of noise.

With Fernanda Viégas and Martin Wattenberg's project *Luscious*, an aesthetics of the unintended expresses itself through the use of algorithms to produce abstract compositions. By transforming images—in this instance, commercial photography—into a data field, and then using visualization techniques to re-present those images as color weightings, *Luscious* attempts to create, in the words of Viégas and Wattenberg, a "visual anagram" from commercial photography. As a generative work of art, *Luscious* is less concerned with equivocation per se than with a set of (ab)errant practices that decode images into color fields. Each image generated is, in effect, an aberration to the extent that it offers up as an aesthetic object a visualization of embedded data that was never meant to be represented as such. As a generative work of art, its algorithmic manipulations allow for a celebration of spurious information. The ad photographs "contain" and thereby *communicate* these data, but the artistic transformation of the message results in errant output that radically differs from the intended signal.

In both projects, the logic of control that serves as a foundation for digital media is undermined in the service of a poetics of noise. Both works embrace the "potential of potential" in errant output and spurious signals. In doing so, they remain open to the creative possibility of error and noise for works of art that are native to a digital environment—and open as well to the seductive invitations of a potential outside of purpose and control.

Notes

1. As James Beniger notes, increases in production speed in the nineteenth century led to a need for increased speed in distribution and consumption—a "crisis of control" that finds its solution in the ascendency of process control systems at all levels of corporate action. See James Beniger, *The Control Revolution*, Cambridge, MA: Harvard University Press, 1989: 241–278.
2. In his popularized account of cybernetics in *The Human Use of Human Beings*, Norbert Wiener discusses the importance of feedback as a measure of the gap between "actual performance" and "expected performance." See Norbert Wiener, *The Human Use of Human Beings: Cybernetics and Society*, New York: Da Capo, 1988: 24.
3. Umberto Eco, *The Open Work*, Cambridge, MA: Harvard University Press, 1989. For a more complete discussion of error, potential, and the poetics of noise, see Mark Nunes, "Error, Noise, and Potential: The Outside Purpose," in *Error: Glitch, Noise, and Jam in New Media Cultures*, ed. Mark Nunes, New York: Continuum, 2010: 3–23.
4. Eco: 50–58. See also: Roland Barthes, *S/Z*, New York: Hill & Wang, 1974: 144–147; and N. Katherine Hayles, *Chaos Bound: Orderly Disorder in Contemporary Literature and Science*, Ithaca, NY: Cornell University Press, 1990: 186–196 for similar readings.
5. Claude E. Shannon and Warren Weaver, *The Mathematical Theory of Communication*, Urbana: University of Illinois Press, 1949: 21.
6. Ibid.: 19.
7. McKenzie Wark, *A Hacker Manifesto*, Cambridge, MA: Harvard University Press, 2004: para. 14.
8. Luigi Russolo, "The Art of Noises" (1913). Online: www.ubu.com/papers/russolo.html (accessed November 23, 2010).
9. For further discussion of the relationship between dada, glitch, and new media art, see Tim Barker, "Aesthetics of the Error: Media Art, the Machine, the Unforeseen, and the Errant," in *Error: Glitch, Noise, and Jam in New Media Cultures*, ed. Mark Nunes, New York: Continuum, 2010: 42–58. See also xtine burrough, "Add-Art and Your Neighbors' Biz: A Tactical Manipulation of Noise," in Nunes, op. cit.: 80–96.
10. Kim Cascone, "The Aesthetics of Failure: 'Post-Digital' Tendencies in Contemporary Computer Music," *Computer Music Journal*, 24, 4, Winter 2000: 12–18.
11. See, for example, Iman Moradi *et al.*, *Glitch: Designing Imperfection*, New York: Mark Batty, 2009.

Bibliography

Barker, Tim. "Aesthetics of the Error: Media Art, the Machine, the Unforeseen, and the Errant." In *Error: Glitch, Noise, and Jam in New Media Cultures*, ed. Mark Nunes. New York: Continuum, 2010: 42–58.

Barthes, Roland. *S/Z*. New York: Hill & Wang, 1974.

Beniger, James. *The Control Revolution*. Cambridge, MA: Harvard University Press, 1989.

burrough, xtine. "Add-Art and Your Neighbors' Biz: A Tactical Manipulation of Noise." In *Error: Glitch, Noise, and Jam in New Media Cultures*, ed. Mark Nunes. New York: Continuum, 2010: 80–96.

Cascone, Kim. "The Aesthetics of Failure: 'Post-Digital' Tendencies in Contemporary Computer Music." *Computer Music Journal*, 24, 4, Winter 2000.

Eco, Umberto. *The Open Work*. Cambridge, MA: Harvard University Press, 1989.

Hayles, N. Katherine. *Chaos Bound: Orderly Disorder in Contemporary Literature and Science*. Ithaca, NY: Cornell University Press, 1990.

Moradi, Iman, Ant Scott, Joe Gilmore, and Christopher Murphy. *Glitch: Designing Imperfection*. New York: Mark Batty, 2009.

Nunes, Mark. "Error, Noise, and Potential: The Outside of Purpose," in *Error: Glitch, Noise, and Jam in New Media Cultures*, ed. Mark Nunes. New York: Continuum, 2010: 3–23.

Russolo, Luigi. "The Art of Noises." 1913. Online: www.ubu.com/papers/russolo.html (accessed on November 23, 2010).

Shannon, Claude E. and Warren Weaver. *The Mathematical Theory of Communication*. Urbana: University of Illinois Press, 1949.

Wark, McKenzie. *A Hacker Manifesto*. Cambridge, MA: Harvard University Press, 2004.

Wiener, Norbert. *The Human Use of Human Beings: Cybernetics and Society*. New York: Da Capo, 1988.

9 LUSCIOUS*

Fernanda Viégas and Martin Wattenberg

Key Words: Averaging, Bucketing, Color Field Painting, Color Theory

Project Summary

Luscious is a celebration of color and composition. The piece pays homage to fashion designers and photographers, those who create rousing images of light and color that fill the pages of glossy magazines. These elements are the departing point for abstract composition. The goal is to create self-standing, forceful arrangements of color that are far removed from photographic content while still referring to the intended mood.

Situating Luscious Within the History of Art

The power of abstract color to convey emotion has deep roots in art. Movements such as Color Field Painting in the 1940s and 1950s altered the use of color from a supporting element of design to the conceptual focus of painting and composition.[1] Kenneth Noland's concentric-circles paintings (*Targets*) take this preoccupation with color primacy to new ground, exploring the relationship between color and form, creating a new visual language.[2]

The idea of turning photographs into grids of abstract color is not new either. Chuck Close's portraits explore a wide range of pictorial possibilities: from faithful, photorealistic brushwork to more abstract, roughly executed color-ring arrangements.[3] Close's concern with surfacing the content of the original photograph, however, marks a point of divergence for *Luscious*. Whereas the former thrives on the viewer's recognition of the subject matter, the latter is adamant about abstraction from content.

Color has also found a place of prominence in digital and new media art. Most work has sought to create color "aggregates" out of content. Shahee Ilyas' *Flags by Colours*, for instance, shows the proportion of colors in country flags around the world.[4] The result is a matrix of 224 pie charts, each representing color usage on an individual flag.

In addition, artists have turned color into a narrative device. In *The Top Grossing Film of All Time*, Jason Salavon reduces each frame of the movie *Titanic* to a single colored pixel.[5] These pixels are laid out sequentially, forming a storyline in pure color.

Luscious partakes of this rich tradition of color and abstraction with a slightly different process and focus. Rather than using reductive methodologies, *Luscious* is a generative work. Starting from a photograph, the goal is not to aggregate all information in the image to a single data point but rather to produce an alternative, abstract composition based on the colors in the original picture.

Technical Perspective: How Was *Luscious* Built?

One of the hallmarks of new media art is the interplay between artistic aspirations and technological possibilities. Our goal for *Luscious* was to mute the meaning of a picture and divert attention from composition. By taking an image and rearranging it—that is, making a kind of visual anagram—we sought to clarify the music of hues and tones.

Although this process subtracts information, the opposite is true from the point of view of the computer. In fact, to make a meaningful visual anagram requires adding a set of invisible scaffolding (what a computer scientist would call "data structures") to each image. Like any scaffold, these structures disappear from the final work, but have a profound effect on its shape. For that reason, and because this process sheds light on some of the unique properties of new media art, we'd like to describe our method in detail, including technical details.

What Is a Color?

Some of the smartest philosophers and scientists have debated the ontology of color (what a color *is*), and arguments about color theories continue to this day.[6] But for better or worse, images on a computer short-circuit these arguments by reducing vision to ones and zeros. To be precise, in most common image formats today, a picture is divided into tiny square pixels represented by the three numbers, ranging from 0 to 255, describing the levels of red, green, and blue light. In this system, for example, the triple (0,0,0) is black, while at the other end of the spectrum (255,255,255) is white. The numbers follow the laws of additive color, so the triple (255,255,0), which contains bright red and green but no blue, is an electric yellow. That's all there is, in the computer's world, to color.

Given the simplicity of model, you might think that it would be easy for a computer program to find the essential colors in any digital image. For example, you might tell the computer to list all the colors—the red, green, blue triples—in order of frequency of occurrence, and pick five or ten that appear most frequently. The trick is that simple colors like pure black, white, or yellow rarely occur in photographs. Instead, each pixel is slightly different, with a (203,183,102) value perhaps having a neighbor of (201,179,99). That means that most photographic images contain thousands of different colors, with no one dominating the color field.

To turn thousands of colors into a representative handful we had to find a way to group related colors into clusters. Before describing our method fully, we'll describe a few ways that did not quite work, but that did provide some intuition for our final technique.

Figure 9.1 The RGB color model mapped to a cube.

How Do You Pick Out the "Key Colors" of an Image?

One way of combining color triples is *averaging*. We could look through all the pixels and find the average red value, the average green value, and the average blue value. This procedure defines an "average pixel" color to represent the image. We tried this, and the results were interesting but uninspiring. Simple averaging turned dramatically colored images into uniform beige or khaki.

A second way of getting around the problem of having too many colors is *bucketing*. Allowing 256 different levels of red, green, and blue means that there are potentially millions of possible colors. This problem has turned up in many technical situations. For example, in the 1990s, when web browsers first became popular, many computers could not display this many colors, so browser authors simplified by creating a special palette of "HTML colors" where there were only six possible values for red, green, or blue, resulting in only 216 different possible combinations.

We could have tried the same idea, changing the values of all the colors in a picture to nearby round numbers. That would change a triple like (248,251,21) into the familiar electric yellow (255,255,0). The problem, as the first generation of web designers will happily complain to you, is that the bucketed palette is *too* simple: using these basic colors obliterates the kind of chromatic subtlety we were hoping to visualize.

Although neither bucketing nor averaging work by themselves, by combining them we discovered a useful technique. Our final method began by creating 216 "buckets" of color, one for each of the three sections of the color cube corresponding to the familiar HTML colors.

Our program—written in Java, familiar to many digital artists as the language of the processing system—adds each pixel in the input image to its corresponding bucket. After all the pixels have been added, some buckets will be more full than others. For a typical image, if we plot the buckets that have more pixels as bigger cubes, we would have a picture that looks something like Figure 9.3.

Our program then looks for buckets that are bigger than any of their neighbors in three-dimensional space. The software then averages the values of all the pixels in these "key buckets" to arrive at a few final colors.

Figure 9.2 Buckets of color.

Figure 9.3 Buckets with more pixels represented as bigger cubes.

Figure 9.4 A circle template.

Figure 9.5 The resulting image where color is filled in by the software program developed for *Luscious*.

What Do You Do With Key Colors Once You Have Them?

In the final step we arranged these colors into concentric circles. For each image to which we applied the *Luscious* method, we divided the image into a set of non-overlapping circles to create a template for the program to fill. Then the program picked out key colors in each of the circles, and drew them in concentric rings.

Luscious Gallery

Working with a set of 26 advertisements from women's fashion magazines, the *Luscious Gallery* focuses on five different lines of products: clothing, accessories, cosmetics, travel, and drinks. Each composition in the gallery combines ads from one of these categories. *Italian Blues* displays clothing advertisements by Valentino, Gucci, and Armani. Even though the focus of the composition is the color blue, each designer invites different tones to his creations. While Valentino dwells on fresh turquoise shades in harsh contrast with bright whites, Gucci mixes less-saturated blues with earthy hues, and Armani descends to a much darker palette allowing for the occasional sober blue.

Escape focuses on travel, using ads by Holland American Line, St. Regis Hotel, and Hawaii Islands as the starting point for the color compositions. Here the gentle blues and greens of water and mountains play against the starkness of St. Regis's black-and-white sophistication. Echoing the multiplicity of travel desires and expectations, the colors express the excitement of sunny days followed by glossy, edgier aspects of nights out.

In addition to "themed" compositions, our initial explorations included pieces that focused on a single brand. *Absolut Luscious* is a composition of three Absolut Vodka ads. Playing off the highly saturated, mostly monochromatic palettes, the piece evokes the vivid, eclectic nature of the original images. *Rosso Valentino* dabs a splash of the maestro's classic red against a pungent background of turquoise and black.

Figure 9.6 *Italian Blues*, part of the Luscious Gallery collection, Fernanda Viégas and Martin Wattenberg 2010.

Figure 9.7 *Warm Glow*, part of the Luscious Gallery collection, Fernanda Viégas and Martin Wattenberg 2008.

By segmenting hues into peak regions, the concentric circles in *Luscious* also reveal subtle plays of color that might be lost when looking at the original photographic images. The Holland America Line advertisement, for instance, with its focus on an impossibly yellow pear, may conceal its special, blue lighting. This highlighting effect is underscored by a set of bluish circles in *Luscious*.

Outcomes and Conclusions

Looking at pictures in a magazine is like walking through a crowded market. You're confronted by so many people calling out for attention, so many simultaneous conversations, that it's hard to hear any one voice. Indeed, you may not even want to

Figure 9.8 *Escape*, part of the Luscious Gallery collection, Fernanda Viégas and Martin Wattenberg 2008.

Figure 9.9 *Absolut*, part of the Luscious Gallery collection, Fernanda Viégas and Martin Wattenberg 2010.

Figure 9.10 *Valentino*, part of the Luscious Gallery collection, Fernanda Viégas and Martin Wattenberg 2010.

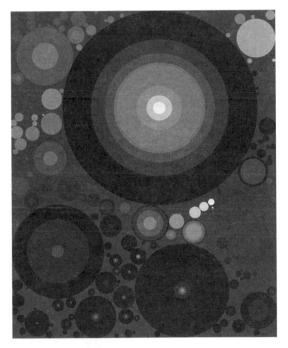

Figure 9.11 The final Holland America Line composition created for *Luscious* by Fernanda Viégas and Martin Wattenberg.

hear most of these voices—the nakedly commercial pitches, the clichéd words. Yet to cover your ears completely would be to surrender too easily.

Luscious is our solution to this problem: a kind of translucent filter, letting through aspects of mood and light while erasing traces of commercial ambition. This translucency is achieved through a mathematical transformation of the numbers that define digital color. The result of using this filter is a new view of familiar images.

We view the pieces in *Luscious* as highly emotional, which may seem paradoxical, given the coldly mathematical process behind them. After all, how can a computer program express emotions? The answer, at least in this case, is that the program is not inventing new feelings to communicate, but rather unmasking intensely human signals in danger of being drowned out by noise.

through photographs that have been uploaded to Flickr.com. Using facial-recognition software to scan the photographs, *Self-Portrait* looks for faces that match my own to varying degrees of similarity. All of the matches are "false positives" because I do not actually appear in any of the photographs. To make these errors more likely, I adjusted the program to be generous in what it considers to be a facial match. I wanted the matching algorithm to have some rigor, but did not want it to be so accurate that matches were never found. My loose target was to find one or more matches per week. As of May 2010, the program has found 466 matches out of the 10.25 million photos it has evaluated (about 2.8 matches per week).

As *Self-Portrait*'s facial recognition software analyzes photographs, it occasionally detects a face where none actually exists—the machine equivalent of seeing shapes in clouds. I find these photographs particularly intriguing. It is as if a spark of imagination exists in the midst of the computer's cold logic. I also like the fact that there is no way to automate finding these errors of anthropomorphism as the machine has no way of knowing when it makes a mistake. So if I want to collect the erroneous images, I have to do the same sort of grunt work that I had relegated to the computer program for *Self-Portrait*.

These face-where-there-is-none photographs became the basis for *Anthroptic*,[2] an artistic/literary collaboration with author Benjamin Rosenbaum. Benjamin wrote eight interconnecting short stories to accompany eight of the anthropomorphized photographs.

Anthroptic was included in a show I had at the PS122 Gallery, New York. I was obliged to monitor the gallery during some of its open hours. While observing the gallery's visitors, I was struck (not for the first time) by how little time people spend

Figure 10.2 Detecting a face where none exists. Photograph by Pam Cash, CC-BY-NC-ND.

looking at art. An artwork that took months to create might capture a gallery visitor's attention for only a couple of seconds. In contrast, media such as literature, film, music, and dance are able to hold the gaze and attention of audiences far longer than an instant.

I wanted to create an artwork that lingers and demands attention. To do so, I decided that my next project would involve creating a web browser add-on. An add-on is a small program that extends a web browser's functionality. Building an add-on would enable me to embed an artwork into web browsers, which in turn would create an artistic space that people would enter every time they opened the browser. Even if my viewers only give the add-on/artwork a momentary consideration each time it is encountered, the time spent with the work would accumulate. In a way, I wanted my conceptual-leaning artwork to be on view for the same luxurious amount of time given to a poster on a dorm room wall.

Introduction to *Tumbarumba*

After we finished *Anthroptic*, Benjamin Rosenbaum suggested having a second collaboration in which we switch roles: instead of Benjamin using photographs as the raw material for short stories, I would use short stories as the raw material for an artwork. We combined that criteria with my proposal that our project take the form of a web browser add-on, and began brainstorming. What emerged is *Tumbarumba*,[3] an anthology/artwork add-on for web browsers.

Tumbarumba is indirectly named after the town of Tumbarumba in New South Wales, Australia, which inspired John O'Grady's poem "The Integrated Adjective" (also known as "Tumba-bloody-rumba"). The poem, in turn, popularized tumbarumba as a synonym for tmesis—the inserting of one word in the midst of another word or phrase. *Tumbarumba*'s title refers to this act of textual insertion: the artwork occasionally combines a fragment of a story (from a set of 12 stories by 12 authors[4]) with a sentence on a webpage that is being viewed. For example, this sentence was modified from one appearing on the *New York Times* website:[5] *Each team's top two draft picks share Caribbean heritage, but Giants General Manager or even a jack surgeon.* The first half of the sentence is news article text, while the text that follows the word "manager" comes from a short story by Heather Shaw.[6] "Manager" connects the two sentence fragments because it is a word that they share in common. The resulting absurd sentence is reminiscent of the Surrealist exquisite corpse game. If the viewer clicks on the inserted fragment, the entire story emerges and eventually takes over the page.

In much the same way that *Tumbarumba* was motivated by my desire to change the instantaneous judgment many bring to art, Benjamin wanted to transform the author–reader relationship:

> Towards this end, the surprise of the unexpected text—the surreal moment of "falling through" the fabric of the everyday, taking a wrong turn and finding yourself in a topsy-turvy otherworld—is central. It is about the interleaving of the fantastic, the imagined, and the intimacy of fiction into a different context. When we go intentionally to read a work of fiction, we are prepared and approach it defensively from a distance. We are ready to judge; we watch ourselves to see if we are entertained. When we read the news, or check how our stock portfolio is doing, or look at someone's blog or a product website, we are defensive in a different way. We do not expect the interior monologue of a character in a crisis to intrude in, for example, an analysis of the nutritional content

of grains. And so there is the chance of creating this magical, liminal space in which the reader experiences a moment of true wonder, the kind they would experience if they *really* found a magic door in the back of a wardrobe, and not just read about it at a safe mediated distance.[7]

Umberto Eco describes our culture as being one in which our poetic enjoyment must be

> artificially induced by means of an intentionally suggestive construct … not only do we have to be pushed to enjoy our freedom to enjoy, but we are also asked to evaluate our enjoyment, and its object, at the very moment of its occurrence.[8]

Tumbarumba is an attempt to disguise the artificial suggestive construct so that the reader is tricked into a non-dialectical moment of wonder.

Benjamin and I agreed that we wanted unexpected text to trigger this wonder via a mild conceptual crisis. As we worked on the project, however, we realized that we differed on how that crisis should resolve.

Tumbarumba's Flow

When a webpage loads, the *Tumbarumba* add-on decides whether or not it will attempt to manipulate the page's HTML code. The decision is essentially arbitrary and is determined by an algorithm that uses the page's content and a unique identifier associated with each installation of *Tumbarumba* as input.

The next step *Tumbarumba* takes is to check the webpage for any words that match a list of keywords for a particular short story. Each story's keyword list was created out of all of the words in the story that are not among the most common 300 words in the English language. This is an excerpt from the end of the keyword list for Heather Shaw's "Little M@tch Girl":

> vacant|vacation|vacations|vantage|vast|vial|vibrators|vividly|voided|vomit|waggled| walk|walked|wall|walls|wanted|ward|watched|weaving|wedging|Wednesday|week| weekend|weeks|wet|whatever|wherever|whole|whorls|whose|willing|wimpy|wine|w inter|within|without|woman|wondered|wonderful|wood|wore|worked|workers|worr ied|worry|wounds|yearned|years|yellow|yesterday|yet|young|younger|zombie

If any of these words match one of the words on the webpage—for example "wine" in the keyword list matching "wine" in the text of a Wikipedia entry on "Rice Wine"— then *Tumbarumba* can proceed.

The add-on selects a sentence on the webpage that contains the keyword. It attaches the first half of the sentence (the words that precede the keyword) with the second half of the short story's sentence (the words the follow the keyword). The Wikipedia Rice Wine page is as follows:

> Rice brew typically has a higher alcohol content (18–25%) than wine (10–20%), which in turn has a higher alcohol content than beer (3–8%).[9]

When this entry is combined with the story's following sentence:

> This close, the burnt metal smell was nearly over-powering the other common Mission smells: wine, vomit, phlegm and feces.[10]

The result is the following hybrid text:

> Rice brew typically has a higher alcohol content (18–25%) than wine, vomit, phlegm and feces.

Along with changing the text, *Tumbarumba* also adds HTML code so that rolling over the inserted text causes the cursor to change to a pointer. If the viewer spots the inserted text and clicks on it, the next sentence from the story appears on the webpage. After a random number of clicks (and additional sentence fade-ins), the entire original page fades out, and a page containing only the text from one of the 12 stories fades in. The story's text is formatted using the webpage's original layout, which can greatly affect the story's linearity. Any images on the page are replaced with photographs from Flickr.com that are selected using tag searches that utilize the story's keyword list.

Errors and Alternate Realities

Benjamin and I do most of our collaboration via email because he lives in Switzerland and I am in New York City. During one of our brainstorming sessions, an idea emerged

Figure 10.3 "Temp" by Greg van Eekhout as displayed by *Tumbarumba* on the *New York Times* website.

that we developed into *Tumbarumba*. The idea was to create an artwork that "while it is engaged, the user would never be 100% sure if she's experiencing a story or if it is a real webpage." I wrote:

> I'm thinking that we provide the sort of experience that Oedipa Maas has in *Crying of Lot 49*—where she isn't sure what is real & what isn't. This is partly inspired by EA's *Majestic* ... but rather than just having hoax websites, we'd actually have the plugin hack the websites the user is browsing.

Majestic[11] was an alternate reality game. Alternate reality games blur the line between the game world and the real world and often extend beyond the usual game platforms. In the case of *Majestic*, the game's content included websites for imaginary organizations and businesses that players were expected to search for and stumble upon. Players were not always certain what was fictional and what was real. As a result, a number of players telephoned the Central Intelligence Agency, having mistaken its website for part of the *Majestic* game world. *Majestic* also automatically contacted players with faxes, Instant Messages, and threatening phone calls. Yes, the game actually would call up its players and threaten them.

Benjamin and I co-founded an online game company in the 1990s, so it is natural for us to incorporate some of the vocabulary of games into our projects. This is evident not only in the inspiration we found in alternate reality games, but also in how *Tumbarumba* can play out in a goal-oriented, game-like manner. *Tumbarumba*'s project website contains a grayed-out table of contents that lists all of the stories contained within the anthology. As each story is discovered, its title on the table of contents becomes an active link to the page on which the story can be found. Some *Tumbarumba* users enjoy the ludic challenge of actively hunting out and uncovering all of the stories.

However, this achievement-oriented approach to *Tumbarumba* undermines the disorienting experience that Benjamin and I would like the artwork to provide. We want users of *Tumbarumba* to have not only the pleasure of finding and reading the stories, but also the almost vertigo-like experience of stumbling upon a nonsensical sentence in the midst of what seems to be a straightforward online text.

Artists who create generative art (art that is automatically created according to a set of rules) are often immunized against fully appreciating the results. Golan Levin once described generative artists as those who create the illusion of an algorithm having control.[12] Just as stage magicians are not mesmerized by their own tricks, generative artists can see through the mechanical trickery that creates the fiction of artificial creativity. Yet I am as susceptible as anyone to *Tumbarumba*'s effect. When reading Jason Kottke's blog, I was flummoxed by this piece of news:

> *Is Cropping A Photo Lying?*
> David Hume Kennerly took a photo of Dick Cheney and his family cooking a meal. Cheney is in the foreground on the right side of the frame, cutting some meat, not food—human bodies. Newsweek used the photo in their magazine, only they cropped out the family and just showed the former VP stabbing a bloody piece of meat with a knife to illustrate a Cheney quote about CIA interrogation methods. Kennerly cried foul.[13]

I re-read the part about Cheney cutting up human body meat several times, trying to make sense of it. Eventually, it occurred to me that this shocking news might actually

be *Tumbarumba*'s doing. Sure enough, rolling my cursor over the questionable phrase it changed to a pointer cursor, and clicking the phrase brought Kiini Ibura Salaam's "Bio-Anger" into view. *Tumbarumba*, triggered by the keyword "meat," had intervened and altered the phrase "cutting some meat while some other family members chat and bustle in the background."

Tumbarumba's textual manipulation is not always as effective (and amusing) as this example. Often the result is grammatically incorrect and nonsensical. However, it is not unknown for humans to write ungrammatical nonsense.[14] *Tumbarumba* sensitizes its users to textual absurdities—of which only a fraction are the effect of the add-on. This heightened awareness is as much of the artwork's experience as is its direct effects. As with any good alternate reality game, the effect can extend beyond the virtual world and into the physical. When I come across an awkward phrase in a physical book or magazine, I occasionally pause for a moment and think I should roll a cursor over the questionable text to see if it is an effect of *Tumbarumba*.

Seeing the Stories

When creating *Tumbarumba*, Benjamin and I were closely aligned in wanting the readers to have the experience of stumbling upon the stories. This can be seen in the invitation to participate that Benjamin sent to his fellow writers:

> Tumbarumba is a conceptual art project that will transform your fiction, creating weird, shocking, transient hybrids which intrude into the everyday, menacing or enticing readers with strangeness, before revealing your stories to them.
>
> Tumbarumba is a secret door which should not be there. Tumbarumba is a strange cave where your story will get secret powers. Tumbarumba will turn your fiction from an ordinary child into a bird, like the brothers in the fairy tale, and it will fly invisibly among us and readers will find it where they least expect it.
>
> Some will stumble upon it. Some will seek it out with grit, luck, and perseverance. But each reader will have to find each story themselves.[15]

Benjamin was particularly interested in the fact that the contributing authors did not know the context in which their works would be seen. Consider how Kafka's *The Metamorphosis* (1915) might be perceived if it were in a book that had the trappings of science fiction (such as a rocket ship on the cover) as opposed to being presented as serious literature.[16] The extratextual trappings in which a story is encased greatly impacts how it is read. When presented as literature, we might view Gregor Samsa's transformation into a giant beetle as metaphor. If presented as science fiction, then there is the expectation that Samsa's condition has a specific cause (perhaps an alien virus) that will prove to be integral to the plot. Authors usually know the context in which their work will be read and will attempt to "come up with a text that satisfies and subverts these expectations."[17] *Tumbarumba*'s contributing authors did not know the form that the project would take, and this lack of knowledge affected what they wrote. Tim Pratt, for example, said that he suspected it would be a weird project, so he wrote a weird story: "Merely knowing it was experimental—not even knowing the parameters of the experiment—made me feel free to write something more experimental."[18] Similarly, Haddayr Copley-Woods wrote:

> I found it both freeing and challenging. I had no idea what the format would be, or what it was, exactly. So that made me be more willing to experiment. But it

also made me want to really push my boundaries. I didn't want to have some story that didn't really push any boundaries, fictionwise, if it was going to be in a boundary-pushing form.[19]

Historical and Critical Perspectives

Tumbarumba has Dadaist and Surrealist lineages. As mentioned earlier in the chapter, *Tumbarumba*'s method of combining sentence halves evokes the classic Surrealist's technique/game of exquisite corpse. An exquisite corpse is a collaborative sentence or drawing that results from several independently created components (sentence fragments, sketches, drawings, or photographs) made without prior knowledge of individual contributions (beyond a few structural guidelines). The name, exquisite corpse, is derived from the sentence generated the first time the game was played: *Le cadavre exquis boira le vin nouveau* [*The exquisite corpse will drink the new wine*].[20]

The Surrealism of *Tumbarumba* goes beyond the surface similarity of technique. Surrealists desired to free creativity from conscious control and the users of *Tumbarumba* find themselves almost unwittingly participating in just such an exercise. When coming upon *Tumbarumba*'s juxtaposed sentence fragments, our pattern-obsessed brains automatically create unlikely narratives while trying to make meaning of the nonsensical words.

Tumbarumba is what Umberto Eco calls an "open work." An open work is one in which "every performance offers us a complete and satisfying version of the work, but at the same time makes it incomplete for us, because it cannot simultaneously give all the other artistic solutions which the work may admit."[21] An open work might offer a framework in which the text alters based on chance or performer/viewer/reader choice. Eco defines such a work as being in *motion* and says:

> the author offers the interpreter, the performer, the addressee a work *to be completed*. He does not know the exact fashion in which his work will be concluded, but he is aware that once completed the work in question will still be his own. It will not be a different work, and, at the end of the interpretive dialogue, a form which is *his* form will have been organized, even though it may have been assembled by an outside party in a particular way that he could not have foreseen.[22]

Tumbarumba is exactly such a work. Benjamin and I have established a set of rules through which webpage text is manipulated and the anthology's stories are formatted. We cannot predict when and how these rules will be realized, but recognize all the possible occurrences as being an intrinsic part of *Tumbarumba*. In a less literal sense, the authors who contributed stories also created open works. The authors were aware that they did not know the context in which their works would be read, and this awareness led to stories that were experimental and responsive to the unknown.

Conclusions and Outcomes

While Benjamin and I were both comfortable with how *Tumbarumba* manipulates a webpage's text, we were less united about how the stories themselves should be manipulated. Benjamin wanted to ensure the reader could ultimately access the story. He thought the moment of disruption should offer the possibility of opening a door to a new world. Through this door a reader might escape from reading about swine flu on

Washingtonpost.com and find herself in a story about compromised love or dueling monster cities. Benjamin viewed the project as giving the readers a journey, and therefore should also provide a coherent destination. A destination perhaps in the form of a link that would take the reader from the story being displayed using the current webpage's format (as in Figure 10.3) to a page on which it was displayed in a plain, straightforward manner.

I was opposed to ever presenting the story in the "right" way, which I saw as subverting the project's openness. I am enamored of how the stories mutate based upon a webpage's HTML code. It reminds me of Tristan Tzara's famous method for making a Dadaist poem by cutting up a newspaper article and randomly pasting it back together.[23] The machine is, to a degree, generating (or at least editing) the story. For me, one reason for using original, unpublished works in *Tumbarumba* was to ensure that there would be no extant, authoritative version of the stories.

I wanted the reader to be given the task of determining how to read the text—does the reader, for example, read the text in the sidebar first, or does she choose to start with what appears to be the main body of the page? I am not troubled by the possibility of a story being incoherent on a given page. The reader will eventually uncover it on another page, which would give another—perhaps clearer—formatting for story. I find it interesting that the reader is left to determine which, if any, was the right version.

If we were to present the user with a final, official version of a story, we would undermine the legitimacy of the add-on's chance-based story formatting. The rearranged texts would be cute and powerless. Instead of actively engaging with a collaged story, the reader would briefly glance at it before proceeding to the final authoritative destination.

Benjamin, in his role as editor, wanted to protect and do right by his writers just as much as I wanted to protect and do right by the artwork. Our compromise was to move forward with my preference with the understanding that we would revisit the decision if any of the contributing authors voiced a concern upon using the beta-test version of the add-on. None did, so *Tumbarumba* does not present the stories in a linear manner (unless they happen to be found on a webpage that has a linear format).

Notes

1. *Self-Portrait* can be seen at www.turbulence.org/Works/self-portrait.
2. *Anthroptic* originated in 2007 as an artists' book commissioned by The Present Group. An online version of the project is available at www.anthroptic.org.
3. *Tumbarumba* was commissioned by New Radio and Performing Arts, Inc. for the Turbulence. org website. It can be downloaded from www.turbulence.org/Works/tumbarumba or www.tumbarumba.org. A simulation of the add-on's effect can be seen (without installing the add-on) at www.tumbarumba.org/tutorial.html.
4. Benjamin Rosenbaum edited the anthology. The short stories are by Haddayr Copley-Woods, Greg van Eekhout, Stephen Gaskell, James Patrick Kelly, Mary Anne Mohanraj, David Moles, John Phillip Olsen, Tim Pratt, Kiini Ibura Salaam, David J. Schwartz, Heather Shaw, and Jeff Spock.
5. www.nytimes.com (accessed May 3, 2010).
6. Heather Shaw, "Little M@tch Girl," in *Tumbarumba*, ed. Benjamin Rosenbaum, 2008.
7. Benjamin Rosenbaum, email, April 24, 2010.
8. Umberto Eco, *The Open Work*, trans. Anna Cancogni, Cambridge, MA: Harvard University Press, 1989: 100.
9. http://en.wikipedia.org/wiki/Rice_wine (accessed May 31, 2010).
10. Heather Shaw, "Little M@tch Girl," in *Tumbarumba*, ed. Benjamin Rosenbaum, 2008.

11. *Majestic* was published by Electronic Arts and is considered one of the first alternate reality games. It premiered on July 31, 2001 and was discontinued in mid-2002. Though it was not commercially successful (garnering only 15,000 players), it was awarded "Best Original Game" at E3 in 2001 and received a "Game Innovation Spotlight" at the Game Developers Choice Awards in 2002.

12. "Interview by Carlo Zanni for *CIAC Magazine*." Online: www.flong.com/texts/interviews/interview_ciac (accessed May 31, 2010).

13. www.kottke.org/09/09/is-cropping-a-photo-lying (accessed September 18, 2009). Used with permission.

14. When he reviewed this chapter, Benjamin Rosenbaum pointed out (as a case in point) that I had erroneously written "for human to write ungrammatical nonsense" in this very sentence.

15. Benjamin Rosenbaum, email, May 8, 2008.

16. Samuel R. Delany discussed this idea using the same example of Kafka in an interview with Sinda Gregory and Larry McCaffery that was published in *Silent Interviews*, Hanover, NH: Wesleyan University Press, 1994.

17. Delany, op. cit.: 31.

18. Tim Pratt, Instant Message to Benjamin Rosenbaum, May 12, 2010.

19. Haddayr Copley-Woods, Instant Message to Benjamin Rosenbaum, May 12, 2010.

20. André Breton, *Communicating Vessels*, trans. Mary Ann Caws and Geoffrey T. Harris, Lincoln: University of Nebraska Press, 1990: 42.

21. Eco, op. cit.: 15.

22. Ibid.: 19.

23. Tristan Tzara, *Dada manifeste sur l'amour faible et l'amour amer*, 1920.

Bibliography

Breton, André. *Communicating Vessels*. Trans. Mary Ann Caws and Geoffrey T. Harris. Lincoln: University of Nebraska Press, 1990.

Delany, Samuel R. *Silent Interviews: On Language, Race, Sex, Science Fiction, and Some Comics*. Hanover, NH: Wesleyan University Press, 1994.

Durozoi, Gérard. *History of the Surrealist Movement*. Trans. Alison Anderson. Chicago: University of Chicago Press, 2002.

Eco, Umberto. *The Open Work*. Trans. Anna Cancogni. Cambridge, MA: Harvard University Press, 1989.

Tzara, Tristan. *Dada manifeste sur l'amour faible et l'amour amer*, 1920.

Zanni, Carlo. "Interview with Golan Levin." *CIAC's Electronic Magazine*, 19, Summer 1994.

Links

www.anthroptic.org
www.benjaminrosenbaum.com
https://developer.mozilla.org
www.ethanham.com
www.flickr.com
http://kottke.org
www.tumbarumba.org
http://turbulence.org
http://turbulence.org/Works/self-portrait

PART VI
SURVEILLANCE

WEB 2.0 SURVEILLANCE AND ART

Christian Fuchs

Surveillance

"Living in 'surveillance societies' may throw up challenges of a fundamental—ontological—kind."[1] Social theory is a way of clarifying such ontological questions that concern the basic nature and reality of surveillance. An important ontological question is how to define surveillance. One can distinguish neutral concepts and negative concepts.

Neutral approaches define surveillance as the systematic collection of data about humans or non-humans. They argue that surveillance is a characteristic of all societies. An example for a well-known neutral concept of surveillance is that of Anthony Giddens. For Giddens, surveillance is "the coding of information relevant to the administration of subject populations, plus their direct supervision by officials and administrators of all sorts."[2] Surveillance means "the collation and integration of information put to administrative purposes."[3] For Giddens, all forms of organization are in need of surveillance in order to work. "Who says surveillance says organisation."[4] As a consequence of his general surveillance concept, Giddens says that all modern societies are information societies.[5]

Basic assumptions of neutral surveillance concepts are:

- There are positive aspects of surveillance.
- Surveillance has two faces, it is enabling and constraining.
- Surveillance is a fundamental aspect of all societies.
- Surveillance is necessary for organization.
- Any kind of systematic information gathering is surveillance.

For Max Horkheimer, neutral theories "define universal concepts under which all facts in the field in question are to be subsumed."[6] Negative approaches see surveillance as a form of systematic information gathering that is connected to domination, coercion, the threat of using violence, or the actual use of violence in order to attain certain goals and accumulate power, in many cases against the will of those who are under surveillance. Horkheimer says that the "method of negation" means "the denunciation of everything that mutilates mankind and impedes its free development."[7] For Herbert Marcuse, negative concepts "are an indictment of the totality of the existing order."[8]

The best-known negative concept of surveillance is that of Michel Foucault. For Foucault, surveillance is a form of disciplinary power. Disciplines are "general formulas of domination."[9] They enclose, normalize, punish, hierarchize, homogenize, differentiate, and exclude.[10] The "means of coercion make those on whom they are applied clearly visible."[11] A person that is under surveillance "is seen, but he does not see; he is the object of information, never a subject in communication."[12] The surveillant panopticon is a "machine of power."[13]

Neutral concepts of surveillance put phenomena such as taking care of a baby and the electrocardiogram of a myocardial infarction patient on one analytical level with pre-emptive state-surveillance of personal data of citizens for fighting terrorism, economic surveillance of private data, or online behavior by Internet companies such as Facebook, Google, and so on, for accumulating capital by targeted advertising. Neutral concepts might therefore be used for legitimizing coercive forms of surveillance by arguing that surveillance is ubiquitous and therefore unproblematic. If everything is surveillance, it becomes difficult to criticize coercive surveillance politically. Given these drawbacks of neutral surveillance concepts, I prefer to define surveillance as a negative concept: surveillance is the collection of data on individuals or groups that are used so that control and discipline of behavior can be exercised by the threat of being targeted by violence. A negative concept of surveillance allows drawing a clear distinction of what is surveillance and what is not surveillance.

Web 2.0 Surveillance

Tim O'Reilly introduced the notion of Web 2.0 in 2005. He stressed that many newer web tools operate as platforms that support various communication functions and technologies and that they constitute an architecture of participation and rich user experience.[14] On the one hand, one can criticize that Web 2.0 is a marketing ideology, that the notion of participation underlying Web 2.0 is only pseudo-participation, that Web 2.0 is dominated by large corporations and commercial interests, that it is an advertising machine, that communication and community-building has also been supported by older Internet applications.[15] But on the other hand, an empirical analysis of how the World Wide Web has changed in the past decade shows that although the importance of information and communication on the web has not much changed, web platforms that support information sharing, community-building/maintenance, and collaborative information production have become more important.[16] There are continuities and discontinuities in the development of the World Wide Web. The web is neither completely new, nor is it the same as ten years ago. One important characteristic of many contemporary web platforms is that they store, process, assess, and sell large amounts of personal information and usage behavior data. It is therefore important to theorize Web 2.0 surveillance and conduct empirical research about the surveillance and privacy implications of Web 2.0.[17]

Economic Web 2.0 surveillance predominantly takes the form of the collection, assessment, and direct or indirect selling of user data and user behavior on profit-oriented, advertising-financed platforms such as Google or Facebook.[18] Advertising is highly targeted to the users' information behavior. Targeted advertising is enabled by economic surveillance. Both targeted advertising and economic Internet surveillance are components of the process of Internet prosumer commodification, which is a reformulation of Dallas Smythe's notion of the audience commodity in the age of the Internet: users actively produce surplus value on profit-oriented web platforms and are endlessly exploited by capitalist Internet corporations that commodify the users, their data, and their information behavior that are sold to advertising clients.[19] Economic Internet surveillance is a category that is subsumed under the categories of class, surplus value, labor, and exploitation on the Internet, which means that economic surveillance is a means for achieving the end of the reproduction of exploitative class relations that are constituted by the production of surplus value by users and the appropriation of this value by Internet corporations.

Manuel Castells characterizes Web 2.0 communication as mass self-communication. Web 2.0

> is mass communication because it can potentially reach a global audience, as in the posting of a video on YouTube, a blog with RSS links to a number of web sources, or a message to a massive e-mail list. At the same time, it is self-communication because the production of the message is self-generated, the definition of the potential receiver(s) is self-directed, and the retrieval of specific messages or content from the World Wide Web and electronic networks is self-selected.[20]

Web 2.0 surveillance is directed at large user groups who help to hegemonically produce and reproduce surveillance by providing user-generated (self-produced) content. We can therefore characterize Web 2.0 surveillance as mass self-surveillance.

> The panoptic sort is a difference machine that sorts individuals into categories and classes on the basis of routine measurements. It is a discriminatory technology that allocates options and opportunities on the basis of those measures and the administrative models that they inform.[21]

It is a system of power and disciplinary surveillance that identifies, classifies, and assesses.[22] Produsage commodification on Web 2.0[23] is a form of panoptic sorting:[24] it identifies the interests of users by closely surveilling their personal data and usage behavior, it classifies them into consumer groups, and assesses their interests in comparison to other consumers and in comparison to available advertisements that are then targeted at the users.

Foucault characterized surveillance: "He is seen, but he does not see; he is the object of information, never a subject in communication."[25] With the rise of "Web 2.0," the Internet has become a universal communication system, which is shaped by privileged data control by corporations that own most of the communication-enabling web platforms and by the state that can gain access to personal data by law. On the Internet, the separation between "objects of information" and "subjects in communication" that Foucault described[26] for historical forms of surveillance no longer exists, by being subjects of communication on the Internet, users make available personal data to others and continuously communicate over the Internet. These communications are mainly mediated by corporate-owned platforms, therefore the subjects of communication become objects of information for corporations and the state in surveillance processes. Foucault argues that power relations are different from relationships of communication, although they are frequently connected.[27] "Power relations are exercised, to an exceedingly important extent, through the production and exchange of signs," "relationships of communication … by modifying the field of information between partners, produce effects of power,"[28] In Web 2.0, corporate and state power is exercised through the gathering, combination, and assessment of personal data that users communicate over the web to others, and the global communication of millions within a heteronomous society produces the interest of certain actors to exert control over these communications. In Web 2.0, power relations and relationships of communication are interlinked. In Web 2.0, the users are producers of information (producers, prosumers), but this creative communicative activity enables the controllers of disciplinary power to closely gain insights into the lives, secrets, and consumption preferences of the users.

Based on a critical theory of technology, the Internet in contemporary society can be described and analyzed as a dialectical system that contains both opportunities and risks that stand in contradiction to each other.[29] The Internet therefore is both a system of cooperation and competition.[30] In the context of surveillance this means that power and counter-power, hegemony and counter-hegemony, surveillance and counter-surveillance are inherent potentialities of the Internet and Web 2.0. But we cannot assume that these potentials are symmetrically distributed because conducting surveillance requires resources (humans, money, technology, time, political influence, and so on). The two most powerful collective actors in capitalist societies are corporations and state institutions. It is therefore likely that companies and state institutions are dominant actors in Internet and Web 2.0 surveillance and that there is an asymmetric dialectic of Internet/Web 2.0 surveillance and counter-surveillance.

Web 2.0, Surveillance, and Art Projects

Eduardo Navas in his project *Traceblog* (Chapter 12) documents search engine queries generated by anti-tracking software on a blog. It is, as Navas argues in his chapter, a "critical commentary on the preoccupation of losing one's privacy," an "aestheticized device invested in critical evaluation of online surfing." The project shows that the problematization of Web 2.0 surveillance is not just a political task for activists, political parties, NGOs, and social movements, but is also reflected in the realm of arts and culture. By making public information that corporate search engines and other corporate Web 2.0 projects normally keep hidden and treat as expropriated private property, Navas thematizes the relation of public and private on the Internet. Online information behavior of individuals takes place in a publicly available virtual space that is privately owned by companies. By agreeing to usage terms, the transaction data generated in this process becomes the private property of companies, users are expropriated and exploited.

Navas' *Traceblog* reminds us that alternatives to the corporate Internet, an Internet based on private property, exploitation, and expropriation, are possible. The new capitalist world crisis has resulted in a renewal of the notion of communism, understood as the project of a self-organized and self-managed participatory economy as alternative to capitalism and state socialism.[31] Navas' project reminds us that the alternative to the capitalist surveillance Internet is a communist Internet that is based on common knowledge and self-managed cooperatives.[32] A commons-based Internet requires the socio-economic context of a truly participatory society.[33] Navas understands *Traceblog* as an "act of appropriation" and thereby reminds us that in order to establish a humane economy, alternatives to the expropriation economy are needed, which can only be established by acts of negating the negative, re-appropriating the expropriated Internet, expropriating the Internet expropriators.

Lee Walton in his project *F'Book: What My Friends Are Doing in Facebook* (Chapter 11) explores Facebook "as a performance venue" by creating, as he writes in his chapter, "a series of video performances" using his friends' Facebook status updates as scripts for videos. Walton created videos that he posted on his Facebook profile and that reflected selected status updates of his Facebook contacts. In the videos, the artist enacted the status update messages. Walton situates his art in the tradition of Marcel Duchamp's readymades. Like Duchamp, he makes everyday objects (in this case status messages) part of an artwork, which comes as a surprise for the audience, especially for those users whose messages are enacted. Other influences for Walton are John Dewey, John Cage, Guy Debord, and Vito Acconoci.

Walton's project blurs "the line between public and private space" and thematizes that private spaces become more public through social media like Facebook. The private-user dimension of Facebook is that content is user-generated by individual users. When it is uploaded to Facebook or other social media, parts of it (to a larger or smaller degree depending on the privacy settings the users choose) become available to lots of people, whereby the data obtains a more public character. The public availability of data can cause both advantages (new social relations; friendships; staying in touch with friends, family, relatives over distance; and so on) and disadvantages (job-related discrimination, stalking, and so on) for users.[34] The private–public relation has another dimension on Facebook: the privately generated user data and the individual user behavior become commodified on Facebook. This data is sold to advertising companies so that targeted advertising is presented to users and Facebook accumulates profit that is privately owned by the company. Facebook commodifies private data that is used for public communication in order to accumulate capital that is privately owned. The users are excluded from the ownership of the resulting money capital, i.e., they are exploited by Facebook and are not paid for their creation of surplus value.[35] Facebook is a huge advertising, capital accumulation, and user-exploitation machine. Data surveillance is the means for Facebook's economic ends.

One of the principles of Guy Debord and the Situationist International was *détournement*: objects of the culture industry spectacle are subverted or their meaning is changed in such a way that they no longer support the system, but communicate an oppositional meaning. Détournement is an artistic form of culture jamming and semiotic guerrilla warfare. "Détournement reradicalizes previous critical conclusions that have been petrified into respectable truths and thus transformed into lies."[36] Lee Walton's project is a détournement of Facebook: he appropriates the platform and transforms its function by creating an artistic space within Facebook that thematizes the relation of the private and the public. Adorno said that the critical function of art is that it negates the logic of capitalism and that "the function of art in the totally functional world is its functionlessness."[37] If the corporate function of Web 2.0 platforms is subverted by turning corporate platforms into something different or introducing a non-corporate logic of art into the platforms in acts of détournement, we are reminded of the possibility of transcending corporatism and the logic of capitalism. This shows that capitalism is not the end of history, but the pre-history of humankind. Walton's project gives us an impetus to think critically about the role of Facebook and other commercial Internet platforms within capitalist society and to reflect about alternatives to an Internet and a society dominated by corporatism.

The works of Eduardo Navas and Lee Walton have in common that they broach the issue of the private and the public on Web 2.0; they remind us that the corporate Internet is today an alienated space dominated and controlled by large companies that expropriate, surveil, and exploit users for economic ends, and that alternatives can be imagined and should be practically created.

Acknowledgment

The work presented in this chapter was conducted in the project "Social Networking Sites in the Surveillance Society," funded by the Austrian Science Fund (FWF) [project number P 22445-G17]. Project coordination: Dr. Christian Fuchs.

Notes

1. David Lyon, *The Electronic Eye*, Cambridge: Polity, 1994: 19.
2. Anthony Giddens, *The Constitution of Society*, Cambridge: Polity Press, 1984: 183f.
3. Anthony Giddens, *A Contemporary Critique of Historical Materialism*, Vol. 2: *The Nation-state and Violence*, Cambridge: Polity Press, 1985: 46.
4. Anthony Giddens, *A Contemporary Critique of Historical Materialism*, Vol. 1: *Power, Property and the State*, London: Macmillan, 1981: xvii.
5. Anthony Giddens, *Social Theory and Modern Sociology*, Cambridge: Polity Press, 1987: 27. See also Lyon, op. cit.: 27.
6. Max Horkheimer, "Traditional and Critical Theory," in *Critical Theory*, New York: Continuum, 1937/2002: 224.
7. Max Horkheimer, *Eclipse of Reason*, New York: Continuum, 1947/1974: 126.
8. Herbert Marcuse, *Reason and Revolution*, New York: Humanity Books, 1941: 258.
9. Michel Foucault, *Discipline and Punish*, New York: Vintage, 1977: 137.
10. Ibid.: 183f.
11. Ibid.: 171.
12. Ibid.: 200.
13. Michel Foucault, *Security, Territory, Population*, Basingstoke: Palgrave Macmillan, 2007: 93f.
14. Tim O'Reilly, *What is Web 2.0?*, 2005. Online: www.oreillynet.com/pub/a/oreilly/tim/news/2005/09/30/what-is-web-20.html?page=1 (accessed August 10, 2010).
15. Christian Fuchs, "Social Software and Web 2.0: Their Sociological Foundations and Implications," in *Handbook of Research on Web 2.0, 3.0, and X.0: Technologies, Business, and Social Applications*, Vol. 2, ed. San Murugesan, Hershey, PA: IGI-Global, 2010: 764–789.
16. Ibid.
17. Christian Fuchs *et al.*, eds., *The Internet and Surveillance*, New York: Routledge, 2011.
18. Christian Fuchs, "Critique of the Political Economy of Web 2.0 Surveillance," in *The Internet and Surveillance*, ed. Christian Fuchs *et al.*, New York: Routledge, 2011; also see *Social Networking Sites and the Surveillance Society*, Salzburg/Vienna: Research Group UTI, 2009.
19. Dallas W. Smythe, "On the Audience Commodity and Its Work," in *Media and Cultural Studies*, ed. by Meenakshi G. Durham and Douglas. M. Kellner, Malden, MA: Blackwell, 1981/2006: 230–256; also see Christian Fuchs, "Labour in Informational Capitalism," *The Information Society*, 26, 3, 2010: 179–196.
20. Manuel Castells, *Communication Power*, Oxford: Oxford University Press, 2009: 55.
21. Oscar H. Gandy, *The Panoptic Sort: A Political Economy of Personal Information*, Boulder, CO: Westview Press, 1993: 15.
22. Ibid.: 15.
23. See Christian Fuchs, "Class, Knowledge, and New Media," *Media, Culture and Society*, 32, 1, 2010: 141–150; and Fuchs, "Labour in Informational Capitalism."
24. Gandy, op. cit.: 15.
25. Foucault, *Discipline and Punish*: 200.
26. Ibid.
27. Michel Foucault, *Power*, New York: New Press, 1994: 337.
28. Ibid.: 338.
29. See Christian Fuchs, *Internet and Society: Social Theory in the Information Age*, New York: Routledge, 2008.
30. Ibid.
31. See Michael Hardt and Antonio Negri, *Commonwealth*, Cambridge, MA: Belknap Press, 2009; also see David Harvey, *The Enigma of Capital*, London: Profile Books, 2010; also see Slavoj Žižek, *First as Tragedy, Then as Farce*, London: Verso, 2009 and "How to Begin from the Beginning," *New Left Review*, 57, 3, 2009: 43–55.
32. Christian Fuchs, *Foundations of Critical Media and Information Studies*, New York: Routledge, 2011: ch. 9.
33. Ibid.
34. Christian Fuchs, *Social Networking Sites and the Surveillance Society*; see also Fuchs, "StudiVZ: Social Networking Sites in the Surveillance Society," *Ethics and Information Technology*, 12, 2, 2010: 171–185.

35. Christian Fuchs, "Labour in Informational Capitalism."
36. Guy Debord, *The Society of the Spectacle*, Canberra: Hobgoblin Press, 2002: 206.
37. Theodor W. Adorno, *Aesthetic Theory*, London: Continuum, 1997: 320.

Bibliography

Adorno, Theodor W. *Aesthetic Theory*. London: Continuum, 1997.

Castells, Manuel. *Communication Power*. Oxford: Oxford University Press, 2009.

Debord, Guy. *The Society of the Spectacle*. Canberra: Hobgoblin Press, 2002.

Foucault, Michel. *Discipline and Punish*. New York: Vintage, 1977.

Foucault, Michel. *Power*. New York: New Press, 1994.

Foucault, Michel. *Security, Territory, Population*. Basingstoke: Palgrave Macmillan, 2007.

Fuchs, Christian. *Internet and Society: Social Theory in the Information Age*. New York: Routledge, 2008.

Fuchs, Christian. *Social Networking Sites and the Surveillance Society: A Critical Case Study of the Usage of studiVZ, Facebook, and MySpace by Students in Salzburg in the Context of Electronic Surveillance*. Salzburg/Vienna: Research Group UTI, 2009.

Fuchs, Christian. "Class, Knowledge, and New Media." *Media, Culture and Society*, 32, 1, 2010a: 141–150.

Fuchs, Christian. "Labour in Informational Capitalism." *The Information Society*, 26, 3, 2010b: 179–196.

Fuchs, Christian. "Social Software and Web 2.0: Their Sociological Foundations and Implications." In *Handbook of Research on Web 2.0, 3.0, and X.0: Technologies, Business, and Social Applications*. Vol. 2, ed. San Murugesan. Hershey, PA: IGI-Global, 2010c: 764–789.

Fuchs, Christian. "StudiVZ: Social Networking Sites in the Surveillance Society." *Ethics and Information Technology*, 12, 2, 2010d: 171–185.

Fuchs, Christian. "Critique of the Political Economy of Web 2.0 Surveillance." In *The Internet and Surveillance*, ed. Christian Fuchs, Kees Boersma, Anders Albrechtslund, and Marisol Sandoval. New York: Routledge, 2011a.

Fuchs, Christian. *Foundations of Critical Media and Information Studies*. New York: Routledge, 2011b.

Fuchs, Christian, Kees Boersma, Anders Albrechtslund, and Marisol Sandoval, eds. *The Internet and Surveillance*. New York: Routledge, 2011.

Gandy, Oscar H. *The Panoptic Sort: A Political Economy of Personal Information*. Boulder, CO: Westview Press, 1993.

Giddens, Anthony. *A Contemporary Critique of Historical Materialism*. Vol. 1: *Power, Property and the State*. London: Macmillan, 1981.

Giddens, Anthony. *The Constitution of Society: Outline of the Theory of Structuration*. Cambridge: Polity Press, 1984.

Giddens, Anthony. *A Contemporary Critique of Historical Materialism*. Vol. 2: *The Nation-state and Violence*. Cambridge: Polity Press, 1985.

Giddens, Anthony. *Social Theory and Modern Sociology*. Cambridge: Polity Press, 1987.

Hardt, Michael and Antonio Negri. *Commonwealth*. Cambridge, MA: Belknap Press, 2009.

Harvey, David. *The Enigma of Capital*. London: Profile Books, 2010.

Horkheimer, Max. "Traditional and Critical Theory." In *Critical Theory*. New York: Continuum, 1937/2002: 188–252.

Horkheimer, Max. *Eclipse of Reason*. New York: Continuum, 1947/1974.

Lyon, David. *The Electronic Eye. The Rise of Surveillance Society*. Cambridge: Polity, 1994.

Marcuse, Herbert. *Reason and Revolution: Hegel and the Rise of Social Theory*. New York: Humanity Books, 1941.

O'Reilly, Tim. *What is Web 2.0?*, 2005. Online: www.oreillynet.com/pub/a/oreilly/tim/news/2005/09/30/what-is-web-20.html?page=1 (accessed August 10, 2010).

Smythe, Dallas W. "On the Audience Commodity and Its Work." In *Media and Cultural Studies*, ed. Meenakshi G. Durham and Douglas M. Kellner. Malden, MA: Blackwell, 1981/2006: 230–256.

Žižek, Slavoj. *First as Tragedy, Then as Farce*. London: Verso, 2009a.

Žižek, Slavoj. "How to Begin from the Beginning." *New Left Review*, 57, 3, 2009b: 43–55.

11 F'BOOK
What My Friends Are Doing in Facebook

Lee Walton

Key Words: Feedback Loop, Embedded Video, Dada, Performance, Readymade, Situationist International (SI)

Project Summary

F'book: What My Friends Are Doing in Facebook explores the popular online social media platform as a performance venue. Walton creates a series of video performances using his friends' Facebook Status Updates as scripts. These video re-enactments are uploaded for public viewing on Walton's Facebook wall.

Project Developer Background

As an artist, I have always been interested in the web as a space for social interaction. My level of engagement with the web is not in programming or developing new technological tools. On the contrary, I am purely interested exploring the web from a user's

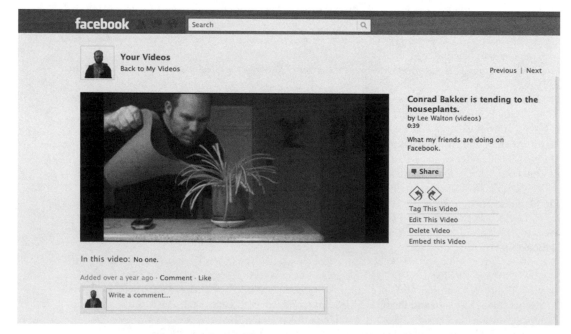

Figure 11.1 Lee Walton performs "Conrad Bakker is tending to the houseplants" for *F'Book: What My Friends Are Doing in Facebook.*

perspective. The web is a complex, social, and constantly growing public space, comparable to that of a thriving city. For me, the best way to experience the city is by walking the sidewalks, talking to strangers, exploring shops, sitting in parks, eating local food, and so on. My leisurely drift is not without acute awareness of the city's environment and its effects—how it makes me feel, controls or determines my actions, reflects popular trends, uses current technologies, employs new strategies in advertising, modes of transportation, and more. In the same way that I examine city spaces, I also examine cyberspace. I experience it, use it, get lost in it, consume it, and live with it. As a mode of questioning and testing the social architecture and structures of cyberspace, I consciously use the web in a way that it was not designed to be used. This mode of operation demonstrates the way we, as a culture, allow the web to shape us. In a city, this can be equivalent to the politics of skateboarding or free-running.

In 2001, I facilitated *Red Ball: San Francisco*, a social web project. In this project, I simply asked the public "Where in San Francisco can we put this little red ball?" Through a website dedicated to the project housing daily Quicktime video updates (today known as vlogging) I began communicating with the public. Within three months, an online community of hundreds of participants from all over the world emerged. Step by step, through a series of votes that incrementally honed in on a single square inch of San Francisco, the public decided to place the ball on the very tip of the home plate at the AT&T Park, home of the San Francisco Giants baseball team.

It is important to understand that in 2001 an interactive web interface was still considered new technology. However, my project only *used* the technology, and the work was not *about* this technology. *Red Ball* was rooted in play and online communication. It tested the web's ability to organize a collective group of global strangers for a common goal outside the realm of commerce or politics. Ten years later, this is the basis of the social web and a function of new communication technologies that have shaped our culture in ways we could not have predicted.

Momentary Performances (2005) were public performances situated in "real" space. These performances directly influenced the concept for *F'Book: What My Friends Are Doing in Facebook*. *Momentary Performances* were created by publicly announcing a descriptive account of a mundane, everyday activity that would happen at a specific location and precise future moment. Here is an example of a performance announcement from the project: *Tuesday at 2pm, man with red belt eating a banana suddenly realizes he is late and runs off into the distance*. After making the announcement, I would coordinate an actor to appear at the location and act out the script precisely at the time indicated. For onlookers without knowledge of the script, the actor blended seamlessly within the public space. These performances stem from my interest in heightening the awareness of everyday actions that are considered mundane in public life. By formalizing these daily actions, basic moments of our lives are transformed into celebrated and anticipated events.

Introduction to *F'Book: What my Friends Are Doing in Facebook*

When I began to explore the social media platform maintained by Facebook, I was instantly fascinated with the activity of the Status Update, where friends were sharing mundane domestic activities of their private lives and treating them as events. I noticed that the updates could be read poetically and autobiographically.

I responded to the user activities defined in the Status Updates by simply selecting particular Updates and using them as scripts for a series of video performances. I would

then interpret these Status Updates and re-enact them in my own home, as if I were the character who would be writing the Update in the future. These videos took the form of very short films that I would upload to my Facebook wall, thus recirculating the performances back into a public space. These videos were often reposted, copied, and distributed by other users, thus creating a virtual feedback loop.

Considering Facebook as a public space, I was also interested in how the private spaces of our living rooms, kitchens, and backyards are becoming more shared and homogeneous through technology, mass consumerism, and popular culture. My project is critical of the way we are using social media to broadcast our daily actions, thoughts, and ideals. Who is watching and listening? How is this information and insight going to be used to influence, shape, and control our future actions? By creating this project I learned that the subjects of my videos were always surprised when they were selected. For them, an individual's action, such as "making pasta while listening to Miles Davis," suddenly became amplified and shared with a larger community than the individual initially anticipated. My subjects could not help but wonder, "Who else is watching?"

Technical Description

The software and equipment used to create *F'Book: What My Friends Are Doing in Facebook* are not specialized. However, I will cite the exact software and equipment I used to make the work, even though the hardware is interchangeable. My decisions were based on personal preferences and available resources. I will also discuss my formal strategies and conceptual reasoning.

Facebook

The subject and site of this project is the way that users freely contribute to a growing collection of Status Updates on the Facebook platform. Facebook is a free social networking website privately owned and operated by Facebook, Inc. Each Facebook user can create a personal profile, add friends, send messages, and share photos, videos, and links. In addition, the Facebook interface enables each user to share a brief description of her activities or thoughts at any time of day, called a Status Update.

Vimeo

I used Vimeo, a video-sharing website, to host the videos created during the project. Vimeo supports high-definition video files, embedding, sharing, and has ample video storage. It also allows user commenting on each video page. In past years, I have preferred the video quality of Vimeo over the similar video-sharing website, YouTube. However, YouTube has caught up with Vimeo's high-definition capabilities and both would work sufficiently well for the purpose of this project today.

iMovie

iMovie is an elementary video-editing software application for Mac users. I prefer its simplicity of design and editing limitations, as this forces me to strip the final videos of superfluous special effects or techniques.

Sony HD Video Camera

I used a consumer-grade Sony HD video camera. Any consumer-grade video camera would have worked sufficiently well for this project. I used a single camera and restaged events to create the illusion of multiple cameras if it was necessary. I did not use an external microphone. Miscellaneous noise effects and sound clips were created with the camera, then later composited during post-production editing with iMovie.

Performance and Video Structure

Performance

Using each selected Facebook Status Update as a short script, I was an actor performing the role of a Facebook user. Considering the vast amount of high-energy spectacle already on the web,[1] I intentionally acted in the opposing manner. In my roles, I aimed to carve out quiet moments. During each video I maintained a straightforward and matter-of-fact demeanor. This careful treatment of seemingly banal events created moments where subtle gestures, facial expressions, sounds, and incidents could become spectacular. Moreover, a rational and practical approach to each activity, no matter how absurd, created irony. I intentionally aimed to create situations of irony and humor that everyone can relate to, thus connecting my audiences.

Video Structure

The overall structure of the *F'Book* video series is directly related to the website and its audience. First, I considered the reality that each video would be viewed within the Facebook interface and therefore would be relatively small. Small visual details within the video proved to be ineffective as they were not always noticeable. In response, each shot was composed to maximize the amount of visual information through composition, directional lighting, and the placement of props. In short, I tried to maintain clarity and simplicity during shooting and editing. Anything that was not essential to the action or script was removed from the shot. Second, I quickly realized that sound was a strong component of the video experience on Facebook. The video could be small, but the audio would remain large. Utilizing sound became an important aspect of each video. Third, I considered the cyber-attention span of Facebook users. I decided that 15–30 seconds was the optimal amount of time for viewing the videos on Facebook. When editing, I consciously cut the video clips, leaving only what was essential for telling the story. My goal was to build suspense while achieving brevity. Timing was of paramount importance and determined the acting, scene selection, and phrasing of each shot.

Relevant Influences

John Dewey, *Art as Experience*

John Dewey (1859–1952) was an American philosopher, psychologist, and educational reformer whose ideas have been influential in education and social reform. His book *Art as Experience* is a significant writing on aesthetics.[2] Dewey believed that aesthetic theory should attempt to explain how works of art are enjoyed in a pure, lived experience. His belief that the art experience is an act involving both the creator and recipient resonates

with me. It is exemplified in the *F'Book* project as the creator relies on the recipients for stage direction, while the recipients revisit their Updates through the lens of the creator. Stemming from this study, Dewey questions how it is that ordinary activities, such as preparing a meal, can yield a particular kind of aesthetic satisfaction.

Dewey's belief that a real, lived activity has formal aesthetic qualities has impacted my thought process and creative intentions. How can I frame life so that we can experience and perceive beauty in mundane everyday activities? In the *F'Book* project, I reframed the daily activities of my friends using the Status Update in a way that Facebook did not intend me to use it. Simply by selecting the activity and creating a short re-enactment video, I have demonstrated to Facebook users that these activities can be viewed and celebrated in an artistic context. My goal was to create a situation where Facebook users might alter their perception of daily activities.

Marcel Duchamp (1887–1968)

Marcel Duchamp was a French Dada artist, whose work had a strong influence on the development of the twentieth-century avant-garde art movement. Duchamp was witty. He enjoyed puns, jokes, and riddles, and his humor and game-like approach to language influenced his art-making process. Best known for introducing the readymade and use of found objects in visual art, Duchamp transformed everyday objects into celebrated works of art. This recontextualization of a banal object altered the object's original signification (what it represented) and its original function. Simply by *deciding* that an object was a work of art, Duchamp shifted the realm of visual art away from a collection of strict aesthetic forms, toward a *conceptual* understanding. He is often casually referred to as the "father of conceptual art."[3]

As Duchamp is a conceptual artist, his influence on this project is noted in the conceptual approach I took to creating the series of videos. First, I selected the Status Updates as if they were readymades. I did not change, influence, or alter the Updates. Like Duchamp, I simply chose the Update and placed it in a different context. Second, humor was an important aspect of the work. Playing with the language of each Status Update, and often deliberately misinterpreting the activities on the basis of puns, double meanings, and innuendo, was central to my interpretation of the Update. Third, my performance of the Status Updates utilized a deadpan delivery. This attitude is co-opted from Duchamp's intentional indifference to the objects he selected as readymades, seen in works such as *Fountain*, where he used a porcelain urinal, and *In Advance of the Broken Arm* in which he used a snow shovel.

John Cage (September 5, 1912–August 12, 1992)

John Cage was an American composer, philosopher, poet, music theorist, artist, and an amateur mycologist and mushroom collector. Cage was one of the leading figures of the postwar avant-garde and one of the most influential American innovators of the twentieth century.

Fundamentally, John Cage has influenced my entire artistic practice. Early in my development as an artist, I learned of Cage's use of chance to determine the outcome of his musical compositions and later his visual art. To do this, Cage subjected all artistic decisions to chance, most often using the Iching, an ancient Chinese text commonly used for divination. This method allowed Cage the freedom to create music that was not ruled by his bias. By distancing himself from aesthetic choices, Cage created music that

was separate from his personal likes and dislikes, or taste. Taste is based on past experiences, and Cage was interested in new experiences. He once said, "My favorite music is the music I haven't yet heard. I don't hear the music I write. I write in order to hear the music I haven't yet heard."[4]

For Cage, the goal of art was self-alteration rather than self-expression. Cage used art to learn about the world. He considered all sound to be musical. He once stated that he preferred the sound of traffic to traditional music.

Although I diverged from strict Cagean tactics regarding choice (I consciously selected the Status Update I wanted to perform), the *F'Book* project used chance and a systemic approach to creating the work as its primary structure. Instead of the Iching dictating my decisions, I used the language of the Status Updates to govern my performances. Once chosen, the Status Updates become concise, immutable scripts that I followed with absolute discipline, making no decisions or alterations. Much like a game, I followed the rules of the script, often bending them as much as possible without breaking them. Ultimately, this playful rule-based structure created a new experience by providing a structure within which I explored the potentially numerous meanings and implications in the language of a Status Update.

Guy Debord (1931–1994)

In 1950, at the age of 19, Guy Debord became actively associated with the Letterist International, a French avant-garde group rooted in theories of Dada and Surrealism. The radically political Letterists fused poetry, music, theater, film, and painting to liberate the individual from the constraints of society and transform the urban landscape. In 1953, through a series of free-associated "drifts," they mapped the psychogeography of Paris. Psychogeography can be defined as the study of how place (geography) makes you feel (psyche). Debord called this technique of urban drifting a *dérive*, the nature of which he defined in his essay "Theory of the Dérive."

> One of the basic situationist practices is the dérives [literally: "drifting"] a technique of rapid passage through varied ambiences. Dérives involve playful-constructive behavior and awareness of psychogeographical effects, and are thus quite different from the classic notions of journey or stroll.[5]

Dérives have been extremely useful in my artistic practice. When applying this playful navigation to real cities, a constructive behavior emerges. Through play, one uses the city in a way it was not designed to be used. It becomes a simple yet powerful activity, one that transforms a public space. Instead of the physical city, the public space transformed by *F'Book* is *cyber*space. Within the space of Facebook, a re-enactment of Status Updates playfully altered the intended function of the social networking site. A reflective feedback loop was created, and the rebroadcasting of performances heightened each Facebook user's awareness of the virtual activities published on the Facebook interface.

In 1957, Guy Debord and a radical faction of the Letterists formed the Situationist International (SI). The SI were emphatically against work, or the production of goods, and theorized that capitalism was dividing society into producers and consumers, or actors and spectators. Effectually, capitalism was separating art and culture from everyday life. The SI believed in an art produced by all people, as opposed to one that is only produced and controlled by those who dominate the economy.

Today, we can see that the theories of Debord, derived from the economic and social theories of Marx and Engels, became a reality when the inequalities inherent to capitalism allow small groups of people to control and influence the production of art, thus shaping culture. However, with the recent development of web and media technology, we are becoming an increasingly producer-based culture. The tools required for the production and distribution of information is becoming accessible to larger amounts of people. We, as the public, are actively employing these tools to write our own story, and to make our own scripts. We are no longer passive, receptive spectators. We have become the actors. As Steven Johnson notes, "Almost all forms of on-line activity sustained are participatory in nature ... Steve Jobs likes to describe the difference between television and the web as the difference between sit back and lean forward media."[6]

In the *F'Book* project, I acknowledged the artistry of ordinary people. My Facebook friends are the creators and actors and I simply cast the spotlight on the theater stage.

Vito Acconci (1940–Present)

Through a continued practice of provocative and radical art-making, Vito Acconci has been a vital presence within contemporary art since the 1960s. Originally a poet, Acconci eventually moved from exploring the space of the page to real, physical space. His confrontational and highly political work questions notions of public space, privacy, social interaction, voyeurism, sexuality, architecture, and more. His work is confrontational, conceptual, and political by nature and takes various forms ranging from performance, film, video, sculpture, architecture, and more. Since the late 1980s he has focused on architecture and design projects.[7]

Following Piece, one of Acconci's most influential works, was first performed in 1969. For this work, Acconci would select a random passer-by in New York City and follow him until he could no longer be followed. The following would last minutes or hours. This activity could take place in a taxi cab, hotel room, apartment, subway, and so on. At the end of the performance, Acconci would photograph the location where he was no longer able to follow the person he selected. Acconci performed this activity every day for one month. After each performance, he would type an account of his activity and send it to a member of the New York art community with the photograph of the final location.

The influence of this project on much of my work is apparent, especially in the case of *F'Book: What My Friends Are Doing in Facebook.* I selected a Status Update just as Acconci selected a passer-by on the streets of New York. I voyeuristically followed the person's actions from afar. Just as Acconci constructed his work for the art community, I created a formal archive of my performance and distributed it to the public on Facebook. I, like Acconci, blurred the line between public and private space.

Conclusions and Outcomes

F'Book: What My Friends Are Doing in Facebook explores Facebook as a public space that is constantly evolving in response to its users. For me, surfing Facebook mimics the randomness of walking down the city sidewalk: running into friends, talking to people, meeting new people, discovering new things, staying up-to-date about current events, and so on. The Status Updates function on Facebook has allowed individuals to easily share their personal daily activities with friends. Through play, my video project reflects this cultural phenomenon while asking critical questions about this new media. For

example, what happens when an individual's personal information is appropriated and redistributed to a larger audience outside this person's intended friend network? Perhaps this is already happening? Who is this larger audience? Does it even matter?

For example, one Status Update that I selected for my project was *Russel Blanks*: *Just washed down a multivitamen with a Pilsner*. My re-enactment extended Russel's activity to a larger audience. As my project gained increasingly more public attention, his activity was shared with thousands of people, not only online via Facebook, but in hotel rooms,

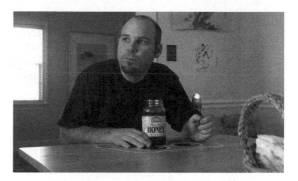

Figure 11.2 Lee Walton performs a status update for *F'Book: What My Friends Are Doing in Facebook*.

exhibitions, magazines, institutions, and now in a textbook. For many on Facebook, the possibility that their Status Update could become a public spectacle brought fear and trepidation. For example, one user sent me a message telling me that she was literally *afraid* to post a Status Update because of my project. Many others commented on how they "thought twice" and were "more aware" of what they posted as Status Updates.

On a more positive, less cynical note, I am celebrating the idiosyncratic beauty of our daily actions. Culturally, we must constantly pay tribute and find poetry in the everyday and unspectacular aspects of our lives. Ultimately, I believe that these everyday moments are the common bonds that unite us, both locally and globally. As a new media art project, I helped raise awareness about the tenuous line between public and private space, facilitated an ongoing conversation about the direction and function of social media, and had a bit of fun doing it.

Notes

1. As of September 2010, the three most popular videos on YouTube are as follows: Justin Bieber, *Baby ft. Ludacris* (300 million views); Lady Gaga, *Bad Romance* (270 million views); *Charlie Bit My Finger* (230 million views). See Richard MacManus, "Top 10 Youtube Videos of All Time," Readwriteweb.com: www.readwriteweb.com/archives/top_10_youtube_videos_of_all_time.php (accessed September 10, 2010).
2. John Dewey, *Art as Experience*, London: Penguin Books, 1934.
3. Marcel Duchamp was often called the "father of conceptual art," although the origination of the title is unknown.
4. John Cage, "An Autobiographical Statement" was written for the Inamori Foundation and delivered in response to having received the Kyoto Prize in November 1989. It is reprinted on Newalbion.com: www.newalbion.com/artists/cagej/autobiog.html (accessed November 24, 2010).
5. Guy Debord, "Theory of the Dérive," *Les Lèvres Nues* #9, November 1956.
6. Steven Johnson, *Everything Bad Is Good for You: How Today's Popular Culture Is Actually Making Us Smarter*, New York: Riverhead Hardcover, 2005: 118.
7. His current work can be viewed on his website: www.acconci.com.

Bibliography

Cage, John. "An Autobiographical Statement." Reproduced on Newalbion.com: www.newal-bion.com/artists/cagej/autobiog.html (accessed November 24, 2010).
Debord, Guy. "Theory of the Dérive." *Les Lèvres Nues* #9, November 1956.

Dewey, John. *Art as Experience*. London: Penguin Books, 1934.

Johnson, Steven. *Everything Bad Is Good for You: How Today's Popular Culture Is Actually Making Us Smarter*. New York: Riverhead Hardcover, 2005.

MacManus, Richard. "Top 10 Youtube Videos of All Time." Readwriteweb.com: www.readwriteweb.com/archives/top_10_youtube_videos_of_all_time.php (accessed September 10, 2010).

Links

A sample video from *F'Book: What My Friends Are Doing in Facebook*: http://vimeo.com/2949980.

Red Ball, an early social media project: www.baovo.com/silentgallery/walton/redball/index.html.

Momentary Performances: http://metromag.com/0p178a3805/momentary-performances.

Experiential Movement and Momentary Performances: http://rolu.terapad.com/index.cfm?fa=content News.newsDetails&newsID=139615&from=list.

Videos that exemplify the viral capabilities of YouTube: www.readwriteweb.com/archives/top_10_youtube_videos_of_all_time.php.

12 TRACEBLOG

Eduardo Navas

Key Words: Data-mining, Discourse, Privacy, Regenerative Remix, Sampling, TrackMeNot

Introduction to *Traceblog*

In April 2008, I had a security issue with one of my web projects, and while doing research on how to improve security, I found the official TrackMeNot website. The Firefox extension, developed by New York University researchers Daniel C. Howe and Helen Nissenbaum, is designed to create search engine obfuscation, meaning that the extension creates *noise*. The developers state on their website:

> TrackMeNot is a lightweight browser extension that helps protect web searchers from surveillance and data-profiling by search engines. It does so not by means of concealment or encryption (i.e. covering one's tracks), but instead, paradoxically, by the opposite strategy: noise and obfuscation. With TrackMeNot, actual web searches, lost in a cloud of false leads, are essentially hidden in plain view. User-installed TrackMeNot works with the Firefox Browser and popular search engines (AOL, Yahoo!, Google, and MSN) and requires no 3rd-party servers or services.[1]

After researching TrackMeNot I learned that some reviewers do not consider it an effective plug-in. The critics argue that contrary to its mission, the extension creates

Figure 12.1, 12.2 *Traceblog* by Eduardo Navas.

information equivalent to garbage, taking space on servers, and possibly even slowing down search engines.[2] Nevertheless, I found TrackMeNot interesting in terms of aesthetics, and decided to appropriate it to develop a new blogging project, which I titled *Traceblog*.

Traceblog is a daily ghost log of my online searches. While I surf the web, TrackMeNot is activated with the aim to cover my online activity. My logs of pseudo surfing are later published on a blog I created using Blogger, Google's weblog service. *Traceblog* is designed to reflect on the archiving of daily activities of any individual who surfs the web, and to ask online surfers to consider the real implications of the current state of online tracking. Consequently, *Traceblog* is not primarily concerned with how well TrackMeNot performs; instead it utilizes the Firefox extension for critical commentary on the preoccupation of losing one's privacy, which also happens to be one of the motivations behind the development of TrackMeNot.[3]

Traceblog was developed in reaction to one of my previous projects titled *Diary of a Star* (2004–2007), a blog that appropriated entries from *The Andy Warhol Diaries*.[4] As exciting as *Diary of a Star* was for me to produce, it consumed more time than I expected because entries had to be carefully written and took much longer to compose than average blog posts. Soon after I finished the Warhol project I began to think about the changes that had taken place with the shift to Web 2.0, and how blogging had changed since 2004. I realized that keeping track of people's surfing activity had become an important element for private, public, and state organizations to data-mine patterns of communication and consumption online.[5] The term "social media" began to be used more often when discussing the growth of early networks such as Orkut, and Friendster around 2004, the period when I began to develop *Diary of a Star*.

I evaluated the changes in online activity since 2004 and decided to develop *Traceblog* to reflect on the new stage that global culture was entering in 2008, during which millions of people around the world willingly shared information about themselves online, via social networks such as Facebook, Flickr, and Myspace, as well as YouTube, not to mention thousands of blogs, which by such time were conventional tools of communication for average Internet users. The result of the social media frenzy is an attitude of sharing that is ubiquitous in 2010, the time of this writing.

In Web 2.0, community users are encouraged to be social under the subtext of constant exposure, at times indirectly and others directly informed by the possibility of becoming a type of celebrity. Anyone can be a "star" in YouTube, if an uploaded video becomes viral, or anyone can feel extremely popular when amassing thousands of friends and "fans" in MySpace and Facebook. For example, since 2005, individual popularity can be measured based on how many people are following a person on Twitter. On these terms, Ashton Kutcher challenged CNN to a Twitter war. Kutcher claimed that he could be the first on Twitter to attain one million followers. Kutcher won.[6] As of May 13, 2010, Kutcher has close to five million followers.[7] Aside from the celebrity element, the implications of this drive for constant exposure and sociability are intimately linked with marketing strategies dependent on data-mining. When I considered the changes briefly noted above, I concluded that blogs fomented online platforms that have developed since 2003. In other words, the blog, as an online form of communication, is the foundational tool of social media as understood in Web 2.0.[8] I decided that developing *Traceblog* to comment on the shift toward constant transparency, connectivity, and data-mining was appropriate; but to be effective, I had to consider what form the blog would take.

Technical Production

The first thing for me to consider before developing *Traceblog* was whether or not to use Blogger as a publishing platform, as I had done for *Diary of a Star*. I also considered the fact that Google had purchased Blogger in 2003,[9] the time when I also began using blogs to develop online resources, such as netartreview.net.[10] After some consideration, I chose Blogger again because I find it of great importance that the service is owned by Google, which is one of the search engines that TrackMeNot uses when it performs automated searches. In this sense, the information comes full circle because Blogger is directly embedded in the system of search, and the purpose of using TrackMeNot could be considered futile to some degree. *Traceblog*, then, becomes an aestheticized device invested in the critical evaluation of online surfing; it adopts the same attitude of Track-MeNot. Instead of concealing or hiding personal information, it directly confronts the very subject of critique: the engines designed for data-mining.

I decided that *Traceblog* should have a default design because its subject of critique is data-mining's relation to blogging. Therefore I chose a blog-template at random from a large set of selections made available by Blogger. The design is titled "Son of Moto (Mean Green Blogging Machine variation)" by Jeffrey Zeldman.[11] I took the CSS template and created an external "about" page, which links to the actual blog. Other than this page I did not change the template's design.

I then had to decide where the pages would be hosted. Since at least 2003, Blogger gave its users a choice of hosting personal blogs on blogspot.com servers, or on external servers of their choice. In order to retain as much autonomy as possible, I opted to host my logs with my own service provider. This option, however, changed because in January 2010 Blogger stopped FTP service to external servers. I received an email notification which explained that by May 1, 2010 I would need to move my logs from my own server to a blogspot.com server. The reasoning behind this move declared by Blogger was the need to allocate resources effectively:

> Only .5% of active blogs are published via FTP—yet the percentage of our engineering resources devoted to supporting FTP vastly exceeds that. On top of this, critical infrastructure that our FTP support relies on at Google will soon become unavailable, which would require that we completely rewrite the code that handles our FTP processing.[12]

From the economic perspective of the hosting company, discontinuing the service seems reasonable when only 0.5 percent of users utilize FTP. However, from the perspective of one of the members of the 0.5 percent group, the implication made by this demand, that is, when all files produced with the Blogger service are to be hosted on a blogspot.com subdomain, is that one becomes a subject to the power that Blogger holds by hosting the files. Hosting all files on their own servers makes the tracking and data-mining of information more efficient, while also centralizing and thus providing greater control over material produced with Blogger. In all fairness, Blogger does give users the option to host their blogs on a subdomain outside of Blogger. Nevertheless, the likelihood of this external hosting is greatly diminished after demanding that all FTP users stop external publishing. Individuals who are less technically inclined are unlikely to set up a subdomain on their own servers.

This decision by the Blogger team demanded that I consider what it meant to move all of my logs to Google servers. I realized that my initial conscious decision to have the files hosted by my service provider was, if not taken away, certainly discouraged. I

further considered whether I should migrate the files to another blogging platform, such as Wordpress. For now, it makes sense to let Google have all of my files, though I could be urged to migrate them when online politics change. As of May 1, 2010, my original address of http://navasse.net/traceblog redirects users to my new blogspot account: http://navastraceblog.blogspot.com.

All of these issues are about blog posts, but I also needed to consider how TrackMeNot functions and how to incorporate its logs on a blog. This part was fairly straightforward. Once TrackMeNot is downloaded and installed, it is easy to customize. I set it to start automatically whenever I launch Firefox, and to do searches once every minute. I learned that if I adjust the settings to be faster than this, search engines shut it down because they detect the automated searches. I usually save the log of my first online session, which in the morning lasts between one and three hours, depending on how much maintenance and work I have to do on my various online projects. I have to remind myself to save the log before closing my browser. I usually do not post after closing the browser, but rather allocate specific times about once or twice a week to make sure I prepare the files to read properly before uploading them to the blog. I do this because the results are random searches that provide sometimes extra-long URLs in need of adjustment with returns so that they fit well within the assigned area of the page design. Unlike typical blogs, comments are closed because I have little time to moderate them, and I don't see how anyone would want to comment on the random material contained within each post. Not having comments makes sense because I consider the blog an art piece that constantly develops publicly online, but which is more of a metaphorical commentary rather than an actual blog that asks viewers to provide feedback with comments.

Historical Influences

Traceblog, like much of my work, is an act of appropriation. It is directly influenced by the tradition of conceptual art since the 1970s, as well as principles of remixing as initially understood in music during the 1980s, and more popularly in new media culture since the 1990s. In conceptual art, the art object is questioned, which means that artists who adopt this practice privilege ideas over material forms.[13] One of the artists I repeatedly reference in my writing is Sherrie Levine.[14] I consider her practice of appropriation, a common strategy employed by conceptual artists, to be in direct conversation with the act of sampling in music. Levine performs acts of selectivity, meaning that she chooses to appropriate or make direct reference to well-known works by male authors to expose the politics of art practice as an activity controlled primarily by men. *Fountain (After Marcel Duchamp)* (1991)[15] is a bronze sculpture of a urinal replica that deliberately critiques Duchamp's *Fountain* (1917). The original readymade sculpture, of which only a photograph remains as verification of its material production, consisted of a public urinal turned upside down on a pedestal. Duchamp submitted his urinal to the Armory Show of 1917 in New York City with the aim to contest how art was understood at the time, especially for a show that claimed no work would be rejected.[16] Duchamp's work, which he submitted and signed with the fictional name "R Mutt," was rejected. His gesture contributed to a shift in focus regarding art practice, in which attention was paid to how an art object comes to be accepted as *art*. In other words, Duchamp exposed that art was actually defined as discourse in a time when mass production was becoming the default mode of communication and exchange.[17]

In terms of discourse, then, Levine *remixes* Duchamp: while Duchamp recontextualized a mass-produced object (a urinal), Levine created an actual sculpture making reference to Duchamp's work using *bronze*, a medium that connotes high-art sculpture.

Her gesture can be read as ironic and critical because a bronze sculpture signifies the preciousness of the object, especially when well polished. A mass-produced urinal would never be made of bronze, including the one Duchamp claimed as a work of art. Levine is appropriating, or sampling in terms of discourse, because, instead of making a direct copy of Duchamp's urinal, she made a cultural reference to his work. The reference to the original sign (the urinal) is perceived as Levine's critical commentary. Ultimately, Levine's work of art includes both the bronze sculpture (the material form) and the critical commentary associated with her sampling (the idea).

It must be noted that Duchamp's critical position is based on making evident the separation of the art gallery from the world at large, while Levine's work is more self-referential: it is no longer primarily concerned with art's relation to the world, but art as an actual institution, which is controlled mainly by men. Levine's commentary, as effective as it is, happens to be specific to the artworld, and is likely to be irrelevant to the average person who is unacquainted with contemporary art practices, including strategies of appropriation. Duchamp's work, on the other hand, is challenging to both the average layperson as well as the art expert since the subject presented—a mass-produced urinal—demands recognition at a basic level of cultural understanding. The urinal is a functional gadget repurposed to create awareness of the separation of art as a specialized field from the world, while Levine's is a commentary at a second level: a *remix* of an art strategy. At the time of producing her own urinal (1991), remixing was well understood as an exercise of self-criticism as well as institutional critique. For both artists, however, the work must be isolated from the world—it must be displayed within the art gallery—in order to be considered *art*. In other words, art works often function as meta-commentary—that is, they are legitimated based on their effectiveness to point to something that exists at a distance—*a critical distance*.

This isolation of objects within the discourse of art to create critical commentary is ruptured in new media art—especially Internet projects, which don't have to leave the Internet to be effective. In fact, they lose their validation when they are presented offline, on CD-ROMs or from a local host.[18] This is what interested me primarily about Internet art—it can only function within the very space it critiques. What becomes more transparent with information-based work is that what makes the work of art an object of *art* is its contextualization, regardless of where the work takes place or is displayed. For example, happenings designed by Kaprow, who performed his works as public events, are always contextualized in terms of meta-action (discourse) by the institution of art, thus entering the specialized space of art criticism. In this sense, the work of online art is ultimately legitimated by the art institution as well, because like any other object, web projects are dependent on discourse. However, the point of interest for me as an artist is not the work's recognition by the institution, but the real possibility that anyone can potentially find and view the project during an online search; whether people may consider it art or not is secondary. It is the potential of dissemination and of questioning of what the online surfer finds that is relevant to my practice. This possibility is unavailable within the enclosed space of the art gallery. The Internet, then, provides an unprecedented framework for crossover to other cultural public spaces.

Levine's work greatly influences my own because her gesture encapsulates the key strategy of sampling often executed in conceptual practice when the primary objective is to question the physical manifestation of the work of art. In essence, her citation of pre-existing works, like Duchamp's *Fountain*, functions as an act of sampling, which has been a default mode of music production since the late 1970s. Sampling in music ran parallel with acts of appropriation in visual culture, but this practice turned out to be

even more popular and well understood within the context of remixing in the 1980s because of music samplers. At the beginning of the twenty-first century, with the ubiquity of computers, sampling is essential for communication and creative exchange online. Most commonly, sampling is implemented in terms of cut/copy and paste.[19]

Traceblog is defined by sampling. As Levine turned Duchamp's banal object into a supposed precious and unique work of art, I take Howe and Nissenbaum's TrackMeNot to develop a blog that consists of material produced with their Firefox extension. Like Levine, I make an obvious reference to the original work. Levine makes both a deliberate visual reference and an explicit textual citation in the title of her work: *Fountain (After Marcel Duchamp)*. My approach differs, as I do not include the original's name in my title. Instead, I chose a title that exposes the actual process that TrackMeNot is designed to perform: to hide in plain view the traces of the online user that could be data-mined. It made no sense to make a formal reference to TrackMeNot since the plug-in is software that runs while Firefox is being used; therefore, the online project resembles a common Blogger template. My strategy also differs in another particular aspect from both Duchamp's and Levine's in that I took a pre-existing tool, designed for critical reflection somewhat similar to art practice (but which nevertheless is not art) to create a work of art.

Traceblog is a conceptual hack. This means that I took two mass-produced elements (blogs and anti-tracking software) originally designed to function in a particular way for mass consumption, and brought them together for the purpose of critical reflection. From the standpoint of Remix, as a form of discourse that spans across media, *Traceblog* is also a conceptual mashup. Similar to a musical mashup, two or more elements are at play simultaneously. *Traceblog* presents the TrackMeNot logs as they are archived each time I launch Firefox. Presenting the material in default mode questions both the logs' and the blog's naturalized states, similarly to how Levine questions Duchamp's original work in relation to the uniqueness of the object of art. Furthermore, the entries are not reader-friendly. In reality, they deny any possible coherent reading, and the most one can hope for is some random scanning of terms. This is a comment on the obsessive nature of online expression, which has become so co-opted by mass media that it can now be read as an empty form of entertainment.

Conclusions and Contentions

Traceblog is a direct result of my ongoing practice as artist and media researcher. It makes the most of the default state of works of art in new media practice as informational forms, not defined by physical presentation. *Traceblog* and similar online works function in a state of flux defined by the growing archive and its relation to the ever-present: the now. In terms of remixed and networked media, I consider this relationship to depend on principles of the *regenerative remix*.[20] The regenerative remix is the recombination of content and form that opens the space for remix as a form of discourse to become specifically linked to new media culture. The regenerative remix can only take place when constant change is implemented as an elemental part of communication, while also creating archives. This implementation, at a material level, mirrors while it also redefines culture itself as a discourse of constant change. The regenerative remix consists of juxtaposing two or more elements that are constantly updated, meaning that they are designed to change according to data flow. Facebook, Flickr, Google, Twitter, Wikipedia, and Yahoo are all defined by principles of the regenerative remix. They are relevant not because of their growing archives, but because they rely on the growth of their communities and the intensive consistency with which members update, combine,

and mashup information online. This means that social networks are dependent on constant updates and principles of the regenerative remix.[21]

Traceblog is also defined by principles of the regenerative remix. It is dependent on the ongoing production of information; that the information is garbage becomes the foundation for critical commentary. *Traceblog* resembles daily life in that it does not have an end date, but will be developed for as long as blogging technology is relevant to create discussion about issues of privacy. *Traceblog* is both a metaphor and the actual thing: it is about blogs and it is a blog. Traceblog is a work about data-mining that exposes information that is data-mined. It is about the relation among resistance, futility, and aesthetics; it is discourse unfolding in real time, isolated as art while extended as part of the blogosphere. *Traceblog* challenges information as commodity fetishism, as the object of art proper while acknowledging the assimilation of information as fetish in all areas of culture, not just the art gallery or museum.

Notes

1. TrackMeNot, http://cs.nyu.edu/trackmenot (accessed May 10, 2010).
2. You can find a list of reviews on the project's front page: http://navasse.net/traceblog. One of the stronger arguments is made by Bruce Schneier; see "Schneier on Security," August 23, 2006: www.schneier.com/blog/archives/2006/08/trackmenot_1.html (accessed May 10, 2010).
3. Howe and Nissembaum state on TrackMeNot's website:

 We are disturbed by the idea that search inquiries are systematically monitored and stored by corporations like AOL, Yahoo!, Google, etc. and may even be available to third parties. Because the Web has grown into such a crucial repository of information and our search behaviors profoundly reflect who we are, what we care about, and how we live our lives, there is reason to feel they should be off-limits to arbitrary surveillance. But what can be done?

4. Eduardo Navas, *Diary of a Star*. Online: http://navasse.net/star.
5. Two concise documentaries that offer an insight into the way emerging technology is used to data-mine and measure people's behavior for the sake of marketing are "The Merchants of Cool," *Frontline*, 2001: www.pbs.org/wgbh/pages/frontline/shows/cool, and "The Persuaders," *Frontline*, 2005: www.pbs.org/wgbh/pages/frontline/shows/persuaders, both written and narrated by Douglas Rushkoff.
6. Simon Vozick-Levinson, "Ashton Kutcher defeats CNN in Twitter War: One Giant Step for Mankind," April 17, 2009, http://popwatch.ew.com/2009/04/17/ashton-twitter (accessed May 13, 2010).
7. Ashton Kutcher's Twitter account has officially 4,865,693 people following as of May 13, 2010: http://twitter.com/APLUSK.
8. See my texts dealing with blogging and micro-blogging: "The Blogger as Producer," June 2007: http://remixtheory.net/?p=203, and "After the Bloger as Producer," June 2009: http://remixtheory.net/?p=378.
9. Leander Kahney, Wired.com, February 22, 2003: "Why Did Google Want Blogger?" (accessed May 13, 2010).
10. Netartreview.net was active from 2003 to 2005, at which time it evolved into newmediaFIX. See http://netartreview.net and http://newmediafix.net.
11. URL: www.zeldman.com, 23 February 2004.
12. Taken from a mass email sent to me by a blogger on February 2, 2010. A general announcement about the FTP service discontinuation can be found at http://blogger-ftp.blogspot.com.
13. There is a vast number of publications dealing with the history of conceptualism. One of the first exhibitions which evaluated the historical importance of conceptual art took place at MOCA in Los Angeles in 1996. See Ann Goldstein and Anne Rorimer, eds., *Reconsidering the Object of Art: 1965–1975*, Cambridge, MA and London: MIT Press, 1996.

14. See Eduardo Navas, "Turbulence: Remixes + Bonus Beats," 3 × 3: New Media Fix(es) on Turbulence, January 2007: www.turbulence.org/texts/nmf/Navas_EN.html (accessed May 15, 2010). A brief account is also available on Eduardo Navas "Remix Defined": http://remixtheory. net/?page_id=3 (accessed May 15, 2010).

15. For information about Levine's *Fountain, After Marcel Duchamp*, see http://collections.walkerart. org/item/object/906 (accessed May 15, 2010).

16. For an extensive analysis of Duchamp's urinal and how it affected art production during the twentieth century, see Thierry De Duve, *Kant after Duchamp*, Cambridge, MA: MIT Press, 1998.

17. Marcel Duchamp, "Apropos of 'Readymades'," in Kristine Stiles and Peter Selz, eds., *Theories and Documents of Contemporary Art*, Berkeley: University of California Press, 1996: 819.

18. I experience this whenever any of my online projects are exhibited in museums. The first time took place when I participated in Art in Motion (AIM), held in February 2001 at the Santa Monica Museum of Art. Friends who congratulated me during the exhibition's opening mentioned repeatedly how they would look at the work later in the comfort of their home. The fact that the work was running from a CD-ROM complicated the work's experience in the museum gallery, as this, somehow, was read by visitors who were web savvy as illegitimate. Some said: "too bad it is not linked to the actual sites" or "I find it odd to navigate online art in a museum. I prefer my house, where nobody is looking at how I interact with it." See www.usc.edu/dept/ matrix/aim/aimii/index2.html (accessed June 10, 2010).

19. The history of sampling can be found in Remix Theory: http://remixtheory.net. A more extensive analysis is available in Eduardo Navas, "Regressive and Reflexive Mashups in Sampling Culture," in *Mashup Cultures*, ed. Stefan Sonvilla-Weiss, New York: Springer, 2010: 157–177.

20. Ibid.

21. Ibid.

Bibliography

De Duve, Thierry. *Kant after Duchamp*. Cambridge, MA: MIT Press, 1998.

Duchamp, Marcel. "Apropos of 'Readymades'." In *Theories and Documents of Contemporary Art*. Ed. Kristine Stiles and Peter Selz. Berkeley: University of California Press, 1996.

Goldstein, Ann and Anne Rorimer, eds. *Reconsidering the Object of Art: 1965–1975*. Cambridge, MA and London: MIT Press, 1996.

Kahney, Leander. "Why Did Google Want Blogger?" Wired.com. www.wired.com/science/discoveries/news/2003/02/57754 (last modified February 22, 2003).

Navas, Eduardo. *Diary of a Star*. http://navasse.net/star (accessed November 20, 2010).

Navas, Eduardo. "Turbulence: Remixes + Bonus Beats." *3 × 3: New Media Fix(es) on Turbulence*. Online: www.turbulence.org/texts/nmf/Navas_EN.html (last modified January 2007).

Navas, Eduardo. "The Blogger as Producer." Online: http://remixtheory.net/?p=203 (last modified June 2007).

Navas, Eduardo. "After the Blogger as Producer." Online: http://remixtheory.net/?p=378 (last modified January 2009).

Navas, Eduardo. "Remix Defined." http://remixtheory.net/?page_id=3 (accessed May 15, 2010).

Navas, Eduardo. "Regressive and Reflexive Mashups in Sampling Culture." In *Mashup Cultures*. Ed. Stefan Sonvilla-Weiss. New York: Springer, 2010.

Rushkoff, Douglas. "The Merchants of Cool." *Frontline*. 2001. Online: www.pbs.org/wgbh/pages/ frontline/shows/cool (accessed November 20, 2010).

Rushkoff, Douglas. "The Persuaders." *Frontline*. 2005. www.pbs.org/wgbh/pages/frontline/ shows/persuaders (accessed November 20, 2010).

TrackMeNot. http://cs.nyu.edu/trackmenot (accessed May 10, 2010).

Vozick-Levinson, Simon. "Ashton Kutcher defeats CNN in Twitter War: One Giant Step for Mankind." Online: http://popwatch.ew.com/2009/04/17/ashton-twitter (last modified April 17, 2009).

PART VII
TACTICAL MEDIA AND DEMOCRACY

TACTICAL MEDIA

Critical Art Ensemble

Tactical media is not a monolithic model, but a pliable one that asks to be shaped and reshaped. The collection of tendencies from which a tactical media practice emerges is bound to change depending on who is asked. In conjunction, cultural context plays such a significant part in the meanings generated that the model has to be constantly reconfigured to meet particular social demands.

To complicate matters further, tacticality has never been theorized to a point of consensus among its users. In fact, even the authors of the original text "ABC of Tactical Media" have not been able to come to complete agreement.[1] On the one hand, Geert Lovink is of the opinion that tacticality is primarily derived from military discourse. Certainly, the root discourse is grounded in this area of consideration. Much about the way in which particular cultural tactics are conceived and executed has been refined through the principles offered by Carl von Clausewitz in *On War*. He clearly understood that "Tactics are the art of the weak," and indeed, deception and trickery are the primary allies of those who must resort to tacticality.[2] In an age of asymmetrical warfare, the interrelationship of tacticality in the theaters of culture and warfare is quite clear.

On the other hand, David Garcia is quick to cite Michel de Certeau as a central influence, for while military discourse may be quite informative, the cultural manifestation of tacticality should also be informed by cultural discourse in order to capture the subtleties of action within the social sphere, which are quite different from those within the world of war. While recognizing the significance of military discourse, Garcia insists that precise articulation relevant to cultural interventions rests within culture itself.

In spite of cultural and theoretical differences and contradictions, tactical media has several principles that seem to have general value (although there are always exceptions). We should begin with the meaning of tacticality as described by de Certeau's *The Practice of Everyday Life*:

> a tactic is a calculated action determined by the absence of a proper locus ... The space of a tactic is the space of the other. Thus it must play on and with a terrain imposed on it and organized by the law of a foreign power. It does not have the power to keep to itself, at a distance, in a position of withdrawal, foresight, and self-collection; it is a maneuver "within the enemy's field of vision," as von Büllow put it, and within enemy territory. It does not, therefore, have the options of planning general strategy and viewing the adversary as a whole within a direct, visible, objectifiable space. It operates in isolated actions, blow by blow. It takes advantage of "opportunities" and depends on them, being without any base where it could stockpile its winnings, build up its own position and plan raids.[3]

In this context, tactical media includes the tools and narratives of cultures of resistance to the typically authoritarian status quo.

Tactical media is a form of cultural intervention. By this, Critical Art Ensemble means that it appropriates an existing semiotic regime and redeploys it in a manner that offers participants a different (hopefully more radicalized) way of seeing, understanding, and (in the best case scenario) interacting with a given system. The already given and the unsaid are the points of reference of a tactical media event. As Stanley Aronowitz says about the postmodern thinker: "We deconstruct the 'givenness' to show the cracks that sutures have patched, to demonstrate that what is taken as privileged discourse is merely a construction that conceals power and self-interest."[4] Much the same can be said about the tactical media practitioner, the difference being that rather than just doing critical reading and theorizing, practitioners go on to develop participatory events that demonstrate the critique through experiential process.

The tactical media practitioner uses any media necessary to meet the demands of the situation. While practitioners may have expertise in a given medium, they do not limit their ventures to the exclusive use of one medium. Whatever media provide the best means for communication and participation in a given situation are the ones that they will use. Neither specialization nor material predetermine or limit action. This is partly why tactical media often lends itself to collective efforts, as there is always a need for a differentiated skill base that is best developed through collaboration.

In conjunction, tactical media practitioners support and value amateur practice— both their own and others'. Amateurs have the ability to see through the dominant paradigms, are freer to recombine elements of paradigms thought long dead, and can apply everyday life experience to their deliberations. Most importantly, however, amateurs are not invested in institutionalized systems of knowledge production and policy construction, and hence, do not have irresistible forces guiding the outcome of their process such as maintaining a place in the funding hierarchy, or maintaining prestige-capital.

Tactical media is ephemeral. It leaves few material traces. As the action comes to an end, what is left is primarily living memory. Unfortunately, as feminist performance theorist Rebecca Schneider has convincingly pointed out, no one has yet to solve the haunting problem of the archive first isolated by Derrida.[5] Tactical media rarely escapes the problems of secondary representation, and the few material trace elements, subservient and partial records of an immediate lived experience, often appropriate the value of the experiential process. After the event is over, photos, scripts, videos, graphics, and other elements remain, and are open to capitulation and recuperation.

In spite of such problems, the situation is not entirely disastrous. Traces and residues are far less problematic than strategic products that come to dominate the space in which they are placed. Monumental works are the great territorializers—they refuse to ever surrender space. Instead they inscribe their imperatives upon it and disallow anything other than passive viewing. They negate generative difference, and are engines of alienated separation. But unlike monumental works (whether these are in fact monuments proper, or even worse, movements, coalitions, campaigns, or programs that have become bureaucracies), the trace is stratified in its interpretive structure. No matter how quickly and profoundly assimilated, it still contains the possibility of radical *action*. This possibility redeems the trace, because it can remind us of minor histories that render credible the belief that something different from the inhumanity and violence of predation economics is possible, and that a continued capacity for direct autonomous action can lessen the intensity of authoritarian culture. Aiming for this possibility, tactical media remains ad hoc and self-terminating.

Notes

1. David Garcia and Geert Lovink, "ABC of Tactical Media," *Tactical Media Networks* and *Nettime*, Friday, May 16, 1997. Online: http://project.waag.org/tmn/frabc.html or www. nettime.org/Lists-Archives/nettime-l-9705/msg00096.html.
2. Carl von Clausewitz, *On War*, trans. J.J. Graham, London: Kegan Paul Trench Trubner, 1911: 210.
3. Michel de Certeau, Luce Giard, and Pierre Mayol, *The Practice of Everyday Life*, trans. Steven Rendall, Berkeley: University of California Press, 1988: 37.
4. Stanley Aronowitz, "Postmodernism and Politics," *Social Text*, 18, Winter 1987–1988: 107.
5. Rebecca Schneider, *The Explicit Body in Performance*, London: Routledge, 1997. See especially "Epilog: Returning from the Dead," pp. 176–184.

Bibliography

Aronowitz, Stanley. "Postmodernism and Politics," *Social Text*, 18, Winter 1987–1988: 99–115.

de Certeau, Michel, Luce Giard, and Pierre Mayol. *The Practice of Everyday Life*. Trans. Steven Rendall. Berkeley: University of California Press, 1988.

Garcia, David and Geert Lovnick. "ABC of Tactical Media." *Tactical Media Networks* and *Nettime*. Friday, May 16, 1997. Online: http://project.waag.org/tmn/frabc.html or www.nettime.org/ Lists-Archives/nettime-l-9705/msg00096.html.

Schneider, Rebecca. *The Explicit Body in Performance*. London: Routledge, 1997.

von Clausewitz, Carl. *On War*. Trans. J.J. Graham. London: Kegan Paul Trench Trubner, 1911.

13 THE GOOD LIFE/LA BUENA VIDA

*Carlos Motta with Eva Díaz, Freckles Studio,
and Stamatina Gregory*

Key Words: Archive, Cinema Vérité, Grass Roots Activism, Installation Art, *Pedagogy of the Oppressed*, Public Opinion, Reflexive Sociology, Relational Aesthetics, Social Activism, *Third Cinema*, *Vita Activa*

Project Summary

The Good Life/La Buena Vida is a multi-part video project composed of over 400 video interviews with pedestrians on the streets of 12 cities in Latin America, shot between 2005 and 2008. The work examines processes of democratization as they relate to US interventionist policies in the region. *The Good Life/La Buena Vida* is formed of an Internet archive (la-buena-vida.info), a video installation, and a series of commissioned texts and articles.

Introduction

The Good Life/La Buena Vida was a four-year project that shaped itself in response to the experience of its making: at first, my idea was to make a documentary about the way in

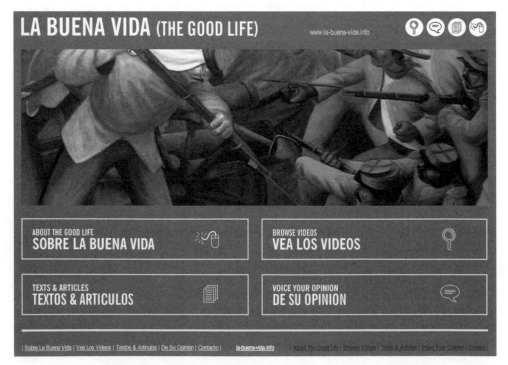

Figure 13.1 *The Good Life/La Buena Vida* by Carlos Motta.

which ordinary Latin Americans perceived the influence of US foreign policy in that region. I knew I wanted to base it on street interviews recorded on video, but thought I would construct a linear narrative (most likely in the form of a film). As I started to gather the hundreds of interviews that compose the work it became apparent that I needed to let the material "tell me" how its form should shape. At the same time, I started to think of formal strategies, artistic methodologies, and (art) historical precedents that treated similar kinds of initiatives.

The Good Life/La Buena Vida became a multi-part video project composed of over 400 video interviews with pedestrians on the streets of 12 cities in Latin America, shot between 2005 and 2008. The work examines processes of democratization as they relate to US interventionist policies in the region. The conversations and dialogues, recorded in Bogotá, Buenos Aires, Caracas, Guatemala, La Paz, Managua, Mexico City, Panamá, Santiago, San Salvador, São Paulo, and Tegucigalpa, cover topics such as individuals' perceptions of US foreign policy, democracy, leadership, and governance. The result is a wide spectrum of responses and opinions, which vary according to local situations and specific forms of government in each country.

Why I Made *The Good Life/La Buena Vida* by Carlos Motta

In 1968 Argentinean filmmaker Fernando "Pino" Solanas made *La Hora de Los Hornos* (*The Hour of the Furnaces*), a radical political documentary and manifesto that unapologetically advocated the construction of a just society, free from the forces of bourgeois neo-colonialism and US and European imperialism. This major work, emblematic of 1960s revolutionary filmmaking, is a heartfelt cry for independence. Solanas and his co-screenwriter Octavio Getino formed the Grupo Cine Liberación (Liberation Cinema Group) and went on to formulate what they called Tercer Cine (Third Cinema), a film practice that articulated the social, political, and economic illnesses of the time from the perspective of "the people." Third Cinema distanced itself from the commercial pressure of Hollywood and the seemingly uncompromising attitude of European films *d'auteur*. Film for the Third Cinema was an aesthetic instrument to politicize, liberate, and create an awakening of critical consciousness.

Similarly, the work of Brazilian pedagogue Paulo Freire was motivated by the rejection of the inequalities of the established social order, which enforced an elitist "banking model" of education in which information is "deposited" into students, who are expected to digest it without asking questions. Freire, alternatively, emphasized dialogue and praxis as means of developing a consciousness that has the power to transform reality. Freire, like Solanas and Getino, was interested in developing critical tools for people to use as means to liberate themselves from oppression.

The decades that followed the release of *La Hora de Los Hornos* shattered Solanas' as well as Freire's social and political dreams. Since the 1970s, the United States has backed several military coups and dictatorships, civil wars, counter-revolutions, and countless other forms of intervention throughout the continent to systematically eradicate any (socialist) project that may have challenged its economic power. Today, 40 years later, Latin America is still bleeding, dependent, ignorant, violent, poor, and oppressed. These works—their political and historical contexts—have been important conceptual and methodological references for the making of *The Good Life/La Buena Vida*.

The work is structured in the form of an Internet archive (la-buena-vida.info), which provides several ways to search or access the material. It holds all of the unedited video

interviews, in an attempt to make the process of the work's making *transparent*, to allow the viewers to reflect on the inherent problems of interviewing, and to see the *fabrication* of these video "documents." The project also maintains a critical distance from the mainstream media's use of similar tactics, such as the interview, to promote "truthful" and "objective" information as well as from the notion of "public opinion." In other words, while *The Good Life/La Buena Vida* uses strategies common to journalism and documentary film, it does not pretend to show "reality as it is." *The Good Life/La Buena Vida* exposes a subjective and personal interpretation of "reality as it should be." These "documents" are not neutral, and my mediation and ideology, as well as that of the interviewees, are explicit.

The Good Life/La Buena Vida asks difficult questions today, after years of exploitation and dependency have determined the fate of the majority of civilians throughout Latin America. This work is born out of a desire to generate an inter-generational public dialogue about the actions of the United States and how they are perceived today, given the different levels of intervention in the region. I was interested in inquiring about the perception of political concepts such as democracy and leadership, and more importantly about their implementation, considering the critical importance that these concepts play in *our* social development. How have these concepts been constructed in countries as diverse as Honduras or Chile, where US involvement has been radically different? Can one speak of democratic nations in Latin America, a geographic region defined by social inequality? What is the role of civilians and/or social movements within the different political systems of the region?

These, among many other questions, are part of an attempt to underline the need for a systematization of inquiry (political, social, and historical) and rejection of abuse, manipulation, and violence. The proposed system does not attempt to impose another hegemonic worldview. Instead, it magnifies unheard voices and opinions about the complex set of relations that have maintained the majority of our continent poor and underrepresented. In the process of creating *The Good Life/La Buena Vida*, my status, and that of those involved in the work, have been reclaimed as conscious, informed, and critical citizens and subjects.

Historical Perspectives

A Selection from "An Interview on the Interview: A Conversation between Carlos Motta and Eva Díaz"[1]

EVA DÍAZ: The last part of *The Good Life/La Buena Vida* project is a searchable Internet archive (la-buena-vida.info) of the over 400 videotaped interviews you conducted with pedestrians in 12 Latin American cities about the history of United States interventions in the region and the socio-political effects of those disruptions. I'll come to the substance of those interviews in a minute, but I want to consider the precedents in film and artistic practice for such a project, and the interrelated issue of your engagement with sociological methods such as field research and participant survey. In particular, an element of your approach seems to be a readdress of the history of artists' uses and appropriations of sociological/social science methods (interviews, data collection/archive management, longitudinal—or in your case latitudinal—studies, and forms of statistical compilation). One can trace a lineage from Hans Haacke's 1970 poll of MoMA visitors' political opinions to your work, for instance. On the other hand, *The Good Life/La Buena Vida* hearkens to late 1950s and early 1960s explorations of new forms of

documentary practices such as direct cinema's innovative use of hand-held cameras and synch sound, or more specifically cinéma vérité's approach to the passerby in street interviews. How did you come to the interview as a formal structure?

CARLOS MOTTA: As I started to consider a formal method to approach my interest in this fascinating yet enormous subject—the way *we* as citizens of Latin America perceive and assimilate personally and collectively the history of U.S. interventions in the region—I carefully looked at Latin American documentary film from the 1950s, 1960s, and 1970s. These decades staged several forms of resistance to what these filmmakers termed "American imperialism and bourgeois neo-colonialism," and witnessed the production of alternative ways of social empowerment via the politicization of culture. Filmmakers such as Fernando Birri and Fernando "Pino" Solanas in Argentina; Carlos Alvarez, and Jorge Silva and Marta Rodríguez in Colombia; Patricio Guzmán in Chile; and Jorge Sanjinez in Bolivia used film as a political tool to inform, instruct, educate, and stir "popular" audiences about their social conditions, and their political needs, rights, and responsibilities.

A shared interest for all of them—and a central subject for my project—was the production of alternative ways to construct "public opinion." A critical position with regard to the largely unquestioned manipulation of the mainstream media's production of political and social consent was essential to the creation of new forms of mediatic interaction. Perhaps influenced by the recently formed cinéma vérité approach in France led by Jean Rouch, and its informal aesthetics, some of these Latin American filmmakers were also going out on the streets equipped with a microphone and a hand-held camera confronting pedestrians with difficult questions, documenting social movements, and talking with individuals and groups about politics and society.

These historical precedents, as well as my growing concern about the corporate structure of the media—and its unapologetically biased reporting in the name of the "public"—led me to use the interview form in *The Good Life/La Buena Vida*. It was soon clear to me, though, that I wouldn't make a film but use only the interview form to underline and contest its potential for the acquisition of knowledge and information. While interviewing is commonly only one of the features of a documentary film (along with a voice-over narration, etc.), the interview for me was the means and the end. Consequently I sought for a form to organize these hundreds of interviews in a "democratic" way, which led me to the creation of an Internet archive (la-buena-vida.info).

ED: I'm glad you mentioned the media and its constitutive effect on public opinion. The agglomeration of the media into mega-corporations points to how the reproduction of the existing social order—the economic structure in which these corporations continue to be some of most profitable institutions owned by the wealthiest people on earth—is the fundamental form of consent they orchestrate. We are (too) familiar with the resulting cycle of fluff and mayhem that characterizes media entertainment logic, particularly for television. When you adopted the posture of the interviewer, but offered your set of seven questions on U.S. intervention and perceptions of democracy, obviously you created dissonance in the familiar media-based model of the interview. Did people pick up on that? Did your subjects reflect, on or off camera, on the form of media agency you yourself posed, or that you solicited from them?

CM: Upon beginning the project in Mexico City in 2005 I had to come up with a methodology to conduct the interviews that would work to achieve the kind of content I was looking for. I realized very soon—after several failed attempts—that the set up of the interviews I had seen and studied from several news channels and documentary films (including Jean Rouch's *Chronicle of a Summer* and Vilgot Sjöman's *I Am Curious*

(Yellow)) wasn't the appropriate one for my project. Generally, in these works, a camera-person and interviewer approach a pedestrian or a group with a microphone in hand and confront them with a direct question, such as, "Do we have a class system in Sweden?" (Sjöman). The pedestrian chooses whether to stop and answer or not. The dynamics of this confrontation, the initial shock it may produce, the attraction or repulsion to the camera, the individual's time constraint, the particular bias intended with the question, etc., forecast the kind of answers that interviewers seek. This fast-paced acquisition of information and opinions on the street is often associated with the notion of "public opinion," which literally means the opinions of the public about a given subject in a public space confronted by the machine of the media. However, Rouch, Sjöman, and other cinéma vérité makers brilliantly deconstructed this notion in the 1960s with the careful insertion of key protagonists in their films (interviewer, interviewees, camera, microphone, etc.) that openly performed and commented on their assigned roles.

I chose a different approach for *The Good Life/La Buena Vida*. I wasn't interested in exposing the mechanisms behind the construction of the notion of "public opinion," but rather in inviting the interviewees to thoughtfully reflect and take time to comment on the questions I asked. Toward this aim, I never approached walking pedestrians but only individuals or groups that were sitting down in parks, waiting on street corners, or hanging out in other public spaces. I invited them to answer the questions after explaining who I was, what I wanted, where the material would be presented, and who was financing me. The idea was to give them as much information about my intention so that we would feel more inclined to have a dialogue.

In other words, and to answer your question more directly, yes and no. "My" subjects picked up "on the form of media agency" I posed most of the time primarily because I told them. Some people chose to truly engage with the questions and would then think of me more as researcher than as a journalist. But others were disappointed to find out that I was an artist and not a journalist that would guarantee them a spot on TV!

A Selection from "Speaking Democracy: Carlos Motta's *The Good Life/La Buena Vida*" by Stamatina Gregory[2]

The good life, as examined in Aristotle's *Ethics*, is engaged with both philosophical contemplation and with the practice of "ethical virtues," which involve participation in the life and affairs of the Athenian *polis*, or city-state. In the third book of his *Politics*, Aristotle details the possible involvement of citizens in these affairs: taking part in deliberative assemblies, holding rotating positions in government, and having a share in judicial office. His accounts reflect a conception of politics as an integral part of social life, instead of the separate and distinct sphere of social activity (such as economics, religion, or the aesthetic) it is relegated to today; even the verb in Greek for "to be a citizen" is synonymous with "to be active in managing the affairs of the city."[3] Although the "state" of citizenship excluded broad swaths of the population such as women, foreigners, and slaves, the structure of the average Greek *polis* required an individual's commitment to civic participation far outstripping what is expected of the average citizen in the modern nation state.[4]

This classical conception of democracy is something which philosopher Hannah Arendt sought to recuperate in *The Human Condition* (1958), finding in Greek and Roman antiquity an extensive privileging of political life and political action which she felt had been lost in modernity. Her work critiques the trajectory of traditional Western political philosophy as an autonomous enterprise that holds itself above and apart from

the world of practical human action, and can be read to assert that a philosophy and life of labor, work, and action—the *vita activa*—must form the basis of democratic participation.[5]

For Arendt, action primarily constitutes public speech, and is the means by which individuals come to reveal their distinctive identities, encounter one another as members of a community, and exercise their capacity for agency.[6] She holds up the Athenian *polis* as the model for this active, essential space of disclosure and communicative speech.[7] This conceptual space for speech and action as delineated by Arendt, as well as the formal attributes of the democratic spaces of antiquity, are evoked in Carlos Motta's *The Good Life/La Buena Vida.*

Hailing from Bogotá, Colombia, Motta was interested in how U.S. interventionism was perceived across the continent, as well as in understanding the role of these events on his own perceptions of what it means to be a citizen, an acting subject in society. Basing his itinerary on cities that had been influenced by specific historical circumstances (sites of failed revolutions, military coups, and economic reforms), Motta, together with local assistants, sought out a range of individuals to speak with in each city. His dialogues with students, teachers, activists, laborers, etc., resulted in a spectrum of opinion which fluctuated according to local situations and forms of government. In Santiago, many responses touched on the overthrow of former Chilean president Salvador Allende in a military coup; in Buenos Aires, the recent economic impositions of the International Monetary Fund were a source of discussion. The dialogues explore the political and social landscapes of each city and the interview subjects' lives, unearthing personal narratives and revealing a breadth of collective memory. Each dialogue takes place outdoors, in parks, plazas, or sidewalks, transforming public space into a space of action through public disclosure.

Formally, the project exists in three parts: a sculptural installation that was initially developed for an exhibition at the Institute of Contemporary Art (ICA) in Philadelphia in early 2008, which since then has traveled internationally;[8] a publication in which artists Ashley Hunt, Naeem Mohaiemen, and Oliver Ressler, and political theorists Tatiana Flores, Maria Mercedes Gomez, and Juan Gabriel Tokatlián present essays in response to the question "What is democracy to you?"; and an online archive, la-buena-vida.info, which holds all video interviews and texts associated with the project. The three parts present different ways of experiencing the work: through a physical simulacrum of participating in dialogue in the installation, through sustained critical discourse of specific social issues as they relate to democratic ideas in the publication, and through a personalized process of navigating the vast amount of research material that the project generated (over 400 interviews, 40 hours of video, and a dozen texts) in the online archive.

In la-buena-vida.info, users initially encounter thumbnail images of all videos in a large grid and can select and watch them at random. The website, however, also offers a more considered way of approaching the material: users can identify videos through a set of broad categorizations based on gender, nationality, age, or profession, or they can review videos with particular subject tags such as "capitalism," "democracy," and "religion." Tagging is a common, vernacular practice in the creation and navigation of blogs and websites—tagging tools are now included in most generic blogging software. For Motta, however, the tagging process is an alternate, more democratic way of thinking through the process of video editing. Although it is also based on Motta's predetermined categories, tagging enables a viewing process partially constructed by the website's users.

The tags themselves—as well as the structure of the interviews and their means of identifying their subjects—take their structure and methodology from sociological or anthropological research. That structure has art historical precedents—August Sander's efforts to compile a photographic archive of German social "types" based on their vocation is the most canonical example.[9] While the process of navigating through the archive is not a process of research in a statistically quantifiable way, it nevertheless is an invaluable repository of oral history. In an evocation of Arendt's space of public disclosure and her theorization of the *vita activa*, or "active life," which became increasingly important to Motta over the course of the project, la-buena-vida.info offers up interaction with hundreds of individuals speaking openly about the ways in which politics intimately affects their lives.

The Good Life/La Buena Vida takes a seemingly straightforward documentary approach to the interview process, though it makes overt references to the democratic spaces of antiquity. Neither strategy, however, is presented as unproblematic. The formal structure of the videos underscores the centrality of the speaking subject. Unlike some documentary work which focuses on the performative interaction between the interviewer or filmmaker and their subjects (along the lines of Michael Moore), Motta keeps the camera on the people he is speaking with, and his presence limited to his questions being read and heard. This is not an effort to efface the role of the interviewer or artist; rather, it functions as an acknowledgment of the critical importance of speech as action, and as a way for the dialogues to symbolically function as open and public.

As a whole, la-buena-vida.info makes a statement about the contested nature of the term "democracy" itself; a complex multiplicity of ideas over which people in political theory, social movements, and cultural practices hold their own sets of debates. Among the plethora of opinions on the concepts of democracy presented in *The Good Life/La Buena Vida*, one in particular recurs: the view that democracy necessarily means more than a single, occasional vote on a predetermined issue, or a vote for one of a set of pre-selected political candidates. A Caracas historian Motta interviews points out that the recent efforts in Venezuela to integrate ordinary citizens in decision-making processes through community councils qualify that country as a democracy. An 80-year-old Buenos Aires woman declares that, despite her age, she has yet to have "lived in an ample democracy," while a lawyer in Guatemala City disavows the term completely for any country limited to electoral processes. In listening to their statements, it becomes apparent to the viewer that Arendt's well-known arguments against representative democracy have a popular echo. For Arendt, the relinquishing of day-to-day deliberation and action to a small number of holders of power destroys the "space of appearance" in which citizenship can be fully realized.[10] The recuperation of this space clearly occupies a wider political imaginary for Motta and his subjects.

Technical Description by Freckles Studio (Antonio Serna and Peggy Tan)[11]

When we were asked to create a web component for *The Good Life/La Buena Vida*, artist Carlos Motta had just completed and digitized the 400 video interviews that spanned over three years in time and geographically covered a good half of the American continent. Our challenge was to translate Motta's video project into an Internet archive (la-buena-vida.info) that would conceptually carry the essence of his project.

The Visual Quilt

The first question we asked ourselves was how we could present all these videos to the public in a way that visually represents the scope of the project. The solution was to create a large quilt of video thumbnails (12 thumbnails wide and 30 deep). The idea for the quilt was inspired by the *The Good Life/La Buena Vida*'s installation component initially presented at the ICA in Philadelphia. At that venue Motta presented a gallery with photos from the project along the walls that surrounded the central video-viewing stands. The website functions in a similar way by immediately presenting the viewer with images from all the videos that emphasize the magnitude of the project.

Navigating Further

The second part of the challenge was to figure out the best way to navigate through this archive and find information of interest. Instead of a traditional navigation system we decided to create a visual search experience that would allow the viewers direct interaction with the video quilt. Viewers would have the option to filter through these videos by selecting specific questions, region, age, gender, occupation, and themes in any combination. This filtering process would reduce the number of thumbnails without repositioning the results, creating a visual chart of the selections in proportion to the sampling interviews. Conversely, keeping the empty frames reminds the user of her editing decisions.

In addition to creating this filtering system, we added time stamps for each question in the videos so that the viewer could choose to jump to a specific answer to a question posed by the artist.

A Note from Carlos Motta about the Artist–Designer–Programmer Relationship

I met with a series of web designers and programmers to learn about the technical and formal possibilities of such form. Among these, Freckles Studio and Dave Della Costa proposed an interesting way of designing the interface and back-end programming. With an Art in General New Commissions Program Grant, I was able to hire them and we worked together for a year in designing the piece. The relationship was very smooth. As a "client" I was able to closely work with them and make sure that my concept was translated visually. Their suggestions and thorough technical knowledge were precise and made my ideas physically and technically feasible.

Afterthoughts on the Internet Archive (www.la-buena-vida.info) of *The Good Life/La Buena Vida* by Carlos Motta

A year into the filming and after realizing that I was actually building a kind of archive, the Internet archive became a useful tool that informed the way I continued to interview. I allowed for longer conversations to take place and started to include an even wider range of subjects; this expansive approach resulted in being increasingly more democratic. Had I opted to go ahead with the original idea of making a film I would have had to "edit" in the back of my mind; this approach, on the other hand, allowed me to be less scripted. Now that the work is finished I am pleased with these decisions. As time has passed, the interviews are frozen in time. The archive represents a particular time period

Figure 13.2 *The Good Life/La Buena Vida* Internet archive, Carlos Motta.

(2005–2008) and is contingent on a set of local socio-political situations to which the interviewees were responding. As such, the archive is now a document. The relationship between the initial urgency of the interviews and their current status as documents is interesting and common to journalism or sociology. Time's effect is inescapable. I think, however, that the archive itself is timeless. It is an *artwork*, whose meaning isn't exclusively dependent on its content but also on its (technical and artistic) form.

Notes

1. This interview was originally published by Art in General (2008) in the catalogue *Carlos Motta: The Good Life*.
2. This essay was originally published by the Institute of Contemporary Art, Philadelphia (2008), in the catalogue *Carlos Motta: The Good Life*, and edited by the author for this publication.
3. The verb is *politheuesthai*. Richard Mulgran, "Aristotle and the Value of Political Participation," *Political Theory*, May 1990: 196.
4. Ibid.: 206.
5. Hannah Arendt, *The Human Condition*, Chicago: University of Chicago Press, 1958.
6. Ibid.: 156.
7. Ibid.: 175.
8. The installation has been presented internationally at the ICA, Philadelphia; Hebbel am Ufer (HAU), Berlin; Fundación Alzate Avendaño, Bogotá; CEPA Gallery, Buffalo; Estudio Abierto '06, Buenos Aires; EACC, Castelló; Fabbrica Europa '08, Florence; LABoral, Gijón; X Biennale de Lyon; Creative Time and Smack Mellon, New York; and San Francisco Art Institute, San Francisco.
9. August Sander, *Citizens of the 20th century: Portrait Photographs 1892–1952*, Boston: MIT Press, 1986.

10. Eric Wainwright, "The Vita Activa of Hannah Arendt," *Politikon: South African Journal of Political Studies*, December 1989: 27.

11. Website design: Freckles Studio (Antonio Serna and Peggy Tan); programming: Dave Della Costa; technologies: PHP, Symfony (PHP Framework), jQuery, jQuery UI, AJAX, MySQL, FLASH.

Bibliography

Arendt, Hannah. *The Human Condition*. Chicago: University of Chicago Press, 1958.

Bourdieu, Pierre. "Lecture on the Lecture." *In Other Words*. Stanford: Stanford University Press, 1990.

Freire, Paulo. *Pedagogy of the Oppressed*. New York, London: Continuum, 2006.

Mouffe, Chantal. *On the Political*. New York: Routledge, 2005.

Mouffe, Chantal. "Deliberative Democracy or Agonistic Pluralism?" *Social Research*. Fall 1999.

Mulgran, Richard. "Aristotle and the Value of Political Participation." *Political Theory*. May 1990.

Sander, August. *Citizens of the 20th Century: Portrait Photographs 1892–1952*. Boston: MIT Press, 1986.

Sarmiento, Domingo Faustino. "Civilization or Barbarism." *The Argentina Reader*. Durham, NC: Duke University Press, 2002.

Wainwright, Eric. "The Vita Activa of Hannah Arendt." *Politikon: South African Journal of Political Studies*. December 1989.

Links

www.actuporalhistory.org

www.democracynow.org

Giuseppe Campuzano, *Museo Travesti*: http://hemi.nyu.edu/hemi/en/campuzano-presentation.

Andrea Geyer, Evidence (Criminal Case 40/61): www.andreageyer.info/projects/criminal_case/CriminalPages/criminalevidence.html.

Sharon Hayes, *After Before*: www.shaze.info.

Ashley Hunt, Corrections Project: http://correctionsproject.com.

Naeem Mohaiemen, Live True Life or Die Trying: www.shobak.org/projects/truelife.shtml.

Oliver Ressler, *What is Democracy?*: www.ressler.at/what_is_democracy.

SOA Watch: www.soaw.org.

Fernando "Pino" Solanas, *The Hour of the Furnaces*: www.youtube.com/watch?v=RLvLjnMvpME.

14 OILIGARCHY

Molleindustria/Paolo Pedercini

Key Words: Globalization, Market Demand, Micro-narratives, Online Gaming, Peak Oil, Politics, Role Play

Project Summary

Oiligarchy is an online game that articulates a critique of the oil industry and of our fossil-fuel-centered economy. Using simple graphics and black humor the game tries to address issues ranging from the depletion of resources to the unethical behavior of transnational corporations.

Project Developer Background

Molleindustria (a fictitious Italian word for "soft industry" or "soft factory") is a website I launched at the end of 2003. My goal was to blend the media-activist tradition with the emerging field of game studies, exploring the expressive and persuasive potential of the medium. I started developing small online games tackling various social issues such as food politics (*The McDonald's Videogame*, 2006), degradation of labor conditions (*Tuboflex*, 2003), gender issues (*Queer Power*, 2004), or the struggle between free culture and copyright (*Free Culture Game*, 2008). The games are often parodying or turning upside-down the conventions of mainstream videogames; in my mind they represent a homeopathic cure to the idiocy of most commercial titles.

The online form, combined with lightweight formatting of the games is a central ingredient for this project. If provocative, innovative, or poignant enough, online

Figure 14.1 The start-up screen for the game *Oiligarchy*, Paolo Pedercini/molleindustria.

content can be virally diffused all over the net by email, blogs, instant messaging, and by the millions of social media users. In this way I can reach a wide audience without relying on commercial channels (often affected by censorship) or traditional art venues (often attended by closed, self-referential circles).

Along with buzz generated by word-of-mouth messaging, Molleindustria received wide media coverage due to the novelty of the project and to some controversies in regards to certain games. For instance, *Operation: Pedopriest* (2007), a dark commentary on Vatican cover-ups of child abuse within the clergy, and *Faith Fighter* (2008), a cheeky satire of religious intolerance, both triggered mainstream media. Even if the content itself was arguably mild, religious groups and a part of the public opinion were not ready to "play" with these topics in video games.

Introduction to *Oiligarchy*

I believe there is a huge potential for learning and communicating alternative ideologies in simulation games representing real-world situations such as *SimCity* because they use a systemic approach to problem solving that forces the player to consider every element as connected parts of a whole situation. Zooming out, observing the constant feedback from the model, thinking globally and intervening locally ... these are the kind of skills we need in an increasingly interconnected world.

It has been argued that simulation games can describe dynamic interrelations and processes better than any other media because they are procedural and dynamic in their very nature.[1] Mastering a simulation game means discovering an intricate web of cause-and-effect relations that can hardly be described by texts, videos, and linear media. This ability to represent complex systems in an intuitive way inspired *The McDonald's Videogame*, a business game that represents the globally distributed production process behind a fast food restaurant. The player, in the shoes of the McDonald's CEO, manages processes from the pasture to marketing, often facing ethically challenging dilemmas, such as choosing to maximize profit at the expense of food safety or environmental sustainability.

Oiligarchy is a further development of this concept. The critique is directed at the so-called "vertically integrated" oil companies like Exxon-Mobil, Shell, or BP. This time I decided not to allude to a specific brand because, in my mind, they are essentially equivalent since mergers in the past decades have resulted in oil corporations frequently changing their names.

Oiligarchy can be considered an extended business game since the player makes decisions and performs actions that are not always in the domain of business. This mixed game-play is meant to highlight the intricate relations between war, politics, and energy corporations. The purely economical activities basically consist of finding new oil fields, building extraction plants, and managing resources. The non-economical activities range from lobbying to increasing the oil demand (for example, by supporting the construction of highways) to obtaining military support to expanding extraction activities in hostile foreign countries.

Technical Description

Oiligarchy was implemented on the Flash platform. Flash was originally conceived as a tool for creating vector-based animations for the web. In the late 1990s, limited band-width prevented Internet users from sharing actual videos and the World Wide Web

was basically composed of static documents containing only text and images. With its lightweight format, Flash made embedding animated content in HTML pages possible, often allowing some degree of interaction. In the years that followed, the simple animation tool evolved into a more complex environment, including an actual programming language and support for video (which enabled the emergence of video-sharing services like YouTube).

Although web development and online video is moving toward open standards (Flash is a proprietary format owned by the Adobe corporation), Flash still remains a valuable game-development tool, especially for beginners and independent game developers who want to make cross-platform products playable on various browsers.

The Design

Despite feedback that many players have found *Oiligarchy* entertaining or even addictive, the fun factor has never been my primary concern in the design of the game. In

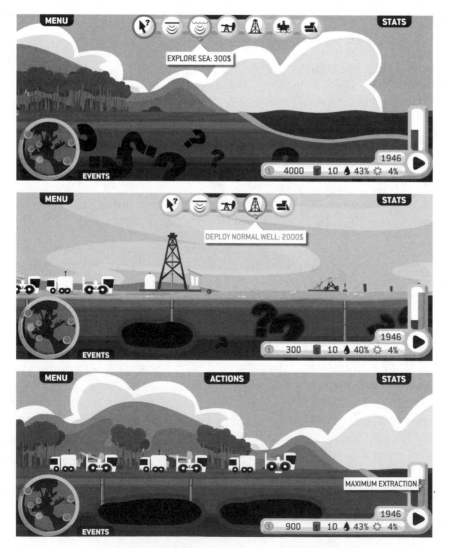

Figure 14.2, 14.3, 14.4 *Oiligarchy* game interface, Paolo Pedercini/molleindustria.

brainstorming a game, I usually start from the player's point of view, which inevitably informs how the model is implemented; then I try to isolate the main forces, variables, and conflicts that can make the playing experience compelling and meaningful.

1. Roleplay

In *Oiligarchy* the players are the "bad guys," the selfish and ruthless executives with a considerable amount of power and agency. Power structures are more clearly understood when players are introduced to them from a privileged position. The player tends to perform actions with both positive outcomes (profits, advancement in the game) and negative "externalities" such as social or environmental costs, and is thus forced to deal with responsibilities in a system that does not really punish unethical choices.

2. Peak Oil

Oiligarchy's main mechanism is loosely based on the Hubbert peak theory, which can be summarized as follows: for any given geographical area, the rate of petroleum production tends to follow a bell-shaped curve. Early in the curve, the production rate increases due to the discovery rate and the addition of infrastructure. Late in the curve, the production declines due to resource depletion. Peak-oil activists argue that if global oil consumption is not mitigated before the peak, the availability of conventional oil will drop and prices will rise causing catastrophic chain reactions in the whole economy.[2]

Oiligarchy popularizes peak oil as a key issue to understanding the present and future crisis and to contribute to the reframing of the vague and deceptive argument of "dependency on foreign oil" that currently dominates political discourse in the United States.

The bell-shaped curve of production is the most counter-intuitive part of the peak-oil theory. Unlike a car that suddenly stops working when the tank is empty, the global crude extraction rate reaches the peak when half of the oil is still underground. Then it declines gradually, but at progressively increasing speed like a rollercoaster slope. This factor deeply affects a typical game session that generally has an expanding phase followed by a contracting phase marked by the struggle to keep up with the demand and the convulsions of the economic system.

3. Oil Addiction

The player's primary objective is to match the market demand for crude oil. The demand is a function of two variables: the gross domestic product (representing the size of the economy) and an umbrella value called "oil addiction." The "oil addiction" variable represents the dependency of the entire economy on fossil fuels. This takes into account a wide range of factors such as agriculture (largely dependent on fossil fuels), public transportation, car-centered urban planning, and so on.

If, at the beginning of the player's turn (every turn is a year in the game world), the oil production is lower than the demand, the system has to face a supply crisis. During a supply crisis the game world reacts in different ways: the government might try to reduce the oil addiction by introducing taxes on gasoline, energy efficiency measures, subsidies to public transportation, and so on. If the government fails to address the crisis, grassroots movements can take autonomous initiatives and lifestyle choices such as encouraging biking and carpooling, or reducing consumption in general. If the

grassroots initiatives are insufficient, the oil crisis becomes a general crisis, possibly impacting the price of food and consumer goods.

The way the government responds to the crisis is directly related to the player's action as she can participate in politics with donations.

4. Politics

Affecting politics is the key to being a successful manager in *Oiligarchy*. The player is encouraged to keep the government "oiled" by playing the "democracy" mini-game that occurs every ten years (a four-year term would have been too disruptive to the main game flow). The democracy mini-game refers to a type of election race, but it does not try to simulate the complexities of the electoral process.

The depiction of the two parties as interchangeable, bulimic, money-burning machines is a satire of the over-the-top spectacle of the U.S. presidential campaign. As a part of the satire, the two parties have no ideological features. In other words, the Republican Party is not intrinsically more inclined to help the oil industry than the Democratic Party. I took this design choice after looking at some data regarding electoral funding by industry. Surprisingly, the oil and gas industries are not particularly partisan industries as they tend to be supported by both parties.[3]

As a result of this design choice, the experienced player would simply choose to "bet" on the party that seems most likely to win in order to obtain the most influence, a behavior that happens in the real world too, as demonstrated by the economist Steven Levitt.[4]

5. Globalization

Oil companies were among the first transnational corporations. The exponentially increasing demand, combined with the gradual depletion of domestic resources starting in the United States from the mid-1970s, forced these businesses to expand their activities all around the world. One of the recurring problems with transnational corporations is their irresponsible behavior toward the territories and communities from which they profit.

Oiligarchy summarizes the problematic aspects of the international oil extraction in different game "levels" inspired by real-world scenarios. Each scenario has its peculiar dynamics and conflicts. The Nigerian scenario, for instance, mirrors the decade-long conflict between Royal Dutch Shell and the tribes of the Niger Delta: drilling destroys the livelihoods of local tribes that will likely stage protests around the oilrigs.[5] In order to continue to profit, the player can corrupt the local government for a crackdown on demonstrators. But the violent state repression can, in turn, escalate indigenous violence and cause the proliferation of guerrilla groups (sadly, this is what happened in Nigeria).

This is just an example of the many micro-narratives disseminated through the game that provide a rich experience for the player and connect what might appear to be disconnected narratives in a globalized economy.

6. Game Over

Oiligarchy has different possible endings:

If the player is a bad manager, for instance, if she becomes bankrupt or doesn't earn enough profits, the company shareholders will fire her.

If the player is a "good" manager and an aggressive *oiligarch* she will work hard to prevent any changes that reduce the oil addiction. This might result in a failed transition to a post-carbon society. The "Mutually Assured Destruction" ending represents a scenario in which the world's superpowers annihilate themselves in a nuclear war for the control of the remaining resources.

The "Retirement" scenario usually happens when a player loosens her grip on politics after the peak oil. Basically it's the happy ending, representing a successful transition to a sustainable economy based on renewable energies. Not surprisingly, it happens only if the player is a decent manager but a bad *oiligarch*.

7. The Message

Sometimes the idea that games can relay some kind of message encounters resistance. Some may ask, aren't games just about action and reaction? Isn't the player free to interact with the game-world in her own personal way allowing any possible interpretation? Are in-game behaviors affecting real-world behaviors, as people against violent games always argue?

These are all valid questions; the interpretation of non-linear texts and their effect on players' minds or behaviors are subjects of intense debate in the field of game studies.

Due to my artistic background, I tend to look at games as representational forms of (mass) media providing depictions of a real-world system. While linear texts such as books or movies tend to use narrative structures, the meaning of games emerges from the relationship between the set of rules constituting the game-play and the perceivable elements such as graphics, texts, or sounds that are governed by these rules. Storytellers generally try to captivate the reader/viewer via identification while game designers provide challenges, choices, and roles that inform the player's experience. Game designers' choices are precisely what shape the "message" of the game, including what you can and cannot do in the game world, the system of punishment and rewards, the player's role and goals, and so on. These are all meaningful decisions, even when they are not made with the intent to *communicate* a social or political message. The inability to speak to the enemy in a first-person shooter game, the removal of civilians in a war game, the absence of racial tensions in an urban simulator are design choices that cannot be considered ideologically neutral. The wish-fulfillment approach taken by most game designers (an enemy without human traits, a war without civilians, a city without racial segregation) shouldn't prevent designers from imagining a different kind of game—a game that explores the problems, contradictions, and moral dilemmas of our world.

Oiligarchy is basically a proof-of-concept for this idea. The game's message does not correspond to its stated goal "be a heartless C.E.O. and make a lot of money." Instead, it implements a series of relationships that collectively tries to describe the challenges and troubles of an oil-dependent economy, how this economy emerged in the United States post-World War II, and how it can be changed. For instance, the algorithm that triggers the "Retirement" ending represents my personal view on how Western countries could switch to a sustainable future. The dependency on fossil fuels in the game can be minimized with a combination of top-down, government-led policies (ranging from supporting renewable energies to nationwide infrastructural rearrangement), a proliferation of bottom-up initiatives promoting alternative lifestyles (such as the rejection of consumerism, promotion of bike transportation, and organic, locally grown farming), and a substantial downsizing of the economy as a whole.

Historical Perspectives

A recurring pattern with regard to new communication technologies is observed in the evolution of cinema, video, comics, pop music, and other forms of expression during the twentieth century. A new medium is initially perceived as a "mindless" source of entertainment, a curiosity or a mere money-maker. Then, gradually, the medium "matures": it develops its own language, it grows in formal complexity, it addresses more profound issues as more cultural producers participate in its development by breaking the rules common to older media and charting new territories. There are many signs that the video-game medium is currently in a phase of qualitative expansion. A movement of independent game developers is experimenting with innovative forms of game-plays challenging the well-established genre and conventions; more artists are embracing games as a form of expression; activists and institutions are using games to convey messages and stimulate discussion around certain issues.

This "maturation" is a combined effect of the democratization of the means of production and the proliferation of alternative channels of distribution. Making games is becoming increasingly easier thanks to design tools that do not require programming skills, open-source engines, and online communities for knowledge sharing. The distribution of games is gradually moving from physical supports to digital delivery over the net. As a result, there are more opportunities for producers operating outside the proper game industry.

Conclusions and Outcomes

One of the most intriguing aspects of making art specifically for the Internet is the overwhelming amount of feedback that you can potentially receive. Online games are primarily played from game portals (the equivalent of video-sharing sites like YouTube) with very active communities that are often linked and discussed from blogs, forums, and social networks. Putting your work on the net, especially when you choose a popular form like video games, might expose you to a broad spectrum of users from different nations, with different ages and backgrounds. For artists familiar with the controlled, polite, and sophisticated art world, receiving hate-mail and silly one-line comments from bored teenagers can be a little unsettling.

Oiligarchy was successful in the online gaming communities: statistics show about two million plays in the first month after the launch. Since the game is easy and free to download, it has been republished on dozens of websites so tracking the overall number of contacts is practically impossible. I estimate more than six million plays but it is impossible to say how many people actually played the game. There are at least 30 fan-made videos on the Internet providing reviews, tips, and walkthroughs, and there are hundreds of user-generated reviews in news aggregators and portals.

It is important to mention that *Oiligarchy* is a fairly long-session game for the online format; a game can take from 30 minutes to a couple of hours to play. This is the degree of complexity I needed for mounting my arguments, at the expense of losing players. The relatively time-consuming format alienated many non-habitual players. The response from the art world and from the mainstream press was lukewarm compared to earlier, shorter works that I published. Ironically, I learned that journalists and people from art circles (not too unlike the general public) are more receptive to quick and easy-to-understand games.

Some major newspapers like the *Guardian* (United Kingdom) and *la Stampa* (Italy) positively reviewed the game but the most interesting reactions came from the

specialized blogosphere: environmentalists (Mother Nature Network), game developers (Gamasutra), and oil specialists (Oil Drum) appreciated the accuracy and the complexity of the game more than anyone else.

Overall, it is a remarkable result for a product that took a few months to develop, absolutely no budget, and no self-promotional efforts.

Notes

1. Ian Bogost, *Persuasive Games: The Expressive Power of Videogames*, Cambridge, MA: MIT Press, 2007: 28–40.
2. See M. King Hubbert, "Exponential Growth as a Transient Phenomenon in Human History," in *Valuing the Earth: Economics, Ecology Ethics*, 2nd edn., ed. Herman E. Daly and Kenneth N. Townsend, Cambridge, MA: MIT Press, 1993: 113–126. See www.hubbertpeak.com/hubbert/1956/1956.pdf. Also see Richard Heinberg, *The Party's Over: Oil, War and the Fate of Industrial Societies*, British Columbia: New Society Publishers, 2003: 185–220.
3. Center for Responsive Politics, "Most Heavily Partisan Industries," *OpenSecrets.org*, 2009. Online: www.opensecrets.org/bigpicture/partisans.php?cycle=1994 (accessed November 20, 2009).
4. Steven D. Levitt, "Using Repeat Challengers to Estimate the Effect of Campaign Spending on Election Outcomes in the U.S. House," *Journal of Political Economy*, 102, 4, 1994: 777–798.
5. Human Rights Watch, "The Ogoni Crisis: A Case-Study of Military Repression in Southeastern Nigeria," UN Refugee Agency, July 1, 1995.

Bibliography

Bogost, Ian. *Persuasive Games: The Expressive Power of Videogames*. Cambridge, MA: MIT Press, 2007.
Heinberg, Richard. *The Party's Over: Oil, War and the Fate of Industrial Societies*. British Columbia: New Society Publishers, 2005.
Hubbert, M. King. "Nuclear Energy and the Fossil Fuels." Spring Meeting of the Southern District Division of Production, American Petroleum Institute, San Antonio, TX, March 7–9, 1956. Online: www.hubbertpeak.com/hubbert/1956/1956.pdf.
Hubbert, M. King. "Exponential Growth as a Transient Phenomenon in Human History." In *Valuing the Earth: Economics, Ecology Ethics*, 2nd edn. Ed. Herman E. Daly and Kenneth N. Townsend. Cambridge, MA: MIT Press, 1993: 113–126.
Human Rights Watch, "The Ogoni Crisis: A Case-Study of Military Repression in Southeastern Nigeria." UN Refugee Agency, July 1, 1995.
Levitt, Steven D. "Using Repeat Challengers to Estimate the Effect of Campaign Spending on Election Outcomes in the U.S. House." *Journal of Political Economy*, 102, 4, 1994: 777–798.

PART VIII
OPEN SOURCE

OPEN SOURCE CREATIVITY

David M. Berry

In many ways, by declaring a work "open source," one is communicating an intention to share. This sharing is a practice within open-source culture that represents something both very new and something very old. It signals that the receiver can take what is given and make it their own, transform it, and redistribute it to others.[1] This social dimension, a material ontology of sharing practices, is crucial to understanding what open source can offer for creative practices. Although open source, or copyleft, has predominantly been seen in the contexts of technical projects, GNU/Linux and Wikipedia being the exemplars, there is no reason why it should be limited to such projects and, indeed, we are starting to see new ways in which open-source methods are used in wider creative communities.[2] This includes the notion of geographic communities who might use such licenses to protect cultural heritage or language rights, for example Welsh, Japanese, or Icelandic cultural works, especially works which are oral and vernacular and which are shared and reused as part of cultural practice.

Traditionally, open source has been assembled around the notion of copyright licenses, essentially agreements between the creator and the user to allow more than just consumption of a product or object, in effect a permissive copyright regime. Today, there is a wide range of different licenses to choose from, from Creative Commons, BSD (Berkeley Software Distribution), the Free Software Foundation (GNU General Public License), or a number of other organizations. This is a story that has been told many times.[3] In essence, open-source licenses can be understood as a certain kind of "persuasive" or "rhetorical" discourse that seeks to stabilize a particular kind of social order, whether that be shared code within a particular framework, enabling certain kinds of practice, such as programming, or a networked form of modular organization. Indeed, the following two chapters, by Michael Mandiberg and Steve Lambert, both describe how using open source or copyleft licenses, in this case the GNU General Public License, is integral to their work.

Here, though, I want to look at licenses that expressly set out to challenge the very foundation of the copyright license itself. These alternative licenses do this by either declaiming the property rights that are by definition a ground for the copyleft license, or else are counter-intuitively permissive or creative, and offer potentialities for new forms of social life. For example, some of the "licenses," for they are not licenses at all, rather more like manifestos, value the underlying sociality and possibility for meaningful social creativity, than traditional open-source licenses that seek to simultaneously give and withhold.[4] Further, these licenses suggest that creativity should not be limited to the palette of licenses that currently exists, but rather that creative communities can develop their own manifestos for sharing, and then return these back into the wider community too.[5] This includes embedding norms and values into the processes of creating new works, such as participation, sharing, mutual aid, aesthetic theories, and so on.

To understand these, it is helpful to think about another way of understanding the social ontologies of open source, through Heidegger's notion of the gathering (*Ding*). Heidegger tries to explain how an object is a special case, a subset of a more connected, richer type of entity that he christened a "thing." A thing, he explained, is always within a referential context, deeply imbued with meaning and able to exert a pull toward itself, which he described as a "thinging." Heidegger argues, for example, that with many new technologies that claim to abolish distance, we are left in the paradoxical situation that we are no longer "near to things."[6] This is a "uniform distanceless" that places objects, and this includes other humans, apart from one another. In contrast, the thing is something which is self-supporting, "stands on its own" or "standing forth"; the thing, Heidegger would say, "does the containing."[7] Thus the thing is active in taking and holding, and hence in giving a gift, in other words, the thing "presences" the thing. Or, put simply, "the thing things":

> The Old High German word *thing* [*Ding*] means a gathering, and specifically a gathering to deliberate on a matter under discussion, a contested matter ... [it] become[s] the name for an affair or matter of pertinence ... [and] denotes anything that in any way bears upon men [or women], concerns them, and that accordingly is a matter for discourse.[8]

For the Romans, the thing that was a matter of discourse was a *res*, and for the Greeks to speak about something they used the word *eiro*. Indeed, *Res publica* meant not the state, as we think of a republic today, but rather "that which, known to everyone, concerns everybody and is therefore deliberated in public."[9] Crucially, it is the notion of gathering that is important here, as a bringing together, binding together, which Heidegger argues creates a world. This world brings nearness to what we are doing and the things that make it up, these are "modest and compliant" in number, not measureless objects of equal value.[10] So by thinking about licenses, open source or otherwise, as "things that thing," that is, things that gather together humans and objects into a nearness that creates a relationship mediated by the gift, there is the potentiality for creativity and sharing.

In order to think about licenses as gathering, first we will look at the "Copyfarleft" license produced by Dmytri Kleiner which argues "for copyleft to have any revolutionary potential it must be Copyfarleft. It must insist upon workers ownership of the means of production."[11] This license declares that different classes in society should benefit from the license differently depending on their class location, so, for example, "a worker-owned printing cooperative could be free to reproduce, distribute, and modify the common stock as they like," whereas "a privately owned publishing company would be prevented from having free access."[12] Here, we see that the license attempts to create a gathering of a particular kind, that is, to encourage class consciousness and an immanent critique of capitalist society. This, of course, would also have an educative function, both in terms of the social ordering created through the license, but also through the "source code" of the society being published and open for discussion and debate. This license, then, clearly demonstrates how social ordering can be introduced, even if only on the plane of the imaginary, giving a potentiality for a different way of organizing.

In contrast, the second license we will look at, the *Res communes* license, "is designed to reject a state-centered legal construct of a commons (or commons without commonalty) in order to concentrate on creating a commons which is shared between us in

collective practices (a commons with commonalty)."[13] Here, the license is gesturing toward a social ordering called the "commune" or the "commonalty" referring to the "global multitude, the people of the whole world."[14] This is a gathering which creates a space of non-owned, shared things that are available to all. This license explicitly declares itself outside "all legal jurisdictions" and argues that it "takes its force and action from the constituent radical democratic practices of the global multitude against the logic of capital."[15]

Lastly, the *Res divini juris* license is "intended to raise awareness of the condition of possibility for sacred spaces, and equally highlights the importance of contestation and debate where matters of public importance (i.e. the common things) are discussed as a political project."[16] This license tries to create a gathering by reintroducing a notion of the sacred as a space where particular kinds of aesthetic works might be separated from global capitalism. Drawing from a Heideggerian critique of the instrumentalizing tendencies of technology and capitalism, the license draws attention to the problems inherent in "treating everything as resources [that] makes possible endless disaggregation, redistribution, and re-aggregation for its own sake." Again, the license draws attention to the limits of the state, which are explicitly challenged by "operat[ing] under a permanent state of exception ... [as] a result of radical democratic practices beyond the state."[17] The license further argues:

> By using this license you are agreeing to allow your work to be shared as a step on the path of revealing. Within the realm of the gods, the work will contribute to a shared new world of collective practices and networks of singularities operating within a non-instrumental and communal life.[18]

This notion of the sacred might bring together a revived notion of how religion and licenses might also be connected as a sacred commonalty. One thinks of the possibilities for a Calvinist license granting special sharing to the Elect, or Catholic licenses that seek to share within the aegis of the Catholic Church. We might also hope to see inspiration for new forms of licenses through the example of the Malaysian batik designers who refused to put their names to their creations so they could be registered for copyright: "[they] believe that each time they create something, it is not they who worked, but it is God who worked through their human body and soul, Gunawan said. 'Being grateful [to God] is sufficient for them'."[19]

These licenses draw attention to the possibility of alternative ways of social ordering, that is, different social and material ontologies for organizing creative endeavors. The void or space that lies at the center of creative practice is what Heidegger calls gathering, and is clearly crucial and inspirational for rethinking the way in which creative practice might be (re)formed. It also allows the possibility of setting out a "constitution" for creativity through the form of an open-source license, where experimentation with the limits and constraints of each license, as a world, can provide artists and creative practitioners with a social means for innovative artistic expression. Hence, each license might create sacred spaces that engender creativity and flourishing by gathering together humans and things into new movements, collectives, and artistic avant-gardes.

Notes

1. Lewis Hyde, *The Gift*, London: Canongate, 2006.
2. Lawrence Lessig, *Free Culture*, London: Penguin, 2005.

3. See, for instance, David M. Berry, *Copy, Rip, Burn: The Politics of Copyleft and Open Source*, London: Pluto, 2008; and Steven Weber, *The Success of Open Source*, Boston: Harvard University Press, 2005.
4. Here I am referring to the fact that the majority of the open-source licenses hold back some element of rights granted by copyright, whether that be the right to distribute under certain conditions, the right to modify, or some other element guaranteed by law. Instead, these nomadic licenses gesture toward social sharing that is not predicated on a prior ownership, in many ways presenting a utopian practice.
5. One way of linking these multiple license projects is to either dual license, allowing users to select how they wish to reuse, but also to consider a dedication to the public domain itself, avoiding the complicating problems of copyright altogether.
6. David M. Berry, *The Philosophy of Software: Code and Mediation in the Digital Age*, London: Palgrave, 2011.
7. Martin Heidegger, *Poetry, Language, Thought*, New York: Perennial Classics, 2001: 169.
8. Ibid.: 172.
9. Ibid.
10. Ibid.
11. Dmytri Kleiner, "Copyfarleft." Online: http://p2pfoundation.net/Copyfarleft (accessed January 6, 2010).
12. Ibid.
13. David M. Berry and Giles Moss, "The Politics of the Libre Commons," *First Monday*, 11, 9, September 2006.
14. Ibid.
15. Ibid.
16. Ibid.
17. Ibid.
18. Ibid.
19. Candra Malik, "Religion Gets in the Way of Batik Copyrighting," *Jakarta Globe*. Online: http://thejakartaglobe.com/national/religion-gets-in-the-way-of-batik-copyrighting/317672 (last modified July 12, 2009).

Bibliography

Berry, David M. and Giles Moss. "The Politics of the Libre Commons." *First Monday*, 11, 9, September 2006.
Berry, David M. and Giles Moss. *Copy, Rip, Burn: The Politics of Copyleft and Open Source*. London: Pluto, 2008.
Berry, David M. and Giles Moss. *The Philosophy of Software: Code and Mediation in the Digital Age*. London: Palgrave, 2011.
Heidegger, Martin. *Poetry, Language, Thought*. New York: Perennial Classics, 2001.
Hyde, Lewis. *The Gift: How the Creative Spirit Transforms the World*. London: Canongate, 2006.
Kleiner, Dmytri. "Copyfarleft." Online: http://p2pfoundation.net/Copyfarleft (accessed January 6, 2010).
Lessig, Lawrence. *Free Culture: The Nature and Future of Creativity*. London: Penguin, 2005.
Malik, Candra. "Religion Gets in the Way of Batik Copyrighting." *Jakarta Globe*. Online: http://thejakartaglobe.com/national/religion-gets-in-the-way-of-batik-copyrighting/317672 (last modified July 12, 2009).
Weber, Steven. *The Success of Open Source*. Boston: Harvard University Press, 2005.

15 THE REAL COSTS*

Michael Mandiberg

Key Words: Activism, "Bus Factor," Firefox, Greasemonkey, Green-tech, Hacktivism, Plug-in, Userscript

Project Summary

The Real Costs is a Firefox web browser plug-in that inserts CO_2 emissions data into airplane travel e-commerce websites such as Orbitz.com, United.com, Delta.com, and so on. Like the nutritional information labeling included on food packaging, this plug-in provides emissions information that is otherwise excluded from travel websites.

Artist Background

The Real Costs builds on many of my prior investigations into intersections between conceptualism, Internet art, and activism. I make art that explores the way the Internet

Figure 15.1 *The Real Costs* by Michael Mandiberg.

shapes subjectivity and consumerism. As an artist, I find structures to shape or modify by inserting and projecting new information. Within common genres including e-commerce, blogs, and opinion-poll sites I create site-specific interventions in this digital vernacular to provoke a moment of contemplation for the viewer. A good example of this is the *Oil Standard* Firefox plug-in that converts all prices on a webpage from U.S. dollars into the equivalent value in barrels of crude oil. When a webpage loads, the script seamlessly inserts converted prices into the page. As the cost of oil fluctuates on the commodities exchange, prices rise and fall in real-time causing the user to reflect on her relationship to the abstract fluctuation of the price of oil. *Oil Standard* synthesized my interest in hacktivism and Internet art, sustainable economics, and information design to create an art piece that opened up a dialogue about oil, economics, and the environment. It was used and discussed by eco-techies, high school classes, progressive politicians, and Internet artists. This project achieved the goal of making abstract information legible so as to create dialogue about the important issues surrounding how we use the Earth's natural resources.

This project intentionally sits in the liminal space between art and design, hacktivism and software development, and situationist intervention and green-tech toolmaking. I often situate my work in this position at the edge of art because it allows me to present unexpected content in familiar forms. The goal is to seduce the viewer through what appears to be a comfortable and usual situation and to create an experience of surprise and wonder. I have done this before, in *Shop Mandiberg*,[1] where in the fall of 2000 I built an e-commerce site as a container for self-portraiture. I made this project just as the dot.com bubble was bursting. I used the e-commerce genre as a location to critique the consumerization of the Internet, assuage my own anxieties about "selling out," and compose a poetic dirge to the dot.com crash that was going on around me. By making art appear in everyday contexts the capacity for art to instigate change is integrated into daily life.

Introduction to *The Real Costs*

The objective of *The Real Costs* is to increase awareness of the environmental impact of certain day-to-day choices in the life of an Internet user. By presenting this environmental impact information in the place where decisions are being made, I hope to impact the viewer, encourage a sense of individual agency, start ongoing discussions, and provide a set of alternatives and immediate actions. In the process, the user/viewer might even consider a personal transformation from passive consumer to engaged citizen.

You can experience the project by installing the *The Real Costs* plug-in into the Firefox web browser.[2] Currently, this plug-in uses the arrival and departure information for each flight on the page to calculate and reinsert the CO_2 that would be produced. It compares the CO_2 produced for that flight to the CO_2 for making the same trip by bus or train, and to the average CO_2 produced per capita for the average U.S. and world citizen. It is configured to work on the websites of the largest global air carriers. A list of these carriers and documentation of all scientific calculations is available on the project Wiki.[3] Anecdotal accounts suggest that most people install the plug-in, test it out on several travel sites to see that it really works, and then promptly forget about it until they book their next flight when the plug-in appears unexpectedly. This moment of surprise shocks people. It makes them see what they are doing in a new light; they understand their own complicit causal relationship to the world, and the pressures that prevent them from breaking this relationship.

Technical Description of a Creative Process

The Real Costs is a Firefox web broswer plug-in, built with the Greasemonkey userscript platform. When you load a page in your web browser, you are loading an HTML document. That HTML document likely includes images, CSS style sheets, javascript, embedded videos, and other components that are fixed in place before you download the page. A userscript is a script that loads after the page has loaded on your computer, and modifies your downloaded version of the HTML document.

Many of these userscripts have been written as plug-ins for the Firefox web browser. Greasemonkey is a plug-in that creates a platform to write userscripts in Javascript, bypassing the more complicated Firefox-specific extension programming language. The Greasemonkey platform has led to an explosion in scripts on repositories such as userscripts.org, which holds over 80,000 Greasemonkey scripts.[4]

When you load a page with *The Real Costs* installed, the script goes through the following procedures: first it checks whether the domain is an airplane travel website. If it is an airplane travel website the script will parse the page from top to bottom looking for pairs of three-letter airport codes, like JFK, CDG, and NRT. Each airline website uses a different set of patterns, so the script associates the right two codes with each other to properly handle connecting flights. It then converts the set of airport codes into latitude and longitude coordinates, calculates the distance between them, adds the total distance travelled and multiplies this by a constant value for the average CO_2 per passenger per mile to find the carbon footprint for this trip. This number is inserted back into the page next to each flight option. Based on this final number, the script inserts an informational graphic above the list of flight options which shows the carbon footprint, as well as information that puts this number into context.

Each artist has his or her own creative process. I like to work within pre-existing structures. I have an informal collection of ideas and a mental list of sites of exploration, and try to find the right match between the idea I want to explore or express and the sites I think are suitable for the kind of site-specific interventions I tend to make.

Figure 15.2 *The Real Costs* on the American Airlines website.

Sometimes I sit down, write out these lists, and actively explore potential matches, but most of the time I do this brainwork while reading the news, day-dreaming in the subway, or while trying to fall asleep. I like to find and reuse new tools for a purpose other than what they were initially intended to do. I usually match an idea to a structure; the structure is the site of curiosity, and I anchor the ideas to that location.

In order to find a close match between ideas and tools, I do a lot of research. To an onlooker, my research activities may not seem like "research," as it does not abide in any disciplinary traditions. I read the news, watch videos, and spend a lot of time looking at art and design online and in the physical world. Concurrently, I am actively considering the platforms and tools that are being used in online communities. While using a new type of web tool, or language, I am thinking about how the tool fits into my art-making process. For instance, I found so many discarded books anonymously given away on stoops in New York City that I could not help but think about what I could do with them; it was this exploration that led to a series of laser cut books and paper works.[5] Most of this labor will have no direct impact on a specific work, but all of it is part of my creative process.

I will often research a technical subject with intensity if I am exploring how I could make something with it; I want to know what the subject can do, but not how it does it. I will take a rough look at many different platforms and languages; most of these I will never use for a project. I regularly learn new tools and languages for projects, but I learn them after I figure out what I want to do. This was not true when I was first learning the tools, but at this point I rarely learn a new language or technique solely to explore it in order to learn what I want to make.

I may develop these ideas far enough to answer some basic technical questions: Is the language/platform flexible enough to do what I am interested in doing? Is the scope of the project something that I can complete? Do I have the skill, or can I collaborate with someone who has the skill to successfully make the project? If all of this is true and I think my idea is rooted in a strong concept, I will move forward.[6]

Historical Perspectives

1. Activist Art and Hacktivism

I made this work informed by a continuum of activist art work. Activist work aims to use art to change the viewer's beliefs. This spirit is felt in moments of political protest, in paintings such as Picasso's *Guernica*, or Hans Haacke's *Shapolsky et al. Manhattan Real Estate Holdings, A Real Time Social System, as of May 1, 1971*. Haacke's exposure of the real-estate transactions of Guggenheim Museum trustee Harry Shapolsky was so contentious the museum's director canceled the show six weeks prior to the exhibition. Activist work can be strongly conceptual; it treats the idea of the intervention as the artistic gesture.

Early Internet artists morphed activist art into the technologically infused hacktivism. Although this term carries some of the same tarnish as other techno-utopian ideas from that imaginary global village, it is still useful. Some of the artists who were called, or call themselves, hacktivists include RTMark/The Yes Men, The Bureau of Inverse Technology, the Institute for Applied Autonomy, and Critical Art Ensemble.[7]

2. Data Visualization and Artist Startups

Data visualization represents large sets of data in a visual form, leading to a new understanding of the information. This technique was spearheaded by financial services

companies, but has been used by artists as well. Martin Wattenberg has notably pioneered both financial and creative visualizations (see Chapter 9). While most visualizations tend toward the aestheticization of information, Josh On's *They Rule* uses the tools of visualization to chart the power relationships among board members of Fortune 500 companies. Tiffany Holmes has traced origins of what she terms "ecovisualization" from work like Hans Haacke's *Rhinewater Purification Plant of 1972*; she also includes work like *The Real Costs*, Brooke Singer's *Superfund365.org*, and Holmes' own *7000 Oaks and Counting*.[8]

Another important context is the growing number of functional projects that straddle the line between a work of art and an Internet startup company. Prior to making this project, I was inspired by projects like Angie Waller's anti-social networking site *My Frienemies*,[9] Ben Engebreth's political statement in the form of a very early energy-monitoring site *Personal Kyoto*,[10] and xtine burrough's Starbucks coffee un-finder site *Delocator*.[11] One of the core motivations in these works is to make something that has a function which changes or articulates how we interact with the world.

Technical and Design Perspectives

1. Open Source

Web programming of the last decade has placed a large emphasis on modularity, the separation of content and form, and the portability of information through standardized data structures and web services. A lot of these principles often fall under the Web 2.0 brand, though many are quick to point out that this is part of a smooth transition: this supposed "upgrade" is largely marketing.[12] A tool like the Greasemonkey userscript platform is part of this shift to customization and modularity.

The ability to make a project like *The Real Costs* is also a result of the Firefox web browser's prioritization of plug-ins and other forms of collaborative peripheral development. This focus on openness and collaboration stems from the means of production itself: Firefox is collectively written through input and contributions from a community of open-source developers. No company owns the code, and anyone is free to use it as long as they continue to share the code.

Open source is a term used to refer to computer software where the source code can be viewed, modified, and used by anyone.[13] The source code contains the modifiable, human readable instructions that are compiled into an un-modifiable computer readable binary code. As the story goes, once upon a time all software was open source. In 1980 MIT researcher Richard Stallman was using one of the first laser printers. Printing took so long that he decided he would modify the printer driver so that it sent a notice to the user when her print job was finished. Unlike previous printer drivers, this software only came in its compiled version. Stallman asked Xerox for the source code. Xerox would not let him have the source code. Stallman became upset and wrote the manifesto that led to the statement that Free Software was "Free as in speech, not free as in beer," and the Free Software movement began.[14] Later, Eric Raymond published *The Cathedral and the Bazaar* which popularized the term "open source." The term is frequently referred to by the acronym FLOSS, which stands for Free/Libre/Open Source Software.[15]

The Real Costs is an open-source project. You can view the source code at https://github.com/mandiberg/The-Real-Costs. By working within an open-source model, I signal my desire to share my work, and accept contributions from others. Others have joined my project by submitting "patches" which are rewrites of sections of code that fix

bugs or add features. Open work results in more frequent code updates, which in turn produces fewer errors during the user experience.

Making artwork in a model used for software development highlights some of the major differences in the goals of these two paradigms, even when they share the same tools. Traditional arguments for open-source development stem from a purely materialist angle: you can write better code in larger quantities through collaboration, and you retain freedom to use the code in a way that most proprietary ventures forbid. One of the traditional guidelines for evaluating the success of an open-source project is the so-called "bus factor": if the lead developer for the project was hit by a bus, would the project stay alive? It is a brutal mental experiment, but it forces the evaluation of the survival of long-term projects like Linux, WordPress, or Wikipedia. I would argue that it is not the most useful tool for evaluating art that also happens to be open source. For an open-source software project, a lack of upgrades and updates is the mark of a "dead" project. Conversely, in the tradition of making art, completion usually marks the end of all revisions. Historically, works of software art have been updated for a period of time before the main creator(s) moved on to a new project. From time to time the artists may work out the major bugs and broken features, though this is not an upgrade or update, but rather maintenance required to keep a project working.

The difficulty of keeping things running is an important consideration. At the time of this writing, I am making a round of maintenance to *IN Network*, *Oil Standard*, *The Real Costs*, and *HowMuchItCosts.us*; all of these are currently broken in one way or another. Maintenance is one of the inherent problems in working with software and Internet art, and something that has vexed curators and museums. How do you display art that was created for technological platforms that are themselves museum pieces, such as vintage 1970s mainframes, punch-card readers, or scripting languages for early web browsers? While curator at the Guggenheim, Jon Ippolito spearheaded the Variable Media initiative, which explored these questions and formulated a set of guidelines for preserving experimental media art, and a method for artists to designate how their works should be preserved if the original equipment is no longer available.[16]

The Real Costs has encountered archival problems quicker than most technology projects, as it is dependent on the airplane websites it runs on, over which I have no control. These sites will inevitably change their HTML/CSS so that the plug-in can no longer decipher which site it is running on and how to calculate the distances and thus the carbon footprint. Or worse, these sites will cease to exist as companies absorb each other: Northwest Airlines and several others have already ceased to exist as companies. In response to this inevitability, I have started making screencasts of all of my projects.[17] These screencasts document the work through video taken from the computer interface, and show the experience of the piece. These will eventually replace the working online versions, as I cannot "preserve" the airline websites themselves.

2. Collaboration

Despite the arts' and humanities' heavy emphasis on the individual creator, there are a number of reasons to collaborate. I often collaborate because the work that comes out of a collaboration is better for having multiple eyes and brains working on it; the project is too big for one person to undertake, and the project requires skills or knowledge that I do not have and/or cannot learn within time constraints. It is worth noting that these are some of the same arguments given for open-source software development.

My primary concerns for *The Real Costs* were the ambitious scope of the project, and

the scientific focus. I turned to former students Carlo Montagnino and Evan Moran for help with coding and design; Carlo, in turn, organized a group of my students who helped with some manual data wrangling. For the science, I turned to the guidance of ecologist Dr. P. Timon McPhearson, who advised me in my research, and was able to consult his own colleagues for the more obscure questions that arose.

Dr. McPhearson helped me negotiate the industry of carbon offsets that was taking off right as I was launching the project. In a carbon offset scheme, a business plants the equivalent number of trees that it would take to convert the CO_2 produced in a year by the purchaser. Theoretically, it sounds like it could be productive in the short term, but science indicates otherwise. All of the companies use annual per capita carbon footprints that were four to eight times lower than the numbers accepted by scientists. Reports on these tree plantations indicated that they were often planted with trees that would never grow in that location, or poorly tended to, leading to the death of the trees. Most importantly, these carbon offsets were modern day "indulgences," alleviating consumers of their guilt from their carbon sins, without changing any of their behaviors. We did not add offsets to the plug-in.

3. Design

Artists make works for an imaginary "viewer" who experiences the work in a white cube. The viewer walks around the work, maybe scratches their chin and nods, but the viewer does not touch the work. Designers create works for a "user" who experiences the work in every way except for the metaphorical (or literal) pristine white cube. Hopefully the user immediately grasps the meaning of the designer's interface or object, does not end up scratching their chin, and touches the work in all the correct places. A media artist has to balance these two creative roles and audience positions.

Design is a tool that can be used to instruct your viewer while she uses your work. I used a number of design tools to help convey complex ideas on *The Real Costs* website, like annual carbon footprints and comparisons between the CO_2 produced from multiple transportation methods. I used design to put these massive abstract numbers into a context that made them understandable for the user. I inserted an infographic that used color and graphics above the trip selection interface. I also created a unit of measurement, the "tree-year," which represented the number of years it took to convert the CO_2 created by the travel back into oxygen. Pounds or kilograms of CO_2 are abstract and meaningless to most people, but a year of a tree's life is something our imaginations can easily grasp. These design elements helped convey the meaning and intentions of the website.

I got carried away while designing. One of the best pieces of feedback came from someone whose job requires her to travel extensively. She wrote to say that while she would love to use the plug-in, she had to de-install it because the banner took up too much real estate in her browser, making it impossible to actually use the air travel site she was browsing. In response, I redesigned the interface to have a much smaller impact. In hindsight, it could probably be cut in half again. While viewers are silent, users talk back.

Conclusions and Outcomes

Looking back on this work two months into the Deepwater Horizon oil spill, from the perspective of the work I am making now, I see the sadness in *The Real Costs*. At the time I had hoped that this would somehow change things. I dressed that hope up in

bright colors and nice design, but now I see how much this work was leading to the next body of work I made that was unabashedly a memorial for a loss.[18]

The other outcome of this work was *HowMuchItCost.us*, a car direction website that took much of the research and data sources from *The Real Costs* and applied them to a non-plug-in based website. *HowMuchItCost.us* is built with Google Maps in a way that the platform intended it to be used, unlike the way I used the airplane travel websites. Using Google Maps in this way meant that the project continues to be more stable than *The Real Costs* in the long term. Additionally, one criticism of the plug-in was that it cut down on the potential audience for the project because it had too many specific requirements for use; a website that integrated the same functionality avoided these requirements and expanded the potential audience. By moving from a plug-in to a website I lost some of the element of surprise of using the plug-in, but I gained stability, and I expanded the range of viewers who were able to access the project.

Notes

* This chapter is licensed under a Creative Commons Attribution-ShareAlike license.
1. Visit http://Mandiberg.com/shop.
2. The plug-in is available at www.TheRealCosts.com.
3. Michael Mandiberg, *The Real Costs*: http://therealcosts.com/wiki.
4. http://userscripts.org/scripts (accessed June 25, 2010).
5. See the videos at http://vimeo.com/3723412 and http://vimeo.com/7136290, or the photos at www.flickr.com/photos/theredproject/tags/lasercutter (accessed June 25, 2010).
6. Often this is the point at which I will write up a grant or research proposal; in this case it helps that I have done all this reasearch, as it will form a large portion of the proposal.
7. It is notable that all of these hacktivists are art collectives, not individual artists.
8. The title of Holmes' piece refers to Josef Beuys' *7000 Oaks*. Tiffany Holmes, "Searching for Stories in the Sea of Data: Promoting Environmental Stewardship Through Ecovisualization," *Journal of Museum Education*, Summer 2007, and Tiffany Holmes, "Eco-visualization: Combining Art and Technology to Reduce Energy Consumption," *Reconstruction 6.3: Studies in Contemporary Culture*, Summer 2006.
9. Angie Waller, *My Frienemies*: http://myfrienemies.com (now offline).
10. Ben Engebreth, *Personal Kyoto*: http://personal-kyoto.org.
11. xtine burrough, *Delocator*: http://delocator.net.
12. Tim O'Reilly, "What is Web 2.0," O'Reilly Radar: http://oreilly.com/web2/archive/what-is-web-20.html, September 25, 2005 (accessed June 25, 2010). Hyde *et al.*, *Collaborative Futures*, FLOSS Manuals: www.booki.cc/collaborativefutures/a-very-short-history-of-collaboration (accessed June 25, 2010).
13. Creative Commons licenses are the non-code corollary to open-source code. These licenses allow creators to exercise their copyright under a "some rights reserved" rubric, rather than "all rights reserved." These licenses have been widely adopted by creators, though media publishers have been more resistant to this change: Routledge did not allow me or Steve Lambert to publish our chapters in this book under a Creative Commons license. You may find a draft of the manuscript for this essay posted at www.mandiberg.com/2011/01/07/a-case-study-of-the-real-costs.
14. One of Richard Stallman's most creative contributions to this movement was the GNU Public License or GPL. Software licensed with the GPL is required to maintain that license in all future incarnations; this means that code that starts out open has to stay open. You cannot close the source code. This is known as a Copyleft license.
15. There is much debate in the subcultures of the Free Culture movement about what terms to use. Some argue that the term "Open Source" is a neutered version of "Free Software" that caters to corporate entities like IBM who see the business potential in a software authoring model that is built around sharing and group work, but can't allow the word "Free" to enter into their business lexicon. While these disputes arise from time to time, the internationally accepted term is FLOSS.

16. www.guggenheim.org/new-york/collections/conservation/conservation-projects/variable-media and www.variablemedia.net (accessed June 25, 2010).
17. See, for example, the videos at http://vimeo.com/mandiberg/videos (accessed June 25, 2010).
18. This work is *FDIC Insured*, a collection of cast-off investment guidebooks engraved with the logos of failed U.S. banks. For images, see www.flickr.com/photos/theredproject/tags/fdicinsured (June 25, 2010).

Bibliography

Holmes, Tiffany. "Searching for Stories in the Sea of Data: Promoting Environmental Stewardship through Ecovisualization." *Journal of Museum Education*. Summer 2007.

Holmes, Tiffany. "Eco-visualization: Combining Art and Technology to Reduce Energy Consumption." *Reconstruction 6.3: Studies in Contemporary Culture*, Summer 2006.

Hyde, Adam, Mike Linksvayer, Michael Mandiberg, Marta Peirano, Alan Toner, Mushon Zer-Aviv *et al*. *Collaborative Futures*. FLOSS Manuals: www.booki.cc/collaborativefutures/_v/1.0/a-very-short-history-of-collaboration (accessed June 25, 2010).

O'Reilly, Tim. "What is Web 2.0." O'Reilly Radar: http://oreilly.com/web2/archive/what-is-web-20.htm (last modified September 25, 2010).

16 ADD-ART
Sharing, Freedom, and Beer

Steve Lambert

Key Words: "Release Early and Often," Open Source, Sharing, Free Software Movement

Before discussing *Add-Art* or "free and open source," we should think about the concept of sharing. As a culture, we have been sharing since the beginning of civilization. Sharing code, especially "open-source" code, is only a recent form of cultural sharing.

We're familiar with the image of scientists working in labs, researching, generating and testing hypotheses, then publishing their work in journals or otherwise presenting their work to the scientific community. As an artist, what I do is not so different from this image. I collect research constantly, I work in a studio, I experiment and develop concepts, and then publish my work in galleries, museums, and other media outlets. As an analogy, this method of researching and publishing extends to writers, performers, musicians, software developers, and anyone else who creates media.

Extending this analogy, repeating the research someone else has done is redundant. The goal is to make progress. Publishing research outcomes enables the work to be documented and thus built upon. Theories and techniques are built upon. Knowledge is built upon. Through this process scientific theories are established, art movements emerge and retreat, musical styles develop and are folded into new styles, software becomes more sophisticated, knowledge is collected and developed, and progress is made over generations. As creative people, we want to be a part of the creation of history and progression of culture. We want to be relevant.

This is why we share our research. "No one creates in a vacuum" is a fitting adage for researchers. We are products of the cultures we are exposed to, where ideas and themes merge and mix.

Figure 16.1 Mock-up demonstrating *Add-Art* on the *New York Times* website.

The cultures before us shared and the resulting developments traveled around the world. Take a moment to consider what has been gained by sharing: this is how all language developed, the written word, boats, gunpowder, weapons, poems, recipes, designs, and on and on. Everything we have has endured through sharing. For example, if I lived in North America in the year 800 CE and wanted to make a basket, someone in my village showed me how. If I, when making that basket, came up with a way to add an interesting pattern or a way for that basket to hold water, then I would share that in turn. In the year 900, that method would probably remain and be taught to the following generations in my village. In this way all the knowledge we have comes from sharing. The foundations of our society and culture are built on sharing.

As our culture has developed, so has technology and economic markets. In the past money changed hands when goods and services changed hands. But relatively recently in our history, our markets have become much more sophisticated and efficient as capital is more likely to move over virtual networks than in a physical marketplace. We live in a society of information, and so markets, especially in the United States, have attempted to capitalize on the transfer of information as well as goods and services.

Information is commodified through intellectual property and restrictive licenses like copyrights and patents, privatized education, proprietary software, and by reselling old information in new formats (LPs to CDs to MP3s, paper books resold as digital books, VHS to DVDs to BluRay discs, and so on), just to name a few ways.

Of course, capital has not changed everything. Most of what we would call culture and society exist alongside but out of the reach of markets. Artists, musicians, writers, and educators still generally do not enter the field expecting to make an outrageous fortune. When it comes to friends and neighbors we continue to share with each other far more than we trade capital. Family, friends, favors, polite exchanges, and gifts are, thankfully, separate transactions from the market system. Additionally, a resistance to the capitalizing of shared information has emerged with new licenses that permit and encourage its transfer rather than lock down and wall off innovation.

Free Software

The Free Software Movement emerged in the early 1980s in response to (arguably misguided) efforts to withhold software program source code to increase profit, such as nondisclosure agreements and the patenting of software concepts so that they cannot be reverse engineered. Prior to this period software was shared fairly openly among researchers and early hackers. Money was made, but software was shared.

The founder of the Free Software Foundation, Richard Stallman, has an informal slogan to help clarify what free software means, "Free as in free speech, not free as in free beer."[1] He also created the Four Freedoms to further explain the guidelines of free software:

Freedom 0: You are free to run the program, for any purpose.
Freedom 1: You are free to study how the program works, and adapt it to your needs.
Freedom 2: You are free to redistribute copies so you can help your neighbor.
Freedom 3: You are free to improve the program, and release your improvements to the public so that the whole community benefits.[2]

When we have these four freedoms with software, it becomes "Free Software." Sounds pretty reasonable, right?

Together the four software freedoms sit well. This structure has allowed for rapid innovation of popular free and open-source programs like the GNU/Linux operating system, the Apache Web Server, the Firefox web browser, and mainstream web publishing software like WordPress. Note that the four freedoms do not mention money, sales, or profits. Free software can be sold. Many businesses offer training, support, and the customization of free software. We could even sell copies of the software, though anyone would be able to do the same. The four freedoms work in concert with business, innovation, and sharing, and they have worked, as a paradigm, for several decades.

By comparison, let us check software commonly used by artists, Adobe Photoshop, against these four freedoms:

- Are we free to use Photoshop for any purpose? Sure, we can use Photoshop to make everything from a corporate presentation to pornography.
- Are we free to study the program and adapt it to our needs? In one way, yes, we can get an Adobe Photoshop manual and learn how the program works, and we can customize the workspace and write Photoshop Actions to script the program and adapt it to our needs. But, these are relatively insignificant changes. The source code is not publicly available and we cannot adapt the software by changing the source code, so thereby Photoshop fails to meet this freedom.
- Can we redistribute copies of Photoshop to help our neighbors? While that may be how *some* people obtain copies of the program, technically this is a violation of the user license, and therefore illegal. The third freedom is violated.
- Can I make improvements to Photoshop and release, or even sell, the Photoshop "Steve Lambert Edition" for the benefit of Photoshop users? No, absolutely not. The fourth freedom is also violated.

Adobe's model is profitable, but in a different way than free software. Adobe's profit model is not based on support and customization, but on selling licenses of their software. Each license, that is, each copy of the software, costs several hundred dollars. This sales model interferes with the four software freedoms. Adobe's model works for business. For innovation, one could argue it works as well – Adobe is a large company that creates quality products. They are certainly an industry leader. But we are not free to improve their work, we are not free to examine it, and we are not free to distribute it.

And what happens if Adobe dismantles, or, perhaps slightly more likely, if they stop supporting or releasing one of the programs they distribute? Their code remains inaccessible. Their work cannot be improved upon even after they are no longer interested in supporting it. In fact, this is how the current most popular blogging software started, by volunteer coders picking up on a nearly abandoned project called b2cafelog and turning it into WordPress.[3] Had b2cafelog been licensed with a proprietary license, WordPress would likely not exist.

In the context of the importance of sharing, and how this applies to software, let's turn our focus to *Add-Art*.

Add-Art

Add-Art is a Firefox add-on that replaces advertising on the Internet with art. When you visit a web page with *Add-Art* enabled, instead of seeing ads, you will see a selection of curated art images that change bi-weekly.

Add-Art is free software as in both "freedom" and "beer." It also builds on earlier free works, primarily the Mozilla project, the Firefox web browser, XML, and the various ad-blocking add-ons that preceded it.

Because Mozilla Firefox is free and open-source software, others are free to build on it by contributing core code or through extensions and add-ons (and creating Firefox software offshoots like CELTX). Add-ons are smaller, sub-programs that extend Firefox's functionality beyond what it is capable of doing "out of the box." An extension might display a small weather forecast in the bottom corner of the browser, or enable you to save your bookmarks to an online social bookmarking service. There are thousands of add-ons available, and the most popular by far is AdBlock Plus.[4]

Add-Art's lineage stems directly from AdBlock Plus, an add-on that eliminates advertising from the Internet. It is, at the time of this writing, the most downloaded extension for Firefox and has been nearly since the time it was introduced.[5] When users discover they have a choice of whether or not to look at ads on the Internet, many choose not to. As a result Adblock Plus was downloaded over 87 millions times between January 2006 and July 2010 and in July 2010 had over ten million active daily users.[6]

I am one of those users. When I saw that Adblock Plus simply took ads off the page and replaced it with blank space I was ... delighted. And it did not take long before I thought, "Why blank space? Why not replace the ads with something more interesting?"

Not knowing how to code such a thing, I sent an email to friends and asked "Would it be possible to replace the blank space created by Adblock Plus with art images? And if so, would you help me?" And by help, I meant, do it for me. They all responded fairly quickly, "yes, technically it's possible and no, I will not help you."

The plan was put on hold.

Around two years later I was a new fellow in the OpenLab at the Eyebeam Art and Technology Center in New York City. Eyebeam has a strong open source and collaborative tradition and after a few weeks I remembered my idea to replace ads with art using Adblock Plus. I sent an email to the other fellows and resident artists, "Would it be possible to replace the blank space created by Adblock Plus with art images? And if so, would you help me?" A few minutes later I got a reply from Evan Harper, "Can you give me a week?"

Evan Harper created the first prototype of *Add-Art*. Our prototype was cobbled together, and it replaced ads with images of bald eagles and American flags, suggesting, in a funny way, my excitement for this particular type of freedom.

We used this proof of concept to apply for a Rhizome Commission, which involved creating a webpage so Rhizome members could vote on submissions. Naively, I did not foresee that Rhizome members would blog about the project and cause a stir before we were even off the ground. This resulted in an article in the *New York Times* about the project.[7] This would have been a great opportunity to recruit interested programmers and volunteers, but I was so caught off-guard that I did not think about using this attention to better the project.

The proposal was popular among the Rhizome Community and the jurors, which resulted in the project winning the 5,000-dollar commission. The attention online and in the press interested a supporter, co-founder of WoosterCollective.com, Marc Schiller. The combined effect was a small budget to get us started with the project.

My next step was to communicate with Wladimir Palant, creator of Adblock Plus. Palant had also built on (then rewritten) the work of those who came before him; programmers Henrik Aasted Sorensen, a person known only as "rue," and Michael McDonald. The slowly growing *Add-Art* team was beginning to build on this work. Because

Adblock Plus code is licensed under Mozilla Public License we could freely modify, adapt, and release a modified version rather than write a new ad-blocker from scratch.

Knowing the Adblock Plus code well, Wladimir Palant was kind enough to write the first version of *Add-Art* for us. Though he did not ask for it (and I am not sure he wanted it), we sent him some of our grant money to compensate him and thank him for his work. Without being able to build on Palant's work, and without his decision to use an open license, *Add-Art* would have been much more difficult to create. With a solid foundation of work generated by those who came before *Add-Art*, I started inviting new people to work on the project.

At first, my plan was to make the project perfect (in terms of its utility) from the beginning. I was striving to create an automated system that needed as little human intervention as possible – as I wanted to create the project, but not administer it long term. I researched content management systems (CMS) which would enable curators to select images that could be automatically loaded into *Add-Art* without writing additional code. I worked with programmer Michelle Kempner on writing a custom CMS that would do a majority of the management and administrative work of organizing the bi-weekly shows. After some time, we abandoned the custom CMS route, researched more, and started using existing code. This went on for a few months and, after much planning and researching, and several false starts, I realized I hadn't accomplished much at all.

I had to change my strategy. While at first counter-intuitive, setting the standard at the level of perfection meant it was difficult to make progress on the code. I had forgotten one of the philosophies of free and open-source coding, "release early and often."

This means, publish something that works to the world, let people use it, discover failures, then release frequent improvements based on user feedback. And if you're lucky, those users will submit improvements as well.

My new strategy was to use the grant money to pay for pizza and beer. I contacted programmer friends with different skill-sets and invited them to weekly meet-ups at Eyebeam to figure out the *Add-Art* code together and create a new release. The pizza and beer helped make the work and the meet-up more attractive.

Unfortunately, no one in the world had the experience of creating a Firefox extension that replaces ads on the Internet with art whom we could ask questions. Sitting around a table with our pizza, beer, and laptops, we were venturing into uncharted territory, but the surrounding area was mapped. We slowly parsed through documentation on creating extensions

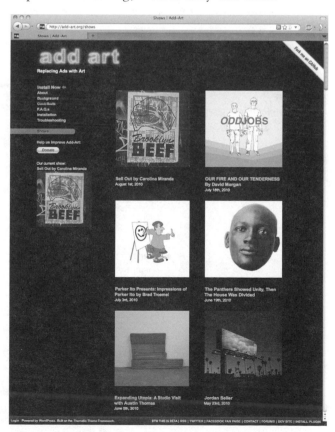

Figure 16.2 Shows promoted on the *Add-Art* website.

on the Mozilla.org site, we entered IRC (Internet Relay Chats) with other developers, we sent emails, and we hacked away at our code creating failure after failure to figure out what worked.

Working in a group allowed us to share ideas and collectively solve problems that were new to all of us. Eventually we had something that was "good enough" and we published our first version: 0.4.2. It was missing features: it required a little too much work on behalf of the user, it did not have an interface, it did not replace every ad that had been blocked with art. But it worked. It replaced most ads with art. And nothing crashed.

The "release early and often" strategy worked. By cutting features and lowering our ambitions from "ideal" to "working" we made the task more manageable and, surely enough, finally made significant progress toward our goal. The software was by no means perfect, but we were making much more progress toward something that could live up to the standards I originally held. Over the coming weeks and months our pizza and beer group built on the codebase, adding features and simplifying the user experience.

Add-Art's shows change every two weeks and, in the beginning, changing the content was a tedious task involving the command line, encryption keys, things I had never heard of before like "md5 and sha1 security hashes," and about four hours of repetitive and frustrating work – because it never worked the first time. This hassle was a motivating factor to improve our code. At each step we examined problems and evaluated as a group what was the most urgent one or two issues to tackle together. Our code was published very early on and we used an online wiki to document our progress, as well as a web-based "ticket system" to keep track of the bugs or issues that needed to be fixed. This enabled those wanting to join our efforts to learn our process quickly and choose a ticket to fix.

In January 2008 we began to make steady progress on *Add-Art* and in May I gave a public presentation of the project at *The New Museum* in New York City. I remember

Figure 16.3 *Add-Art* "ticket system" to keep track of the bugs or issues that needed to be fixed.

finishing some final touches the day of the presentation and I had my head so buried in the logistics and technicalities of the project for so long, I had not thought about the conceptual and cultural aspect for months. At the first public presentation of the project, not surprisingly, no one cared much about the technical accomplishment. They all had questions about "what it means for the web" and clarifications on the legal issues (there are none – you are free to manipulate data on your own computer). In this way, our release early and often approach worked again. No one cared that *Add-Art* wasn't technically perfect (besides us). The project worked, the technical guts were more or less invisible to most, and the cultural and conceptual aspects took the limelight.

At the time of this writing *Add-Art* has replaced ads with art for an average

Figure 16.4 Art replaces advertisements on the Salon.com website.

of 15,000–20,000 users every day for the past two years. Over 60 different shows have been curated, of all kinds of work from photography, to drawing, to digital art, animation, and performance documentation. It is an ongoing process and there are still things that could be improved, but it works, and it is free, and you can get it at http://add-art. org.

Conclusions

If there are two major lessons here, I would sum them up as follows.

1. The Importance of Open Licenses and Sharing

No one person created this project. And no one person should create a project of this magnitude. We were able to, as Sir Isaac Newton, and later Linus Torvalds of the GNU/ Linux kernel, put it, "hoist ourselves up on the shoulders of giants."[8] Open licenses used by those who came before us enabled us to focus on the work we needed to do instead of inefficiently rebuilding software that already existed.

And it does not end with *Add-Art*. Since *Add-Art* is licensed with a GPLv3 license,[9] anyone is able to build on our work and fix issues (there are some remaining from our earliest iterations), or create something new in the future that we could never imagine today.

2. Working Iteratively or "Releasing Early and Often"

If you wait to release a free and open-source project until it is "just right," you risk getting lost in your own process and are missing out on user contributions. Working in

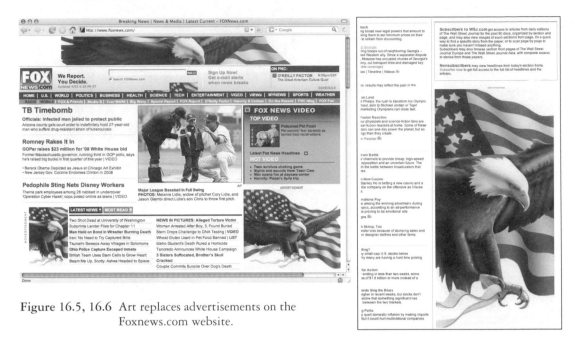

Figure 16.5, 16.6 Art replaces advertisements on the
Foxnews.com website.

iterations and releasing beta versions makes the project more effective and conducive to more obtainable production goals. It also enables real-world feedback and contributions from users.

Outcomes: It's Not All Great

There is always more that can be done. Other valuable lessons include ongoing challenges I face in supporting and maintaining this project.

One constant issue with free and open-source software is documentation. For instance, how can you communicate clearly to new developers the reasons for making the decisions you made in the past or how those resolutions were executed? Where does a new developer start working on the ongoing project? What does that sloppy code you wrote mean? It is important to realize there is an audience for your work outside your

Figure 16.7, 16.8 Art replaces advertisements on the NYMag.com website.

brain, so what might make sense to you probably makes no sense to a person viewing the project for the first time. Document your process, annotate your code, and be ready to answer questions.

Having done much of that, there is still a high barrier to involvement in *Add-Art*. Every combination of technology *Add-Art* uses (like javascript, XML, GIT, and so on) narrows the field of people who will be experienced with this particular combination of technologies. How can you help newcomers with code that is so particular to your project?

While working on our project, we found that the documentation of the Mozilla project and other code was often too dense to understand. As grateful as we were to those who came before us, sometimes those who are brilliant at coding did not create the best documentation. I tried to make sure we did not make the same mistake for the next creative person who wants to use our code for a future project.

Another issue that plagues *Add-Art* is the lack of understanding of free and open-source software. The art is selected by various curators. Curators give some assurance of intention and quality of the images displayed. Curators are selected by past curators. This is done so no one person has control over what is shown on *Add-Art*. Nonetheless, not everyone likes the art. In fact, for nearly every show we have ever produced, someone does not like the art. They will often make a comment in our forums, which is why we built the forums.[10] I never expected every viewer would like every exhibit all of the time. But when I do not like a museum show, I do not complain to the director and demand a change. Like most museum-goers, I realize that the show is not for me. Ocassionally I change my mind over time – a piece might grow on me. Learning that I do not like some artworks helps me to understand why I favor others. I consider a "bad show" (in my opinion) to be a learning experience that I was open to having when I walked into the museum.

The problem is that people mistake the project for a product. A product is usually accompanied by customer service. Behaving as if one does not like a product, if someone does not like the art on *Add-Art*, they may complain, expecting "customer service" to fix it. However, it does not work according to the "customer service" paradigm. The developers of free software projects do not respond in the same way to complaints. They are more likely to say, "Yeah, I know that is a problem, why not get down here and help us fix it?"

This extends to requesting (or sometimes demanding) top-down fixes (e.g., "make an *Add-Art* for Safari/Chrome/fill-in-the-blank!") instead of submitting code, hiring someone if they do not have the skills, or otherwise taking ownership and initiating the new project or modification themselves.

Worse, people who perceive free and open-source projects as products are used to insisting on satisfaction. I can relate. When I pay for something and I am disappointed with how it worked, I complain and sometimes demand a satisfactory outcome or threaten to take my business elsewhere. With a free software project, these threats are rather meaningless.

But can we really blame anyone for this confusion of product for project? Commercial software and the capitalist paradigm have a decades-long head-start in shaping the way people think about consuming versus participating in and creating the software they use.

Free software is not a product, it is a gift. There is no customer service because there are no customers. Anyone can take charge and build on the code to fix a problem. In fact, the people making the software already have. And you can, too.

Add-Art is a free and open-source project and has been developed by the following people:

Steve Lambert: http://visitsteve.com
Wladimir Palant: http://adblockplus.org
Jamie Wilkinson: http://tramchase.com
Matt Katz: www.morelightmorelight.com
Tobias Leingruber: www.tobi-x.com
Ethan Ham: www.ethanham.com
Michael Mandiberg: www.mandiberg.com
Jeff Crouse: www.jeffcrouse.info
Sean Salmon: www.seanaes.com
Evan Harper: www.evanharper.com
Michelle Kempner: http://robotclothes.com
Dan Phiffer: http://phiffer.org
Mushon Zer-Aviv: www.mushon.com
Alyssa Wright: http://web.media.mit.edu/~alyssa
Hana Newman

Notes

1 The Free Software Definition: www.gnu.org/philosophy/free-sw.html.
2 Ibid.
3 See: http://codex.wordpress.org/History.
4 AdBlock Plus: http://adblockplus.org.
5 See https://addons.mozilla.org/en-US/firefox and https://addons.mozilla.org/en-US/firefox/browse/type:1/cat:all/sort:popular – you can compare and see that AdBlock Plus historically has been the most popular and has the most downloads.
6 Ibid. Adblock Plus page on the Mozilla Add-Ons site: https://addons.mozilla.org/en-US/firefox/addon/1865.
7 Andrew Adam Newman, "Web Fight: Blocking Ads and Adding Art," *New York Times*, May 14, 2007: C8.
8 Sam Williams, *Free as in Freedom: Richard Stallman's Crusade for Free Software*, March 2002, O'Reilly. Online: http://oreilly.com/openbook/freedom/ch09.html#67568.
9 GPLv3 is the General Public License version 3 from the Free Software Foundation. It is a license which covers the four freedoms. www.gnu.org/licenses/gpl.html.
10 http://forum.add-art.org.

Bibliography

Williams, Sam. *Free as in Freedom Richard Stallman's Crusade for Free Software*. O'Reilly, 2002. Online (available for free): http://oreilly.com/openbook/freedom.

Links

http://add-art.org
http://forum.add-art.org
http://github.com/slambert/Add-Art
www.fsf.org
www.ted.com/talks/larry_lessig_says_the_law_is_strangling_creativity.html

PART IX
HACKING AND REMIXING

HACKING AND REMIXING

Stefan Sonvilla-Weiss

Current remix practices have evolved along with the popularization of computers and the corresponding communication technologies around the globe. Media convergence, the transformation of hitherto analog texts, pictures, photographs, music, movies, and artworks into universal encoded digital data, marked out a revolutionary shift in post-industrial modalities of production, communication, reception, and perception of audio-visual information.

From a historical standpoint, the appropriation, imitation, reuse and recombination of significant styles, materials, and artifacts pervade almost all cultural epochs in the process of creating something new. Each historical style (Greek, Roman Antiquity, the Renaissance, Modernity), for example, sees periods of transition where there is a proliferation of ambiguous stylistic elements that more allude to their historical examples than depict them. In postmodernist architecture, Philip Johnson's Sony Building in New York became a landmark of "neo-eclectic" architecture, which borrows elements and references from the past, replacing the aggressively unornamented modern styles by reintroducing color and symbolism to architecture.

In contemporary art, form and content are in permanent flux and tested in vast playgrounds of varying concepts, practices, manifestations, interpretations, and validations that unmask art as a social, cultural, political, and economic system.

Coevally the word "art" invokes almost boundless permutations and combinations such as anti-art or anti-anti-art, accompanied by its random ramifications of pop art, concept art, electronic art, new media art, digital art, computer art, virtual art, and so forth.

Dada as a cultural movement in the early twentieth century signaled a new chapter in early modernism as an influential precursor of several avant-garde threads, ranging from Fluxus to Culture Jamming and Hacking. Key to a sound understanding of today's remix practices are these early experimental forms of combining visual and literary art, sound and music, stage design, and performance that elicited novel art practices and techniques such as photomontage, collage, and readymades.

In succession the Situationist International movement in the 1950s and 1960s took up Dada's anti-bourgeois and anarchistic position with a view to coalesce Surrealist art and Marxist politics against the first wave of mass media and advertising, which one of the main protagonists, Guy Debord, aptly dubbed *The Society of the Spectacle* in his book of the same title.

In Debord's view, "the spectacle is not a collection of images, but a social relation among people, mediated by images"[1] that can be interpreted as the inverted image of society in which relations between commodities have supplanted relations between people, in which passive identification with the spectacle supplants genuine activity. In response to this total occupation of social life by commodities, Situationists drew upon a

series of experimental study fields in constructing a self-consciousness of existence within a particular environment or ambience, such as unitary urbanism and psycho-geography, which were to propagate the union of play, freedom, and critical thinking.

Michel de Certeau, one of the most influential theorists of "the everyday" in the 1980s, brought into the discussion the ways in which people individualize mass culture, altering things from utilitarian objects to street plans to rituals, laws and language, in order to make them their own. The utility and potential of digital technologies had not yet emerged and is therefore not present in de Certeau's work; however, his models of strategies and tactics put the "user" in the foreground. The concept of "consumption" is expanded in the phrase "procedures of consumption," which then further transforms into the "tactics of consumption" that became seminal in the emerging realms of digital cultural production and participation.

In his Google Map mashup work *JoyceWalks*, Conor McGarrigle attempts to revive de Certeau's "act of walking" (which for him is to the urban system what the speech act is to language) and Situationist-inspired psychogeographical routes by applying a participatory-driven locative media concept that combines GPS, mobile phones, and Google Maps. This user-driven locative media approach probes iterative concepts of re-enactment (in this case, participants recreate aspects of *Ulysses* with mobile technology) and user-generated content based on an open architecture for sharing content and data between communities and applications.

Today's communication technologies weave themselves into the fabric of everyday life until they are indistinguishable from it. The ever-increasing possibilities to inter-act with computer technology can lead to both techno-utopia and dystopia. A society fully wired and connected is prone to control and surveillance, even though civil counter-strike techniques (hacktivism) aim for "equiveillance," a state of equilibrium, or at least a desire to attain a state of equilibrium, between surveillance and counter-surveillance.

Are these viable models that will protect us from total control? To what extent are we captivated in complicity, and how can we develop alternative strategies and models without pushing the exit button?

Pigeonblog, an interactive and collaborative artwork by Beatriz da Costa, critically reflects on such observations where individuals and citizens are in danger of becoming the involuntary subject and object of existing and yet unknown surveillance techniques. From data-mining and profiling to RFID tagging, there is hardly any of our individual, social, or public spaces unaffected by wired data control mechanisms. What the artist originally conceived as a surprising combination of an animal–human–technology network aiming at collection and distribution of air-pollution data by means of pigeons, which carried sensing devices with them, eventually turned into an extended scope of investigation into how animals might be deployed as a means of civic counter-surveillance.

The situation at the turn of the twenty-first century resembles in some respects the surveillance situations of the early twentieth century. The surveillance technology that helped constitute modernity is, so to speak, an unfinished project. People find them-selves subject to scrutiny by agencies and organizations interested in influencing, guiding, or even manipulating their daily lives.

However, the widespread adoption of new technologies for surveillance purposes has rendered that scrutiny discrete and invisible. Physical presence has become less neces-sary to the maintenance of control, to keeping individuals within a field of influence. Consequently, the enormous amount of information and knowledge resources available

on ubiquitous, circumfluent displays in private and public spaces raises new questions on private/public safety, control and legal issues, for example in consumer detection.

Whether you like it or not, the core truth is: if you are in the web, people will find it out ...

Note

1. Guy Debord, *Society of the Spectacle*, Detroit: Black & Red, 1983: 2.

Bibliography

Debord, Guy. *Society of the Spectacle.* Detroit: Black & Red, 1983.
De Certeau, Michel. *The Practice of Everyday Life.* London: University of California Press, 1988.
Chandler, Annemarie and Norie Neumark. *At A Distance: Precursors to Art and Activism on the Internet.* Cambridge, MA: MIT Press, 2006.
Sonvilla-Weiss, Stefan. *(IN)VISIBLE: Learning to Act in the Metaverse.* New York: Springer, 2008.
Wilson, Stephen. *Art + Science Now.* New York: Thames & Hudson, 2010.

17 PIGEONBLOG

Beatriz da Costa

Key Words: Blog, DIY, GPS, Interspecies, Intervention, Micro-controller, Sensor

Project Summary

Pigeonblog is an initiative involving pigeons, humans, and information technologies. *Pigeonblog* enabled homing pigeons to fly with small air-quality sensors allowing them to "blog" about current pollution conditions in the area.

Project Developer Background

Pigeonblog emerged out of my desire to combine politicized artistic interventions with interspecies interaction. Animals have worked with humans for centuries. Ranging from agriculture, to transportation, protection, rescue, and sports, there don't seem to be many areas in human social evolution that were accomplished without the help of animals—be it the horses, camels, or elephants used as mounts; oxen and mules to carry supplies; or dogs used for fighting and protection. Since animals often exceed humans in their ability to sense, fight, and survive in extreme conditions, their involvement in military operations and law enforcement comes as no surprise. I was particularly interested, however, in the usage of animals as a form of sense-enhancing protheses, often used for navigation, orientation, and retrieval. One example are, of course, dogs with their keen ability to sense drugs, corpses, toxins, or whatever else humans might have trained them to detect. Nowadays, bees and wasps are also being trained to sniff out chemical substances. Another current example is the training of dolphins in the detection of sea mines as part of the U.S. Navy Marine Mammal program. The case most relevant for the context of *Pigeonblog*, however, is the historic involvement of pigeons in the military and law enforcement.

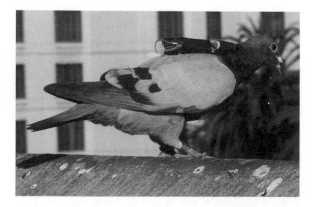

Figure 17.1 A pigeon wearing the *Pigeonblog* "backpack," consisting of a sensor, GPS, and GSM modules during the project premiere at the 01 Festival in San José, California, 2006.

The homing instinct of pigeons allows them to always find their way back home, no matter if they find themselves in known territory or in areas they have never been before. "Home" usually means the place where they were born and are being fed, but pigeons can also be trained to navigate between two different places (so long as they are receiving food on each end), as was often the case with carrier pigeons. Pigeon-postal systems, where pigeons were used to deliver mail, obviously existed independent from military and police operations, but they found heavy use in those areas as well.

The Persians are often credited with the initial training of the birds over 2,000 years ago, and the Romans are said to have used messenger pigeons to aid their military. Much more recent examples include the involvement of messenger pigeons during World Wars I and II. Pigeons assisted with the communication between troops and were often released by soldiers in distress to report on their current whereabouts and needs. The United States had an entire Pigeon Corps operating in both wars, and so did many of the Allies. Pigeons were hard to detect and capture and therefore an ideal means for covert communication. Another example is the use of pigeons by the police in the Indian state Orissa. A pigeon-post messaging system was maintained there to the very end of the twentieth century and was mostly used to circumvent power outages and other disruptions of modern communication systems. Orissa is a large state, and densely populated in the coastal regions, but the interior of the state is hard to inhabit and only sparsely populated. During difficult weather seasons, regular means of communication between the capital and the more remote villages often breaks down completely and the pigeons provided an indispensable emergency back-up system. In addition to carrying messages, German inventor Julius Neubronner thought to enlist pigeons as covert surveillance conspirators and attached little cameras to their bodies at the very beginning of the twentieth century. This rather new approach to aerial photography drew interest from the German war department, again due to the difficulty of detecting pigeons on radar as well as various other methods of capture that might be used by the enemy. After coming across images of those pigeons online, I asked myself in what capacity might activist-minded artists work with pigeons today, and the ideas and thoughts that came up in relation to that question eventually resulted in *Pigeonblog*.

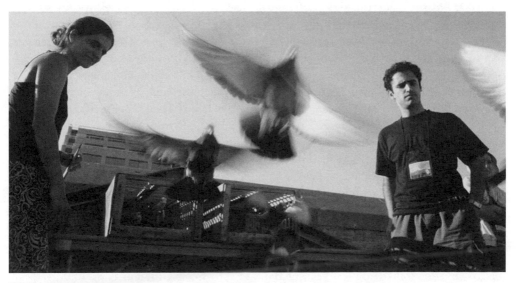

Figure 17.2 Releasing the pigeons at the 01 Festival.

Pigeonblog: A Brief Reflection Four Years Later

Pigeonblog was developed in 2006. I first wrote about the project in the following year. Since then my thoughts about the project have changed, and the strengths and weaknesses associated with the project have been commented on by many others. Even my own use of language doesn't quite seem the same any more. And, as is the case with many projects, *Pigeonblog* has been discussed in many different contexts, each one giving it its own unique flavor and mode of interpretation. For the purpose of this book, I have been asked to write about the project as part of the "Hacking" section, and will do my best to examine the project through that lens.

Pigeonblog was a collaborative endeavor between homing pigeons, a pigeon fancier, an artist, two engineers, and an air-pollution scientist consultant.[1] The artist and the engineers produced a series of small air-pollution sensing devices designed to be carried by the pigeons while in flight. The devices were enabled to send text messages to a server, and thus allowed the birds to "blog" the pollution data in real time. We created logs of those blog posts and visualized the data using the Google Map application programming interface (API). *Pigeonblog* was an attempt to combine DIY electronics with a grass-roots take on scientific data gathering and pollution monitoring. How could we team up with non-human species in the fight for environmental justice?

In a technical sense, *Pigeonblog* very much fit the "tinkering" aspect of what hacking as a practice implies. We combined automotive pollution sensors (sensing carbon monoxide and nitrogen dioxides) with a micro-controller, a SIM card (like the ones used in cell phones), a GPS module (transmitting latitude/longitude/altitude), and a GSM module allowing for communication with cell phone towers. Together these elements created a device that was recording pollution information, combined with location awareness, and the ability to automatically send text messages containing both data to our server for visualization. From a technical standpoint that was not an easy task. In fact, the artist/engineering team worked many hours over the course of a year in order to create a functional device. While each technical component wasn't all that complicated, the combination of all four capabilities, and the fact that we had to work with very tight size and weight requirements (pigeons shouldn't carry more than 5 percent of their body mass), made it a very challenging "hack" to pull off. The pollution visualization provided another challenging task. Fortunately, the Google Map API is open, and is designed to support customization of an array of standard modifications, data feeds, and so on, and has become a sought-after tool used by companies, non-profit organizations, and individuals alike. So we were able to make good use of it. However, our visualization entailed an entire Java-based visualization back end, going well beyond the more common map customization. So in a sense, we had to hack Google Maps as well.

"Hacking" can imply many different things, and the figure of the hacker has shifted meaning several times in recent history. Originally, the thirst for understanding a complex system, taking it apart, and then reassembling it in a novel way was a key quality of the hacker. Today the hacker is more often than not described as the ultimate criminal, the geek savant who uses his or her talents to create chaos and danger in the world. For others the hacker represents a figure of ultimate freedom, the hero of the underground, fighting state and corporate power in ways that the rest of us can only dream of. Wherever you stand on this spectrum, however, I believe that certain meanings of the term fit both of these images. To "hack" at something, to take it apart and repurpose it for something else, can be done toward many different ends, and need not have anything to do with computing at all. For example, with *Pigeonblog* we hacked

knowledge production, information distribution, interspecies perception and relations, and academic disciplines just as much as electronics, Google maps' API, and text messaging protocols.

At the time I was particularly interested in experimenting with hybrid practices situated between the arts and sciences. I am trained as an artist, but various areas in the life sciences have fascinated me for a long time. I have been involved in several collaborative art projects addressing current political questions related to recent developments in genetic engineering. As artists/lay scientists,

Figure 17.3 Screenshot of the *Pigeonblog* website.

we trained ourselves in laboratory techniques and other skills needed to actually experiment and explore that area. We identified as amateurs in those areas, and were very interested in seeing how far we could go, without actually having any scientific training. With *Pigeonblog*, however, we attempted to conceive and realize a project that would serve both the arts and sciences on more than just a conceptual level, while continuing to experiment with an activist-oriented art practice. The combination of art/science/activist work, then, could be seen as a "hack" of the role often assigned to contemporary artists today. Rather than confining ourselves to merely reflect on current scientific and political events, a task commonly expected from contemporary artists, we prefer to look back to a time when the arts and sciences were much more closely aligned, and when building things that worked and had scientific validity wasn't at all uncommon for both artists and scientists.

We also hacked various forms of knowledge production coming out of institutions like academia, especially in the sciences. Any knowledge presented as "fact" is usually conveyed in a voice of authority, aimed to assure a trusting public that the research conducted is serious, of significant value, and represents tax dollars or private funding well spent. With *Pigeonblog* we chose to adopt a "voice" that implied quite the opposite. Distributing information through the persona of a pigeon was not only a playful approach, but it was also meant to exemplify the importance of grass-roots scientific initiatives in a world where science is usually conducted by the very few that are "in the know," for later disclosure to the "unknowing many." In a similar vein, we chose information distribution methods that represent the opposite of a carefully planned official statement or announcement. Rather we were reporting "from the trenches" as the project unfolded.

Pigeonblog was developed and implemented in Southern California, which ranks among the ten most polluted regions in the country. Its aims were: (1) to invoke urgency around a topic that has serious health consequences but lacks public action and commitment to change; (2) to broaden the notion of a citizen science while building bridges between scientific research agendas and activist-oriented citizen concerns; and (3) to develop mutually positive work and play practices between situated human beings and other animals in techno-scientific worlds.

When thinking of pigeons, people often think of the many species found in highly urban environments. Commonly referred to as "flying rats," these birds and their impressive ability to adapt to urban landscapes aren't always seen in a favorable light by

their human cohabitants. At least by association, then, *Pigeonblog* attempted to start a discussion about possible new forms of cohabitation in our changing urban ecologies, and made more visible an already existing world of human–pigeon interaction. At a time where species boundaries are being actively reconstituted on every level, a reinvestigation of human to non-human animal relationships is more important than ever.

Pigeonblog was inspired by a famous photograph of a pigeon carrying a camera around its neck taken at the turn of the twentieth century. This technology, developed by the German inventor Julius Neubronner for military applications, allowed photographs to be taken by pigeons while in flight. A small camera was set on a mechanical timer to take pictures periodically as pigeons flew over regions of interest. Currently on display in the Deutsche Museum in Munich, these cameras were functional, but never served their intended purpose of being used as an assisted spy technology during wartime. Nevertheless, this early example of using living animals as participants in surveillance technology systems provoked the following questions: What would the twenty-first-century version of this combination look like? What types of civilian and activist applications could it be used for?

The "Science" Behind the Art

Facilities emitting hazardous air pollutants are frequently sited in, or routed through, low-income and "minority" neighborhoods, thereby putting the burden of related health and work problems on already disadvantaged sectors of the population who have the least recourse to defend themselves against this practice. Recent studies have revealed that air-pollution levels in Los Angeles and Riverside counties are high enough to directly affect children's health and development.

With homing pigeons serving as the "reporters" of current air-pollution levels, *Pigeonblog* attempted to create a spectacle provocative enough to spark people's imaginations and interest in the types of action that could be taken to reverse this situation. Activists' pursuits can often have a normalizing effect rather than one that inspires social change. Circulating information on "how bad things are" can easily be lost in our daily information overload. It seems to me that artists are in the perfect position to invent new ways in which information can be conveyed, and participation can be inspired. The pigeons became my communicative objects in this project and "collaborators" in the co-production of knowledge.

Pigeonblog also helped to provide entry into the health and environmental sciences. The largest government-led air pollution control agency in Southern California is the South Coast Air Quality Management District (AQMD), covering Orange County and the urban areas of Riverside and Los Angeles counties. Despite AQMD's efforts, in addition to major air-quality improvements achieved since the 1905, pollution levels in the region still surpass national regulatory health standards. In 2005 ozone levels exceeded the federal health standard for ozone on 84 days, or nearly one-quarter of the calendar year.

In addition to simply displaying the data, the project addressed the way in which air-pollution measurements are currently conducted. The South Coast AQMD controls 34 monitoring stations in its district. These are fixed stations that cost approximately tens of thousands of dollars per station. Each station collects a set of gasses restricted to its immediate surroundings. Values in between these stations are calculated based on scientific interpellation models. Stations are generally positioned in quiet, low-traffic areas, not near known pollution hot spots, such as power plants, refineries, and highways. The

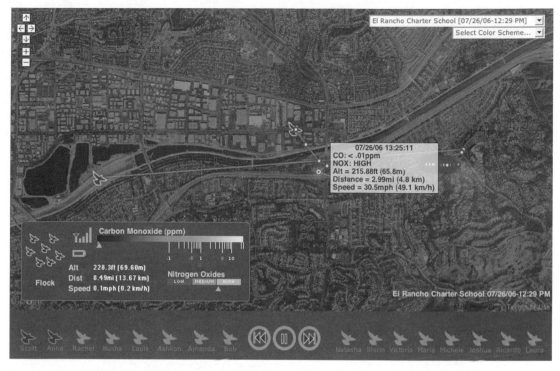

Figure 17.4 A *Pigeonblog* pollution visualization.

rationale behind this strategy is to obtain representative values of the urban air shed as opposed to data "tainted" by local sources in the immediate surroundings.

Our "pigeonbloggers" had the potential to test these interpellation models. Not only were they collecting the actual information while in transit, but they also were flying at about 300 feet altitude, an altitude that has proven difficult to assess by other means. In fact, most flying targets are themselves sources of pollution. Airplanes in particular have this problem, and obviously cannot easily fly at such a low altitude.

Recent behavioral studies of pigeons have revealed that in addition to the commonly accepted theory that pigeons orient themselves in relation to the Earth's magnetic field, they also use visual markers such as highways and large streets for orientation. Flying about 300 feet above the ground, pigeons are ideal candidates to help sense traffic-related air pollution, and to validate pollution dispersion in those regions. Depending on the location of the initial release, the pigeons could also report ground-level information at locations were AQMD-sanctioned monitors were not available.

The pigeon "backpack" developed for this project consisted of the sensor/GPS/GSM units already described. In addition to the GPS and communication elements, the unit also contained the corresponding antennas, a temperature sensor, and other supporting electronic components. Because of its design, we essentially ended up developing an open platform, short message service (SMS) enabled cell phone, available to be rebuilt and repurposed by anyone who is interested in doing so. While the development of the basic functionality of this device took us about three months, miniaturizing it to a comfortable pigeon size took us three times as long. After some initial discomfort, many revisions, "fitting sessions," and balance training in the loft, the birds seemed to take to the devices quite well and were able to fly significant distances (up to 20 miles).

The pigeons that worked with us on the project belonged to Bob Matsuyama, a pigeon fancier and middle school shop and science teacher, who became a main collaborator in the project. He volunteered his birds for *Pigeonblog* and helped the pigeons train and interact with us. After many trials and test flights in Southern California with Bob and his birds, we felt ready to introduce the project to a larger audience. Pigeons flew on three occasions, once as part of the Seminar in Experimental Critical Theory, an event sponsored by the University of California—Irvine's Humanities Research Institute, and twice as part of the Inter Society for Electronic Arts (lSEA) Festival in San Jose. All three of these events took place in August 2006 and the observing human audience members got a chance to interact with the birds and retrieve the collected pollution information. The birds that worked with us in San Jose belonged to a local San Jose pigeon fancier.

The reactions to *Pigeonblog* were diverse. The work was embraced and applauded by many, but there were also critical comments by others, primarily the People for the Ethical Treatment of Animals (PETA), who accused *Pigeonblog* of animal abuse and conducting non-scientifically grounded experiments. PETA's campaign did not result in action beyond the public statement issued by the group, but it tainted the experience for a brief moment. Animal abuse was certainly not practiced as part of the project, nor was animal rights a topic that the project was hoping to create public dialogue around. *Pigeonblog* was cross-species art in action, and the collaboration with the birds was central to the project. However, on a more positive note, PETA's critique raised very important questions regarding the legitimacy of arts/science experiments. PETA's accusations were built on the belief that *Pigeonblog* was not scientifically grounded and should therefore cease its activities. Is human–animal work as part of a creatively inspired political action somehow less legitimate than the same type of activity when framed under the umbrella of science? Apparently so in the case of PETA, but why?

The device itself also raised the interest of many people. There were, of course, the "technophile fans" of the project who simply admired the "coolness factor" of putting electronics on birds. More significant to us, however, was that environmental health scientists queried us to learn about the technology we developed, and wondered if the device could be used for their own research, which was geared toward tracing pollution exposure to humans. Another group of people who inquired about the project were ornithologists (both professional as well as hobbyists) looking for cheap and feasible ways to track birds of all kinds. Finally, there were the many emails from pigeon fanciers around the country wanting to become involved in the *Pigeonblog* project itself by contributing their pigeons, as well as environmental activists who simply wanted to be supportive of the project's goals.

Whereas the technophile fans were perhaps the least interesting community to us, it was at least partially linked to the type of work that technoscience artists engage in. Communities that had questions regarding the technology and its potential usefulness for other research endeavors, though at times surprising, made a certain sense to us. After all, the project did produce a very small, lightweight, and inexpensive device that couldn't be purchased commercially. But what we didn't expect at all was to receive an invitation to participate in a Defense Advanced Research Projects Agency (DARPA) grant geared toward the development of small, autonomous aerial vehicles designed around the aerodynamics of birds! Nor did we expect their related inquiries regarding the feasibility of measuring pulmonary artery pressure in birds during flight. I was quite surprised, as it seemed obvious to me from this work that a DARPA grant is the last thing we would want to be involved with, and that I am neither a biologist nor a

veterinarian. I was quite curious as to why I was suddenly being associated with areas of expertise that I was in no way qualified to respond to.

I think one of the answers is certainly evident in the ways that *Pigeonblog* and its collaborators were portrayed by the media. Major national and international newspapers as well as national television and radio news channels ran stories about the project. In nearly every instance, I was referred to as "Beatriz da Costa, researcher at the University of California ..." Researcher implied "scientist" for many people, far more than "artist," so it is not surprising that the audience of such broadcasts would assume I was from the hard sciences as opposed to the arts. The fact that such reports often centered on the technology component of the project also contributed to that perception.

This experience made me think quite hard about future directions I might take with *Pigeonblog*. I wondered if the project lost its political potential by becoming too closely associated with the university, and by my association as an "agent" working within it. How should *Pigeonblog* continue? Should I focus on potential contributions to "hard science," and link *Pigeonblog* data to existing air-pollution models in order to justify the project's scientific validity to criticism raised by groups such as PETA? And what would this approach entail? Would large amounts of money now have to be raised to conduct a "scientifically sanctioned" study? Would pigeons have to be flown for several years, eventually accumulating enough data to publish results in a scientific journal rather than at an arts festival? Wouldn't this end up creating the same trap of eventually developing expertise while becoming less accessible to a non-expert public? Is this how I'd want to spend my time as an artist?

For me, at the time of the project, I think the most inspiring and gratifying inquiry came from the Cornell University Ornithology Lab, which asked me to serve on the board of its current *Urban Bird Gardens* project, which is part of its citizen science initiative. The citizen science initiative involves bird observation and data gathering conducted by non-expert citizens, ranging from the elderly to schoolchildren. Unlike other "outreach" programs conducted by universities around the country, Cornell's citizen science initiative actually uses the collected data as part of its research studies. Several projects conducted under the citizen science agenda, such as *PigeonWatch*, *Urban Bird Studies*, and now *Urban Bird Gardens*, overlapped in their aim and audience with the ambitions *Pigeonblog* set out to address—creative outreach, political engagement, and participatory science. *Pigeonblog*'s original aim was to situate itself between the academy and non-expert participants. While a link to the institution was maintained, we continued to operate as a small group of individuals, intent on "hacking," on taking apart, re-examining and reassembling models of knowledge gathering, information distribution, and public participation.

Note

1. *Pigeonblog* development team: Beatriz da Costa (artist), Cina Hazegh (engineer), Kevin Ponto (engineer), Rufus Edwards (scientific consultant), and Bob Matsuyama (pigeon fancier) and his homing pigeons.

18 JOYCEWALKS

Conor McGarrigle

Key Words: *Dérive*, Detournement, "The Logic of Selection," Mash-up, Psychogeography

Project Summary

JoyceWalks is a participatory art project which uses Google Maps to remap routes from James Joyce's *Ulysses* to any city in the world, generating walking maps for participants to explore the city of their choice adopting the form of the Situationist *dérive*.

Project Developer Background

JoyceWalks had its origins in an older 2006 web project, *The Bono Probability Positioning System (aka Google Bono)*,[1] which presented itself as a service for visitors to Dublin, claiming:

> We know that for a visitor to Dublin an important attraction is the possibility that they may see U2 frontman and international celebrity Bono. The Bono Probability Positioning System version 2 Google Bono (beta) utilises Dublin's extensive surveillance camera network in conjunction with facial recognition software, Google Maps and advanced probability techniques to allow visitors to determine the probability of seeing Bono in any of the most probable locations in Dublin's city centre in real time.

The site was a Google Maps mashup which located live feeds from Dublin city's extensive traffic camera network on a map of Dublin, allowing the site visitor to view live feeds of the city while giving the probability that they would see Bono at that particular loca-

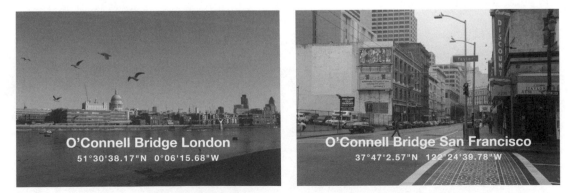

Figure 18.1, 18.2 Two views of the O'Connell Bridge as interpreted by *JoyceWalks* participants.

tion. Interestingly, the project, while obviously not all it claimed to be, was taken up by U2 fan sites (of which there are a surprising number) and tourism sites. It had obviously assumed another role, presumably as a useful interface to live camera views of Dublin, for U2 fans and for potential visitors to Dublin. I liked the way that the project had quite unintentionally taken on these multiple identities: as a net.art project being exhibited at festivals and, for whatever reason, as a popular site for U2 fans and tourists, and it led me to think more about designing projects which would facilitate its users in their own interpretations, taking the work beyond my original intention.

Introduction to Joycewalks.com

Project Description

The project is based on the annual June 16 Dublin Bloomsday celebrations where Joyceans and tourists follow in the footsteps of Leopold Bloom on his travels through the city, re-enacting the fictional events of *Ulysses* in a major event of the Irish cultural tourism calendar.

JoyceWalks remixes the cultural trail of Bloomsday by transplanting the routes from Dublin to any other city in the world where, removed from their local significance, they are transformed into an obscure set of instructions to be used for navigating urban space in new and unexpected ways. The project draws on the Situationist technique of the *dérive*[2] (or "drift") which involves exploring the city according to sets of predefined instructions and seeks to provide a framework for participants to employ while building a critical and creative engagement with the city. *JoyceWalks* overlays the physical space of the city with a conceptual remapping allowing the user to navigate familiar streets as if they were the Joycean streets of 1904 Dublin, allowing the participant to re-enact the (fictional) footsteps of Leopold Bloom wherever they may be located.

The project has both web- and street-based components; participants create an individual walking route for the city of their choice, print out their customized map, and use the map as a guide to exploring the city. Participants have the option to also document their walk with videos and photographs and to share these on the *JoyceWalks* site as a Google Maps mashup.[3]

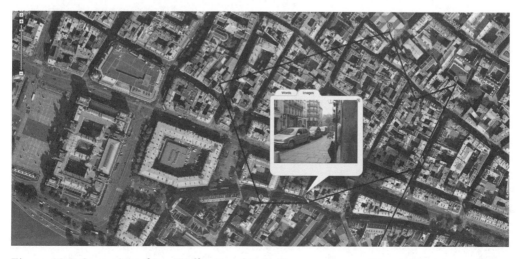

Figure 18.3 Screenshot of *JoyceWalks* created in Paris.

Project Background

The original impulse which led to the creation of Joyce Walks was threefold; First, I was interested in exploring the Google Maps mashup as a platform for art in a way that would play against the dominant idea of the mashup as an informative tool.

Second, I wanted to develop a project which would facilitate ephemeral, playful interventions in urban space drawing inspiration from the technique of the *dérive* developed by the Situationists in the 1950s and 1960s which would, even in a small way, re-enchant urban space.

Finally, I was interested in the nature of the participant's role in "participatory art" with a particular focus on whether a truly participatory experience, that is, one in which participant action can transform the meaning of the work to the point where it can be thought of as having a shared authorship, is in fact possible.

These aims coalesced into *JoyceWalks*, a Google Maps mashup that provides the user/participant a method of navigating the city designed to subtly disrupt expected modes of operation, in effect a *dérive* generator using the locative capabilities of the Google Maps infrastructure to allow the user to wander aimlessly, with purpose. To this end I adopted and remixed the notion of the cultural trail, in this case Bloomsday, but any spatially expressed cultural activity would work.

The cultural trail, a familiar mainstay of the tourist industry in almost any city, represents the spatial commodification of culture in what Sharon Zukin characterized as "the symbolic economy of cities."[4] Without dwelling too much on the role of culture in the modern urban economy, it will suffice to say that cultural trails are a known quantity. We understand how they operate, we can predict expectations about trails, and it is this familiarity which makes them the perfect tool for disrupting our experience of the city through the process of remixing and reframing at work in *JoyceWalks*.

Technical Description

Before exploring the concepts behind *JoyceWalks* I want to briefly discuss how it works on a practical level.

The project comprises the following four interconnected sections: the routes, the online component, walking in the city, and documenting the traces.

The Routes

The starting point was the annual Bloomsday celebrations in my native Dublin. Bloomsday is a typical cultural product that can be seen in almost any city in the world today. It involves re-enactment, a cultural trail, pageantry, a granting of locational identity to culture, and a renegotiation of the spaces of the city according to a predefined cultural narrative. It is celebrated by retracing the footsteps—preferably in Edwardian period costume while travelling in a horse and carriage—of characters from James Joyce's *Ulysses*, the actions of which unfold on a single day in Dublin in 1904. Many chapters in *Ulysses* have a clearly identifiable route followed by the characters in the course of the narrative, and it is these routes re-enacted every June 16 in Dublin which form the basis of *JoyceWalks*.

The original routes were first mapped out in Dublin using a GPS unit with a close adherence to the text of individual chapters of *Ulysses*. Each route selected takes place within a single chapter, nine or ten points of significance are identified and expressed as points of longitude and latitude with each point having an associated text from *Ulysses*—with the location specifically mentioned in the text.

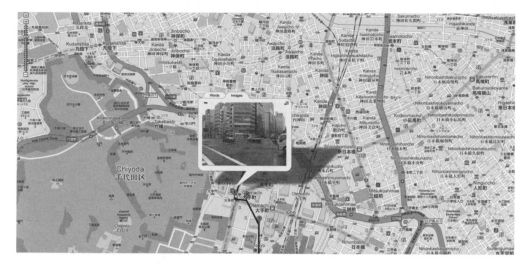

Figure 18.4 Screenshot of *JoyceWalks* created in Tokyo.

Online Component and Remapping

The main interface of *JoyceWalks* is the project website, *joycewalks.com*. To participate in *JoyceWalks* the user visits the website and is invited to create his/her own *JoyceWalk*. The first step is choosing a city to walk in. Through typing the name of a city, the interface loads a Google Map of the chosen city, you are then asked to select a center point, a crucial step as it creates a customized remapping unique to the center point selection. Finally, the user selects a chapter route from the menu and the route is automatically remapped to the city of your choice and displayed onscreen as a Google Map mashup. While displaying the new route in the chosen city, the mashup also allows the user to read the associated text for each point on the walks and to view a video of the original Dublin location.

JoyceWalks is based on the Google Maps API,[5] a set of programming tools which allow anyone to create their own application incorporating Google Maps. At a technical level the remapping is executed through a procedure of linear transformation (with the center point as origin) that moves each point of longitude and latitude to an analogous location in the new city. The newly remapped route is an isometric reflection retaining the relationship between all places of significance in the route; and it is in effect an exact copy of the original Dublin walking route. However, though it may be an exact Cartesian copy, transferring it onto the topology of a different city, where the cultural significance of the original locations is lost, renders each route as abstracted walking instructions. While these instructions have no local significance, they have curiously been found to still carry echoes of their original purpose.

Walking the city

JoyceWalks most importantly takes place at street level, each remapped route generates a printable walking map to guide the user on his/her walk. A facility to download a route to a GPS device as well as a mobile version are now under development but were deliberately left out of earlier versions to emphasize this traditional experience of trying to find your way with a map, a familiar locative experience and one very different in character to using the latest locative technologies to navigate the city.

To ensure the uniqueness of each generated walk the project has many in-built features to ensure variability; to map a route the user must select a center point of the city and the route is generated in relation to this center point, the points of the walk are draggable and repositionable, there is no snapping to the line of streets, points are joined by straight lines, taking them through buildings and obstacles which the walkers must negotiate at street level, increasing the routes' contingency on local conditions. In the practice of *JoyceWalks*, when shoe hits pavement, the clarity of the web drops away with the often confusing realities of navigating real space with these less-than-perfect Google Maps and the project stands or falls at this experiential level.

Leaving Traces: Documenting and Recording

A record of each walk created by *JoyceWalks* is saved as a map trace in a database. This database holds the most complete record of the project with every walk saved as a trace on a map as abstracted lines which are nonetheless suggestive of the activities they represent. After a walk is completed, participants have the option of uploading images or videos documenting their walk to create a Google Maps mashup. The database of all walks created is then searchable by city for other users to view the route walked and its associated images and videos. In this way, every walk exists as a trace on a map, as a memory of an experience personal to its participants and through the optional documentation of the experience. A tension always exists in live work between the work itself and the documentation of the work. This tension is emphasized in *JoyceWalks* as the work itself exists as an amalgamation of a multiplicity of experiences raising questions about the balance between open participation and appropriation. The question of documentation contributes to this, as it inhabits the shifting ground of authorship in the work addressing notions of the authenticity of co-authorship when the work is more clearly identified with one author.

Did Someone Say Participate?

The role of the participant is central to the *JoyceWalks* project. I would suggest that for a work to be participatory in any meaningful sense it must be significantly (re)created by the actions of the participants, and must go beyond the familiar approach of much participatory work in which the role of the participant is to "complete" or "activate" the work, while the authorship of the work remains very clearly with the artist. A key aim of the project was to explore whether a truly participatory experience, that is, one in which participant action can transform the meaning of the work to the point where it can be thought of as having a shared authorship, is in fact possible.

The approach I adopted was to create what I describe as a participatory framework which would internalize this essential freedom through supplying a set of tools which provided a set of procedures for action rather than dictating the mode of operation. To achieve this there is, of course, a need for the artist to relinquish some of their control over the work.

Even though this was a stated aim, I have to confess that sometimes I wish that every participant would document their walk extensively so that even though I cannot be there I can live vicariously through these documents. I am invested in the contemporary impulse to document everything in exhaustive detail, yet have to recognize that there is another way. Richard Long's 1967 *Line Made by Walking* shows a line in a field marked into the grass by repeated walking. As a record of activity the image is evocative,

suggestive but ultimately unknowable. Long describes it as a "distillation of experience"[6] which can never compete with that experience. These documents of experiences, to paraphrase Michel de Certeau,[7] can only ever refer to the absence of what has passed but miss the act of passing itself. Similar to Long's distillation, *JoyceWalks* begins with the act of passing, and its documentation, like the experience itself, is left to the participants. For the artist, the important thing is knowing when to relinquish control, allowing the work to be directed by the participant.

Knowing Your Tools

JoyceWalks adopts the form of the Google Maps mashup, a familiar format to most web users, but one that is not without its own problems. I adopted the mashup with the awareness that maps are not neutral, objective documents. Instead, they are subjective, political documents with an inherent logic that needs to be decoded.[8] Google Maps is in an unusual position because, while not immune to these criticisms, as illustrated by its willingness to blur out areas of their maps at the request of governments[9] or by the vast inequality of its coverage, it also offers users an extensive set of tools within its API with which to overlay the maps with users' own re-encoding of the space. While this offering assists in deflecting this criticism, it is not a panacea. Indeed there remains a persistent doubt over whether the format of the mashup itself really lends itself to criticality or is there, to invoke Lev Manovich,[10] an inbuilt logic of selection that favors mashups which locate Starbucks or crime rather than exposing systems of surveillance and control, or even critiquing the medium itself?

In response to these concerns the *JoyceWalks* approach differs in that whereas most mashups are informative in intent, mapping practical data or revealing hidden histories, *JoyceWalks* allows users to map an imaginary landscape. It overlays the physical space of the city with a conceptual remapping, allowing the user to navigate familiar streets as if they were the Joycean streets of 1904 Dublin, thereby allowing the participant to re-enact the (fictional) footsteps of Leopold Bloom wherever they may be. This re-encoding is designed to interfere with and disrupt the existing encoding of the space allowing for the temporary insertion of a space produced through the actions of its participants.

For me the work has two aspects: *JoyceWalks* my personal project and *JoyceWalks* the public project which operates at this point fairly independently of my involvement through its website. I think it is worth elaborating on the difference, as I suspect that the two modes of operation mirror the way *JoyceWalks* operates in the real world.

The personal project is an ongoing part of my art practice. It is a public performative work where typically I am invited to lead groups of walkers in the context of an art event or festival. Each performance is very different, drawing on the interests of the participants, the nature of the event, and the city where it takes place. These performances are then documented as part of my art practice. At another level, whenever I am in a new city I will normally walk a personal *JoyceWalk* as a way of getting to know the city beyond the obvious places, these walks are often not documented but have proven to be a very effective method of exploring and getting to know the psychogeographic contours of a new place. Personal feedback leads me to believe that this is a common use of the project.

Without my direct involvement, the public project is ongoing. The 24-hour *JoyceWalks* event was a concentrated version of this usage, enabling me to gain insight regarding user tendencies. I have found that documenting the walks and uploading images to create a mashup does not happen in the majority of cases. This makes sense in

many ways: if the point of the work is the event, then the documentation of it seems extraneous, especially in the current version where it requires access to a computer. The other possibility is that while the routes are mapped on the website, the walks never happen. While this is no doubt true in some cases, I get fairly regular feedback from participants, mostly in the form of brief notes, to say that they enjoyed their walk. So I presume that most walks do in fact take place.

24-hour *JoyceWalks*

For Bloomsday 2008, I put out a call for participants to plan and enact a Bloomsday *JoyceWalk* as part of 24 hours of psychogeographical action. The call was straight-forward: use the *JoyceWalks* site to generate a walking map for whatever city you will be in on June 16 and walk that walk. I also suggested, but did not mandate, that particip-ants document their walks with photographs and videos to create a Google Maps mashup using the *JoyceWalks* mashup generator. The call resulted in 80 walks taking place in 39 cities around the world with each walk being saved as a map in the search-able project database.

Twenty-four-hour *JoyceWalks* was, most importantly, a participant-led intervention. The event was organized with a minimal set of instructions or guidelines other than the basic instructions for mapping a route and walking that route on June 16. For the project to succeed it needed to retain an essential openness, to be non-prescriptive so that participants would determine their own mode of operation. Some walks were organized as group outings, some as solo strolls, while others were undertaken by artists already involved with psychogeographical projects such as those in Mexico City by Lab-oratorio de Situaciones[11] or in Jundiai, Brazil by Quadrafónica Urbana[12] who incorpo-rated it into their existing practice as a new technique. While some were extensively documented, others exist only as ephemeral events acknowledged only by a trace on a map. I know of at least one walk planned for Marrakesh which was abandoned when the walkers discovered that the Google Map bore no relation to the actuality at street level, an event which was a failure on one level but could still be considered as a successful psychogeographical exploration of the city. For me, the important aspect was that the project was adopted by the participants, that they made it their own, and that it responded to their concerns rather than simply enacting a part in a larger work.

Historical Perspectives: The Production of Tactical Space

To gain a perspective on the art historical and theoretical underpinnings of the project, I would like to go back to the writings on space and place of the influential French the-orist Henri Lefebvre. Lefebvre argued that urban space is a site of contestation and, in *The Production of Space*,[13] laid out what was at stake in his theory of spatial production. Space, according to Lefebvre, cannot be considered as an empty, neutral container in which objects and people are situated.[14] Rather, space is a social product, defined by a complex set of interrelationships and the "outcome of a sequence and set of opera-tions."[15] This production process results in a multiplicity of interconnected and overlap-ping spaces which influence, and are influenced by, each other. Space, Lefebvre suggests, is not superseded whenever a new space is produced, but rather each space overlays pre-viously produced spaces, resulting in a multi-layered space in which the layers "co-exist, overlap and interfere" with each other. That is, the dynamic relationship between these layers establishes the nature of social space.[16] Social space in turn acts as a tool of control

in that it is "what permits fresh actions to occur, while suggesting others and prohibiting yet others."[17]

If, as Lefebvre argues, space is in a state of continuous production, a state continually being brought into existence, then it is the process rather than the product which is of most interest. This leads one to an acceptance that location, for example as defined by a set of coordinates of longitude and latitude or by being named in a text, is of small importance in and of itself. Of greater significance is how that location is related to other locations and to the practices defining that location. It is the practice, the procedures, and the process that lead up to, for example, standing at a specific location as a participant in a locative art work that matter, rather then the GPS coordinates of that location.

In this sense I consider *JoyceWalks* as a producer of temporary ephemeral spaces produced by a complex set of interrelationships. The spaces produced take the properties of what Lefebvre called "lived space," where users transform and manipulate imposed space in order to make it their own.[18] This space disrupts and interferes with the existing spatial encoding and, I would propose, suggests new modes of spatial practice outside of existing spatializations.

The spaces produced by *JoyceWalks* can be further described by Michel de Certeau's account of space as the locus of tactics. De Certeau considered the very act of walking in the city as an act of "tactical" resistance, famously calling pedestrian movements "one of those real systems whose existence in fact makes up the city."[19] *Space*, according to de Certeau is *place* actuated by the "ensemble of movements deployed within it" which "occurs as the effect produced by the operations that orient it, situate it, temporalize it."[20] It could be said that space is place+practice and so the streets are transformed into the space of *JoyceWalks* through the actions of the participants as they walk the *Joyce-Walks* routes in a temporary transformative appropriation of place. In this way they can be considered tactical interventions as tactics, according to de Certeau, insinuate themselves into "the other place fragmentarily, without taking it over in its entirety."[21] They are opportunistic ways of operating within a system, of manipulating the imposed system and turning it to its own advantage.

JoyceWalks adopts these positions as a theoretical framework and sets out to provide a set of developing procedures to facilitate urban interventions which explore, reveal, and disrupt urban space, producing ephemeral spaces which "co-exist, overlap and interfere" with the spaces of the city producing temporary re-encodings of the spatial code which in turn facilitate alternative and critical spatial readings of the city. It is a hybrid work informed by Situationist practice, by locative media, and by the tradition of the walking artist to develop a critical spatial practice that is participatory in nature and open-ended.

Conclusions and Outcomes

In considering whether the project is effective, or indeed even a success, I consider the role of *JoyceWalks* as that of a catalyst. It facilitates and allows for work to be made, for interventions to occur which would not have happened without it. These actions thus go beyond the confines of *JoyceWalks* and establish their own way of being, their own mode of operation independent from the project.

While it is important not to over-claim the significance of these small spatial interventions, I propose that these tactical appropriations of space have the potential to produce critical spatial knowledges—*JoyceWalks* is structured to retain an essential

openness in its offering of a set of procedures without a prescriptive mode of operating, so that while it is the action of the participants which actuates the space of *JoyceWalks*, they are not defined by it. The work hinges on the interaction between the walkers and the route with each space produced being a unique contingent spatio-temporal event. With almost 600 *JoyceWalks* in over 70 countries, each walk also sits within a larger ongoing work involving a geographically dispersed series of tactical interventions facilitating multiple re-encodings of the spatial code, enabling alternative and critical spatial readings of the city.

In its remixing of the cultural trail, *JoyceWalks* asks the seemingly simple question: What happens if you move it? Through displacing the cultural trail from the site of its locational identity, one assumes that it neutralizes that identity and removes not only its role in the construction of this cultural economy of the city but also, collaterally, the cultural resonance of its engagement with the text and site. In actuality the results are more nuanced and less straightforward than they would appear. Certainly the geographic displacement neutralizes the specifically locational elements of the narrative but in the process forces a re-engagement with the idea of the cultural trail. *JoyceWalks* remains a cultural trail, but one in which the operational conventions have been disrupted. It reframes the cultural trail not as an instrumentalized spatial product of the cultural economy but as a socio-spatial production of a temporary, ephemeral space. As the project shifts between the certainties of its online presence with the all-encompassing, totalizing viewpoint of Google Maps to the often confusing realities of navigating through the *JoyceWalks* remix of the cultural trail, participants must reimagine its meaning, reinvent its procedures, and rethink the mode of operation. Through this process, the participants produce a temporary re-encoding of the spatial code which in turn facilitates alternative and critical spatial readings of the city.

Notes

1. Google Bono no longer functions because the majority of Dublin city camera feeds have been taken offline. A version is still available at www.stunned.org/bono/googlebono.htm.
2. Guy Debord, "Theory of the Dérive," in *Situationist International Anthology*, ed. Ken Knabb, Berkeley: Bureau of Public Secrets, 2006: 62.
3. A mashup is a webpage or application that uses or combines data or functionality from two or more external sources to create a new message or service.
4. Sharon Zukin, *The Cultures of Cities*, Cambridge, MA: Blackwell, 1995.
5. Application programming interface.
6. Statement carried on Richard Long's official website: www.richardlong.org (accessed May 15, 2010).
7. Michel de Certeau, *The Practice of Everyday Life*, Berkeley: University of California Press, 1984: 97.
8. The approach introduced by what has become known as critical cartography, of whom the best-known proponent was J.B. Harley with his 1989 essay "Deconstructing the Map," *Cartographica*, 26, 2, 1989: 1–20.
9. Google maps images with intentionally obscured data, Wikipedia: http://en.wikipedia.org/wiki/List_of_places_blurred_out_on_Google_Maps (accessed June 15, 2010).
10. Lev Manovich, *The Language of New Media*, Cambridge MA: MIT Press, 2001: 123–129.
11. www.flickr.com/photos/laboratoriodesituaciones.
12. http://quadrafonica.blogspot.com.
13. Henri Lefebvre, *The Production of Space*, Cambridge, MA: Blackwell, 1991: 86.
14. Ibid.: 68.
15. Ibid.: 73.
16. Ibid.: 86–87.

17. Ibid.: 73.
18. Ibid.: 39.
19. De Certeau, op. cit.: 97.
20. Ibid.: 117.
21. Ibid.: 32.

Bibliography

Batty, Michael. "Thinking about Cities as Spatial Events." *Environment and Planning: Planning and Design*, 129, 1, 2002: 12.

de Certeau, Michel. *The Practice of Everyday Life*. Berkeley: University of California Press, 1984.

Harley, J.B., Paul Laxton, and Center for American Places. *The New Nature of Maps: Essays in the History of Cartography*. Baltimore, MD: Johns Hopkins University Press, 2001.

Kluitenberg, Eric. "The Network of Waves Living and Acting in a Hybrid Space." *Open*, 11, Hybrid Space, 2006: 6–16.

Knabb, Ken. *Situationist International Anthology*. Berkeley: Bureau of Public Secrets, 2006.

Kwon, Miwon. *One Place after Another: Site-Specific Art and Locational Identity*, Cambridge, MA: MIT Press, 2002.

Lefebvre, Henri. *The Production of Space*. Cambridge, MA: Blackwell, 1991.

Manovich, Lev. *The Language of New Media*. Cambridge, MA: MIT Press, 2001.

Pickles, John. *A History of Spaces: Cartographic Reason, Mapping and the Geo-Coded World*. London: Routledge, 2004.

Wood, Denis. *The Power of Maps*. New York: Guilford Press, 1992.

Zukin, Sharon. *The Cultures of Cities*. Cambridge, MA: Blackwell, 1995.

Links

Google Maps API: http://code.google.com/apis/maps/index.html.
JoyceWalks: www.joycewalks.com.
GoogleBono: www.conormcgarrigle.com/google_bono.htm.
Situationist Texts Online: http://library.nothingness.org/articles/SI.
Bloomsday: www.jamesjoyce.ie/listing.asp?id=29.

PART X
PERFORMANCE AND ANALOG COUNTERPARTS

INTRODUCTION

Ken Goldberg

Like bread, data is freshest the moment it's made. Though the Internet can deliver information at nearly the speed of light, most of its data has been stored in memory for days or weeks. We accept the short shelf-life of data like news, sports scores, and stock quotes, but in some cases, data is created fresh on request.

When artists encounter a new medium they ask: what can it express that could not be expressed before? For the Internet and digital networks that are the subject of this book, there are many possible answers. One unique quality of net.art is its potential to facilitate live, visceral experiences that are accessible beyond the gallery or theater. The idea is to use the network to incorporate elements of "telepresence": a live connection with a distal (in contrast to virtual) analog environment, installation, or performance. This can be especially powerful when the artist creatively employs the participatory, bi-directional aspects of the network to actively engage the audience as participants rather than spectators. In the mid-1990s, Nina Sobell, Emily Hartzell, and Richard Wallace experimented with presenting weekly improvisational performances using an Internet webcam and chat system from a studio at New York University. Such performances can be highly engaging and raise the possibility of sustaining availability over time. Incorporating mechanical elements such as machines and robots can allow a telepresence installation to remain online 24/7 for months or years. Even as early as the 1980s, artists used the standard telephone interface to allow participants to control a mobile robot with camera on community access television. A challenge associated with all electrome-chanical systems is to move beyond the novelty, or "gadget" factor to create resonant and aesthetically powerful experiences. One key is to raise questions in contexts beyond the system itself.

The two artists featured in this part, Joseph DeLappe and Jonah Brucker-Cohen, have established international reputations by incorporating physical elements into their web-based artworks to create experiences rich in historical and cultural allusions.

Joe DeLappe integrates the distal and virtual in his Spring 2008 re-enactment of Mahatma Ghandi's 1930 march in protest at the British salt tax, *The Salt Satyagraha Online.* Alluding to the Hindu origins of the term "avatar," DeLappe performed a 240-mile "march" through the virtual terrain of Second Life. To create a visceral element of engagement and subjectivity, DeLappe engaged his own body by building a treadmill interface that directly linked his walking with that of his avatar. DeLappe performed the march on the treadmill over a three-week period at the Eyebeam space in New York.

DeLappe's hybrid performance, which references Marina Abromovic and Ulay's *Great Wall Walk*, raised the prospect of civil disobedience in a political climate charged by the contentious 2008 U.S. Presidential campaign.

In contrast, Jonah Brucker-Cohen incorporates physicality into a web-based installation that playfully engages with violence and deconstruction. *Alerting Infrastructure!* (2003–) references Chris Burden's 1985 "Samson" installation, where a turnstile mechanically converts the entry of each visitor into an incremental advance of a battering ram that translates popularity into literal breakdown of the gallery walls. Brucker-Cohen brings this classic work into the twenty-first century with a website where each remote visit ("hit") activates a jackhammer that pummels the wall of the gallery where it is installed (in over a dozen galleries in nine countries). This installation might be interpreted in terms of Marx and Schumpeter's theories of creative destruction and is reminiscent of the performances of Survival Research Labs. The work can also be viewed as a jarring reminder of the events of September 11, 2001.

Artists like DeLappe and Brucker-Cohen continue to explore how new representations can express new knowledge. But representations can misrepresent.[1] The web can provide access to remote agency without institutional authority. If Orson Welles' 1938 production of *War of the Worlds* was the defining moment for radio, what is the defining moment for the web? Just as the inventions of the telescope and microscope in the seventeenth century moved epistemology to the center of intellectual discourse for Descartes, Hume, Locke, Berkeley, and Kant, the web has the potential to recalibrate our definitions of knowledge and experience in the century ahead.[2]

Notes

1. Nelson Goodman, "Art and Authenticity," in *Languages of Art*, Indianapolis: Hacket Publishing, 1968.
2. Ken Goldberg, ed., *The Robot in the Garden: Telerobotics and Telepistemology in the Age of the Internet*, Cambridge, MA: MIT Press, 2000. Archive of networked telerobots: http://goldberg.berkeley.edu/art/tele.

Bibliography

Goldberg, Ken, ed. *The Robot in the Garden: Telerobotics and Telepistemology in the Age of the Internet*. Cambridge, MA: MIT Press, 2000.
Goodman, Nelson. "Art and Authenticity." In *Languages of Art*. Indianapolis: Hacket Publishing, 1968.

19 THE GANDHI COMPLEX
The Mahatma in Second Life

Joseph DeLappe

Key Words: Durational Performance, Game Art, Gandhi, Mixed Reality, Second Life

> The rhythm of walking generates a kind of rhythm of thinking, and the passage through the landscape echoes or stimulates the passage through a series of thoughts. This creates an odd consonance between internal and external passage, one that suggests that the mind is also a landscape of sorts and that walking is one way to traverse it.[1]

> There is certainly a relationship between the synthetic world and the real one, and it is quite real on both sides.[2]

Project Summary

From March 12 to April 6, 2008, I re-enacted Mahatma Gandhi's Salt March to Dandi in Second Life using a treadmill. This work of durational performance entitled *The Salt Satyagraha Online: Gandhi's March to Dandi in Second Life*, coincided with the 78th anniversary of the Salt March, Gandhi's seminal act of non-violent resistance to British rule. The original march was made in protest at the Salt Act of 1882 and has been considered the historical turning point in Gandhi's struggle against Great Britain's rule of India; the re-enactment took place at Eyebeam Art and Technology in New York City and in Second Life. During the project I walked 240 miles (386 km) on a customized treadmill that translated my steps to control the steps of my avatar, MGandhi Chakrabarti,[3] as he/I/we journeyed throughout the online territory of Second Life (SL).

The live and virtual re-enactment of the walk took place over the course of 26 days, averaging six hours and ten miles a day (three rest days were taken that coincided with those taken on the original march by Gandhi and his followers). The *Salt March Reenactment* was the first of a series of mixed-reality projects, performances, sculptures, and actions involving the interpretive reification of Mahatma Gandhi as avatar, inspiration, foil, and muse. The following will detail the background, development and implementation, technical description, conclusions, and outcomes of this experiment in mixed-reality performative re-enactment.

Figure 19.1 *The Artist's Mouse* by Joseph DeLappe.

Project Developer Background

In 1998–1999 I produced my first works that involved computer games. I created a mechanical appendage that attached a pencil or paintbrushes to my computer mouse. *The Artist's Mouse* was invented to reverse-engineer this ubiquitous desktop interface device while at the same time creating a way to track mouse movement utilizing analog art-making tools. Eventually I moved toward using this device while playing computer games, as the mouse action was typically rather intense during game play. The first game played utilizing my contraption was the original version of *Unreal*, first released in 1998. Replacing my mouse pad with 10 × 10" sheets of paper, I proceeded to play using the pencil-equipped mouse. The results were quite unexpected—I had created abstract drawings that literally mapped the experience of playing through several levels of this very popular and violent first-person shooter (FPS) game.

Soon thereafter I began to engage in online multiplayer games, starting with *Quake*. I continued to use *The Artist's Mouse*, eventually creating larger drawings, some taking as long as a month to create, that represented all of my computer usage.[4] In playing *Quake*, I was struck by the use of texting to communicate between players—typing on a keyboard while immersed in such a fully realized 3D graphic virtual gaming environment seemed wonderfully anachronistic. Two years later, in the spring of 2001 I used the texting system in my first gaming performance in a multiplayer game—*Howl: Star Trek Elite Force Voyager Online*. Entering the game as "Allen Ginsberg," I proceeded to perform his seminal Beat poem *Howl*, carefully typing the entirety of his poem through the text messaging system. The performance took close to six hours. I was a neutral visitor. I did not shoot, I simply stood still, typing, to be killed again and again in what could be considered a Sisyphean process of performance, death, and reincarnation. At the time I had no idea whether this was interesting or important or innovative. This was truly a creative experiment in what I thought of as online street theater taking place in a new kind of public space.

The Artist's Mouse and *Howl* were followed by a series of textual, performative, interventionist actions, including such works as the *War Poets Online: Medal of Honor*, *Quake/Friends* and *Et tu Sir Alfred*, 2003, *The Great Debates* in 2004 and, more recently, the ongoing *dead-in-iraq* project which began in 2006.

dead-in-iraq is an act of memorial and protest. I type all the names of U.S. military casualties of the Iraq War into *America's Army*, the wildly popular online recruiting and marketing tactical FPS game funded by the Defense Department. Though my previous online works share a common conceptual and critical stance toward engaging popular culture, *dead-in-iraq* and the ongoing *iraqimemorial. org*[5] are much more overtly politicized. While the former focuses on U.S. military casualties, the latter creates an online context for artists to propose imagined memorials to

Figure 19.2 *Quake/Friends* by Joseph DeLappe.

the many hundreds of thousands of Iraqi civilian casualties from the war. The terrorist attacks of 9/11, the Iraq War, the war in Afghanistan and the ongoing "War on Terror" have focused my creative energies as an artist—I shifted from works that critically and humorously "played" computer games and culture, to works that seek to actively use the Internet to engage in overt political agency. Author Rita Raley refers to this work as "not necessarily an attempt to cease play but a kind of play against play."[6]

Figure 19.3 *dead-in-iraq* by Joseph DeLappe.

iraqimemorial.org and, particularly, *dead-in-iraq* proved to be foundational in how I conceptualized Gandhi as my performative avatar. The creation and eventual dissemination of *dead-in-iraq* resulted in severe verbal attacks on my person, both from within and outside of the game. Gamers typed comments ranging from "STFU" to "Not this cunt again!" to "someone should go and break this guys legs!" As the work became widely covered in the media, the resulting emails, comments to articles, and blog postings heavily criticized my efforts to utilize the *America's Army* game as a forum for protesting and memorializing fallen U.S. soldiers.[7] Many questioned my patriotism, my motives, and my chosen venue. The criticism typically involved some form of the "This is just a game!" comment or the "why don't you go protest on the steps of the federal building" stance (to this I would reply, "This IS the federal building," but I digress).

dead-in-iraq was perhaps unique in my experience as an artist, as I found that what began as a personal gesture became a bit of a media phenomenon. Through interviews and by directly engaging the aforementioned commentators and bloggers attacking my work, I found myself interacting with my work's audience while the work was still being created.

Nietzsche famously said: "If you gaze long into an abyss, the abyss will gaze back into you."[8] *dead-in-iraq* and *iraqimemorial.org* both, respectfully, yet critically, draw attention to very dark and disturbing subject matter. The basic impetus behind both of these works was to draw attention to the brutal and senseless nature of the war in Iraq. The constant negative feedback when engaging in politically unpopular actions are, of course, not unexpected—yet to constantly be attacked, criticized, and generally vilified by those you are trying to reach eventually takes a toll. The effect of focusing my creative energies upon issues of death and war, on a personal level, was not entirely positive.

Both before and during their execution, these works involved intensive research into the context of historical memory and history of protest. When researching protest over the past 100 years, all roads inevitably lead to Mahatma Gandhi. His creative and innovative ideas, actions, and beliefs have profoundly transformed the very notion of protest. As I read further into the life and writings of Gandhi, I discovered his unique ability to approach acts of self-sacrificing, physical protest with a sense of joy, humor, and love that was undeniably inspiring. I found solace in his words, his actions, and his fortitude in the face of great opposition. The first notion of directly engaging the Mahatma in my creative pursuits occurred during a text-based debate with one of my many detractors. The writer, in the midst of attacking me for my work, accused me of "having a Gandhi complex." I found it quite curious that this would be considered a pejorative. The resulting work is, in part, a way to reply, "If you say so!"

Introduction to Gandhi in Second Life: On the March

MGandhi's Salt March in Second Life began on the southwestern edge of the largest mainland on March 12, 2008. MGandhi followed a basic navigational strategy in SL: walk toward other avatars, greet them, describe the nature of the re-enactment, offer to be "friends," share a copy of his walking stick, and invite others to join him on the march. Very specific rules were set for my travels in SL, including a strict avoidance of the typical "in-world" transportation methods of flying and teleporting from one location to another unless absolutely necessary (i.e., when confronted with the end of an island or region in order to get to the nearest landmass, or, more often when MGandhi haplessly strolled onto many of the private areas featuring automated security controls that would remove my avatar by teleporting me hundreds of miles away—this became a random if unintentional method of navigating the rather large expanse of SL). But mostly, MGandhi walked.

At the start of the journey, I was not sure if I would be bored or find myself uninterested by spending such extended periods within the confines of Second Life—SL had generally failed to secure my interest in the past. Yet the journey was fascinating every step of the way—the sense of discovery and wonder was intense. Walking on the treadmill to propel my avatar in-world created an odd synthesis of physical labor and virtual exploration that undeniably intensified the experience. Gandhi believed wealth without work to be meaningless. I found the walk to be fulfilling in part due to the sweat and exertion necessary to explore this online space—contrary to the other 50,000+ residents in-world at any given moment, I was physically earning the environment that was being projected upon the wall in front of my treadmill.

Moreover, the typically private act of engaging in online activities from a home computer was transformed into a public, physical spectacle. I stopped along the way to chat with hundreds of avatars, informing each one as to the nature of my "walk across Second Life" telling them that "my human is on a treadmill making me go." Residents of SL were generally very happy to see me—several sought me out day after day to join me in the walking. At Eyebeam, many stood next to me or sat behind me in easy chairs, watching transfixed or talking with me as I navigated through SL. One spectator who watched me for over an hour said it was curious, just as MGandhi was my avatar she was starting to think of me on the treadmill as hers.

By the end of the re-enactment I had lost eight pounds and became so in synch with MGandhi that my ability to clearly delineate between the online and the real world had become temporarily muddled. On more than one occasion I found myself wanting to "click" on people, and experienced brief instances of SL déjà vu during off hours in New York City when suddenly a subway stairwell would briefly transport my mind's eye to an equivalent memory of my virtual travels. When I walked on

Figure 19.4 MGandhi chats with another avatar in Second Life, Joseph DeLappe.

the treadmill I further reinforced this confusion of physical and virtual space—it became a daily occurrence to find myself nearly falling off the treadmill whenever my Gandhi avatar stumbled, whether due to connection lag or virtual misstep while scaling a mountain.[9]

The 240-mile march across SL with my treadmill powered Gandhi ended on April 6, 2008, at a reproduction of the commemorative statue that sits at the beach in Dandi, India.

Technical Description

The primary technical issue presented by the treadmill-powered march through SL was how to adapt the treadmill as a game controller. In solving the problem of enabling a treadmill for my purposes, I extensively researched the use and invention of exercise machines adapted as gaming devices through a variety of online sources. Utilizing a treadmill was not, in and of itself, particularly innovative; in fact, my first clear option was to buy a version of a treadmill game controller, *The Gamerunner*.[10]

Sadly, *The Gamerunner* was unavailable for purchase and remains so to this date.[11] As such, I investigated a number of hacks and DIY projects online, while also seeking input from fellow researchers at Eyebeam. What I found interesting was that, of much of the advice from several more technically adept individuals (MIT-trained electronics engineers among them), the suggested solutions were often innovative and creative, but tended to go overboard in the use of digital hardware and programming to solve what was, in actuality, a fairly simple technical problem. To make one's avatar walk in SL, one pushes either the "W" key or the forward arrow key. I surmised, correctly, if I could find a way to translate the movement of the treadmill into what the computer would recognize as the activation of the forward arrow key, I would have my solution.

Eventually, I discovered two DIY hacks online that were combined to solve the problem. The first hack, found on instructables.com, allowed me to shortcircuit a standard keyboard, thus appropriating the use of the aforementioned forward arrow key to work in concert with a treadmill.[12] I combined this hack with online instructions on how to enable an exercise machine to walk an avatar in SL using a standard, powered treadmill.[13] From this example, I attached magnets to the flywheel of my treadmill to activate a reed switch, appropriated from a bicycle odometer, that I then wired into the shortcircuited keyboard's forward arrow key—thus creating a simple, if inelegant, solution. This combination of hacks resulted in my Gandhi avatar walking a bit faster than the default speed of others in SL as the magnets and reed switch functioned to essentially mimic what would be a constant tapping of the forward arrow key. This became one of those "happy accidents," as the Mahatma was a notoriously fast walker in real-life, often leaving much younger followers struggling to keep up.

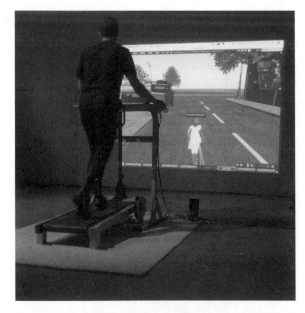

Figure 19.5 Joseph DeLappe walks his avatar through Second Life using a treadmill.

I chose a Nordic Track *Walkfit* self-powered treadmill that I found on eBay for less than $200. The "self-powered" treadmill was crucial, as the nature of my walk through SL would require me to start and stop as needed. Of course, electricity powers the vast majority of treadmill machines on the market today. Moreover, it would have been more than a little contradictory to recreate Gandhi's Salt March utilizing such a motorized exercise machine. Gandhi was a champion of physical labor and self-sufficiency—he was not opposed to technology, but believed "The machine should not tend to make atrophied the limbs of man."[14]

The *Walkfit* treadmill was wonderfully analog in design and usage, it featured wood trim and a simplicity that was very appropriate to the re-enactment. To allow me to stand, walk, and interact with my computer while on the treadmill, I created a tall desk mirroring the design of a commercially available product that incorporates a treadmill for standard office usage, the *Steelcase Walkstation*.[15] To complete the performance environment, I installed the entire unit upon a 6×8 sisal rug which faced the large screen projection of my point of view in SL.

Historical Perspectives

When I first performed in FPS games and online communities, a formative insight was the consideration of these online virtual environments as a new type of public space. Street theater, contemporary performance art, popular culture, and everyday experiences greatly influenced my intentions, perspective, and thought processes.[16] As the Salt March re-enactment was proposed and created at Eyebeam Art and Technology in New York, I was keenly aware of the city's rich history of works exploring durational aspects of performance art. I consider the Salt March re-enactment to be, in part, an homage to these earlier works, albeit with the inevitable migration into virtual environs, the new public commons.

Linda Montano visited my university while I was in graduate school in the late 1980s. I was deeply affected by her work and in particular her dedication to time-based works of extreme duration. In *7 Years of Living Art*,[17] she lived each year in one color, making her entire wardrobe and living and work spaces the same hue, based on corresponding colors taken from the Hindu Chakra. In other works, she famously tethered herself to the artist Sam Hseih for a year and practiced fortune telling as a performance art—these works I found undeniably powerful.[18] Laurie Anderson's early New York City street-based performance *Duets on Ice*, where she played violin while standing in ice skates encased in blocks of ice and performed until the ice melted, has long been a personal favorite. Joseph Beuys' 1974 seminal durational performance *I Love America and America Loves Me* greatly impacted me; besides spending three days in a New York gallery with a live coyote, I was intrigued by his belief in "social sculpture," works made with the intention of shaping society and politics. Ant Farm's *Eternal Frame*, the 1976 video documenting this San Francisco-based collaborative's re-enactment of John F. Kennedy's assassination in Dallas, Texas, is a personal favorite, too.

Additionally, walking as a methodology of performance art has a powerful lineage in contemporary art history—one that deeply influenced my conceptual development. Some works include: Marina Abromovic and Ulay's 1988 *Great Wall Walk*; Richard Long's 1967 *Line Made by Walking*; and Vito Acconci's 1969 *Following Piece*, where the artist followed strangers on the streets of the city until they entered a private space.

Outside the world of contemporary performance art, various comedy sketches influenced how I approached developing creative strategies to perform online. Of particular

note in this regard is *Monty Python's Flying Circus*, episode 11, which features the wildly absurd "Bately Townswomens' Guild Presents the Battle of Pearl Harbour." In this sketch, the male cast dresses in drag to act as old ladies bashing each other senseless with purses in a muddy field, a unique re-enactment of the famous World War II battle.[19] Further into the realm of comedy, I would count the work of Andy Kaufman as particularly influential, specifically his legendary readings of F. Scott Fitzgerald's *The Great Gatsby*, word for word, to confused and angry audiences.

Conclusions and Outcomes

Contemporary reenactments and their means are slowly eroding the need for accountability to an original source and relying instead on the efficacy with which its performance, or the reproduction of that performance, can act as an emotional and interpretive link between the past and our imperfect present.[20]

I have not the shadow of a doubt that any man or woman can achieve what I have, if he or she would make the same effort and cultivate the same hope and faith.[21]

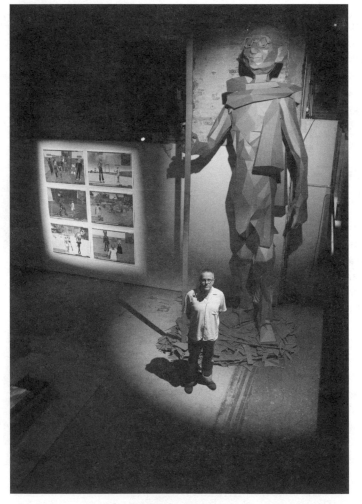

Figure 19.6 Joseph DeLappe with his 17-foot cardboard Gandhi.
© Christine A. Butler.

Gandhi's March to Dandi in SL continued my interest in expanding the possibilities of durational, interventionist performance in an online context; but it was also simply an extraordinary experience. In the days that followed the end of the re-enactment, the feeling of great euphoria was slowly overtaken by melancholy—I found myself both saddened and conflicted upon the conclusion of the march. I missed MGandhi and the daily experience of the re-enactment.

Over the course of the march I had been thinking about how best to document and, in a way, process the experience into a series of documentary artifacts and objects. Performance art is fleeting in its very nature, but there is a history of durational and one-time events that is accessible and relevant due to documentation and artifacts. Toward this end, the march was copiously documented with screenshots and video of the treadmill re-enactment in action. Yet I was interested in making the

documentation more corporeal. To further explore my emotional connection with my avatar, and to attempt to physically embody the enormity of the experience of being MGandhi, I extracted the 3D model from SL and processed this information into several sculptural renditions of my avatar. I started small with a diminutive eight-inch-tall 3D print made using rapid prototyping equipment. Utilizing the same 3D data, I eventually made a series of gigantic sculptural reproductions of the avatar, recreated as complex polygonal recreations entirely from cardboard.

17-Foot Cardboard Gandhi

While walking in SL I began to envision a monumental-sized Gandhi figure. Most statues of Gandhi, including the one in New York at Union Square, are roughly human scale. Creating a larger-than-life representation of my MGandhi avatar seemed audacious and oddly appropriate. I settled upon using a shareware application, Pepakura Designer,[22] the popular papercraft program used by enthusiasts to create some rather amazing, albeit generally tabletop-scale, reproductions of everything from anime figures to airplanes. I adapted this program to create a 17-foot-tall reproduction of my MGandhi avatar constructed entirely out of corrugated cardboard and hot glue. The resulting 17-foot figure is a monumental physical representation of MGandhi created from very simple materials. The figure was crafted at the same height as Michelangelo's *David*—a fitting conceptual connection to this iconic work of art that depicts the unlikely hero just before he slays Goliath. My entire sculpting process has been described and documented, in detail, on *instructables.com*,[23] which I see as an unorthodox but highly effective way to further share the results and methods of my work.

I set out on this "journey" for a variety of reasons—to pay tribute to the vision and creativity of Mahatma Gandhi, to continue to explore the nature of creative interventions in online spaces, to investigate notions of physical and virtual embodiment, to challenge the expectations of avatar representation, to incorporate bodily exertion and durational constraints to an online performance, and to see if I could perhaps discover, through the act of doing, something of what it would have been like to be Gandhi, to be like Gandhi, and finally, to further explore the very notion of protest. Furthermore, while conducting the Gandhi work in SL I continued to engage the *dead-in-iraq* and *iraqimemorial.org* projects—being MGandhi helped me to do so with a renewed sense of purpose. While the re-enactment certainly touched on the aforementioned concepts, the work ultimately functioned on a much more personal sphere; I found myself, unexpectedly, to be profoundly transformed by the experience.

Notes

1. Rebecca Solnit, *Wanderlust*, New York: Penguin Books, 2000: 6.
2. Edward Castronova, *Synthetic Worlds*, Chicago: University of Chicago Press, 2006: 47.
3. Chakrabarti was selected from the varying lists of predetermined surnames made available when registering a new avatar on SL. I chose this name originally for its connection to the Hindu "Chakra," and recently learned that this just happens to be the surname of an Indian writer, Mohit Chakrabarti, who wrote the book *The Gandhian Philosophy of Spinning-Wheel*, New Delhi: Concept Publishing Company, 2000.
4. These drawings were entitled *Work/Play*, involving all activities on my home computer. Over the years I continued this practice by migrating my contraption to my desk at the University of Nevada, Reno.
5. www.iraqimemorial.org.

6. Rita Raley, *Tactical Media*, Minneapolis: University of Minnesota Press, 2009: 106.
7. *dead-in-iraq* essentially went viral on the Internet. I was interviewed and featured on Wired. com, Salon.com, CNN Domestic and International, National Public Radio, along with numerous game-oriented websites and blogs.
8. Friedrich Nietzsche, *BrainyQuote.com*, Xplore Inc., 2010. Online: www.brainyquote.com/quotes/quotes/f/friedrichn103625.html (accessed June 13, 2010).
9. It became readily apparent over the course of the march through SL that this online community was not designed to facilitate travel on foot.
10. http://gamerunner.us.
11. I am actually quite happy that I did not utilize this commercial product, as the treadmill and desk I eventually used for the re-enactment allowed for a greater level of customization, both in terms of use and appearance.
12. www.instructables.com/id/Hacking-a-USB-Keyboard.
13. http://moriash.blogspot.com/2006/08/more-scenic-walk.html.
14. Louis Fischer, *The Essential Gandhi*, New York: Random House, 1962: 254.
15. www.steelcase.com/en/products/category/tables/adjustable/walkstation/pages/overview.aspx.
16. In the early 1990s, I briefly lived in Tampa, Florida. Driving onto the campus where I worked at the University of South Florida, I came upon a surreal vision. In the ungodly high heat of the summer, a group of medieval warriors in full period dress—jousting, pummeling, and otherwise attacking each other with padded weapons in large open fields of grass.
17. www.lindamontano.com/living_art/index.html.
18. During her visit to San Jose she read my palm and told me "You should be a priest."
19. Python (Monty) Pictures Ltd, 1969, episode 11.
20. Robert Blackson, "Once More … With Feeling: Re-enactment in Contemporary Art and Culture," in *Playback_Simulated Realities*, Edith Russ Site for Media Art, 2008: 126.
21. Eknath Easwaran, *Gandhi the Man*, Berkeley: Nilgiri Press, 1997: 145.
22. See www.tamasoft.co.jp/pepakura-en.
23. www.instructables.com/id/Build-a-17-Tall-Cardboard-Papercraft-Gandhi.

Bibliography

Blackson, Robert. *Once More … With Feeling: Re-enactment in Contemporary Art and Culture, Playback_Simulated Realities*. Edith Russ Site for Media Art, 2008.
Castronova, Edward. *Synthetic Worlds*. Chicago: University of Chicago Press, 2006.
Easwaran, Eknath. *Gandhi the Man*. Berkeley: Nilgiri Press, 1997.
Fischer, Louis, ed. *The Essential Gandhi*. New York: Vintage Books, 1962.
Raley, Rita. *Tactical Media*. Minneapolis: University of Minnesota Press, 2009.
Solnit, Rebecca. *Wanderlust*. New York: Penguin Books, 2000.

Links

www.delappe.net
http://saltmarchsecondlife.wordpress.com
www.instructables.com/id/Build-a-17-Tall-Cardboard-Papercraft-Gandhi
http://eyebeam.org

20 ALERTING INFRASTRUCTURE!
Challenging The Temporality of Physical versus Virtual Environments

Jonah Brucker-Cohen

Key Words: Access Logs, Cyberspace, Decay, Hits, Metaphor, *Samson*, Virtuality

Project Summary

Alerting Infrastructure! is a physical hit counter that translates hits to the website of an organization into interior damage of the physical building that the website or organization represents. The focus of the piece is to amplify the concern that physical spaces are slowly losing ground to their virtual counterparts. The amount of structural damage to the building directly correlates to the amount of exposure and attention the website gets, thus exposing the physical structure's temporal existence. The project has been active in nine countries (Ireland, Peru, Brazil, USA, Spain, Canada, Belgium, Germany, the Netherlands) to date.

Introduction and Historical Perspective: An Emerging Tangibility of Networked Information

In recent years, there has been an ongoing trend in both the media art world and research communities to expand methods of representation of digital information beyond the "virtuality" of the screen into physical or tangible forms. This is made evident by projects that attempt to add a physical component to the experience of visiting a website or those that represent data as some type of physical form or output. My interest in this shift of modes of representation lies in specific research and artistic projects that manifest network information as physical output but instill a critical analysis of the network interaction they represent. Physical output is important because it allows digital objects and instantiations to exist on the same level as the people who experience them, i.e., in the physical or "real" world. This direct relationship also allows for a clearer and more substantive understanding of how these systems exist on a human scale and not purely within the computer screen or on the Internet. One example of such a shift was Natalie Jeremijenko's *Live Wire* (1995) project, a dangling string that shook back and forth to signify network traffic on the Local Area Network (LAN) at the Xerox Parc Research Laboratory in Palo Alto, California.[1]

This was a primary example of a project that used simple output to convey a seemingly complex set of relationships about a network and those who used it. By glancing at the string at any given point in time, one could get a sense of how many people were on the premises, the amount of data traffic moving through the LAN, and, although the "wire" did not provide details about activities occurring on the network, the estimated "productivity" of employees became visible. Another example of this type of networked visualization was *Pinwheels* (2001),[2] a project completed in the Tangible Media Group at the MIT Media Laboratory.

This project manifested stock-market data as spinning pinwheels on the wall of the laboratory. The faster or slower each of the pinwheels spun, the better or worse the particular stock associated with the given wheel was reporting that day.

Pinwheels added a physical display to the ambient information of the stocks trading at the stock exchange. By shifting this information into the background and peripheral areas of the space (and subsequently the visitor's mind), an ambient notification of the trading activity communicated through the network was manifest in physical space. Both of these projects represented a "shift in context" of seeing networked information purely on the screen, to creating a tangible connection to the information through physical objects that inhabit the same space as those retrieving the data. Also showing stock-market data in a physical format is *The Source*, created by the UK-based artists Greyworld. *The Source*, an eight-story-high kinetic sculpture situated at the London Stock Exchange, consisted of a grid of cables arranged in a square with nine spheres on each cable that moved independently up and down the cables. Each sphere acted as an animated pixel that showed fluctuations in the current stock market in order to give a visual physical depiction of the state of the economy at any given point in time. This project exemplifies a networked sculpture that enabled data visualization to occur outside of the screen while functioning as an alternative display system for a public dataset.

Technical Description: Networking Multiple Perspectives with *Alerting Infrastructure!*

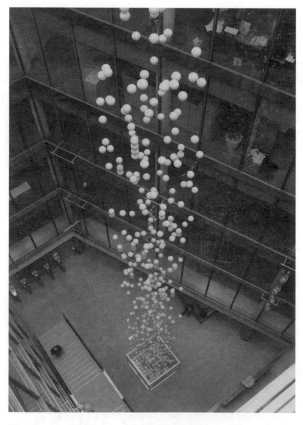

Figure 20.1 *The Source* © Greyworld.

Relating to this theme of representing virtual activity as physical movement or actions, I created *Alerting Infrastructure!* in 2003 to exhibit interactive elements that rely on two separate vantage points: (1) users directly experience an event in the form of physical realization; (2) users trigger this event through a form of online interaction. These vantage points were combined in the project to form one interactive experience that relied on understanding multiple perspectives to be communicative. My intent was to provide a clear connection between the contexts I addressed (online and physical) in order to maintain a critical approach to each context and question their connection to each other through typical forms of interactivity. In most cases, a typical interaction with the Internet takes place from the home, office, school, or on the street through a desktop or laptop computer or mobile phone. These experiences usually involve the World Wide Web (WWW) as an interface to the Internet, allowing people to browse websites coded with

HTML (HyperText Markup Language), make transactions, and interact with client-side software (such as Java applets, Adobe Flash movies, Javascript, and so on) that can operate in a web browser. Most, if not all, of these types of interactive experiences are displayed on a computer monitor, cellular telephone, or PDA (Personal Digital Assistant) screen. Thus, many of our experiences with online spaces take place through some form of display technology.

Recognizing this ubiquitous screen-based paradigm, *Alerting Infrastructure!* departed from the relationship between interaction and display by imparting a physical action that responded to what was previously a virtual, screen-based relationship between users and websites. The fundamental intention of the project was to distinguish the connection between physical locations and their online "equivalents." The project displayed and provided information about the physical locations and the organizations they represented. By imparting a physical relationship between the two locations, new associations could form between people visiting these spaces and their understanding of how "connected" the world around them could be. Imparting these types of physical consequences also raises questions about how physical structures such as buildings and the organizations that occupy them are losing importance to their virtual counterparts. Does a website hold more inherent meaning than the structure or organization it represents? This could be argued in two ways: first, since a website can undoubtedly receive more visitors than a physical structure, it is possible for the website to gain more attention and subsequently more importance than its physical counterpart. Second, since a website does not degrade or deteriorate after prolonged use or exposure, it maintains its ability to deliver the same experience to visitors over time without regular maintenance, aside from updating the content. Charles Jonscher writes about how "visits" to a website should not be seen as "physical visits." This type of interpretation is an example of the standard belief that this form of "visit" was or is not possible on the Internet:

> The visitors would be "surfers", people going from site to site on the Internet to see what others had posted up for them to see. The Internet would cease to be just a private domain where people might send each other messages (although that would still happen): it would become a very public domain in which, in effect, anyone could become a publisher. Put up your news on your website and then sit back and wait for visits. These would of course not be physical visits— more like peeks through a long-distance but very sharp lens.[3]

Alerting Infrastructure! and projects like it prove that these types of interactions are not only possible but also help to instill new understandings of online interaction through creating connections between web users visiting online spaces and people simultaneously inhabiting the physical locations represented by those online spaces. In particular, *Alerting Infrastructure!* recreates online presence in physical spaces and demonstrates how people could affect both spaces.

When further examining the connections between physical and online worlds, there is evidence that the naming conventions and metaphors associated with online systems are often misleading in their relationship between their virtuality and the physical reality for which they were named. Examples of these misconceptions range from Albert Gore's interpretation of the Internet as an "Information Superhighway"[4] to software names such as "Portals" that consist of software or websites designed to allow users simultaneous access to multiple resources online or the traditional "Desktop" metaphor.[5] Often, these naming conventions have little to do with the action or function of the object or software

in question and are more consistent with the branding and hype associated with the introduction of new technologies. Metaphors can change the way we relate objects and locations to imposed and implied meanings, and can often lead to new understandings and relationships between these objects.[6] The example of the ubiquitous term, "search engine," which can be defined as "computer software used to search data (as text or a database) for specified information or a site on the World Wide Web that uses such software to locate key words in other sites," has become so ingrained in our digital lifestyles that most people would not be able to function or navigate the Internet without it.[7]

Alerting Infrastructure! followed this trend of questioning the metaphor in the common lingo, "hits." The project interprets "hits" on a website as one that has both a virtual effect on the server, and a physical effect on the space referenced by the website. Online visitors caused a jackhammer to create a physical "hit" on the outside or inside of the building related to the website, in order to deconstruct the conventional method of assessing how sites gain visitors and global attention on the web. In addition to viewing the destruction of an actual building, visitors could also see the amount of destruction their visit caused by viewing a hit counter on the website. This information allowed for a closer connection between the virtual visitors and the space they were affecting. *Alerting Infrastructure!* was successful because the relationship between the destruction imposed by the drill and the virtual hits to the online component was a reminder that physical space is not often impacted by virtual attention. From 2003 to 2009, the project was installed 12 times in nine countries. Also, the project was successful because it showed how physical space was becoming less necessary for organizations and individuals to own, occupy, and maintain, since virtual destinations can have countless more visitors without showing any visible signs of decay from use over time. *Alerting Infrastructure!* literally showed the deconstruction of physical space by our increasing use of digital space. As more people visited the gallery website, as opposed to the gallery itself, the gallery deteriorated.

The physical effect of this installation was similar to *Samson*[8] (1985), a project by Los Angeles-based artist, Chris Burden, that consisted of a mechanical structure of wooden beams that sustained the roof of the gallery.

As visitors' bodies were counted upon entering the gallery (via a turnstile), the beams were forced against the wall. The more visitors that entered the space, the further the beams would push outward, eventually leading to the room's collapse. This installation not only instilled fear in the gallery visitor because the walls could collapse at any moment, but also made visitors question the fundamental relationship between the structure and the space it occupied.

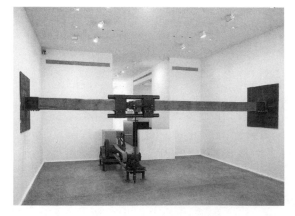

With *Alerting Infrastructure!* this relationship was compounded by the fact that virtual spaces are also gaining in momentum as valid replacements for some physical locations and other forms of tangible media. The project created a visual event to demonstrate the simple connection between an online visitor and how that visitor might affect the physical space represented by the website.

Figure 20.2 *Samson*, Chris Burden, 1985. Photograph © Zwirner and Wirth, NY.

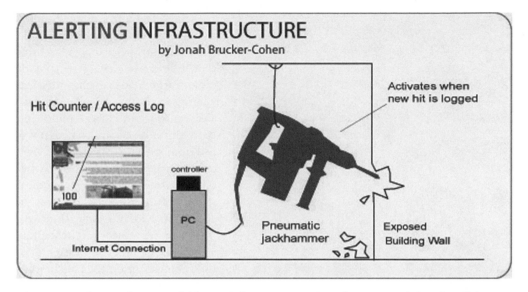

Figure 20.3 System diagram of *Alerting Infrastructure!* 2003 web view, Jonah Brucker-Cohen.

The project, however, did not address subtleties of this connection such as how far away the virtual visitor was from the physical structure relating to the website, or why they were visiting the site. Also, I did not track unique visitor hits on the website, therefore when one continually refreshed the page, the jackhammer would turn on. This may have contributed to an incorrect correlation between the amount of web traffic and the destruction caused by the jackhammer.

Despite an exponential amount of "bricks and mortar" spaces maintaining online presences, there is minimal connection between the people simultaneously inhabiting these two spaces.[9] *Alerting Infrastructure!* was created to amplify the concern that physical spaces are slowly losing importance in relation to their virtual counterparts. The project exposes the temporal nature of real-world spaces by causing structural damage to the buildings that directly correlates to their website's amount of exposure and attention.

Alerting Infrastructure! functioned by scanning access logs of a website for new unique visitor hits and translating each new hit into physical output in the form of activating a large pneumatic jackhammer. With each new virtual hit, the jackhammer slowly destroyed the walls of the physical building. Since websites and virtual interfaces can garner an almost unlimited amount of virtual hits without showing any visible signs of decay or extended use, the project illustrated a shift in context that the seemingly harmless act of visiting a website can have dire consequences in the physical world.

Despite these omissions, the insights gained from this project were that people enjoyed the sense of destruction caused by the drill in this

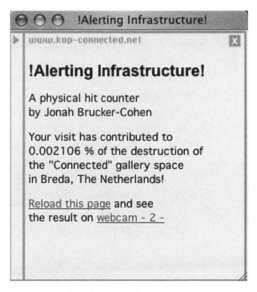

Figure 20.4 *Alerting Infrastructure!* online hit counter.

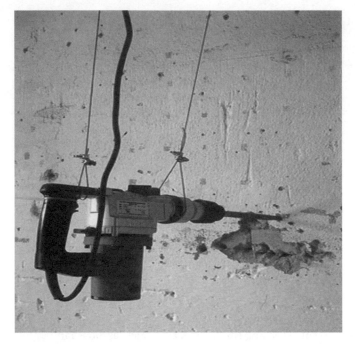

Figure 20.5 *Alerting Infrastructure!* installation view in 2006, Jonah Brucker-Cohen.

context. They felt a closer connection to the web visitors who were simultaneously visiting the website that represented the structure or organization where the physical visitors were standing. The project also made a clear connection between online visitors and physical visitors and demonstrated how online spaces are gaining in importance, while the role of physical spaces diminishes in terms of attention and visitors. Improvements to the project might include a more exact measure of each visitor's time spent on the page, rather than just counting each visitor.

This binary relationship was a good way of measuring attention to the site, but it would have been more accurate to count the number of minutes each visitor spent on the site and represent that number with destruction made by the jackhammer. *Alerting Infrastructure!* was one example of bringing one of the purely virtual characteristics of the Internet such as hits into the physical domain by creating an object that left a physical impression of virtual actions and activity. The project also connected virtual and physical spaces in order to provide a communications channel between the physicality of one type of space, translated into the decay of another form of space.

Conclusion

Diverging from the context of online spaces into those of physical spaces, *Alerting Infrastructure!* was a project meant to instill consequences into visitors to an online space such as a website. As Internet use steadily grows, the act of visiting websites has become a common and almost expected way of distributing and obtaining information. The act of typing in a website URL (Uniform Resource Locator) to access a page has become second nature to most people, regardless of their technical experience. The proliferation of websites as virtual representations of physical locations has also reached a saturation point.

Media theorist Wendy Hui Kyong Chun describes the connection between online and physical spaces as one that is difficult to place.[10] This could be because of the lack of obvious geographic properties in online spaces, despite most of them having direct relationships to physical places that they represent.

> Cyberspace lies outside all places and cannot be located, yet it exists. One can point to documents and conversations that "take place" in cyberspace, even if cyberspace makes such phrases catachrestic. Moreover, cyberspace as a heterotopia simultaneously represents, contests, and inverts public spaces and places.[11]

Indeed, cyberspace tends to counteract the typical properties of physical spaces since it cannot be "located" on a physical map nor can it even be ensured that specific locations can be re-accessed at future times in the same way as physical spaces. Disseminating this idea further, *Alerting Infrastructure!* existed as a unique bridge between these two spaces in order to provide a tangible form of connectivity between simultaneous visitors to both spaces, enabling them to connect in novel ways.

Notes

1. Natalie Jeremijenko, *Live Wire*. Online: http://tech90s.walkerart.org/nj/transcript/nj_04. html (accessed March 6, 2010).
2. Hiroshi Ishii *et al.*, "Pinwheels: Visualizing Information Flow in an Architectural·Space," in *Extended Abstracts of Conference on Human Factors in Computing Systems*, Seattle: ACM Press, March 31–April 5, 2001: 111–112.
3. Charles Jonscher, *The Evolution of Wired Life: From the Alphabet to the Soul-catcher Chip—How Information Technologies Change Our World*, London: John Wiley & Sons, 1999: 65.
4. Ibid.: 65.
5. Victor Kaptelinin and Mary Czerwinski, eds., *Beyond the Desktop Metaphor: Designing Integrated Digital Work Environments*, Cambridge, MA: MIT Press, 2007: 5.
6. George Lakoff and Mark Johnson, *Metaphors We Live By*, Chicago: University of Chicago Press, 1980: ch. 1.
7. Merriam-Webster's Collegiate Dictionary (10th edn.), Springfield, MA, 1994.
8. Chris Burden, *Samson*, 1985. Online: www.thecityreview.com/f01pcon1.html (accessed January 22, 2010).
9. Albrecht Schmidt and Hans-W. Gellersen, "Visitor Awareness in the Web." Online: www10.org/cdrom/papers/425 (accessed February 5, 2010).
10. Wendy Hui Kyong Chun, *Control and Freedom: Power and Paranoia in the Age of Fiber Optics*, Cambridge, MA: MIT Press, 2005: 52.
11. Ibid.: 52.

Bibliography

Berners-Lee, Tim and Mark Fischetti. *Weaving the Web: The Original Design and Ultimate Destiny of the World Wide Web by Its Inventor*. San Francisco: Harper, 1999.

Burden, Chris. Samson. *1985*. Online: www.thecityreview.com/f01pcon1.html (accessed January 22, 2010).

Chun, Wendy Hui Kyong. *Control and Freedom: Power and Paranoia in the Age of Fiber Optics.* Cambridge, MA: MIT Press, 2005.

Greyworld. "The Source." Online: http://greyworld.org/archives/31 (accessed May 14, 2010).

Kaptelinin, Victor and Mary Czerwinski, eds. *Beyond The Desktop Metaphor: Designing Integrated Digital Work Environments*. Cambridge, MA: MIT Press, 2007.

Ishii, Hiroshi, Sandi Ren, and Phil Frei, "Pinwheels: Visualizing Information Flow in an Architectural Space." In *Extended Abstracts of Conference on Human Factors in Computing Systems*. Seattle: ACM Press, March 31–April 5, 2001.

Jeremijenko, N. *Live Wire*. Online: http://tech90s.walkerart.org/nj/transcript/nj_04.html (accessed March 6, 2010).

Jonscher, Charles. *The Evolution of Wired Life: From the Alphabet to the Soul-Catcher Chip—How Information Technologies Change Our World*. London: John Wiley & Sons, 1999.

Lakoff, George and Mark Johnson. *Metaphors We Live By*. Chicago: University of Chicago Press, 1980.

Merriam-Webster's Collegiate Dictionary (10th edn.). Springfield, MA, 1994.

Link

Live Wire: http://tech90s.walkerart.org/nj/transcript/nj_04.html

INDEX

Page numbers in **bold** denote figures.